KASPER OP...

THE WAY OUT

INVISIBLE INSURRECTIONS AND RADICAL IMAGINARIES

IN THE UK UNDERGROUND 1961-1991

The Way Out: Invisible Insurrections and Radical Imaginaries in the UK Underground 1961-91
Kasper Opstrup

ISBN: 978-1-57027-328-5

Cover painting: *Sudarshana Chakra* by Ferdinand Ahm Krag (2016).
Photo credit: Kristoffer Juel Poulsen.
Cover & interior concepts by Jesse Jacob / jukas.dk
Interior layout by Margaret Killjoy

Released by Minor Compositions 2017
Wivenhoe / New York / Port Watson

Minor Compositions is a series of interventions & provocations drawing from autonomous politics, avant-garde aesthetics, and the revolutions of everyday life.

Minor Compositions is an imprint of Autonomedia
minorcompositions.info | minorcompositions@gmail.com
Distributed by Autonomedia
PO Box 568 Williamsburgh Station
Brooklyn, NY 11211

www.autonomedia.org
info@autonomedia.org

TABLE OF CONTENTS

ACKNOWLEDGEMENTS x

I. INTRODUCTION

1.1. Apocalyptic Futures of the Past 2

1.2. From Beyond 13

1.3. The Constraint of Souls 19

II. THE SIGMA PROJECT

2.1. On the Ecstatic Edge 36

2.2. First Connective Points: Beat, Situationism and the 1960s 41

2.3. Sigma – A Potted History 53

2.4. The Invisible Insurrection 63

III. THE ANTI-UNIVERSITY OF LONDON

3.1. Society as a Madhouse 76

3.2. The Anti-University 87

IV. THE POLITICS OF EXPERIENCE

4.1. Beyond Art and Politics 98

4.2. Lead, Follow or Get Out of the Way 105

4.3. Who Owns You? 115

V: ACADEMY 23

5.1. 'Curse, Go Back!' — 122

5.2. Academy 23 — 136

5.3. Wild Boys Always Shine — 144

VI: THEE TEMPLE OV PSYCHICK YOUTH

6.1. Our Aim is Wakefulness, Our Enemy is Dreamless Sleep — 152

6.2. The Frequency of Truth — 173

6.3. The Wastelands of the Real vs the Kingdoms of the Occult — 178

6.4. When Nothing is True, Everything is Permitted — 183

VII: INVISIBLE INSURRECTIONS AND RADICAL IMAGINARIES

7.1. A Sinister Dream Factory — 190

7.2. Across the Great Divide — 199

VIII: AFTERWORD

8.1. Conclusions — 206

ENDNOTES — 210

LIST OF WORKS CITED — 224

ACKNOWLEDGEMENTS

This work was produced in order to obtain the PhD-degree at the London Consortium, Birkbeck, University of London. It was largely written in the period from 2009 – 2012. The following is with only minor alterations identical to the original thesis.

With special thanks to Barry Curtis, Esther Leslie, Stewart Home, Mikkel Bolt Rasmussen, Fabian Tompsett, John Eden, Joe Berke, Mark Pilkington, Tania Ørum, Jakob Jakobsen, Peter Davis, Matthew Levi Stevens, Maitreyi Maheshwari, Kathleen Pullum, Oisín Wall, Stevphen Shukaitis, and Leo Zausen.

Dedicated to Aggi & Edgar.

I. INTRODUCTION

> I mean, brethren, the appointed time has grown very short; from now on, let those who have wives live as though they had none, and those who mourn as though they were not mourning, and those who rejoice as though they were not rejoicing, and those who buy as though they had no goods, and those who deal with the world as though they had no dealings with it. For the form of this world is passing away.
>
> - 1 Cor 7: 29-31

1.1.

Apocalyptic Futures of the Past

Are we on the brink of living in a drowned world? Or will the rise of the internet realise the promises of communism? Whether the future brings digital utopias or ecological disasters, the various hopes, fears and desires for a new age constitute a radical imaginary which is concerned with producing an unknown future which it, simultaneously, wants to produce a new type of wo/man to inhabit. It is a pre-occupation with living in if not the End Times then at least a post-apocalyptic wasteland where humanity ultimately is doomed and it resurfaces as the perennial popular belief that we are living at a time when humankind is in the midst of a great transformation, be it from the industrial to the digital or from the Age of Pisces to the Age of Aquarius. It is concerned with death but it is also concerned with survival and it poses the question: how should we live if we want to survive even though we probably are doomed? To the groups and collectives inspired by this imaginary, it has been evident that the Earth was heading for disaster but also that we have the technologies to prevent this disaster from wiping us out, meaning that these groups actively have been pursuing a project of human survival as a social and scientific challenge.

This cultural current can be traced back to medieval heresies like those of the Brethren of the Free Spirit or the Anabaptists that sought mystical unity with the godhead while they, simultaneously, often have been seen as proto-communist movements (Cohn 1957; Vaneigem 1986). In the language of hereticism, it is an idea that the Kingdom of Heaven is immanent, rather than transcendent. Besides giving birth to revolutionary hopes, dreams of

utopia, paradise on Earth and the Promised Land, it has influenced thinkers like Charles Fourier and Henri de Saint Simon, in turn becoming parts of the mythology of both anarchism and communism (Egbert 1970: 3-67).

The followers of this tradition desire to realise an Edenic state of primitive communism, but due to this double lineage stemming back to both social and religious movements, as much as this current is concerned with hopes for a new way of organising the world, it is concerned with a lurking fear that 'the dreadful' has already happened.[1] In order to produce communism, it is necessary to produce a new humanity – 'the production of man by man' as Marx puts it in his 1844 Manuscripts – but it is not an attempt at reinstalling an inner/outer binary. On the contrary, it shows a quest for a reconciliation of opposites which, as I will argue in what follows, is part of this tradition. In opposition to the Augustinian separation of the City of Man and the City of God and the Lutheran distinction between political and spiritual authority, already the anabaptist preacher Thomas Müntzer (c. 1488 – 1525) – who was one of the leaders in the German Peasant's War with the battle cry *"omnia sunt communia* – all things are common!" (Müntzer 1524) – viewed the transformation of inner or spiritual man, a theme drawn from his readings of Christian mystics, as inseparable from the transformation of the outer order (Toscano 2010: 71).

The millenarian remainder in our way of thinking is inherently linked to ideas of an end to the present order and the emergence of new future unknowns. These ideas found a new home among the various modernist avant-garde movements who desired to create a *tabula rasa*. By the early 20th century, the artistic avant-gardes had become not only repositories for radical political ideas but also millenarian ideas which in the last part of the century were a cultural mainstay. Take, for example, Theodore Roszak (1975: 48) who, when commenting upon the rise of New Age philosophy in parts of the counter-culture, defines it as a search for (a new) religion, but religion as a matter of experience, not of belief and transcendence, i.e. it was to be non-transcendental and immanent. Indeed, if one sees the counter-culture as a latent yearning for spirit alone, this goes a long way to explain the problematic relation to the 'thing' – by which I mean the commodity – in the counter-culture, leading to the once ubiquitous accusation of 'selling out' (Frank 1997; Heath et al. 2005).

During the 20th century, the millenarian desires earlier expressed through heretical movements found cultural expression on a mass scale. This move might be seen in parallel to the broader movement in the West towards a post-secular society where radical ideas got transferred from their original context – a socio-political one – and found second life arousing the cultural imaginary as myths and visions of future perfects. David Weir

(1997) has convincingly argued by using the case of anarchism that when political movements no longer have a social foundation, their ideas are often haunting the cultural imaginary. For instance, the rise of artists like Georges Seurat and other self-proclaimed anarchist artists happened at the same time that anarchism faded away as a social movement at the end of the 19th century. If we follow this line of thought, the same can be argued for religious ideas, that when they no longer create congregations of believers, they are likely to have an afterlife where religion can be treated dispassionately as a cultural phenomenon instead of in a theological perspective. As we shall see in my case studies, even though the language is often superficially religious, the effect is the opposite: an attempt at reclaiming transcendence from religious dogma.

The concern of this book is a peculiar brand of grandiose politics, related to the New Left but informed as much by speculation, dreams and wild desires as by any kind of realist politics. Indeed, it is politics as revelation. Due to its double lineage, bridging the chasm between 'inner' and 'outer' states, as much as this tradition is about social transformation, revolt and revolution, it is about what the alchemists of yore called 'the great work' which transforms not only base metals but also the self. It is concerned with revolution in the head, but it still dreams of smashing the system. Often, it takes the form of a type of surreal humour in the tradition of Dada in Berlin while it, roughly speaking, aims towards a state of realised communism combined with a new set of acephalous beliefs. The imagined future would consist not only of associations of free men working with the means of production held in common but also of the dissociation of ritual from belief, i.e. where the former is instrumentalised to create community by collectively expanding the limits of the self. The tendency to bridge the gap between inner and outer through an interest in combining political theory with radical psychiatry is conspicuous in the 1960s counter-culture in general where psychic emancipation was explicitly associated with social liberation. Opposing the war in Vietnam involved self-exploration as much as street politics. The cultural Left had thought about these issues before, though. In championing Marx and Freud simultaneously, the Surrealists, for example, had already in 1924 denounced capitalist business-as-usual as psychic repression in their first manifesto.

My primary interest over the following pages is to use a cultural history of a few initiatives from the London-based counter-culture of the 1960s and their aftermaths – a history which until now has not been written into the annals of neither art history nor political history – as a prolegomenon to understand and discuss our present and thus, in a way, to plunder this material for contemporary purposes. My four case studies shared a belief in that behaviour is dependent on social conditioning and that – after the

failure of the major political revolutions of the early 20th century, be they rightwing or leftwing – change is dependent on cultural revolution. In Marxist terms, they desired to create an apparatus for the production of subjectivity in order to intervene into the social reproduction of labour.

None of my case studies were ever fully realised which may be fitting since they revolved around notions of invisibility, clandestinity and secret societies. Conceptualised around 1961, sigma came closest to realisation in 1964 and had all but faded away by late 1967. The Anti-University of London existed from about late 1967 to 1970 in one form or another but only had a proper physical form with its own premises and so on during the spring of 1968. Academy 23 only ever existed as a series of articles in *Mayfair*, published in between 1968 and 1970, as well as the final chapter of William Burroughs's interview book from 1974, *The Job*. The Anti-University and Academy 23 can both be seen as bifurcations from sigma, just as sigma can be seen as a synthesis of Beat and Situationism. Many of the people involved like Alexander Trocchi, R. D. Laing, Joseph Berke and William Burroughs were or had been 'sigmanauts,' fellow travellers who, simultaneously, exemplify the inherent contradictions in the counter-culture of the 1960s.[2] This overlap between a group of people and a set of ideas in my case studies means that individual names often as not are used as a convenient shorthand for a group of collaborators. Finally, thee Temple ov Psychick Youth (TOPY) which existed from roughly 1980 to 1991 can be seen in direct continuation of the counter-culture as an attempt at realising Academy 23, thus bridging the gap between the counter-culture of the 1960s and the tactical media scenes of the 1990s.

More particularly, this book is an examination of a specific idea – the creation of a new type of university in order to instigate a new age on a planetary level through cultural production and experimental education, a task my four case studies approached through, respectively, a centre, an anti-university, an academy and a temple – as it was being performed by a pop-cultural clash between the remnants of the European avant-gardes and ideas from the budding US counter-culture. My aim is deliberately not to attempt to 'explain' these 30 years of cultural resistance and make it into a representation of a state of affairs. Rather than a politics of representation my concerns are with a politics of subjectivation. This means that I primarily will use my material to ask questions rather than to provide answers.

Overall, I examine the material as related to a science of apparatuses – or *dispositifs* in the terminology of French philosopher Michel Foucault whose inquiries into power, discipline and control, as we shall see, are fundamental for this field – or, better, a technology for cultural engineering. I

am interested in sketching not only the subjectivities and biopolitical utopias envisioned by my case studies but also the abstract principle behind these in order to make it possible for this knowledge to be taken up and expanded upon by anyone who wants to embody or express it in a concrete specificity.

In the public consciousness, the term 'cultural engineering' is often associated with the writings of behavioural psychologist B. F. Skinner who wanted to change the underlying contingencies in order to change man, a form of redesigning the environment to reach utopia which so far had eluded what Skinner called 'the literature of freedom'. This literature had according to Skinner (1971: 42-3)

> identified the other people and has proposed ways of escaping them or weakening or destroying their power [...] but it has made the mistake of defining freedom in terms of states of mind or feelings, and it has therefore not been able to deal effectively with techniques of control which do not breed escape or revolt but nevertheless have aversive consequences. It has been forced to brand all control as wrong and to misrepresent many of the advantages to be gained from a social environment. It is unprepared for the next step, which is not to free men from control but to analyse and change the kinds of control to which they are exposed.

To this end, Skinner found that "what must be changed is not the responsibility of autonomous man but the conditions, environmental or genetic, of which a person's behaviour is a function" (Skinner 1971: 75) which opens the term towards interpretation in terms of not only systems theories but also a system of apparatuses.

The way I am using the term is thus based on an approach to culture as if it was a closed system which can be manipulated not unlike the adaptive feedback system in cybernetics but ultimately based on a behaviourist proposition: that the interplays of human and machines can be described using a stimulus/response model which, in the context I am examining, is based on cultural techniques such as *détournement,* cut-ups and, in general, aesthetic and affective means. Both Alexander Trocchi and Genesis P-Orridge explicitly referred to themselves as cultural engineers. They wanted to awaken and activate the general intellect. In interviews, P-Orridge (2006: 283) calls himself a cultural engineer and explains his use of the term:

> Whilst Burroughs was indeed a classical literary figure of the Twentieth Century; and Gysin a classic Twentieth Century "Renaissance" artist – who together bequeathed to us through intuitive science, a method and a prophetic appreciation of meaning, a pivotal approach to questions of perception and the nature and origin of literature and art – they can only be fully appreciated and, perhaps, finally understood, in terms of their central and passionate inner agendas and obsessions when re-considered and re-assessed as serious, conscious and masterful creative/cultural alchemists and practicing magicians, a mission for which I have taken the linguistic liberty of coining the term/occupation 'Cultural Engineer'.

For P-Orridge, the term thus refers to being a 'cultural alchemist' who tries to effect change in the world by will alone while using popular culture as an alchemical jar. As such, his basic premise is to project his ideas into the public arena of popular culture to see whether they survive or not in their own right or what kind of interactions and confrontations they generate. The creation of TOPY was, for example, an attempt to "see what happens when de-mystified occult and shamanic practices are released non-hierarchically into popular culture" (P-Orridge 2008: 406).

It is a central part of my argument that the groups, collectives, affinities that I am analysing, can be seen as experiments with cultural engineering which, ultimately, would be on a planetary scale, rooted in a desire for the world to become if not utopia then most certainly another world. They desired to produce a new symbolic order, a cultural imaginary filled with images, snap-shots, assemblages of catastrophe, redemption and desire fulfilment; radical freedom to be whomever, nameless, wildness. As such, an obvious predecessor is Alexander Bogdanov who, besides being a systems theory pioneer, ran the Proletkult in the years immediately after the Russian revolution, thus facing questions of not only how to use art to exceed what one is able to articulate for oneself but also to assert the supremacy of transformation as an existential situation.

What these groups held in common was a desire to intervene in this shard of messianic time we call the present on the level of everyday life. Just as the artistic avant-gardes strived to merge art and everyday life, thus superseding the category of art, the politics of these initiatives are equally striving to merge politics into everyday life, going beyond both art and politics in order to supersede capitalist relations by producing new subjectivities. New forms of life produced by the meetings of messianism, Marxism and magick, a radically unknown future which has nothing to do with

what came before it. Ephemeral as it was, their production was a call for world revolution, carried out by artistic means and without any victims.

Often, these imaginaries aimed for a certain kind of communism but it was not just a 'simple' dichotomy between, on the one hand, a future primitivism (Zerzan 1994; Kaczynski 2010) or, on the other, one of the techno-utopias from popular science-fiction and fantasy (Nuttall 1967; Dery 1997).[3] Instead, it was a form of communism that is a withering away of the political itself; a concern for the creation of new socio-political commons from which our everyday worlds can be re-imagined. This merging between politics and life shows that an invisible politics of oppositional clandestinity must necessarily be a kind of biopolitics, a form of power that regulates social life from its interior, concerned with the production and composition of subjectivity and collectivity under capitalist social relations. It manifests itself as attempts at cultural engineering that aims at changing the world through creating an alternative apparatus which can produce new forms of life by producing a new kind of wo/men.

The aim was to produce something that does not yet exist, something we cannot know what will be. It would be the creation of something completely other, a total innovation. Therefore, as much as my analyses concern certain cultural objects, mind sets, assemblages of words, images and ideas, they are about life itself but not understood in any essentialist manner (Thacker 2010): it is about how we are living together and what spaces we create to live in, questions raised by cultural producers concerned with preparing for a Great Leap Forward where they one moment imagine they are Fidel's compañeros and the next that they are part of Chu Teh's Eight Route Army during the Long March.

Under the reign of bio-political, spectacular capitalism, questions around identity, subjectivity and collectivity are central for any discussion of future possibilities. Therefore, I will in the following tentatively introduce a theoretical framework – primarily the notion of biopolitics – within which to understand my historical analyses. Some researchers, especially in early British Cultural Studies, apply a Marxist model to the fields of cultural production, subcultures and anti-capitalism (e.g. Hebdige 1979). This strain of thinking has some influence from the Frankfurt School, but especially from the structuralist Marxism of, for example, Louis Althusser or the early Roland Barthes. The main focus of this more orthodox approach concentrates on the production of meaning where those who control the means of production, i.e. the economic base, essentially control a culture. Since my focus is centred around a notion of invisible insurrections, my approach is largely based on examining cut-ups of the superstructure with its ideas, dreams, visions, radical imaginaries where it is essentially about

producing ideas and memes in order to, in the extreme, control thought or, on a lesser level, influence how meaning acts through clusters of language and information. It represents attempts at connecting the general intellect with a social body. My concern is thus with an invisible and imperceptible politics which, at the same time, is open and psychedelic. It acts like a virus and spreads through contagion. It has become immaterial and moved beyond not only representation but also what is regularly understood as politics.

The notion of biopolitics finds its contemporary usage in the writings of Michel Foucault, appearing for the first time in his *History of Sexuality, 1: The Will to Power* (1976). Here he describes how power no longer focuses on the right to kill in order to protect a sovereign, but instead shifts its focus to the protection of a population. Before Foucault, the term had a hundred-year long history stemming from the *Lebensphilosophie* of Arthur Schopenhauer and Friedrich Nietzsche in Germany and Henri Bergson in France (Lemke 2011) and its lineage can be traced even further back to Greek antiquity as, for example, the Italian philosopher Giorgio Agamben (2006) does. In contrast, Michael Hardt and Antonio Negri (2009: 114) see it as connected to the response to the crisis in the 1970s where there was a shift from the welfare state to the neoliberal state which operates through biopolitical forms of production and control.

For Foucault, it was a means of describing a society where power and control have become internalised in behavioural patterns. He defined it as "the attempt, starting from the eighteenth century, to rationalize the problems posed to governmental practice by phenomena characteristic of a set of living beings forming a population" (Foucault 2008: 317). Major theorists who have expanded on Foucault's notion include, most prominently, Agamben as well as Hardt and Negri, but also thinkers like Paolo Virno and Maurizio Lazzarato. During the last decade, the notion has found common usage among intellectuals in order to reflect on such heterogeneous issues as the war on terror, the rise of neoliberalism as well as biomedical and biotechnological innovations such as stem cell research and the human genome project, evolution and engineering.[4]

In their trilogy of books (*Empire* (2000), *Multitude* (2003), *Commonwealth* (2009)), Hardt and Negri focus on a process of metamorphosis which can 'create a new society within the shell of the old' – as it says in the constitution of the Industrial Workers of the World (IWW) – through the biopolitical production of subjectivity. Biopolitics thus becomes a key scene of political action today, i.e. the struggle over control or autonomy of the production of subjectivity where the political project becomes about opening the way for mutation and free creation on the "biopolitical plan of

the immanence of social life" (Hardt et al. 2009: 17). They introduce a terminological distinction between bio-power and biopolitics (Hardt et al. 2009: 56), a distinction they find suggested by Foucault's writings even if not used consistently by him which I will not do either. Rather crudely, they define bio-power as the power of life and biopolitics as the power of life to resist and determine an alternative production of subjectivity. An alternative production of subjectivity takes the form of a biopolitical event which is always "a queer event, a subversive process of subjectivization that, shattering ruling identities and norms, reveals the link between power and freedom, and thereby inaugurates an alternative production of subjectivity. [...] Being is made in the event" (Hardt et al. 2009: 63).

Production, work, and its refusal are central. For Hardt and Negri, the capacities of bio-political labour power exceed work and spill over into everyday life. Since work has become immaterial, it is possible to think and form relationships in the street, at home, etc. and not only on the job. We, meaning everybody who works, in an office, a school, a factory as well as the unemployed and the underemployed (Shaviro 2011), are, thus, being exploited not only from nine to five, but all the time. Since the extraction of a surplus has extended well beyond the classic factory, this means an increasing appropriation of what Marx in his *Grundrisse* (1858) called the 'general intellect' – the accumulated knowledges and capacities of human life as a whole including things like habits, everyday practices, forms of know-how, etc. – by neo-liberal capitalism.[5] Thus, capitalism not only commodifies and sells quantifiable goods and services but also feelings, affects and ways of being.

Bio-political class struggle takes the form of exodus. By this, Hardt and Negri mean "a process of *subtraction* from the relationship with capital by means of actualizing the potential autonomy of labor-power. Exodus is thus not a refusal of the productivity of biopolitical labor-power but rather a refusal of the increasingly restrictive fetters placed on its productive capacities by capital" (Hardt et al. 2009: 152). This echoes Mario Tronti's classic statement of 'the refusal to work' from *Operaia e Capitale* (Work and Capital, 1965). The escape from control can be performed in a variety of ways and refusals, e.g. as vagabonds, by operating outside the field of representation, by using an imperceptible politics, etc. (see Papadopoulos et al. 2008).

Central to the production of subjectivities is the notion of the *dispositif*, commonly translated into English as 'apparatus' which is the word I also use. Foucault used the term increasingly from the mid-1970s onwards when he began to concern himself with what he called 'governmentality'. In a 1977 interview, he defined it as a network of heterogeneous elements

– discourses, institutions, laws, propositions, police measures, etc. – oriented by a strategic purpose. The apparatus itself is the network that can be established between these elements. It is a play of power which is linked to certain limits of knowledge that both arise from it and condition it, a set of strategies of the relations of force supporting certain types of knowledge (Foucault 1977). According to Hardt and Negri (2009: 126), it is constituted by the material, social, affective and cognitive mechanisms active in the production of subjectivity. Agamben (2006: 3) emphasizes that it is at the intersection of power relations and relations of knowledge, that it appears.

Agamben traces the etymology of the word *dispositivo* back to a theological legacy stemming from the Christian paradigm of *oikonomia* – the root of the word 'economy' – which is a set of practices, measures, and institutions that aim to manage, govern and control the behaviours, gestures and thoughts of human beings. For Agamben, the term "designates that in which, and through which, one realizes a pure activity of governance devoid of any foundation in being. This is the reason why apparatuses must always imply a process of subjectification, that is to say, they must produce their subject" (Agamben 2006: 11). It is thus anything that has the capacity to "capture, orient, determine, intercept, model, control, or secure the gestures, behaviours, opinions, or discourses of living beings" (Agamben 2006: 14). Agamben sees the phase of capitalism in which we live now as a massive accumulation and proliferation of apparatuses to the extent that today there is not a single instant in which the life of individuals is not modelled, contaminated or controlled by some apparatus (Agamben 2006: 15). The subject is exactly that which results from the relentless fight between living beings and apparatuses where the apparatus is first of all a machine that produces subjectifications. Only as such is it also a machine of governance (Agamben 2006: 20).

An apparatus is thus composed of bodies, technologies and discourses, traversing the traditional materialist categories of the economy and ideology while incorporating less quantifiable aspects such as affect. What is important in this context is that it operates on a level beyond representation; it is immaterial, invisible and works by forming our attitudes through assemblages of words, images, sounds, stimuli. As Hardt and Negri (2000: 319) argues, the production of subjectivity is essential for biopolitical capitalism since it becomes the "non-place of power" through which we are being controlled through desires, affects, ideas and the like as well as the economy.

In his essay, Agamben calls for a profanation of the apparatus. The refusal of identity, becoming invisible, might be one such counter-appropriation of the apparatus. The impetus towards clandestinity might then be seen

as an attempt to escape subjectification as a productive form. As we shall see in Chapter Two, this was central for Alexander Trocchi but it can also be seen as a strand in insurrectionary anarchism from Mikhail Bakunin (Cunningham 2010) to more contemporary groups such as CrimethInc, Ex-workers Collective, and the Invisible Committee, who a few years ago encouraged the insurrectionary Left to "[f]lee visibility. Turn anonymity into an offensive position" (Invisible Committee 2009: 112). What these groups have in common is that they view clandestinity, becoming invisible, as ways to avoid identification and thus articulate a refusal of spectacular, biopolitical capitalism by becoming anonymous and imperceptible. In general, the refusal of roles and identities in favour of anonymity, multiple names and pseudonyms has been a recurrent tactic within anarchist and ultra-Left pro-revolutionary milieus where it has been practiced by, for example, Amadeo Bordiga and Jacques Camatte among many others. As such, anonymity and collectivity can be seen as both a threat and a promise depending on whether one is on the inside or the outside: it is a threat of faceless terror but it is also a promise of solidarity and equality.

1.2.
From Beyond

Several critiques have been made of Negri's position and the division between bio-power and biopolitics. One of the most influential during the last couple of years has been the one coming from the group around the French magazine *Tiqqun* (2 issues, 1999 – 2001) in which the Invisible Committee also made its first appearance. Due to the group's explicit focus on apparatuses in the text 'A critical metaphysics could emerge as a science of apparatuses...', originally published in *Tiqqun 2* (2001), I will examine their ideas a bit more closely. For the Tiqqun group, Bloom, named after the main protagonist in James Joyce's *Ulysses* (1922), is the isolated subject of the modern era and, thus, the new dominated subjectivity of the masses. They write: "Since Bloom first penetrated the heart of civilization THEY have done everything THEY can to isolate him, to neutralize him. Most often and already very biopolitically, he has been treated as a disease – first called *psychastenia* by Janet, then *schizophrenia*. Today THEY prefer to speak of *depression*." (Tiqqun 2011: 149). Tiqqun insist on seeing biopolitics as solely what Negri would call bio-power. They write (Tiqqun 2011: 150):

> On closer inspection, biopolitics has never had any other aim but to thwart the formation of worlds, techniques, shared dramatizations, *magic* in which the crises of presence might be overcome, appropriated, might become a centre of energy, a war machine. [...] *Biopolitics holds a monopoly over remedies to presence in crisis, which it is always ready to defend with the most extreme violence.* [...] A politics that challenge this monopoly takes as its starting point and centre of energy the crisis of presence, Bloom. We call this politics *ecstatic*. Its aim is not to rescue abstractly – through successive re/presentations – human presence from dissolution, but instead to create participable magic, techniques for inhabiting not a territory but a *world*. [...] Those who, as a final reprieve from their passivity insist on calling for a theory of the subject must understand that in the age of Bloom *a theory of the subject is now only possible as a theory of apparatuses.*

Compared to Negri, Tiqqun takes a stance of outside oppositionality in contrast to the inside-but-against position that grew out of Italian *Autonomia* and which Negri is opening up for with his dichotomy.[6] Of interest to my analysis of TOPY in Chapter Six is that what matters instead for Tiqqun (2011: 174) is to produce a 'critical metaphysics' which will be a 'science of apparatuses' that "*recognizes the crisis of presence and is prepared to compete with capitalism on the playing field of magic* [...] WE WANT NEITHER VULGAR MATERIALISM NOR AN 'ENCHANTED MATERIALISM'; WHAT WE ARE DESCRIBING IS A *MATERIALISM OF ENCHANTMENT.*"

Today, there has been what – with Howard Slater's (2012a) combination of Paul Virillio and Ludwig Feuerbach – can be described as an 'endocolonisation of the species-being'. The fact that each being is now produced by apparatuses represents a new paradigm of power (Tiqqun 2011: 184). Tiqqun introduces their 'science of apparatuses' as a triad which consists of crime, opacity and insurrection which they, ultimately, equals to a "science of crime" (Tiqqun 2011: 175) but here I am more interested in a definition of the apparatus proper. Tiqqun has been included in the contemporary discussion of communisation theories (e.g. Noys 2011) where communisation has been discussed as the communist production of communism in the here and now; as a process which is already underway instead of something that will arrive on the other side of, say, the dictatorship of the proletariat. Communisation theories are related to older notions of structuralist Marxism where a key figure, French philosopher Louis Althusser, also made investigations into what he called the 'ideological state apparatus.'[7]

Althusser (1970) points out that the primary ideological state apparatus producing subjectivity in feudal times was the church, but under mature capitalist social formations it has become what he calls the educational ideological apparatus, a point I will return to. For Tiqqun, the educational system no longer bothers to present itself as a coherent order. Instead it is a hodgepodge of "so many apparatuses meant to keep bodies immobilized" (Tiqqun 2011: 202).

An apparatus, from their perspective, is a space polarised by a false antinomy where everything that happens within it is reducible to one or the other of its terms. Thus, every apparatus starts from a couple and "[a] couple, and not a pair or double, for every couple is asymmetrical, includes a major and a minor premise" (Tiqqun 2011: 188). These premises are two different modalities of aggregating phenomena, where the major premise describes what is normal and the minor what is abnormal. That which is not normal is consequently defined as its negation, e.g. a medical apparatus will in this way bring the 'sick' into existence as that which is not well (Tiqqun 2011: 188):

> Within the biopolitical, that which is not normal will thus be presented as pathological, when we know from experience that pathology is itself *a norm of life* for the sick organism and that health is not linked to a particular norm of life but to a state of *robust normativity*, to an ability to confront and to create other forms of life. The essence of every apparatus is to impose an authoritarian distribution of the sensible in which everything that comes into presence is confronted with the threat of its binarity.

The apparatus wants to become part of us, to invade our bodies as a virus, which is why we have to develop the art of becoming perfectly anonymous. Whenever we stand out we remain entangled in apparatuses. That the worker is both producer and produced under spectacular, bio-political – or neo-liberal – capitalism is partly due to the fact that after its biopolitical turn, it is not just material forms of energy that capital seeks but non-material energies of labour power and vital force as well.

Tiqqun sees the imperial slogan as "ALL POWER TO THE APPARATUSES!" (Tiqqun 2011: 201). This, then, is where Empire can be met on its own terrain.[8] A possible project of resistance would, thus, be to take over 'the powerhouses of the mind', as Trocchi called for already in the early 1960s even though it, as we shall see, was William Burroughs who went viral. In 'the coming insurrection' – which in a way will come about due to a sort of Sorelian image-myth (see Chapter Four) – it will then often suffice to liquidate the apparatuses sustaining the enemies in order to transform them where they in times past would have had to be shot.

According to the Tiqqun group, the only strategy that can bring down Empire is diffuse guerrilla warfare. This strategy they see as the defining characteristic of Autonomia and the Italian '77-movement. They write (2011: 85):

> Unlike combatant organizations, Autonomia was based on indistinction, informality, a semi-secrecy appropriate to conspiratorial practice. War acts were anonymous, that is, signed with fake names, a different one each time, in any case, unattributable, soluble in the sea of Autonomia. [...] This strategy, although never articulated by Autonomia, is based on the sense that not only is there no longer a revolutionary subject, but that it is *the non-subject itself* that has become revolutionary, that is to say, effective against Empire.[9]

Successful insurrections are transformative experiences which are as much about the shattering and avoidance of identities as the construction of them and, thus, as much about the generation of fantasy and disorder as well as of political constitutions. One of the central figures in the movement of 1977, Franco 'Bifo' Berardi (2009: 93) writes: "The 1977 movement – in its colourful and creative Italian version and in its British one as well, which was punk, gothic and disturbing – was founded on one intuition: desire is the determining field for every social mutational process, every transformation of the imagination, every shift of collective energy." To the question 'what is desire?', he answers (Berardi 2009: 118): "Desire is not a force but a field. It is the field where an intense struggle takes place, or better an entangled network of different and conflicting forces. Desire is not a good boy, not the positive force of history. Desire is the psychological field where imaginary flows, ideologies and economic interests are constantly clashing."

Autonomia can thus be seen as a shift from a more classical Marxist position towards a broadening from the movement to society. In order to follow the mutations of society, autonomist thinking mutated "from the bounded factory to all throughout the social factory, and from a focus on particular labours to the socialized forms of labour found through everyday life" (Shukaitis et al. 2012: 3) and came to include, for example, a politics of gendered labour, self-organised spaces of squatting and cultural places, the so-called social centres, as well as a bringing together of militant resistance with what elsewhere would have been thought of as counter-cultural and/or artistic avant-garde topics. In the English-speaking world, it has been mainly seen as a way to bring together a Marxist analysis of class with the conceptual tools of poststructural analysis of subjectivity and culture (Shukaitis et al. 2012: 4) just like Berardi moves between an autonomist/compositional analysis of class and the schizo-analysis of Deleuze and Guattari in his double focus on labour and psychopathology.

The central question for Berardi becomes how to struggle against the appropriation of the general intellect. This, he finds, is done by reconnecting it with the social body since only this will start a process of real autonomisation from the grip of capitalism. In his writings another concept from Italian Workerism is being elaborated, namely the concept of compositionism. In workerist parlance, the root of autonomy, the ability to organise against exploitation, is to be found in the cultural components of the social fabric where myth, ideology, media and advertising all are producing effects in the composition of society. When they find a common ground, they produce effects of recomposition while they, alternatively, produce effects of decomposition when they support exploitation and destroys solidarity (Berardi 2011: 128).

For Berardi, the notion of composition is very close to Felix Guattari's notion of subjectivation where as the technical composition of labour consists in ascertaining who produces, what they produce, and how they produce in today's global economy. The compositional analysis thus recognizes the forms of capitalist exploitation and control while, at the same time, it gauges the means which are at our disposal for a project of liberation from capital. Following Guattari, Berardi (2011) proposes that we should explore how artistic practice evokes the complexity of the present and consider the conditions in which we find ourselves.

For Guattari (1996: 193), subjectivity is multivalent and polyphonic: there is no one dominating factor, for example the economic, which determines our social being. To stay inside a bio-metaphor, thinking ecologically we might see subjectivity in terms of multiplicity, a complex aggregate of heterogeneous elements where decentred relationships are important, i.e. there is no transcendent principle, no teachers, etc. Besides these, psycho-geographic relations to architecture, to a collective, to economic factors are also important. This ecology implies a certain kind of self-organisation, what Guattari (1996: 196) called *auto-poiesis*, i.e. the creation of a self. Subjectivity is thus formed predominantly by an individual even though it can sometimes be a result of group formation, but what is important is that new cartographies of subjectivity can be invented. Guattari (1996: 194) wrote: "The machinic production of subjectivity can work for the better as for the worse. At best, it is creation – the invention of new universes of reference; and at its worst, it is the mind-numbing mass mediatization to which billions of individuals today are condemned."

In order to produce new subjectivities, Guattari looked to Immanuel Kant's aesthetic and the notion of the disinterested response (Guattari 1996: 198). With art and poetry we form a relationship with a part that detaches itself from the object – especially in terms of rhythm and movement. This aesthetic response involves a kind of atypical desire, a break with the norm, "a rupture in a sense, a cut, the detachment of semiotic content – for example, in a Dadaist or Surrealist fashion – [which] can be at the origin of mutant centres of subjectivation" (Guattari 1996: 200). It produces ruptures in the dominant which themselves produce new refrains that hold together the heterogeneous in new ways. This asserts the importance of new forms of organisation as well as the importance of breaking with the old.

A central critique of the notion of biopolitics is that the living body is regarded less as an organic substratum than as molecular software that can be read and rewritten. It thus becomes potentially ethically and morally questionable since it challenges the prevalent views of freedom and will by saying that we are all manipulable through culture, i.e. it hides

a semi-totalitarian vision. Seen as a technique, it, simultaneously, spans and goes beyond the traditional political spectrum from left to right or, maybe better, it is just as applicable for the right as for the left. It is double-edged while, at the same time, it fulfils the prophecy that capitalism must itself produce what will supersede it. In his discussion of the value form in Moishe Postone's *Time, Labour and Social Domination* (1993), Slater (2012a: 93) notes that

> [w]ith labour as a pivotal social form in capital (and, as abstract labour, profiling how labour mediates and manages itself), it is offered that the social mediations that ensue are productive not only of goods, but of social relations that themselves are objectified and made abstract. What is instaurated in this way, by 'a social function of labour', are forms of institution and procedures that 'rule' over the society as a whole. In effect the worker produces, by means of this socially mediating form of labour, 'an abstract structure of social domination' that formerly went under the name of God. This has many parallels. For Althusser it is what he calls the 'society effect', for Foucault it is the '*dispositif*' or 'apparatus' and for Deleuze and Guattari it is the 'abstract machine'. What these all amount to is the intensification of social mediation.

Thus, this 'intensification of social mediation' is producing and dominating us in a network where control is no longer exerted on a macrosocial or anatomic level. Instead it is exerted at an invisible level that cannot be ruled, since it happens through the creation of linguistic and operative automatics (Berardi 2009: 200).

As we shall see in proceeding chapters, part of the collective, radical imaginary of the 1960s was exactly to establish an alternative apparatus, a cultural war machine in Deleuze and Guattari's sense, where the machinic is an assemblage that functions immanently and pragmatically, by contagion rather than by comparison, insubordinated neither to the laws of resemblance or utility and where production means the process of becoming (Massumi 1992: 192). According to this, living bodies and technological apparatuses are machinic when they are in becoming, and organic or mechanical when they are functioning in a state of stable equilibrium. A ramification of this could be that social domination has become the aim of production, whether from above or below or beyond.

1.3.
The Constraint of Souls

While I have been writing, my topic has taken on renewed relevance not only through the 2011 insurrections that found expression in, for example, the Occupy movement, the Spanish Indignados and the Arab Spring – the so-called 'movements of the squares,' which denotes the bodies congregating in physical and public spaces. There have also been the various struggles around the increasing neo-liberalisation of higher education. In both instances, a central tactic has been the founding of ephemeral free schools and ditto universities.[10] These have been used as a way of coming together informally and experimenting with the pooling of resources and the production of a new collective 'we' such as it, for example, was the case with the Tent City University or the Bank of Ideas which existed from c. November 2011 to February 2012 as part of Occupy LSX.[11] In general, some of the common denominators for this trend have included an urge to self-determination and autonomous knowledge production, a desire to construct autonomous platforms dedicated to creative DIY methodologies for the general public where information is shared, where learning just happens with no designated teacher, or where the teacher, if present, is modelled on Joseph Jacotôt, Jacques Rancière's ignorant schoolmaster, who did away with interpolation by teaching a subject he did not know.[12]

At their most fundamental, these attempts with a type of free-schooling are attempts at abolishing authority that always leave a remnant of anarchism or, at least, anti-authoritarianism even though the theory of communism and the parlance of Marxism often have taken a more central stage than the former much maligned ideology.[13] As the philosopher Simon Critchley (2012: 146) has noted, if a tendency marks our present time, it is the increasing difficulty in separating forms of collaborative art from experimental politics. This is, among other issues, related to a massive resurgence of interest in Marxism and the relationship between art and politics in the wake of the financial crisis of 2008 as well as to a range of newer artistic paradigms from the 'relational aesthetics' of the late 1990s (Bourriaud 1998) to the wider practices of socially engaged art and what

has been labelled 'art-activism' (Felshin 1995; Helguera 2011; Bishop 2012; Thompson 2012). This latter term has, as Gavin Grindon (2011: 81) also has noted, two common art-historical frames. One is formal: the post-modern move towards collective or participatory art practices (Roberts et al. 2004; Stimson et al. 2007). The other is critical and historical: that of the revolutionary ambitions of the historical avant-garde, a framework that has produced a wealth of criticism (Foster 1996; Buchloh 2001; Hopkins 2006) in the wake of Peter Bürger's *Theory of the Avant-Garde* (1974) and his later modifications of his position (Bürger 1992; Bürger et al. 1992).

The concatenations between aesthetics and radical politics were already well established by the last half of the nineteenth century (Egbert 1970) with, for example, the Realist painter and Communard Gustave Courbet (1819-1877) – friend and collaborator of the first self-proclaimed anarchist, Pierre-Joseph Proudhon (1809-1865) – who strived to represent the actual human misery of the lower classes in paintings such as *The Stonebreakers* (1849-50, destroyed 1945). Traditionally, though, the inception of what has become known, with Bürger's term, as "the historical avant-garde", art movements which where explicitly political from their inception, has been dated to the publication of *The Founding and Manifesto of Futurism*, by the Italian writer Filippo Tomasso Marinetti (1876-1944), as an advert on the front page of the French daily newspaper *Le Figaro* on February 20, 1909.[14]

For the modernist avant-garde movements it was an explicitly stated aim to work contrapuntal to social movements with interventions into space, trying to re-invent culture in its totality by realising social transformation through consciousness-raising. The underlying belief was that if you could transform man, you could transform society, or, to paraphrase Che Guevara, it is not only about remaking the world, it is also about remaking the self. Just as often as it took the form of social activism, agitation and propaganda, it resulted in experiments with alternative ways of living and other forms of life than the ones passed down through History and tradition. Unfortunately, the reception of the avant-garde tends to focus on either the avant-garde as political or the avant-garde as an aesthetic movement, where the latter may or may not have a relation to the esoteric tradition, instead of seeing it as a two sides of the same coin.

Bürger defined the avant-garde as characterised by attacking the bourgeois institution of art and attempting to reconcile art and life. It became possible when art had become autonomous and reached its 'full unfolding' (i.e. all schools of art – impressionism, expressionism, etc. – were co-existing in a 'simultaneity of the radically disparate'). The avant-garde was then able to go beyond the modernist system-immanent critique of art in favour of a self-critique where art was being negated in order to realise itself

so art and life could come together in a Hegelian sublation resulting in a revolution of everyday life. I disagree with Bürger on a number of points, especially his view on the neo-avant-garde of the 1960s, but, nonetheless, I find his study the starting point for any avant-garde definition.[15]

My aim is not to establish any avant-garde definition, though. Following Ørum 2009, I tend to see the cultural avant-garde more loosely as the experimental side of modernism. Thus suffice it for now to say that in desiring to make life into art and art into life by going beyond art as well as politics, my starting point is in direct continuation of Dada and Surrealism and, thus, of the aesthetic program of the historical avant-garde. In a literal sense, the sigma project constituted its own vanguard by being "nothing all men shall not one day become" as the Scottish former Beat and ex-Situationist Alexander Trocchi wrote in his 1961 sigma manifesto which I will examine closely in Chapter Two. Additionally, the 'sigmanauts', as Trocchi designated the loosely affiliated individuals that were meant to constitute sigma, occupied an avant-garde position by seeing their present from the future.

Instead, in what follows I will pay particular attention to the idea that a radical break is dependent on a need to learn everything anew such that social transformation becomes a matter of deconditioning and reprogramming, in short that radical education can bring about a cultural revolution. As Thomas Frank (1997: 13) wrote in his study of 1960s advertising in the US: "The meaning of 'the sixties' cannot be considered apart from the enthusiasm of ordinary, suburban Americans for cultural revolution. And yet that enthusiasm is perhaps the most problematic and the least-studied aspect of the decade." My focus is mainly on collective cultural production but this production is often as not ephemeral and invisible, purely discursive, an art that does not wish to be seen. Instead, knowledge production and experimentation become central in an information war, opening up alternatives and imaginary lines of flight, showing that another world is possible.

In this heady environment of apocalyptic visions and messianic hopes, I will thus examine a cultural program for social change through mental revolution, a perceived evolutionary step which I contextualise as a movement from the artistic and political avant-gardes towards what Roszak (1975) has called the 'Aquarian frontier' which, simultaneously, describes a move towards pop culture. Each in their own way, my chosen examples tried to intervene from a background of art, politics and esotericism into the pop-cultural mainstream of the Cold War period with an idea about an experimental other future.

My main concern is with an aesthetic subcurrent constituted by concatenations of art, radical politics, mysticism and educational ideas. This

subcurrent is discernible in the cultural history of the West back to, at least, the Marquis de Sade and is easily traceable from there to, for example, Comte de Lautréamont to Surrealism and the modernist avant-garde movements to the post-WWII cultural rupture which has been mythologised as 'the Sixties'. As such, the Sixties might symbolise the first time concerns from the avant-garde, radical politics and pop culture melted together, where political revolutionaries became pop cultural heroes (and where the way to become a pop cultural hero perhaps was to pose as a political revolutionary).

One of the reasons why cultural production takes centre stage in this context is, as McKenzie Wark (2013: 171) also notes, that what is distinctive about the Situationist and Post-Situationist project is that it presents "a certain poetics that it wants to make instrumental." This poetics is connected to the idea that one has to use what is already there. The artist is no longer a sole genius creating *ex nihilo*. 'Plagiarism is necessary, progress demands it', as Lautréamont's famous adage goes. It is an idea which is related to not only the Situationist *détournement* which I will look closer at in Chapter Two and which we can tentatively define with Raoul Vaneigem (1967: 264) as the "reinsertion of things into play." It is also related to the fundamental insight that the world is perceived as if there is no longer any outside. Capitalism itself will produce the means with which to overthrow and go beyond it. As such, détournement becomes a move of self-defence, using the weight and the power of the opponent against itself. The artists I will examine in the following chapters are well aware of this analogy to martial arts. Trocchi, for example, wrote about the invisible insurrection as a sort of 'mental jiu-jitsu' and William Burroughs wanted the students at Academy 23 to study karate and aikido among a whole range of subjects intended to expand and/or alter the students' consciousness.

The period in which I am interested spans from 1961 when Alexander Trocchi wrote his essay on the invisible insurrection to 1991 when the first incarnation of TOPY acrimoniously dissolved amid rumours of satanic child abuse and the like. The poetics I am examining can easily be followed through direct descendants from the temple, such as the Association of Autonomous Astronauts, to the tactical media scenes of the early 2000s to the hacktivism and occupy-scenes of today. I have chosen to stop my cultural history – which, like the objects it describes, is necessarily unfinishable and open-ended – in 1991 ('the year punk broke'). [16] This year marks not only the dissolution of the Temple but also the abolishment of the Soviet Union (which was formalised on 26 December 1991), thus creating a conceptual turning point from the New Left of the 1960s (Keucheyan 2010) to the New New Left of the millennium, which has shown a distinctly other character with its alterglobalisation

movements and, more recently, Occupy. As such, the background is the transformative years of the Cold War from its peak in the 1960s until it faded out and gradually made 'the outside disappear' (as the subtitle to the catalogue from the 2013 exhibition at the Haus der Kulturen die Welt in Berlin, *The Whole Earth – California and the Disappearance of the Outside* (Diederichsen et al. 2013) states), most explicitly symbolised with the collapse of the Soviet Union.

The radical imaginary of the period found expression in assemblages of symbols, images and myths interwoven into the vocabularies of contemporary art, education and politics, thus taking part in delimiting how we are able to talk about the present and think about the future. Central to this imaginary is a belief that aesthetics can change the way we think and thereby change the way we act, thus preparing us for the unknown. It posits a type of revolution that wants to engineer human consciousness. It follows that cultural revolution becomes a kind of collective re-education that breaks the habits of obedience which have become internalised as a second nature in the exploited classes, a logic which can also be found in the writings of Paolo Freire (1974) and Frantz Fanon (1961).

Before beginning my exposition I want to discuss the constitutive elements of my field of research. First and foremost, it is not about 'art' in a narrow sense as a specialised field but in its expanded sense where it includes film, music, literature, happenings and so on. This means that the term 'art' as I use it in the following pages often is interchangeable with notions of creativity and cultural production in general. The latter might be the more precise term. Like the Situationists, who saw strikers, rioters and revolutionaries as creative agents, Trocchi was trying to free up an understanding of creativity that would no longer be accepted as being contained within individuals but as something existing between them, a concept reminiscent of Teilhard de Chardin's idea of a 'noosphere' where the omega point now would be the realisation of art into life. It follows that the forms creativity can take are also widened: tape recordings, portfolios, crime, revolutionary activities. It is a type of cultural production that wants to engineer culture through the viral distribution of new ideas while remaining cognisant that to remake the world is to reinvent the self.

The new social and new religious movements become the invisible forces that shape our worldview, constituting an imaginary which has been concerned not only with speculating about un-alienated existence, but, more often than not, it envisions a next step in evolution, aligning it with the occult tradition. Since the social impact of cultural production is hardly quantifiable it is necessarily also about the invisible which, again, can be understood as another word for the occult. My chosen examples are therefore a

series of speculations around new types of universities which would be run and organised by artists, architects, intellectuals, activists and so on while explicitly paying attention to the invisible and the excluded.

Through my first case study, I will examine the concept of an 'invisible insurrection'. The sigma project was at heart an idea about creating a new type of self-organised university which would detonate this insurrection and which was expected to have a snowball effect. In turn, it would become the catalyst for a cultural revolution which would produce the new wo/man to inhabit an unknown future not too far removed from the vision of classical anarchism. This cultural takeover would consist of a way to alter people's consciousness instead of a way of directly obtaining political control.

Trocchi was an archetypal cultural revolutionary – or 'cultural engineer' – and thus an important predecessor to contemporary ideas about art and activism as well as discussions of the relations between culture and politics (e.g. Raunig 2007; Bradley 2007; Holmes 2009a; Cauter el al. 2011).[17] In the sense used throughout this book, the notion of 'cultural revolution' has not taken on its full Maoist meaning. Instead, as R. G. Davis (1968: 52), a co-founder of another seminal 1960s group, the San Francisco Mime Troupe, explained in an essay on the 'cultural revolutionary':

> [The cultural revolutionary] is a professional and an amateur. He is professional at one thing and an amateur at another. He's never a single efficiency expert, never simply a 'professional freak', he is always a multi-faceted personality. An actor today, a director tomorrow and next week a writer. A writer today, a publisher tomorrow and a book salesman next year. A theoretician today and a business administrator tomorrow. Example: Che came from the hills and headed the Bank of Cuba; Fidel waters tobacco plants now and talks agricultural technology; the master theoretician is an amateur farmer. A revolutionary plays roles that he is called upon to fulfil by history and necessity.

Seen in this perspective, art became important not only as a place for discarded and forgotten knowledges which could be revisited and examined on the cultural level and, hopefully, work as a sort of eye-opener but also as a place where it was thought alienation could be criticised and overcome. It was thus an art that would be conscious of its own potential, inspired by, among others, Sorel and Marinetti (Opstrup 2009), and which would explore how the use of image-myths could be used to mobilise mankind and

push toward a new step in evolution by, for example, the use of memes – not in the meaning of image-macros as it is commonly used on the internet today but as a way to describe how ideas go viral and spread like spores in the wind through bits of image, text, myths, parafictions. In general, my case studies wanted to de-mythologise but more often than not they ended up creating new myths and fictions in order to draw a symbolic map of the future, thereby creating an image politics which to this day strongly influences how we think both creativity and activism.

This mythological warfare might signify a realisation that the revolutionary moment might have come and gone and that power no longer can be seized the old way, or, better yet, that the coming insurrection will, in order to be successful, no longer be characterised by a violent upheaval. As McKenzie Wark (2013: 136) has noted, the failure of the worker's revolution might be that it relied on the same thoughts and methods as the successful bourgeois revolutions before it. Instead, it is about re-thinking social change as something stemming from the inside.

This is not to completely turn inwards nor is it to suggest that attending to our selves and the production of our own subjectivity can solve all the world's problems, but it is to say that attention to a notion of subjectivity which is polyphonous and heterogeneous must accompany any obvious political strategy. Seen in this perspective, it might be a question of creating more, not less: more mutations, more lines of flight, more alternative temporalities, more experimentation. Throughout this book the university will both be a name for the site of this experimentation while acknowledging that the university can also be the name for exactly that apparatus of capture that also produces conservative and/or superficially liberal subjectivities.

Addressing these questions of subjectivity is also addressing some of the central questions throughout this book: how are these new subjectivities produced? Are other forms of life possible under capitalism or is one always reproducing one's own alienation? What are the means of cultural revolution? If there is no outside then how do alternatives evolve? If we can inhabit a post-revolutionary world by an act of will, by becoming subjects who live alternatively, then what type of action is needed to break away from past conditioning? How do art, activism, education and mysticism open up for new types of subject formation? How do new forms of socio-political commons come into being? What is the role of art and cultural production in this? If the insurrection is invisible then how can it be recognised? What is the topography of the utopian map drawn up by the new 'mythologies for the space age'?

Basically, my argument is centred around the claim that the counter-culture consists of both political and hedonistic poles, which I translate into an activist and an occult position. Keeping this double current in mind, I look at, on the one hand, attempts to make new schools and institutions in order to deprogram and recondition mankind to a new future, and, on the other, on how they have used tactical media and a certain type of post-Situationist aesthetics in order to intervene in the present. It serves as a case in point that the underground and its immediate descendants are exactly characterised by this fundamental doubleness, that it is about both inner and outer. The failure of its world transforming project might be localisable in the separation of the two when people choose only the politics or only the aesthetic in its original meaning as that which speaks to the senses.

Contrary to Roszak (1969) who found that the counter-culture was characterised by a move from the political towards the mystical, or Ørum (2009) who finds that the experiments of the 1960s points the opposite way, from lifestyle to terrorism, my argument is thus that the two are fundamentally inseparable. They mark a tendency which is best understood in unison and which can be fruitfully examined as a technique for cultural engineering by looking at some of the collectives concerned with creating alternatives by challenging notions of art and education. The central puzzle is therefore an uncovering of what means the underground wanted to use to reach what ends with sigma as my starting point.

Part of my argument is that these initiatives, by coming from the modernist avant-garde movements, are operating in a post-political space beyond a traditional conception of Left and Right – even though my case studies are posited on the ultra-Left the various techniques are easily recuperable by the Right – where power is located in the everyday and in affects, commodities, architecture, cultural production and so on (objects, commodity fetishism, fan culture) thereby creating a science of apparatuses. I examine these apparatuses primarily through two intersecting themes: the production and composition of individual and collective subjectivities; and the construction of new affective communities.

In a world variously called postmodern, late capitalist, or simply Empire, a world in which power has been decentred, virtual centres of power exist everywhere. We might say that these virtual centres of power are our own subjectivities, and thus that the battle-ground against this bio-power is in some sense ourselves. Hence the importance in understanding politics – and political art practice – as not just being about institutional and ideological critique, but furthermore as involving the active production of our own subjectivity. Already in the 1960s, Timothy Leary noted that it was

up to three types of subjectivity to bring about the 'great evolution of the new age that we are going through now', namely, according to him, the dope dealers, the rock musicians and the underground artists and writers (quoted from Neville 1970: 119). In the language of contemporary art and its theoretical articulations, we might say this production of subjectivity is a specifically expanded practice since it always involves a diversity of projects and programmes. All of this points toward the importance of creative pedagogy; teaching practices that involve student participation, workshops, 'laboratories', and other teaching models that do not mimic the top-down structures in existence elsewhere. Such pedagogical practices can contribute to the active and practical involvement of individuals in determining their own intellectual and creative projects, and indeed their wider lives.

This opens the field for not only educational ideas but for a re-invention of the university. Coming from within the art world, as a call to action from cultural producers, the history I am highlighting can in many ways be seen not only as a forerunner for tactical media, art-activism and the various struggles around education but also for contemporary art's focus on the gallery space as a potential site for experimental learning. The various experiments with learning and knowledge sharing are not only limited to the context of new occupation movements but have also become part of the dominant discourses of the international art scene where questions concerning the relations between art, research, education and biopolitics are being debated (e.g. Madoff 2009; O'Neill et al. 2010; Duignan et al. 2010; Allen 2011, Ivison et al. 2013). Education is thus one of the major struggles over social reproduction today.

In the context of free universities, art collectives and the like, a type of educational – but not necessarily didactic – art had already in the 1960s become half architecture, half labyrinth, a site where magick and Marxism were able to co-exist, where emphasis was placed on social relations and the intensive modes of engagements through which these emerge, and where it was possible to speculate about and experiment with new forms of life, a central theme from the Situationists to the present. It was a call to creativity, to become actively involved in strategies and practices that will allow us to produce, transform and perhaps even go beyond our habitual selves.

When the university began in the Middle Ages it was a place to wrest dogma out of the hands of fossilised use by the Roman Catholic Church and the powers it represented. Then, the university for a period became the educational apparatus that would educate future leaders and tycoons. Today, it seems to be instrumentalised for the research of vested interests by

corporate powers and the so-called free market – which to a certain extent can be filed under anarcho-capitalism in its Friedmanesque rampage and attack on the commons, leading to questions of primitive accumulation, enclosures and alternative economies such as, for example, Bataille's theories for an economy of expenditure or the ideas of a gift economy per, for example, Marcel Mauss or Lewis Hyde, which played a great part in the theorisation of art throughout the 20th century. In contrast to these, the examples I am working with proposed to utilise the university as a site for deprogramming and relearning, for experimentation, for epistemological autonomy and for coming together in new socialities and new communities where nothing in particular had to happen. The fact that nothing was happening and happening slowly might even be the whole point since it created new situations, open for informal learning and improvisation, which related directly to the cultural revolution's battleground: quotidian life and everyday experience.

As such, my objective is an exploration of outsides to a world made prison proposed by an expanded art practice that contradictorily juxtaposes heterogeneous elements while, paradoxically, admitting that there is no outside. The specific area I'm examining through this perspective can be seen as a border zone between what could be categorised as forms of communism and shamanism, or an outer movement that wants to create new communities and new forms of living, and an inner movement which is more patchwork spiritual and wants to produce the new individuals to inhabit these communities.

The occult, shamanistic moods of the counter-culture might be explained by the dispersion of acid culture in the mid-1960s and the general rise in the recreational use of hallucinogenics which are known to provide (pseudo-)mystical experiences in the psychedelic consciousness (Lee et al. 1985; Roberts 2012; Adams et al. 2013). More importantly, the occult marks a duplicitous discipline that promotes a sense of control by attributing a supra-national dimension to the arrangement of objects. In the sense I use it here, it is also intimately related to the fields of psychology and (anti-)psychiatry, the dark matter of the soul where queries into the occult become interventions into the grey zone between psychiatry and religion. Additionally, it can be seen as a way of contesting how we normally think these categories, since the occult remains the site of a certain potenza in the field of praxis that stands at the intersection of historical, political and aesthetic concerns while challenging the way we think about inter-subjective relations, the territorialisation of the body socius and the process of subjectivation (Lachman 2008; Vetter 2012).

Methodologically, I am relying on a multidisciplinary approach to the dialectics of politics and 'occulture'; a game of truth and authenticity where

the discussions to a certain extent take place on the levels of fantasy and shadow play. By using a multidisciplinary approach rather than an interdisciplinary one, I wish to underline that the two movements I am concerned with, one inner and one outer, are meant to be thought of in unison, not one and then the other. I am not using theory in order to comprehensively explain my four case studies. Rather, I use it pragmatically in order to understand some of the themes and failures of the cultural struggles in our immediate past. Stylistically, at the beginning of chapters and subchapters I have chosen to adopt a montage approach, juxtaposing titles and quotations in order to create an excess of meaning, thus emphasizing the artificiality of any cultural history.

Overall, my research draws upon my background as a member of an art collective – working in a field combining literature, fine arts, design, architecture, self-publishing and curating influenced in parts by the tradition I am examining. Additionally, it draws upon a fusion of methods including interviews, textual analysis and archival explorations. My theoretical framework consists as much of 'low' theory (Wark 2011) and fringe knowledge as of 'high' theory drawing on the more institutionalised traditions of primarily French post-structuralism and German critical theory as well as various (revisionist) readings of Marx. Regarding the latter, it is especially the Left communist tradition as it came to the fore in the writings of the Situationists as well as the autonomous tradition stemming back to the Italian *Operaists* in the 1960s that I find have been able to provide a terminology to describe the oppression of everyday life from the 1960s onwards. My approach thus brings into dialogue both theory and praxis and is transversal in that it moves within and beyond disciplines, institutions, publics, radical politics, creativity as well as occult and occluded concepts and experiments.

The claim to originality is twofold: on the one hand, it is an analysis of examples that have not been properly historicised and, on the other, it is a way of reading this history which concentrates on its relationship to the present in the tradition of, for example, Benjamin's dialectical images while paying special attention to the fundamental doubleness of my field. As such, I am performing both an aesthetic and a sociological analysis of these collectives in order to examine the complementarity of social and psychological revolution through both an imagery pointing towards the modern, esoteric tradition and a political way of organising in order to create community and produce new subjectivities.

This raises questions about the status of institutional critique and the possibility of self-institutionalising successfully over a period of time. During the 1970s and 1980s many experiments in living were initially inspired by

ideas about art as intervention where artists had to participate in a bigger whole, form a collective or establish communes of like-minded individuals in order to engage with society and, ultimately, perceived 'reality'. Examples of this are numerous in both Europe and the US after the 1960s from the social experiment/"free city" Christiania in Copenhagen, Denmark, to the Metropolitan Indians roaming the streets of Milan and Bologna in Italy. But is it at all possible to constitute alternatives to capitalism, a utopian outside, a re-enchantment of the inside, a counter-public sphere, a pocket of resistance, a temporary autonomous zone? Or is radical social transformation in one's lifetime just another teenage pipe dream with a good swinging beat, part of the collective unconscious and the mythology of consumer capitalism? It is a history of failure, obscured by a rejection of rationality, but, nonetheless, a history of building community through creative living, hinting at what an invisible insurrection might look like and what unimaginable future it might lead to if the coming insurrection fails to arrive.

The radical imaginary of the 1960s – which I view as the beginning of the present – was primarily occupied with ideas about space: inner space, outer space, infinite space, reclamation of space upon which to build the shadow society. But it was also an idea about changing the world by will alone. This happens to be Aleister Crowley's famous definition of modern magick – spelled with a k to differentiate it from mere illusionism. Crowley would have a tremendous impact on the occult revival of the 1960s and in his philosophy – as in most parts of the Western esoteric tradition – everything is related to everything else and everything is vibrant which means that one can intervene with precision to change the bigger pattern.

This points towards one of the overall goal for the counter-culture: it desired to advance beyond the established professional categories to where one no longer is an artist, cleaner, writer, worker, professor and so on, but instead a collective united in a new all-encompassing 'we'; they wanted to overcome alienation and the separations of capitalist society in order to rediscover a new whole – a mystical whole, but also a whole which was purely non-transcendental and immanent. To give an example: the great work of Thelema – the religion founded by Crowley which heavily influenced 1960s religious movements such as the Church of Scientology and the Process Church of the Final Judgment – was to reconcile opposites which, *en passant*, was comparable to overcoming the gap identified by Bataille between the homogeneous and the heterogeneous (Opstrup 2004). This quest to overcome separations is emphasised by Crowley (1997: 306-7) when he writes in *The Book of the Law*, the holy book of Thelema published in 1904, that we shall "[b]ind nothing! Let there be no difference made among you between one thing & any other thing; for thereby

cometh hurt [...] The Perfect and the Perfect are one Perfect and not two; nay, are none!"

Throughout the early 21st century, the field I am examining has received renewed and increasing interest in the human and social sciences where it methodologically has been characterised by the interaction between French post-structuralist theories and Italian post-Marxist/operaist theories. As such, I am interested in adding the singular stories of my case studies to a growing archive of past protests and struggles in order to make it possible to learn from the past on the way to creating a more just society while, additionally, advancing an understanding of these stories as examples on cultural engineering.

Several books have been published over the past few years which have shared an interest in the post-Situationist concatenation of art and activism and inquired into a similar territory as my own inquiries, e.g. Raunig 2007, Shukaitis 2009, Cauter et al. 2011, Wark 2011 as well as the writings of Brian Holmes and Gregory Sholette. In general, my approach runs in parallel and expands upon the approach from the above-mentioned authors but it differs from theirs by putting more weight on artistic intent and practice, inner exploration as well as the psychedelic aspect of these practices which I see as informing (as well as being informed by) the social organising and political philosophising. Thus, it adds new knowledge to the growing field of literature on the relation between art and activism in the contemporary by expanding our knowledge of the past and, hopefully, producing a micro-awakening in its Benjaminian sense by juxtaposing the past with the present. To a certain extent a focus on potential similarities between movements, affects, and styles can also mask real differences; but to the extent that the focus remains on a kind of *realpolitik*, there are better sources available. My focus is primarily on the cultural imaginary as well as the evolution and transmutations of an idea about communication and another way of living which has been promised.

Regarding the structure, I will commence by mapping the sigma project in Chapter Two. So far, sigma has not been properly historicised even though an increasing interest has been indicated by, for example, Wark 2011. Nonetheless, the project seems to have been written more or less out of both cultural and political history, relegated to margins and footnotes, and, if mentioned at all, portrayed as a spectacular failure which was doomed from the start due to primarily heroin addiction. Instead, leaving judgment on the project's successes behind, I will analyse the project with special attention to its connective points to not only Situationism but also to the Beats, Anti-psychiatry, the architectural avant-garde and Black

Power activists to name some of the most prominent examples. Additionally, I will contextualise Trocchi's idea about an invisible insurrection.

After analysing these constitutive parts, I move in Chapter Three from sigma to the Anti-University of London (AU). This was initiated by a group of anti-psychiatrists with direct connection to sigma and can in many ways be seen as an attempt at realising its basic idea. The AU grew out of one of the seminal events of the 1960s in London: The Dialectics of Liberation Congress (DoL), held in the Roundhouse, Camden in 1967 which I will also examine more closely based upon a privileged access to Peter Davis' video archive from the event which has never been made publicly available. Viewed together, the Congress and the AU become examples of how the energy of collaborative work and intellectual reflection can be placed at the service of dialogue-based projects with the capacity to generate imaginative approaches and to structure new behavioural patterns.

In spirit, these events seem to have been unrecognised descendants of the Macy Conferences which were held annually from 1946 to 1953 in order to set the foundations for a 'general science of the workings of the human mind' (Pias 2004). The Macy Conferences included not only Gregory Bateson but also Norbert Wiener in its core group and were seminal in the evolution of cybernetics and system theories. These imaginaries of feedback loops and closed systems, lived reality as a sort of Skinner Box or other operant conditioning chamber, something that can be engineered socially and culturally, are fundamental for any understanding of the invisible insurrections.

After analysing and historicising sigma and the Anti-University I will extrapolate some of the key insights from the preceding two chapters in Chapter Four. In this chapter I will examine the 'politics of experience' with a title borrowed from R. D. Laing's 1967 book. Using this term I will explore the basic political programme of the action university branch of the UK Underground and examine the positions of my first two case studies.

In Chapter Five, I will pick up the historical thread again and examine William S. Burroughs's ideas for Academy 23 while also discussing the cut-up method, his collaborations with Brion Gysin, creating a 'third mind', as well as the invention of dreamachines and other technologies for changing the mind that would go on to influence TOPY. This discussion will be continued in Chapter Six where I place TOPY historically in continuation of the Academy while also viewing it as a predecessor to the tactical media groups and mind invaders of the 1990s and early 2000s.

Chapter Seven will open up for a broader consideration of the imaginaries of my case studies and their oscillation between political and hedonist

poles while looking at their relations to not only new social movements but also new religious movements. This will lead to some reflections on possible escape routes from the present before, finally, a short conclusion in Chapter Eight sums up the main points.

My field of study can arguably be defined as Post-Situationist since my starting point, the sigma project, splintered off from the Situationist International and defined itself in accordance with the Situationist point of view. The field constitutes a network of semi-autonomous groups, which overlap not only with each other, but also with politically radical milieus and cultic environments as well as with a contingent of the international avant-garde of happenings, Fluxus, mail art, performance and conceptual art. It is important to emphasise that the movement is never in a one-way direction, it is always back and forth in a state of constant flux where the pendulum points in the direction of hedonist and/or mystical poles one moment and towards political the next as we shall see in the following chapter.

II. THE SIGMA PROJECT

> This, then, is the beginning, a tentative organization of a sea of ambiguous experience, a provisional dyke, an opening gambit. Ending, I should not care to estimate what has been accomplished. In terms of art and literature? – such concepts I sometimes read about, but they have nothing in intimacy with what I am doing, exposing, obscuring. Only at the end I am still sitting here, writing, with the feeling I have not even begun to say what I mean, apparently sane still, and with a sense of my freedom and responsibility, more or less cut off as I was before, with the intention as soon as I have finished this last paragraph to go into the next room and turn on.
>
> - Alexander Trocchi 1960: 251-252

2.1.

On the Ecstatic Edge

The above epigraph ends what would be Alexander Whitelaw Robertson Trocchi's (1925–1984) final novel, *Cain's Book* (1960). In its time, *Cain's Book* was a literary scandal that challenged the censorship laws of the day not unlike sigma friend and collaborator William S. Burroughs's *Naked Lunch* (1959). It firmly established Trocchi in the public eye not only as a Beat writer mainly inspired by 'sodomy', as he declared at the Edinburgh Literary Festival in 1962, but also as the 'Lord of Junk' and the 'First Prophet of Permissiveness'. As Aleister Crowley half a century earlier had been labelled 'the wickedest man alive' by the popular press, the American novelist Lynne Tillmann recalls that Trocchi in the mid-60s was regarded as the most evil man in England (Home 2006a: 403), meaning that people blamed him for bringing in heroin and corrupting young people as it is clear from Andrew Murray Scott's erroneous 1991 Trocchi biography which is subtitled *The Making of the Monster*.[18]

Scottish by birth, Trocchi grew up in Glasgow. In the early 1950s, he made a name of himself in Paris by editing the literary journal *Merlin* (11 numbers, 1952-55), named after the famous sorcerer from the Arthurian legends and thus already hinting at an alignment with the occult revival of the 1960s. Additionally, he wrote a string of erotic novels for Maurice Girodias' Olympia Press as, for example, *Desire and Helen* (1954) or *White*

Thighs (1955).[19] In 1955, he joined the Letterist International (LI), a Parisian avant-garde group that would be instrumental in creating the later Situationist International (SI). This eventually led to that even though Trocchi left Paris for the US in 1956 – spending time with, for example, Terry Southern, Wallace Berman and the Beats as well as finishing his most memorable novel, the aforementioned *Cain's Book* (1960), on a scow on the Hudson river – Debord nevertheless regarded him as a founding member of the SI.[20]

In a sense, the open-endedness of *Cain's Book* sums up Trocchi's more ambitious project for creating an alternative society. This should be done through a type of proto-Free University which would expand into experimental town planning, thus pointing towards a new way of organising and living in the city. The sigma project was a call for total innovation, an effort to produce something that did not yet exist as well as a call to arms for the 'conscious' cultural engineers. The goal was to take over the popular imaginary through a mixture of aesthetic production with collective re-education. Since it never happened, it can be seen as a perpetual opening gambit. Although it never happened, it had a seminal influence on the budding British hippie underground, not least due to that, as Andy Roberts (2012: 87) points out, Trocchi was one of the first in Britain to distribute LSD along with his ideas. Apparently, he received the drug by post at his Notting Hill Gate apartment from Michael Hollingshead, an acquaintance of Timothy Leary who would later go on to set up the World Psychedelic Centre, a mini-version of Leary's Millbrook, in London in 1965 which goes to show the close connections between the US and the UK underground of the 1960s. These are also emphasised by Trocchi's biography: while in the US, he lived not only in New York but also in Taos, New Mexico and Los Angeles where he participated in the founding of the Beat commune in Venice Beach with, among others, Wallace Berman and Neal Cassady. During this period he also experimented with mescaline in the Mojave desert and painted driftwood in Aztec-resembling patterns and colours. The latter objects can be seen in the documentary *Cain's Film* (1969) where Trocchi calls them 'futiques', antiques of the future, a name he would later apply to the production of sigma in general.

In material terms, the remnants of sigma consists of a collection of newsletters, posters, architectural blueprints, pamphlets and manifestos which Trocchi mailed to friends and acquaintances. They can be conceived as a kind of chain letters which were primarily distributed in France, Holland, the UK and the US. These are collected in *The Sigma Portfolio* (SP, 36 – 40 numbers, each a mimeographed collection of loose, coloured sheets of typewritten A4 paper, 1964-1967) which still exists in various degrees of completion at some legal deposit libraries.[21] The idea was that subscribers

would receive a folder with the first batch of texts – consisting of Trocchi's manifestos, a letter from Stan Brakhage, etc. – which could then be added to as time went by.[22] The group who read and discussed this log of an idea reads like a who-is-who of the Sixties' underground: William Burroughs, Michael X, Jeff Nuttall, R. D. Laing, John Latham, Bob Cobbing, Joseph Berke, Allan Ginsberg, Colin Wilson, Michael Hollingshead, Cedric Price, and the list goes on.

In 1962, Trocchi ended up back in Europe as a fugitive from US drug laws. [23] After a short spell back in Glasgow he settled in London as a registered heroin addict on the NHS. From 1962 to 1964, he was part of the SI's central committee and its editorial collective until he resigned on good terms, not unlike Asger Jorn, due to the SI's refusal to take part in sigma. The break was made public in *Internationale Situationniste #10* (1966). Contrary to the SI's established myth of radical exclusions, the announcement stated that "it was mutually agreed that the SI could not involve itself in such a loose cultural venture [...]. It is therefore no longer as a member of the SI that our friend Alexander Trocchi has since developed an activity of which we fully approve" (quoted from Robertson 1988: 120). Scott (1991: 168) reports that Debord after the resignation wrote to Trocchi that "[y]our name stinks in the minds of decent men". According to Greil Marcus (1989: 387), who interviewed Trocchi about the SI in 1983, it was due to Trocchi's involvement with people like Allan Ginsberg and occult writer Colin Wilson, whom Debord dismissed as 'mystic cretins', that Trocchi stopped working with the SI. To Debord, the involvement was an unspoken resignation. Nevertheless, Trocchi defined sigma as "in accordance with the natural evolution of the Situationist point of view" (Sigma Portfolio 18, 1964). Below, I shall return to the relations between sigma and Situationism which is the first connective point, I will explore. My emphasis will be on especially the early SI which represented a tendency to bind psychoanalytic ideas with dialectical materialism (Martin 1991: 178) analogous to sigma's interest in combining inner explorations with outer alternatives.

Even with these various credentials to his name, Trocchi's epitaph has primarily been as a novelist who, after showing initial promise, disappeared into an obscure world of heroin addiction and writer's block in order to end up selling rare books in Notting Hill. Mostly forgotten at his death in 1984, interest started to rise with the *Edinburgh Review* printing a special issue on him in 1985. In the 1990s, he again received a bit of attention from the young Scottish writers around the magazine *Rebel, Inc* like Irvine Welsh, Kevin Williamson and so on. This reception of Trocchi has often been coloured by Scottish nationalism and an effort to claim at least Trocchi-the-writer for Scotland, paying special attention to *Young Adam* which was even made into a 2003 film starring Ewan McGregor and Tilda Swinton.

The renewed interest in the 1990s also produced the TV documentary *A Life in Pieces* and a book by the same name, edited by Allan Campbell and Tim Niel. The latter collected the interviews made for the documentary alongside fragments of Trocchi's writings, tape transcripts, odd letters and appreciations from a group of people who, primarily, were writers themselves. Their interest was mainly in the novels and why Trocchi was 'silent' after *Cain's Book*. Thus, they fail to pursue some of Trocchi's dissatisfactions with writing or to go into the more communal and counter-cultural activities with sigma and, not least, the intentions behind it. Among the interviewees, only a few such as Burroughs and Leonard Cohen acknowledges sigma at all – respectively seeing it as an excuse for not writing due to writer's block (Campbell 1997: 135) or by perceiving Trocchi as the general-secretary for a secret, revolutionary organization (Campbell 1997: 162) – while Jeff Nuttall laments that money already raised for sigma's perennial plan to establish an "Anti-University/Arts Centre/Fun Palace" were "frittered away on drugs, drugs and more drugs" (Campbell 1997: 282).

John Calder, Trocchi's UK publisher, sums up the general attitude towards Trocchi. He remembered the then recently deceased Trocchi in the *Edinburgh Review*, August 1985, as someone who "might have become the outstanding British writer of his generation but was destroyed by his addiction" (Campbell 1997: 34). Sigma was dismissed with one sentence: "What Sigma was really about was unclear to all except a few devotees, but it gave Trocchi an excuse to avoid getting on with a sequel to *Cain's Book*" (Campbell 1997: 34). Notable exceptions which treat sigma a bit more fairly are Howard Slater's short essay on Trocchi, 'Alexander Trocchi & Project Sigma' (1989), as well as a chapter on Trocchi at the end of McKenzie Wark's *Beach Beneath the Street* (2011) – a history describing the network of people involved in the Situationist International. In general, though, the focus has been on the Beat novelist rather than the 1960s cultural conspirator who desired to instigate the invisible insurrection.

In contrast to this tendency, I am primarily interested in Trocchi after he had gone beyond writing to become a full-time dreamer and astronaut of inner space. Throughout the 1960s, Trocchi insisted on a radical, utopian practice which overlaps in significant ways with the heritage of the artistic avant-garde in both political and aesthetic terms and the broader, pop-cultural revolt of the 1960s in general. Upon his return to the UK, Trocchi summed up in intelligible terms the vision of the Beats and the Situationists and set about trying to realise it. Sigma would be cultural engineering on a planetary scale. Future subjectivities to inhabit an unknown future should be produced through intervention into cultural production.

In order to discuss this vision in a detailed and critical way, I will examine its evolution in the early 1960s where the 'sigmanauts' – as Trocchi calls them in Jamie Wadhawan's short documentary film *Marihuana Marihuana* from 1972 – struggled to create not only a new type of university but also a modern myth meant to mobilise the masses so they would create an alternative society themselves. I will also examine the intentions behind sigma, its connective points and how it mutated in significant ways. To begin with, I will pay particular attention to a few of its key influences, especially focusing on its connections to Beat and Situationism before I move on to its major aspects and the concept of an 'invisible insurrection.'

2.2.

First connective points: Beat, Situationism and the 1960s

In a way, the main achievement of the 1960s was to popularise ideas from the modernist avant-garde of the 1910s and 1920s among the common public, thus de facto doing away with any notion of an avant-garde position. It was no longer possible to stand apart, ahead of the mindless mob. Instead one had to be 'engaged', as Jean-Paul Sartre demanded it in his seminal *What Is Literature?* from 1949. The early 20th century avant-garde movements had existed long enough – with their infectious call for the absolute new – to be institutionalised and historicised. After the Second World War, Futurism had been discredited due to its involvement with Fascism, the anarchic Dada had been eclipsed by Surrealism, which preferred more organised political affiliations, and Surrealism had lost its revolutionary momentum which had seen it work in concordance with the French Communist Party during the 1930s.[24]

New movements started to emerge, challenging the old avant-garde's hegemony. The relations of this neo-avant-garde to what came before it were complicated and ambiguous. The SI, for example, was critical towards the Surrealist movement, but imitated it in organisational terms with the use of a political party structure and committees with the power to admit or expel. Applauding the avant-garde techniques and tactics, they argued against its confinement to the literary and artistic sphere and advocated a system of worker's councils and direct participation (Plant 1990: 155). The Beats, on the other hand – themselves a constituent mix of Zen, Dada and Be-Bop among other influences – took inspiration from another strain in Surrealism and were preoccupied with mapping uncharted zones of the human psyche, combining drug shamanism with romantic excess.

Sigma was inspired by its predecessors but it was also part of its time. One can easily recognise a few powerful themes shared by a number of practices throughout the 1960s by examining it. Art, happenings, street theatre – interventions into space and everyday life inspired by Antonin Artaud's ideas about a Theatre of Cruelty, the Dada movement in Berlin

and Marxist theories of the role of culture in post-industrial society – were meant to raise consciousness and undermine existing institutions through effecting a change within individuals.[25] The artists's mission was to provide context and structures for future events. These events would ideally create a revelation, an awakening that would raise the audience's awareness from passive spectators to active participants and co-producers of the cultural moment. The realisation of art into quotidian life was perceived as a way to overcome alienation and the contradictions of capitalism by making the freedom the bourgeois artist ideally possessed available for all. In short, the proletariat had to become artists themselves with life as their material, thus realising Lautréamont's poetry made by all and the dreams of the avant-garde about a re-enchanted world, where images no longer just mirror other images but refer to something ontological.[26]

With the Beats, the tendency to gather in communes which became predominant in the 1960s (Gordon 2008; Boal et al. 2012) was already perceptible. As Martin Lee and Bruce Shlain (1985: 61) write in their social history of LSD, the Beats had understood that the problem was largely social in nature, but it was so extreme that the only sensible response was to pursue radical options outside the cultural norm and retreat into small groups of like-minded individuals. The Beats were not as much a political avant-garde as a mystical avant-garde more focused on hedonism than on activism; 20th century inheritors to the Beghards and Beguines of the Middle Age who travelled across Europe as holy beggars, establishing their own free houses along the way. As such, they were part of an imaginary of fellow travellers gathering to engage in a critical practice of producing autonomous spaces for new practices which were seen as more desirable, more fulfilling of human potential and more sustainable. The Beats, thus, popularised a notion of the underground as a 'cultic milieu'. For many of these fellow travellers there was a sense that 'communism' or 'anarchism' or whichever revolution they subscribed to – the majority of 1960s activism seems to be more concerned with autonomy in the present than communism in the future – equalled a sort of essentialist 'order of nature'. This presupposed an ability to recognise 'true' desires which later has been questioned by the proponents of post-structuralism, while, at the same time, being one of the general critiques of most kinds of anarchism.

The Beats were right on the threshold to when a general valorisation of bohemian and alternative lifestyle would leak into popular culture through the various youth subcultures: teddy boys, b-boys, mods, rockers, skinheads, hippies, freaks, punks, goths, etc. This general feeling of youthful rebellion, alienation and disgust with bourgeois tradition is clear in the following quote from Beat writer Terry Taylor's novel *Baron's Court, All Change*, coincidentally the first English novel to mention acid trips

(Roberts 2012: 121). The protagonist's older sister asks what the problem with the neighbour's son is (Taylor 1961: 115). He answers that the son is a

> future zombie. A slave to tradition. A part of the great ugly machine of life. A bowler-hatted man. A civilian soldier. A person in a queue. Do you know what is going to happen to him? He'll be made a chief clerk at his office in about twenty-five years' time. He'll get married and have about four kids, and when his wife has had them she'll grow fat and ugly. They'll go to the pictures and the local once a week, he'll go to a football match every Saturday afternoon, he'll follow up the TV serial religiously, he'll get drunk as a lord and smoke a cigar at Christmas, mind you, he'll have sex every Sunday morning when he and the Mrs have a lay in, and when he reaches forty he'll realise that what he's doing is exactly the same things as he was when he was thirty, except he'll have a few more stomach ulcers.

> "But what's wrong with all that? He'll be happy."

> "You might as well say that a peasant in China is happy with his one bowl of rice a day, just because he's used to it."

> "It's the same thing."

> "It's *not* the same thing. Young George won't be living his own life. He'll be living a life that's been handed down to him – that's been left him in a will. He won't think or act for himself, in fact he won't even think at all. He'll be driving a car that has dual-control, but he won't be able to fight against the other steering wheel."

Interestingly, in relation to the concatenation of activism and mysticism which desires to reconcile the contradictions of capitalist society that I will discuss later on, the exchange between brother and sister continues:

> She stopped eating her tribal dish, put her knife and fork down, and sat there staring at me.

"What's the matter?" I asked.

"I'm beginning to realize the reason why you carry on like you do. It's your birth sign. Aquarius, isn't it? Let me see. You'd probably make a faithful socialist because you have to fight for some dream or course. Charles Dickens was an Aquarian. You're probably a bit of a mystic as well."

"Remind me to cross your palm with silver sometime. But also remember that I'm a student of the occult myself."

As with the occult, the role of drugs – especially hallucinogenics such as mescaline and LSD but also amphetamines and hash – cannot easily be ignored when examining the hedonist poles of the underground of the 1960s and beyond. Drugs had already gained notoriety in literary and artistic circles through the explorations of mescaline by, for example, Henri Michaux, Ernst Jünger and Aldous Huxley as well as the whole tradition of writings on drugs, e.g. Thomas de Quincey or Aleister Crowley for that matter (Plant 1999; Boon 2002). In general, the use of drugs was an important political catalyst where it enabled many a budding radical to begin questioning the official mythology of the governing class. Those elements of the hip scene that turned on found it increasingly difficult to identify with those of an 'older' mindset. It was an "initiation into a cult of secrecy, with blinds drawn, incense burning to hide the smell, and music playing as the joint was ritualistically passed around a circle of friends" (Lee et al. 1985: 129).

Famously, Trocchi referred to himself as a 'cosmonaut of inner space' and when interviewed by the BBC Radio Scotland in 1962 (transcribed in Campbell et al. 1997: 142-150), he stressed that drugs helped him to access other states of mind and that he – as 'one of the discoverers in the realm of human emotions' – had a moral duty to 'experiment with strange and unknown states of mind'. This was a point of view that also resonated with sigma co-conspirator R. D. Laing (1967: 105) who later would write that "[w]e respect the voyager, the explorer, the climber, the space man. It makes far more sense to me as a valid project – indeed, as a desperately urgently required project for our time, to explore the inner space and time of consciousness. Perhaps this is one of the few things that will make sense in our historical context".

Drugs were thus part and parcel of not only a quest for social justice, but also a process of self-discovery and personal authenticity which was

open-ended, ripe with images of the future and linked to the occult revival of the 1960s, cf. the hazy, dream-like and drug-fuelled portrayal of London in Donald Cammell and Nicolas Roeg's film *Performance* (1970) where James Fox plays a gangster on the run who finds temporary refuge among the city's more bohemian fringe, personified by Mick Jagger and Anita Pallenberg.

Many who experimented with mind expanding drugs and hallucinogenics such as LSD found that the drug raised questions about the nature of personal identity and consensus reality (Roberts 2012: 87). This often led them to explore, as we shall see in more detail below with Academy 23, other techniques of consciousness expansion such as yoga as well as immersing themselves in the tradition of magick and mysticism as it is known from not only The Hermetic Order of the Golden Dawn and Crowley – who, like Trocchi, was a heroin addict that experimented with mescaline and other hallucinogenics – but also Helena Blavatsky and the theosophists who arguably were some of the first to introduce ideas from Hinduism and Buddhism to the West (Lachman 2012). The underground thus became a place for the repressed and the damned in its Fortean sense of 'the excluded', that which is relegated to a life in the shadows, dreaming of altered stated and other worlds. In itself, the 'occult' has always been an underground movement dead set on a flight from reason, thriving on secrecy and conspiracies as James Webb (1974) has shown.

Sigma wanted to combine the exploration of inner space from the Beats with the Situationists' outlook on society, thus combining the revolutionary tradition of the avant-garde with a hodgepodge of ideas ranging from psychedelic freedom to radical psychiatry in order to outline a politics of civil disobedience and cultural warfare which, ultimately, would overthrow society. As the Surrealists had brought Freudian dream analysis into a Bolshevik artistic putsch, the SI had their psychogeography and their conception of alienation, ideas that would overflow into sigma. Where the Beats had focused on peak experiences, inner vistas and mysticism, the SI's focus was keenly on the transformation of everyday life. The historical avant-garde's attack on tradition, its calling for rupture and its attempts to create a new identity and a new collective subjectivity were all carried forward with the the SI which was even closer aligned with the revolutionary tradition and a Marxist critique of capitalism than Surrealism had been.

Since Debord's suicide in 1994, the SI's project has been thoroughly mapped and historicised (e.g. Plant 1992; Home 1996; Ford 2005; Jakobsen et al. 2011; Wark 2011). Even though sigma in general is either ignored or passed over rapidly, these studies have all contributed to an expanded notion of the International beyond the circle around Debord in Paris,

showing how Situationist ideas evolved in Italy, Denmark, Sweden, Holland, Germany and the US. As Wark (2011: 3) puts it: "We do not lack for accounts of the Letterist International (1952-1957) and the Situationist International (1957-72) that succeeded it. [...] Rather, it is a question of retrieving a past specific to the demands of the present."

As an introduction to the SI, it thus suffices to say that from the mid-1950s to the early 1970s, the SI developed a revolutionary theory as well as a revolutionary practice. Of great importance to the post-Situationist art field was not only an idea about total revolution but also its appropriation of the field of art as a space for experimental politics. Firstly, art needed to be its own suppression and question its own validity. This was the early stage of the SI which correlates to a more bohemian critique of provincialism. Secondly, art had to be abandoned altogether. This latter position moved towards a political critique of alienation. The former artists were to become all-refusing political revolutionaries, taking the creative urge from the level of representation into direct action by 'creating situations'.

The early SI – created in 1957 by a fusion of various post-war artistic movements (the International Movement for an Imaginist Bauhaus, led by Asger Jorn after COBRA had played itself out, the Letterist International (LI), a splinter group from Isidore Isou's Letterist group led by Guy Debord, as well as Ralph Rumney's one man London Psychogeographical Association (LPA)) – split up in 1962. When they met up the movements had a desire to change the world in common, but, by 28 July, 1957 – when the SI was formed in Cosio d'Arroscia, Italy – they had agreed, as Rumney (1999: 118) reminisces with the use of hindsight and a vocabulary that was not fully developed at the time, that already in their present

> [i]t is rather the world which is going to change man's very nature, and the role of those who yesterday sought to change the world will become critical if humanity can come to want to survive fully and passionately the cataclysmic disintegration of the integrated spectacle.

The SI was critical both towards the artistic avant-garde and Marxism. Applauding avant-garde techniques, they argued against its confinement to the literary and artistic spheres. They rejected vanguardism as it is known from, for example, Leninism and advocated a system of worker's councils and direct participation (Jappe 1999; Hussey 2001). Debord had been a member of *Socialisme ou barbarie* from autumn 1959 to May 1961 and was afterwards an advocate of worker's councils. This latter group had been founded in 1949 by Cornelius Castoriadis and Claude Lefort and the SI

adopted much of its political theory, from the characterisation of the Soviet Union as a state bureaucracy to the idea of council communism which would give all power to the workers and their autonomously formed councils instead of to the party.

Castoriadis' thesis was that Soviet Communism failed due to the Leninist concept of the vanguard party which concentrates state power in the hands of a new bureaucratic elite, thus producing a new form of exploitation. In modern society, the central contradiction between the owners of the means of production and the labour force is replaced by that between 'order-givers' and 'order-takers' (Robertson 1988: 114). This contradiction should, according to Castoriadis, be recognised as the sole mainspring of revolution which basically would call for people to take control of their own lives through autonomous, self-managed worker's councils. Ultimately, revolution did thus not entail the taking of state power but rather the abolition of the state. These ideas about the cold war being fought between state capitalism and free market capitalism influenced Debord's theories of respectively the concentrated spectacle and the diffused spectacle. Debord's brand of Left communism can be seen as an important predecessor to the Italian Autonomous Marxists of the 1970s by theorising revolution as a never-ending process of critique that, as Richard Gilman-Opalsky (2011: 104) has pointed out in his book on spectacular capitalism, destabilises the ideology of the dominant class without proposing a new hegemony to take its place.

The concept of the spectacle has by far been the SI's most important contribution to the art theoretical field. For Debord, the spectacle is a social relation between people. It is mediated by a barrage of images which overwhelms the senses of the individual spectator so all that was once directly lived now has become mere representation. It is the negation of life that has invented a visual form for itself proclaiming that all social life is mere appearance (Debord 1967: 14). It is important that the spectacle is not an abstract illusion, it is a worldview that possesses a material reality. Gilman-Opalsky (2011: 15) writes that the spectacle is a particular strategic interpretation of the world that functions as an operational logic (i.e. ideology) that effectively organises society in both structural and superstructural terms. He goes on to note that spectacular capitalism keeps up exploitation, while keeping down revolt and that we remake the spectacle every moment we accept it. (Gilman-Opalsky 2011: 76).

The idea of the spectacle goes back to Roman gladiators, the appropriation of entertainment, art, and festival for political and control purposes. It is a technology of art put in the service of power. Where spectacle was once a way for state and church power to keep the masses under control, it is now

how global corporate powers keep the masses in commodity illusion. In an analysis which resembles Cornelius Castoriadis' from the *Socialisme ou barbarie* group, at first, Debord differed between two types of spectacle, the diffuse and the concentrated but this was later revised. In his comments on the spectacle, Debord (1988: 8) found that he lived in the society of the integrated spectacle, more or less synonymous to the media apparatus:

> In 1967 I distinguished two rival and successive forms of spectacular power, the concentrated and the diffuse. Both of them floated above real society, as its goal and its lie. The former, favouring the ideology condensed around a dictatorial personality, had accomplished the totalitarian counter-revolution, fascist as well as Stalinist. The latter, driving wage-earners to apply their freedom of choice to the vast range of new commodities now on offer, had represented the Americanisation of the world, a process which in some respects frightened but also successfully seduced those countries where it had been possible to maintain traditional forms of bourgeois democracy. Since then a third form has been established, through the rational combination of these two, and on the basis of a general victory of the form which had showed itself stronger: the diffuse. This is the *integrated spectacle*, which has since tended to impose itself globally.

And he continued (Debord 1988: 9):

> The integrated spectacle shows itself to be simultaneously concentrated and diffuse, and ever since the fruitful union of the two has learnt to employ both these qualities on a grander scale. Their former mode of application has changed considerably. As regards concentration, the controlling centre has now become occult: never to be occupied by a known leader, or clear ideology. And on the diffuse side, the spectacle has never before put its mark to such a degree on almost the full range of socially produced behaviour and objects. For the final sense of the integrated spectacle is this – that it has integrated itself into reality to the same extent as it was describing it, and that it was reconstructing it as it was describing it. As a result, this reality no longer confronts the integrated spectacle as something alien. When the spectacle was concentrated, the greater part of surrounding society escaped it; when diffuse, a small part; today, no part. The spectacle has spread itself to the point where it now permeates all reality.

In essence, the modern spectacle is the autocratic reign of the market economy as well as the totality of new techniques of government which accompanies this reign (Debord 1988: 2). It is hierarchical power evolving on its own. Its alpha and omega is separation and its function is the concrete manufacture of alienation. Debord (1967: 24) even goes on to state that the "spectacle is *capital* accumulated to the point where it becomes image." As such, the spectacle can be seen as a neo-Baroque image apparatus which keeps us sedated, keeps us in line through the use of image-myths and bio-power.

The spectacle can be total manipulation of meaning-making processes through theatrical events that serve the production of power and the managerial needs to control and spin a good story in the face of bad news. Thus, it becomes a battle over consciousness and a dominant worldview. The basic premise for Debord's theory rests on the claim that there is a casual relationship between the dominant ideology and the general worldview of everyday people and, as such, it is a theory of hegemony even though it differs from the more well-known theory of Antonio Gramsci.[27] The notion might be more related to what the German philosopher Walter Benjamin called 'phantasmagoria' in his *Arcades Project* (1939).

Benjamin described the new urban-industrial phantasmagoria as a dream world where the objects take on meaning as "dream-images of the collective" (Benjamin 1940a: 389). This is what gives the objects and commodities a political meaning. Benjamin's goal was to interpret the historical origins of this dream into dialectical images with the power to cause a political "awakening." The explosive force of the dialectical images – juxtaposing what has been with the now while being encountered in language (Benjamin 1940a: 462) – will be able to jolt people out of their dreaming state, resulting in an awakening of critical consciousness. He writes: "The now of recognizability is the moment of awakening" (Benjamin 1940a: 487), meaning that when one recognises the past in the present one is able to see through some of the mechanisms of power or, at least, realise "how long [the] present misery has been in preparation" (Benjamin 1940a: 481). This insight is empowering since it "does not cause him sorrow, but arms him" (Benjamin 1940a: 481). A certain amount of time and patience is needed, though, since "[t]he first tremors of awakening serve to deepen the sleep" (Benjamin 1940a: 391). As David Cooper (1967: 11), co-organiser of the Dialectics of Liberation Congress which we shall return to in the following chapter, wrote in the reader he edited after the event: "We have to take over time and own it."

In a literal sense, communism is the creation of new commons, but, if Marx and his successors are to be believed, communism can only be the result of

a world wide proletarian revolution which forcibly overthrows the united states of capitalism (Cohen 1992: 38). On the basis of the international power of the worker's councils, it will then root out the essential characteristics of the capitalist economy: wage labour, commodity production, the division of the globe into nation-states, and the separation of town from countryside. As its target it has the formation of a global association of the producers, a planetary human community where production is geared entirely towards the satisfaction of human needs and desires. This moneyless, stateless, classless society is the vision at the heart of Marxism.

The 'other' communism, i.e. that of the Soviet Union, was, in fact, as Castoriadis and Debord would be fast to point out, capitalist regimes where the basic division in society between a class of wage slaves and a small and privileged minority, the haves and the have-nots, where upheld and the former controlled the latter's labour power in the interests of accumulating capital. As Cohen (1992: 38) points out, the Stalinist bourgeoisie, "which is no less a bourgeoisie for having become fused with the state apparatus, was a product of the failure of the international revolution in the years 1917-23; isolated and alone, the Russia of the worker's Soviets and of international Bolshevism could only succumb to an agonising process of internal degeneration and counter-revolution."

Whereas Russia and Germany on the one hand and the US on the other would exemplify respectively the concentrated and the diffused spectacle, Debord argued in *Comments on the Society of the Spectacle* (1988) that France and Italy had pioneered the integrated spectacle. This latter type of spectacle more closely resembles our media-saturated contemporary with its Murdochs and Berlusconis. Here, spectacular government has become the master of memories and of all 'plans that will shape even the most distant future.' The highest goal is to turn secret agents into revolutionaries and revolutionaries into secret agents. Debord (1988: 10): "It is in these conditions that a parodic end of the division of labour suddenly appears, with carnivalesque gaiety; all the more welcome because it coincides with the generalised disappearance of all real ability."

This generalised disappearance is visible throughout the 20th century and can arguably be directed against a lot of contemporary 'creative activism' as well: when social movements become co-opted by aesthetics or vested interests, they often seize to have a social foundation (Frank 1996; Boltanski et al. 1999). Due to that the spectator always waits to see what happens next, he never acts in the society of the spectacle. He will no doubt like to be regarded as an enemy of the spectacle's rhetoric but he will use its syntax. This is one of the most important secrets of spectacular dominion's success. In contrast to this, to be known outside spectacular relations is to

be known as an enemy of society (Debord 1988: 18). One of the results of the dominion of the integrated spectacle has been that general community has gone. Debord (1988: 19): "There is no place left where people can discuss the realities which concern them, because they can never lastingly free themselves from the crushing presence of media discourse and of the various forces organised to relay it."

The infamous split of the SI in 1962 can, roughly speaking, be seen as a separation of the ludic and the analytical, mirroring in some ways the contention between the anarchic Dada and the more party-oriented Surrealist movement – play and analysis – 40 years earlier. The former aspect of the SI is often understood as being continued by the Bauhaus-Situationists, or the 2nd SI, around Jørgen Nash in Scandinavia (Slater 2001; Jakobsen et al. 2011), while the latter is understood as being continued by the specto-Situationists, or the 1st SI, around Debord in France. This latter branch was officially dissolved in 1972 when it was reduced to four members while the former sporadically appeared in primarily Denmark and the south of Sweden up through the 1970s. The split goes to show that the SI, just like sigma, got caught between the old role of the artists and the new role of art.

The story of Situationism has often been framed as if it turned into a bi-polar struggle between the so-called 1st and 2nd SI post-1962, but, besides the Copenhagen – Paris angle, the invisible insurrection was already happening many places simultaneously, including Jacqueline de Jong publishing the English-language *Situationist Times* (6 issues, 1962-1967) in the Netherlands and Trocchi publishing in London. In fact, the Situationist movement produced a number of periodicals, also including but not limited to the German Gruppe Spur's *SPUR* (6 issues, 1960-1961), *Heatwave* (2 issues, 1966) and *King Mob Echo* (6 issues, 1968-1971) in the UK as well as *Black Mask* (10 issues, 1966-1968) in the US (Vague 2000; Rosemont et al. 2005; Hahne et al. 2011), thus building networks by trading 'zines, a trait that aligns it to the *samizdat* tradition as well as Mail Art and which would be passed on to punk and the more general counter-culture (Duncombe 1997).

In relation to sigma, it is especially relevant that the early SI wanted to unite political engagement and artistic experimentation. Before the split these tendencies were perceived as a unified practice where there was an unmistakable expression of the twofold and indivisible use of action and representation, of political and aesthetic means in the situation. As the collective wrote in its early 'Contribution to a Situationist Definition of Play' (1958), it is a matter of 'struggle' and 'representation': "the struggle for a life in step with desire, and the concrete representation of such a life". They wanted to confront society's recuperation of artistic expressions with

the representation of society appropriated by the avant-garde, thus continuing the project of a permanent mental revolution, situating themselves to the left of Trotskyism (Bolt 2009: 88) while seeing themselves as carrying the key to communitarian life. As Gilman-Opalsky (2011: 81) also notes, a Situationist politics thus consists largely in creating situations – through visual art, film, performances, and other innovative demonstrations – that shift people's interpretation of the world away from its acceptance.

If we look at what the SI actually did, there were a series of interventions which have been more or less canonized – delivering manifestos translated word for word from French to English with a strong Flemish accent while applauding madly after each sentence, playing a tape with one's presentation while sitting motionless besides the recorder – but mostly there seem to be a lot of détourned photo novels, collages made of pictures from fashion and advertising combined with crudely written Marxist slogans or commentaries on everyday life. Mixed-media cut-ups and painterly 'modifications' like Asger Jorn's *The Disquieting Duckling (Den forunderlige ælling)* (1959) (see, for example, Steiner et al. 2006). A proto-punk aesthetics before Jamie Reid and Malcolm McLaren appropriated it. And as we saw above, there were also the publications. The SI produced an impressive amount of theoretical essays and analyses, mainly published in their own Parisian-based journal, *Internationale Situationniste* (12 numbers, 1958-1969) and overflowing into the two seminal works of situationist theory, Debord's *Society of the Spectacle* (1967) and Raoul Vaneigem's *The Revolution of Everyday Life* (1967).

The split came about due to that many of the involved artists insisted on artistic activity as well as a non-dogmatic, open and anarchic practice that left it to the audience to draw the conclusions, while the more theoretically inclined circle around Debord wanted to move away from artistic practice towards an all-refusing, revolutionary political theory influenced by, for example, Anton Pannekoek and council communism (Home 1988: 41-44; Bolt 2004: Ford 2005: 101-112). The Bauhaus Situationists defined it (Nash et al. 1962) as a split between mobility (them) and position (Debord). It goes to show that at its strongest – in a self-defined avant-garde – the relation between art and politics, between cultural production and social change, is always fragile. Art always risks becoming too contradictory, too easily co-optable, being used aesthetically to make anything palatable, while politics risk becoming shrill and dogmatic.

> Nothing more natural than an obscene heresy or monstrous cult should develop in the mind of an individual (for all men are an embodiment of history) who has delivered himself into the power of an infernal drug and smiles to see the destruction of his own faculties.
>
> - Charles Baudelaire 1860: 78

2.3.

Sigma – A Potted History

Mobility in terms of practice also defined sigma. It would be a communal affair with tactics decided in-situ, depending on what would be available when. Keywords were play and participation combined with an autonomous stance in relation to society which included self-organising, self-institutionalising, self-publishing, self-distributing, etc. Since it only ever existed as an idea, it is difficult to ascertain the extent to which some of the minor projects were developed. Knowledge lies in the hands of those who participated, part of an oral history everybody had their own take on. To rely on, there is mostly the portfolio and a certain overflowing into the underground press in general (for example *International Times*, vol. 1, issue 2 and vol. 1, issue 4, both from 1966).

In Trocchi's words the invisible insurrection would have to be a cultural *coup de monde*, not a military *coup d'etat* like Lenin's. In order to change the course of history, it would have to be on a planetary scale. Sigma was intended to become a primitive micro-model of a possible future, a way of life indescribable in words but built around 'spontaneous action-universities' that would constitute nodes in a network of experimental communities imagined to blossom up just outside the major cities of the world. It was intended as propaganda-by-the-deed, encouraging everybody to join and come together and do it with others themselves. Barry Miles (2010: 136), himself a central figure on the UK Underground scenes of the 1960s due to his management of the book shop Better Books at 92 Charing Cross Road, refers in passing to sigma in his history of London countercultures after WWII where he calls it "a magnificent junkie dream." But even though sigma was a pipe dream, a mirage, it was dreamt big and its founding essay describes in surprisingly concise terms

the sort of political-aesthetic utopia envisioned by the earlier avant-garde movements.

Already by the late 1950s, Trocchi had become interested in focusing creative production on the production of life itself. This was not unlike the SI's position that, eventually, everyone will become an artist and that "the work of art of the future will be the construction of a passionate life" (Vaneigem 1967: 155). Trocchi wanted to create a 'conspiracy of equals' – or a 'mafia of the elect' as the painter Felix Topolsky describes sigma in *Cain's Film* (1969) – who would work together to engineer culture. He needed to stop identifying with the specialised profession of author in order to become something more fluid, something harder to pin down, albeit connected to the construction of spaces and situations which can be designated as temporary autonomous zones, experimental learning spaces, states of exception or just altered states. This transformative nature is essential to sigma: it is always reaching beyond itself. It wanted to realise the urge to, simultaneously, lead and vanish.

Debord (1967: 135) had already noted the contradictory importance of occupying an avant-garde position while, at the same time, moving towards invisibility. He called for the most advanced artists to stop identifying themselves as such: "Art in the period of its dissolution, as a movement of negation in pursuit of its own transcendence in a historical society where history is not yet directly lived, is at once an art of change and a pure expression of the impossibility of change. [...] This is an art that is necessarily *avant-garde*, and it is an art that *is not*. Its vanguard is its own disappearance." This points towards the redefinition that happened in art with the international collectives post-1945 where, through conferences and tireless publishing, art successfully moved away from an object-bound practice towards a more performative, tactical mode which ultimately wanted to realise a fuller notion of art.

By focusing on both inner and outer, soul and society, sigma wanted to combine a 'politics of ecstasy' with a 'politics of experience' to quote the titles of two seminal 1960s works by respectively Leary and Laing which, taken on their own without necessarily referencing the books, describe two of the key aspects of the sigma synthesisation. Trocchi was interested in utopian free-play, in the full unfolding of being, but realised that in order to constitute it as a semi-permanent alternative, it was dependent on revolution. Already, Canjeurs and Debord (1960: 393) had written:

> Utopian practice makes sense, however, only if it is linked to the practice of revolutionary struggle. The latter, in its turn, cannot do without such utopianism without being

> condemned to sterility. Those seeking an experimental culture cannot hope to realize it without the triumph of the revolutionary movement, while the latter cannot itself establish authentic revolutionary conditions without resuming the efforts of the cultural avant-garde toward the critique of everyday life and its free reconstruction.

In his insurrectionary proposal (SP2), Trocchi declared that "literature is dead." The writing of anything "in terms of capitalist economy, as an economic act" is not interesting because "we also want to paint and we also want to sing." Instead, he wanted to become a situation-maker, an architect of happenings. He did not want to produce commodities (such as a mass-market novel), he wanted to produce a new way of living where the role of the produced objects would be to produce and shape the subject. Seen in this perspective, Trocchi did not as much stop writing as he expanded the concept of it, directing it towards a more conceptual and performative territory where he could contest established meanings and values.

The sigma co-conspirators wanted to create a unified platform from where those involved could be serious contenders in the struggle over culture and where previously dispersed peers and like-minded individuals could gather. The name was chosen because in mathematical practice, it designates the sum, the whole (SP3). This reflected their conviction that everybody would some day be included in sigma. The name was consequently spelled in the lower case to signify an adjectival use. It was an intervention on the level of language with an idea of a new way of life. As a meme, it wanted to spread its own image of social domination through contagion and thus gain hegemony over our imaginaries, our collective dreams about our everyday lives.

The legacy from both the Beats and the Situationists is evident in Trocchi's central themes which are archetypical avant-garde: the enemy is time and history, the division between art and life must be overcome, play is more important than work, drugs are mind-expanding, ergo a positive force, fixed assumptions and stereotypes must be undermined and conventional categories must be transcended. In short, these themes necessitate the transvaluation of all values and the overcoming of the specialisations of society in order to become a non-specialised specialist, a professional amateur in the words of Asger Jorn or the un-alienated man famously described by Marx at the beginning of *The German Ideology* (1845: 53) who can do "one thing today and another tomorrow, to hunt in the morning, fish in the afternoon, rear cattle in the evening, criticise after dinner [...]

without ever becoming hunter, fisherman, shepherd or critic." History is a nightmare from which we must awake, and when we do we will realise that the human possibilities are limitless.

Trocchi was well aware that there were a considerable number of collectives in the 1960s with nearly identical goals to his own. He wanted these to link themselves adjectively to his project. That it caught on a bit can be seen in that a few numbers of *International Times* (*IT*) – flagship of the UK underground press – were designated as 'a sigmatic newspaper' in its masthead.[28] Another sigma newspaper was *The Real Free Press of Amsterdam* (Nuttall 1970: 198). It follows that Trocchi wished for sigmatic Provos, sigmatic Chicago Surrealists, a sigmatic Panic movement, sigmatic members of the Motherfuckers, a sigmatic Art Worker's Coalition and so on. Sigma was always open to both collective and individual endeavours and Trocchi stressed in SP17: 'List of People Interested' that the 50 names listed were "in no sense a group [...] they are INDIVIDUALS who have, at one time or another, expressed a serious interest in the possibilities implied in the sigma project." It is difficult, as Robert Hewison (1986: 108) also notes, to estimate how far Trocchi's ideas penetrated beyond his circle, or even within it, but his two most important statements, 'A Revolutionary Proposal: The Invisible Insurrection of a Million Minds' (SP2) and 'Sigma, a Tactical Blueprint' (SP3) were widely circulated.[29]

In the aforementioned BBC Radio Scotland interview from 1962 when he was still based in Glasgow (Campbell et al. 1997: 142-150), Trocchi told that he was going to London to set up a spontaneous university along the lines of Summerhill (Neill 1960; Vaugh 2006) but for adults. He had been part of experimenting with this kind of new, experimental learning space in New York where it had grown with an astounding speed. In London, him and his co-conspirators planned to make it pay in the sense that those attached to it would use parts of the 'university' as their artistic and literary agents. The money generated from this would then be contributed towards internal research. There would be no professors, or, put another way, the one speaking at any given moment would be the professor. The way to matriculate was simple: anyone who could come in and feel comfortable would be welcome to remain.

In July 1964, Trocchi set about trying to realise the project by circulating friends and contacts with a series of typewritten pamphlets and manifestos (Hewison 1986: 107), duplicated onto coloured A4 size paper and assembled as the Sigma Portfolio. The SP was seen as both a 'futique' in itself and a vehicle for artists to pool their resources; a work-in-progress that basically shared information which would be hard to obtain otherwise and where people could participate by contributing. Bits were added to it

continuously. In effect, it was the creation of a sort of 'global' chain-letter, a strategy that in itself show the double lineage from Beat and Situationism in sigma.

In Trocchi's circle, the idea had been pioneered by the American Beat artist Wallace Berman. Berman spoke about new forums for art while editing, hand-printing and distributing his own magazine *Semina* (7 issues, 1955-64) through the mail system, implementing the strategy in the mid-1950s around the same time as Ray Johnson and Fluxus, thus constituting an alternative root to the Mail Art Movement which is traditionally traced back to Johnson (Embray 2009). As Scott (1991: 169) also notes, it can, additionally, be seen in the tradition of Letterism where the adherents wrote to each other, thus eschewing the principles of commercial publication, an idea that would be carried over into sigma which also was to be a publisher.

How to begin a project on this scale? Trocchi directly addressed this question in SP2:

> At a chosen moment in a vacant country house (mill, abbey, church or castle) not too far from the City of London, we shall foment a kind of cultural "jam session": out of this will evolve the prototype of our spontaneous university. The original building will stand deep within its own grounds, preferably on a river bank [...] We envisage the whole as a vital laboratory for the creation (and evaluation) of conscious situations; it goes without saying that it is not only the environment which is in question, plastic, subject to change, but man also.

After the founding 'jam session' the 'sigmanauts' would be ready to take over the world: "We envisage an international organization with branch universities near the capital cities of every country in the world. It will be autonomous, unpolitical, economically independent" (SP2).

Doomed from the beginning, in hindsight the culmination of sigma's particular quest for creating an alternative society and found a counter-cultural university also came in July 1964, when the portfolio started to circulate. At the end of this month, the 'sigmanauts' met with a group of primarily anti-psychiatrists, including R. D. Laing, David Cooper and Clancy Sigal, at Braziers Park, a country house near Ipsden, Oxfordshire. This was the home of a community of "quiet, self-sufficient, middle-class intellectuals, totally square with heavy overtones of Quakerism and Fabianism" (Nuttall 1968: 212).[30] The group around Laing would later, in 1965, go on to

found the Philadelphia Association which played an important role in the creation of London Anti-University.[31]

Jeff Nuttall, who was instrumental in setting up the meeting between the artists and the anti-psychiatrists – intended as one of the founding 'jam-sessions' – described the weekend in his classic *Bomb Culture* (1968: 156; 210-7). According to his account, it was completely chaotic with bickering, heavy drinking and Trocchi overdosing on heroin the very first night. Clancy Sigal, who gave a semi-fictitious account of the meeting from the point of view of the anti-psychiatrists in the novel *Zone of the Interior* (1976), agreed with Nuttall. In Sigal's thinly disguised account, the anti-psychiatrists from the Clare Council – named after mad rural poet John Clare and the fictional counterpart to the Philadelphia Association – met with the artists from NON-RUT (spell it backwards), led by the junkie novelist Sy Appleby, at the Quaker-run Armistice Hall. NON-RUT is described by Sigal – in quotation marks but without reference – as a "multimedia inter-communications network of fashionable working-class poets, action artists and ex-Committee of 100 militants still looking for a way to blast the public conscience" (Sigal 1976: 197). Sigal's alter ego in the novel, Sidney Bell, concluded that the artists they met at the meeting were even madder than the mad and schizophrenic, the anti-psychiatrists normally lived alongside in experimental communities such as Villa 23 and Kingsley Hall.

One episode that apparently convinced the group of anti-psychiatrists that "[t]hings aren't going too well" (Sigal 1976: 197) – Nuttall also mentions it as a symbol of the chaos surrounding the meeting – was John Latham spray painting a book to a wall in his bedroom. In his monograph on Latham, who would later become a founding member of the Artist Placement Group, John Walker (1995: 72) briefly noted: "Sigma failed to materialise at the Oxfordshire meeting because the highly individualistic participants could not agree on common aims, procedures and sources of finance." According to Walker, one of the concrete proposals – successfully deployed earlier by the Situationists who partly were funded by selling pictures donated to them by, for example, Asger Jorn – was to ask successful artists to donate work for sale. In the event few proved willing to comply.

Tom McGrath (1985: 43) also mentioned this 'sigma international collection' – meant to include both Pablo Picasso and Salvador Dali and intended to take care of the economy – in his remembrance piece on Trocchi written just after the latter's death. As he recollects it (1985: 43) the collection idea was the reason why Trocchi was fond of saying that "the money will look after itself!", since it consisted of donations from sympathetic artists and was expected to be worth thousands of dollars. It was meant to be used as collateral against which money could be borrowed.

Furthermore, showing the connections between sigma and Academy 23, the topic of a later chapter, he remembered Trocchi's contribution to the meeting at Braziers Park as outlining the ideas "he and Bill Burroughs had discussed about a free university" (McGrath 1985: 43). Nothing came out of the gathering immediately, though. It can be seen as the beginning of the end for sigma which the meeting *de facto* had proven impossible for the time being. Instead, some of the people associated with the Philadelphia Association would organise related events during the next few years which eventually would lead to the Dialectics of Liberation Congress as we shall see in the next chapter.

The sigma portfolio consists of loose papers with no structural organisation. The very first number of the portfolio, coming just before the two manifestos, is, for example, a poster which says MOVING TIMES down the one side and 'project sigma' down the other. This broadsheet states that Trocchi is the general editor, Nuttall is the associate editor and that the title (i.e. 'moving times') is courtesy of William Burroughs. It gives some general info on price and subscription and it prints various short texts, e.g. 'the barbecue' by Trocchi, 'martin's folly' by Burroughs, some extracts from *The Theatre and Its Double* by Artaud as well as various quotes from SP2 and SP3 attributed in general to "William Burroughs, Robert Creeley, Alexander Trocchi, Uncle Tom Cobbley,... etc.". The info section states that "[f]rom now on you are invited to take part in a continuous international concordium concerning the future of things" (SP1).

The MOVING TIMES/sigma poster was meant to be hung in the underground, the London Tube that is, and in the streets of the city. It can be seen in the tradition of sharing information through fly-posting known from, for example, Victorian times and as an early example of what today would be called 'guerrilla marketing.' Rejected by London Transport, it ended up being mainly posted in cafés instead (Slater 1989: 28). The portfolio also includes, for example, an essay by R. D. Laing as well as correspondence between Trocchi and Stan Brakhage. Another promotional poster included is the blueprint and explanation for Cedric Price and Joan Littlewood's *Fun Palace* (SP25) which I shall return to. This reached out towards the architectural avant-garde of the day such as the Archigram group or Paolo Soleri. Additionally, it fitted well with the situationist focus on psychogeography and built environment. SP12: 'Subscription Form' describes the portfolio as "an inter-personal log constructing itself to alert, sustain, inform, inspire and make more vividly conscious of itself all intelligence from now on."

The theme for the first five numbers of the portfolio is occupying the present as an open future politics. The overall idea is reminiscent of Debord:

all must change at once or nothing at all, the existing institutions need to be completely restructured, an idea also associated with R. D. Laing and David Cooper who approached it from a more Marxist-Leninist account in, respectively, *Psychiatry and Anti-Psychiatry* (1967) and *The Grammar of Living* (1974). Sigma was a dream-demand for culture rupture where the sigmanauts would "seize the grids of expression and the powerhouses of the mind" (SP2). This would create a new order of things where what had to be seized first and foremost was ourselves. The activities were expected to "snowball" and effect a change within individuals, thus undermining existing institutions.

In the context of sigma as a heroin-fuelled dream, it is interesting that radical psychiatrists were involved in the project. As Andrew Wilson (2005: 69) points out, the journey through inner space to reorder the self and form a new society, which were so important for a lot of the art-political initiatives of the 1960s, could be seen as a corollary of the position of the mad in institutional culture, where hallucinogenic drugs had been used clinically within psychiatric treatment for years. To the anti-psychiatrists of the 1960s and 1970s the process of defining someone as mentally ill were perceived to be about power exercised by the state against those individuals who behave in socially deviant ways. This insight lead Laing (1967: 95) to define schizophrenia as "*a special strategy that a person invents in order to live in an unliveable situation*" while insisting that madness "need not be all breakdown. It may also be a break-through. It is potentially liberation and renewal as well as enslavement and existential death" (Laing 1967: 110). To cure such people would mean to reform society in order to make it liveable. The study of especially schizophrenia in, for example, Laing's *The Divided Self* (1960), was from the start a defining element of a cultural revolution with no spectators, only participants. Thus, Trocchi's drug-induced altered states signified in themselves an alternative, an exodus from the sane, capitalist society.

Contrary to the earlier avant-garde, Trocchi did not want an impossible *tabula rasa*. He wanted to take over the world by taking over its immaterial production. The explicitly stated purpose of writing the first manifesto was to establish an "international association of men who are concerned individually and in concert to articulate an effective strategy and tactics for [...] cultural revolution" (SP2), an association that would be more a syndicate than a corporation even though Trocchi acknowledged that "the venture must pay." This kind of economic pragmatism was necessary due to that "in a capitalist society any successful organization must be able to sustain itself in capitalist terms" (SP2) since "the confusion of value with money has infected everything" (SP3). It was no longer an option to stand outside capitalism. Therefore, the sigma centres would be financed by

simultaneously acting in the cultural industries as independent publishers and solicitors. To this end, Trocchi created the company Cultural Enterprises, Ltd. in 1964 to focus on cultural engineering, imagining the income to arrive from subsidies, commissions, retail, shows, fees, etc. Along with the emphasis on that "no one is in control, no one is excluded" in the blueprint, this emphasises a debt to 19th century anarchism where similar *petit bourgeois* remnants can be found in the thought of the first self-proclaimed anarchist, Pierre-Joseph Proudhon, who was against corporatism and big business but supported the local entrepreneur.

The general sigma agenda is stated in SP 5: 'General Information' which was distributed under the masthead "PROJECT SIGMA – A TACTICAL EXPERIMENT IN METACATEGORICAL INTERACTION":

> We must invent effective behavioural procedures which negate the status quo in form as well as in context. We must exploit loopholes in the systems, underground ways of getting to the people and making them think. We have to remember at all times, that the only 'enemy' is non-personal spiritual ignorance, breeding fear, hysteria, schizophrenia [...] it is the object of sigma to bring all information out in the open [...] [and] to make men conscious of their conditions [...] the conventionally passive audience must be brought back to collaborate in the making of the cultural moment.

The apocalyptic undertones of Trocchi's thinking as well as the necessity of action are surfacing in statements like "the world is awfully close to the brink of disaster." In fact, "we are waiting for an accident which can't be predicted but which we have a duty to avoid" (SP5). Both the early avant-garde and sigma saw the future as apocalypse written across the sky but while the avant-garde embraced catastrophe as a deluge that would wash away the shackles of monarchy and papacy, sigma wanted to avoid the catastrophe. They both agreed, though, that if there was to be a future, bourgeois society would have to go.

Not only was it necessary to leave the existing institutions behind and self-institutionalise, creating one's own network, it was necessary to simultaneously create the new collective subjectivities that would make use of this network. In order to do this, all information needed to be out in the open. This points to that sigma was engaged with the "truth," it was about existence itself, basic drives and emotions. It can be seen as a predecessor to the underground's 'information wars' of the 1980s which TOPY were involved in as well as we shall see. It was a way of preventing anybody

from positing themselves in a hierarchical position by withholding essential knowledge. The transparency thus emphasised that knowledge is power. Producing new types of knowledge can be seen as a way to contest the established powers and create new counter-powers while keeping its operations transparent is a way of democratising this knowledge.

To the co-conspirators the passing of information through a network would thus be enough to transform society. It would result in a structural transformation of the system by empowering its participants to take informed action. Additionally, in its echoing of John 8:32, "And ye shall know the truth, and the truth shall make you free," it hints at some of the messianic remainders in many radical, cultural collectives such as sigma, or TOPY for that matter. This messianic stream is also conspicuous in a letter Trocchi wrote to his brother Jack from Paris in 1955: "Revolution is the answer [...] a new attitude [...] The revolution has already happened in me. I am outside your world and am no longer governed by your laws" (quoted from Scott 1991: 64).

> The conscious and intelligent manipulation of the organized habits and opinions of the masses is an important element in democratic society. Those who manipulate this unseen mechanism of society constitute an invisible government which is the true ruling power of our country.
>
> - Edward Bernays 1928: 37

2.4.

The Invisible Insurrection

Both sigma and the early SI believed revolution should be culture-led. Debord (1958: 53) had made it clear in his 'Theses on Cultural Revolution', published in *Internationale Situationniste #1*, that the "goal of the situationists is immediate participation in a passionate abundance of life by means of deliberately arranged variations of ephemeral moments." Cultural activity in its totality is "an experimental method for the construction of everyday life, a method that can and should be continually developed with the extension of leisure and the withering away of the division of labor (beginning with the division of artistic labor)" (Debord 1958: 53). It would be necessary with an international association of "those who demand the right to work on a project that is obstructed by present social conditions" (Debord 1958: 53). To attain this goal, art would need to stop being a "report about sensations and become a direct organization of more advanced sensations" (Debord 1958: 53).

This points towards a central theme for the Situationists, for Trocchi and for the Sixties in general: the right to self-determination, a demand connected to the myth of the affluent sixties, perceiving that it was a question about how to spend one's leisure time now that robotics and computers would soon release people from work. As Fredric Jameson (1984: 188) has shown, this myth was connected to the Green revolution and the industrialisation of agriculture and industry, but it proved false with the global energy crisis of the early 1970s. In stressing the need for immediate action, Trocchi followed Debord (1958: 54) who had concluded:

> it is necessary to struggle without waiting any longer for some concrete appearance of the moving order of the future. [...] If we are ever to arrive at authentic direct communication (in our working hypothesis of higher cultural means: the construction of situations), we must bring about the destruction of all the forms of pseudocommunication. The victory will go to those who are capable of creating disorder without loving it.

The invisible insurrection would be instigated with *détournement*, the situationist technique of disrupting communication by turning already existing elements upside-down and inside-out or by sampling past cultural products and integrate them into new creations not unlike Gysin and Burroughs's cut-up technique. In short, 'mental jiu-jitsu' as Trocchi calls it. The détournement consists of treating histories and ideas as common property that can be re-configured at will. It is not simply plagiarism since plagiarism upholds private property in thought by trying to hide its theft. Instead, détournement treats all culture as common property to begin with. As Wark (2011: 41) writes, détournement is not treating culture as a creative commons, nor as a wealth of networks, free culture or remix culture, but "as an active place of challenge, agency, strategy and conflict. Détournement dissolves the rituals of knowledge in an active remembering that calls collective being into existence." Language itself – its history of ideas, its commons of past immaterial production in the form of info work, cultural work, cognitive work – becomes a Duchampian readymade to be appropriated into new configurations. Debord and Gilman (1956: 18) wrote:

> Détournement not only leads to the discovery of new aspects of talent; in addition, clashing head-on with all social and legal conventions, it cannot fail to be a powerful cultural weapon in the service of real class struggle. The cheapness of its products is the heavy artillery that breaks through all the Chinese walls of understanding. It is a real mean of proletarian artistic education, the first step toward a *literary communism*.

Another influential term from the SI's vocabulary is the notion of psychogeography. Debord (1955: 8) defined this as "the study of the precise laws and specific effect of the geographical environment, consciously organized or not, on the emotions and behaviour of individuals." As we saw in the Rumney (1999: 119) quote above, this 'universal psychogeography' becomes the domain of cultural production and artistic practice. Debord

(1955: 8) continues: "The charmingly vague adjective *psychogeographical* can be applied to the findings arrived by at this type of investigation, to their influence on human feelings, and more generally to any situation or conduct that seem to reflect the same spirit of discovery." In this context, it is important that the production of psychogeographical spaces are intimately connected to a total insubordination to habitual influences (Debord 1955: 11), it is the constant experience of the ever new by breaking with the dominant pattern.

Knowing that as soon as revolt is defined it "provokes the measurement of its confinement" (SP2), the mental jiu-jitsu would also be employed to avoid recuperation. The enemy of sigma was lack of awareness, alienation, time itself, recalling Futurist leader Marinetti (1909: 14) who, in his first manifesto, declared that "time and space died yesterday." A complete rupture with the past was necessary to realise full modernity. In order to invent new behavioural procedures, Trocchi (SP2) describes in detail a new type of autonomous university that doubles as a utopian community reminiscent of Charles Fourier (1972) and William Morris (1890) as well as the experimental college in Black Mountain, North Carolina, (Duberman 1972) which had been formative in the American context as a sort of autonomous institution without grades.

Demands for the prototype of the spontaneous university were that the space should be big enough to house the "astronauts of inner space" (SP2) with all their "dream machines and amazing apparatus."[32] Additionally, it should be able to support light industry and allow for spontaneous architecture and eventual town planning: "Each branch of the spontaneous university will be the nucleus of an experimental town to which all kinds of people will be attracted for shorter or longer periods of time and from which, if we are successful, they will derive a renewed and infectious sense of life" (SP2). The vision is reminiscent of both the Dutch artist Constant Nieuwenhuys' *New Babylon* project as well as Cedric Price and Joan Littlewood's *Fun Palace*, not surprisingly given mutual acquaintance and shared artistic roots.

New Babylon was envisioned as a megastructure spread out over the existing city or countryside in a mix of multilevel, minimalist structures, scaffolding and modern set design, a scientific utopia of non-commodity socialism where scarcity and suffering would be confined to history (Sadler 1998: 105-156). For Constant, the paradigm of both architectural and social utopia would be an ever-shifting maze, architecture as half labyrinth, half laboratory. The citizens of New Babylon would roam freely through a radically decentred environment where architecture no longer would be a concrete manifestation of the controlling social order. In its

post-revolutionary new social order, religion would not exist and factories and production lines would be placed out of sight. The city itself would be elevated on stilts and columns, leaving the ground below for the circulation of traffic. Due to a combination of free time and free movement, Constant hoped that distinctions between work and leisure as well as between public and private space would disappear. By 1974, he had become disillusioned with the project though (Ford 2005: 78) and was certain that if people were granted the freedom of New Babylon, they would violently abuse each other, just like the inhabitants of J. G. Ballard's ultra-modern dystopian nightmare in *High Rise* (1975), written at about the same time, degenerate into small feral tribes and start to wage war upon each other between the floors.

More practical and on a lesser scale, The Fun Palace, planned for the Lea Valley Regional Park, East London, came a bit closer to realising the spontaneous leisure Trocchi had in mind. While Constant proposed a much more modest installation of New Babylon for the Stedelijk museum in Amsterdam (Sadler 1998: 134), Price and Littlewood got as far as satisfying fire regulations. The Fun Palace promised technical services such as "charged static vapour zones, optical barriers" and "warm air curtains," resulting in that it would be "the FIRST GIANT SPACE MOBILE IN THE WORLD it moves in light / turns winter into summer....toy....EVERYBODY'S / What is it?" as it reads on the promotional poster included in the sigma portfolio. All unrealised works, New Babylon, Fun Palace and the Sigma Centre were pre-occupied with socially interactive architecture and adaptability. They were meant to grow into imaginary cities which would be a continuous *dérive*, a drift through an ever-changing psychogeographical landscape.

Trocchi's vision for a possible future thus consisted of new, experimental cities growing up like a shadow society outside the capital cities of the world. At the centres of these new cities, the sigma university would be self-funded and pro-actively internationalist at a peer-driven level and rhizomatic, rather than top-down.[33] This shadow society would produce its own unimaginable future as an integral part of the whole environment, not just a place for specific training, and create cells internationally, aiming to take over the whole cultural field. It was important to be close to the centres of power, the capital cities, because it would make commuting easier for the international students and staff while, at the same time, signify engagement with the topics of the day instead of an escape into some sort of pastoral, utopian community (SP3):

> We must be within striking distance of the metropolis since many if our undertakings will be in relation to cultural

> phenomena already established there [...] we have always envisaged our experimental situation as a kind of shadow reality of the future existing side by side with the present 'establishment,' and the process as one of gradual 'in(ex)filtration'.

The main objective for the sigma centres would be to produce new social relations, internally as well as externally, through producing new situations as an end in themselves. This would result in an expansion of consciousness, thus producing the invisible insurrection in a way which easily can be seen in continuation of the Situationist programme. The Situationists had already written in 'Instructions for an Insurrection,' published in *Internationale Situationniste* #6 (1961), that the greatest difficulty in creating a new type of revolutionary organization would be to establish new types of human relationships within the organization itself. This would have to be a collective project explicitly concerned with all aspects of lived experience and the creation of a new life:

> The different moments of situationist activity up till now can only be understood in the perspective of a reappearance of revolution, a revolution that will be social as well as cultural and whose field of action will right from the start have to be broader than during any of its previous endeavours. The SI does not want to recruit disciples or partisans, but to bring together people capable of applying themselves to this task in the years to come, by every means and without worrying about labels. This means that we must reject not only the vestiges of specialized artistic activity, but also those of specialized politics; and particularly the post-Christian masochism characteristic of so many intellectuals in this area (Situationist International 1961: 86).

Sigma's attempt at going beyond what was, was based on the idea of an autonomous university which would detonate the invisible insurrection by educating and organising cells internationally. It was not about destroying the existing institutions and escalating the class struggle, it was about ignoring them and create one's own. At the spontaneous universities, the participants should learn "how to be if we are to be and do together at all" (SP3) while creating "a new conscious sense of community-as-art-of-living" which was to be regarded as "a continuous making" (SP3). The goal of the dispersed "action-universities" "now, today and tomorrow" would be to create a universal community in which art and life no longer were divided.

In times of systemic change and political upheaval, old dreams of autonomous universities – dreams appearing in times of crises like the anarchist free schools of the 1920s and 1930s or the Free University movement of the 1960s and 1970s – which can both produce knowledge of historical roots and possible futures to the present find new expressions. In this perspective, sigma – with its emphasis on the need to mind invade and re-educate and its call for reconditioning and the making of a new type of university to produce another world – stands as an important historical root to our own contemporary life under neo-liberal capital. It mirrors our own quotidian struggles with their renewed focus on knowledge production and, by default, value production as issues to organise around.

Already in 1943, Herbert Read had published his *Education through Art* (1943) in the same spirit of remodelling society and its values through an education system with art at its centre, collapsing disciplinary divides. The interest in the concatenations of art and education, of artistic research versus scientific research, is also conspicuous in the context of Fluxus and Joseph Beuys as well as in the early avant-garde: when Hugo Ball and Emmy Jennings founded the Cabaret Voltaire in Zürich in 1916, and thus initiated the Dada movement, they originally wanted to start an anarchist free school (Weir 1997: 233).

In the context of the production of new subjectivities, it is significant that Trocchi chose a university as the nucleus for his messianic dreams, even though it would be a spontaneous one where people were communising, pooling resources and sharing knowledge in-situ. It stresses the need for deprogramming and re-education and emphasises that we are conditioned into reality, that it is a question of breaking old habits to learn how to be together anew. It also stresses that it is through social interaction, mutual recognition, experience and sharing, in short, through experimental learning spaces that new subjectivities might be produced and new forms of life invented.

The university as institution is one of the prime producers of subjectivity today. Louis Althusser (1970) noted in his essay on 'ideological state apparatuses' that in order for capitalism to reproduce itself, it is necessary not only to reproduce production but to reproduce the relations of production, i.e. producing workers, managers and executives, which, ultimately, are relations of exploitation:

> The mechanism which produce this vital result for the capitalist regime are naturally covered up and concealed by a universal reigning ideology of the School, universally reigning because it is one of the essential forms of the ruling bourgeois

ideology: an ideology which represents the School as a neutral environment purged of ideology (Althusser 1970: 30).

The idea that it is necessary to liberate education and counter-educate and the ideas about self-determination and free universities were central themes in the 1960s where it was crucial in third world liberation movements as well (Fanon 1961; Ilich 1970; Freire 1974). It becomes a theory of cultural revolution as collective re-education that can break the habits of obedience which have become internalised as a kind of second nature (Jameson 1984: 188). The idea has had an enormous impact on cultural-activist scenes in the West where it still plays a part in its imaginary.

In his 'Blueprint' (SP3), Trocchi sketched some preliminary steps to commence upon in order to create a successful spontaneous university. Firstly, money would be earned through experimental publishing on, among other ideas, the back of playing cards, on matchboxes, in the personal columns of national newspapers, on toilet paper and on all manner of labels. Secondly, the co-conspirators would initiate the founding jam-session and thus realise the spontaneous action-university itself, a dream that would re-occur in the underground with Burroughs's Academy 23 and the Anti-University as we shall see, but also with, for example, the London Free School, founded by, among others, John Hopkins and Rhaune Laslett in Notting Hill, 1966. A third step for sigma to commence upon would be to take over UNESCO – a symbol of the bureaucratisation of all culture – on a world level, similar to what the early Situationists had envisaged in their 'Situationist Manifesto' (1960) which Trocchi translated, rewrote and to a certain extent détourned with Phil Green in 1964 as SP18.[34] In this latter version, it stated:

> We propose immediate action on an international scale, a self-governing (non-)organisation of producers of <u>the new culture</u> beyond and independent of all political organisations and professional syndicates which presently exists [...].
> They can, that is to say, initiate nothing on a sigmatic level which would not finally imply their own obsolescence.

As if to stress the conspiratorial character of the project, they added a bit further down that "sigma does not exist except for those who are with it" (SP18). The original SI manifesto solely proposed an autonomous organisation of the new culture, finding that the existing organisations are able to organise only what already exists (Situationist International 1960: 2). In its opening lines, the manifesto sketches what was perceived as the central

contradiction in the then contemporary situation: the powers that be had created a meaningless life which made it impossible to enjoy the benefits of the technological progress.

In effect, the strategy of self-publishing and self-distributing passed down from Wallace Berman and Letterism was cutting out the middle man and the brokerage system. Thus, sigma's first proposed move was to "eliminate the brokers." In contrast to the Futurists who wanted to set fire to the library shelves and flood the museums, the sigmanauts wanted to self-institutionalise their own economically independent and autonomous sigma-centres, seizing the right to self-determination. The former expected a catastrophic revolution destroying the institutions and doing away with the shackles of aristocracy and class structure, the latter was more interested in mental revolution and inner growth as a liberating practice, thus undermining and outflanking instead of violently overthrowing, the existing institutions. They wanted to increase our knowledge of freedom (which had to become self-conscious) thus diminishing the influence of professional politicians, but, as Gardiner (2008: 78) also notes, in its mix of the playful and the polemical, the Sigma Portfolio throughout stresses individual consciousness-raising (cf. SP37: 'Pool Cosmonaut') before the formation of contingent activist communities. The issue was creative leisure since "man has forgotten how to play," one of the central arguments of Situationism, partly in debt to (at least the title of) Johan Huizinga's *Homo Ludens* (1938) and its idea that human civilisation goes from Homo Faber, working man, to Homo Sapiens, thinking man, to Homo Ludens, playing man.

After the preliminary moves, the blueprint summarised three additional goals: 1) sigma had to be an international index – a sort of database registering and organising all "situation-making" groups in the world. Trocchi was, for instance, in contact with the New Experimental College in Copenhagen before it moved to Thy, Denmark in 1966 where it became *Verdensuniversitetet* (Eng.: The World University), and he planned to publish on their initiatives in the portfolio. 2) Sigma as spontaneous university and 3) sigma as an international cultural engineering cooperative which would function as a) an international pipeline, b) producers of cultural promotion, c) cultural agents – acting as a sort of talent scouts – and d) cultural consultants – meaning advising on quality, ideas as well as the buying and selling of art. This meant that, for example, writers who had been discovered and groomed by sigma would also have their work published by sigma with a percentage of the profit going back into the project. As such, it is an elaboration of the idea of sigma as an independent and experimental publishing initiative.

Many of the sigma ideas were based on social interchange around discussions, drugs, knowledge sharing, cultural production, printing, making, distributing. A snapshot of this scene c. 1964 where the movement was at the peak of its power has been preserved by Timothy Leary (1980: 114):

> Six months later, in Alex Trocchi's nerve-pulse heart chamber, people sitting around taking the Trocchi-trip. Door opens. Ronnie Laing enters. Sits on mattress. Begins to describe some Tantric sex rituals that an old schizophrenic patient-cum-guru had described to him. Soft Scot burr. Exquisite psychedelic poetry. He had all our heads in his graceful hands. Especially the women".

During 1966-7, sigma as a collective project started to fade, probably due to its lack of success in 'capitalist terms' in combination with excessive drug use. In 1966, sigma wanted to convert Cultural Enterprises, Ltd. into a registered charity but failed even though sigma still received donations. Trocchi had, for example, just received 500 pounds from American patron of the arts Panna Grady to set up an office for sigma but blew the money on junk.[35] By the end of 1966, sigma was still quite active as reported by Burroughs in a letter to Gysin dated 15 December 1966, telling him that he is taking an active part in sigma since he has realised 1) that he might as well use an already existing organization, and 2) that anyone "who gives young people something to do that means something to them can take over the youth of the world." (Burroughs 2012: 242). Over the next few years though, one by one, the 'directors' – Burroughs, Topolski, Choules, Hatcher, Diamond, Dorn – resigned until only Trocchi remained.

At this point in time, it seems safe to say that sigma only existed within the minds of a few individuals and that even Trocchi might have been preoccupied with other projects by late 1966. At least, it is stated in *IT* from early November 1966 (vol. 1, issue 2, p. 3, under the notion 'sigmavision') that the only two active 'sigmatists' (even though "strictly speaking there are no inactive sigmatists" (*IT*, vol. 1, issue 2, p. 3)) at that time in London were Peter Whitcombe and Tom Joseph who were looking for a house to start a sigma centre and to add works to the sigma collection in order to raise money. According to the notice, Trocchi had made all present sigma resources available to them. In the UK, it seems sigma was outflanked by psychedelic culture even though, as Robertson (1988: 121) also notes, Trocchi's enthusiasm had ensured that the Situationist discourse became embedded, albeit unrecognised, in the formation of the UK Underground.

Parts of sigma survived in the remnants of the Provo movement in Amsterdam where a sigma centre was operating as late as 1973 under supervision of Trocchi-associate and magician Simon Vinkenoog.[36] The inconsistencies that Ford (2005: 157) points out in the SI can be applied to sigma just as easily: there remains a huge question mark over the attitude to feminist issues and a lack of fit between the anti-hierarchical organisation programme and the actual self-limitation: it was hierarchical and dominated by one man.

That Trocchi's centrality for the project eventually became a problem for some of those involved is obvious. As early as Christmas 1964, central co-conspirators Jeff Nuttall, Bruce Lacey and John Latham were working on creating a total environment for the basement of Better Books (Miles 2010: 142). This project they named 'sTigma' – sigma without Trocchi. Mick Farren, writer and singer in the Deviants and later the Pink Fairies, described in his autobiography *Give the Anarchist a Cigarette* (2001) how Trocchi was ridiculed for the sigma idea by, for example, Michael Horowitz, but how younger people fell for it in the late 1960s when Trocchi was involved in a jazz record shop with Michael X in the Notting Hill area, because he 'actually had a plan' with 'a little more fun' and 'prankster flamboyance'.[37] Farren (2001: 35) concluded:

> Sure, Sigma was impossibly romantic, wildly utopian and fundamentally unworkable. Sure, if Trocchi's Invisible Insurrection had been attained and put into practice, we would all have died of either starvation or cholera in the first eighteen months. Okay, so it was the pipe dream of an opiate-dependant poet. Back in those days of golden haze, though, it was also exactly what many of us wanted, and within a year or so a great many of us would be playing variations on Trocchi's initial themes and embracing them as our own.

That Trocchi himself never completely abandoned the idea is clear. As late as in 1971, he was contacted by one of his early sigma co-conspirators, the above-mentioned Michael X (aka Michael de Freitas aka Michael Abdul Malik). X rose to fame as a black revolutionary in the late 1960s but was also an early sigmanaut as well as part of creating the London Free School which would eventually result in the outdoor Notting Hill Carnival.

By 1971, X had fled to his native Trinidad in order to avoid the heat in London. He soon wrote Trocchi to tell he had the perfect site for a university based on the sigma ideas which he wanted to call the University of the Alternative (Williams 2008: 203). It was to be either that or a black

agricultural cooperative to be run in conjunction with the Nation of Islam, i.e. as a sort of black power back-to-the-land commune. Trocchi immediately began fundraising by contacting, among others, John Lennon and Yoko Ono while receiving support from, for example, R. D. Laing, Feliks Topolski and William Burroughs in order to turn Trinidad into a 'real centre for international youth'. The plans again got thwarted by insufficient resources as well as Michael X's imprisonment for murder in 1972, resulting in his execution in 1975 (Naipaul 1974).[38]

III. THE ANTI-UNIVERSITY OF LONDON

> I'm talking about something that is so impossible, it can't possible be true. But it's the only way the world is gonna survive, this impossible thing. My job is to change five billion people to something else. Totally impossible. But everything that's possible's been done by man, I have to deal with the impossible. And when I deal with the impossible and am successful, it makes me feel good because I know that I'm not bullshittin'.
>
> - Sun Ra, quoted in Szwed 1997: 295

3.1.

Society as a Madhouse

Throughout the 1960s and into the early 1970s, alternative institutions ebbed and flowed. According to Rebecca Zorach (2010: 84), at the peak of the movement in the late 1960s there were as many as 450 free universities around the US. By 1975 most had disappeared. Chiefly, they were not conceived as replacements to the degree-generating university but as anti-capitalist alternatives. Offerings were eclectic, but politics and cultural critique often merged. Like sigma, the AU was one of the more elusive (re-)educational experiments with institutionalisation in the 1960s.

First and foremost, its genealogy can be traced to the Free University movement which in itself has a dual lineage. On the one hand, the free universities grew out of the Civil Rights freedom schools in Mississippi and, on the other, they grew out of the Free Speech Movement in Berkeley, California, 1964 (Zorach 2010: 85). The latter also staged the first student takeover of an administration building, Sproul Hall, in the fall of 1964 (Lee 2012: 93). In the US, these new universities received a substantial push by the organising done by Students for a Democratic Society (SDS) around the 'institutional' universities. SDS railed against impersonal university policies perceived as turning students into fodder for corporate America and would later include the cell that became the Weather Underground – an example on an inverse trajectory to the one we have followed with sigma, i.e. theirs' went from engagement with hip, communicative warfare towards militancy and terror (Berger 2006; Pekar et al. 2008).

Before the Free Universities appeared, a range of literature was already popular from A. S. Neill's *Summerhill* (1960) to Paul Goodman's *A Community of Scholars* (1962). The latter argued for an institutional exodus and a new self-valorised praxis along the lines of Black Mountain College. Ultimately, it points to how the educational foci ebb and flow through the utopian tradition stemming back to Plato's *Republic* (c. 380 BC), e.g. Robert Owen who wanted New Harmony to have a university (Ozmon 1969). In 1967, the Free University movement exploded just to rapidly fade away after 1972. Around 1975, some libertarian educators, like Ivan Ilich, still thought about deschooling but in general it had become more the kind of home-schooling of, for example, the Christian right (Miller 2002). Writing in 1970, Jeff Nuttall (1970: 198) still found that the Free University movement was the backbone from which the strength of the underground must ultimately spring, describing the Free Universities as consisting largely of "voluntary week-end schools at which radical academics can meet their non-academic counter-parts and pool their ideas."

Another important part of the AU's genealogy can be found in the intellectual milieu of what David Cooper in 1967 coined as 'anti-psychiatry' in the aforementioned *Psychiatry and Anti-Psychiatry*. Anti-psychiatry has come to mean many things and has been applied to groups as diverse as Democratic Psychiatry in Italy and Socialist Patient's Collective in Germany. In the UK, however, the term originally applied to the small group of psychiatrists, psychoanalysts and former psychiatric patients around R. D. Laing where the term was meant to "denote the position of those who point out that it is not people who are *mad*, but the relations between them" (Berke 1969b: 410).[39] Before the term was coined, Laing referred to the same conglomerate of ideas as 'existential-phenomenological' psychiatry. As we saw in Chapter Two, it entails a view on schizophrenia as a transformative state involving an attempt to cope with living in a sick society. By attempting to radicalise by relating personal problems to larger social problems it can be seen a predecessor to the feminism of the 1970s.

Anti-psychiatry was a break with the established social institution of psychiatry, inspired by, among other influences, Michel Foucault's 'great incarceration' and his *Madness and Civilization* (1961). It focused on the subjective side of being mad and centred around the psychiatrist's ability to be empathetic combined with an experimental attitude where personal experience became the criterion of truth. Like Trocchi, the anti-psychiatrists in London saw themselves as 'mind-commandos' who wanted to take over the means to produce who we are while living among their patients in community houses such as Kingsley Hall in Bow, London or wards such as David Cooper's Villa 21 where schizophrenics, at least in the public

mind, roamed around free and untreated, strung out on LSD, thus renegotiating the relation between patient and therapist.[40]

The experiments with self-institutionalising in the context of, specifically, Kingsley Hall, the DoL congress, and the AU, were partly inspired by Jules Henry's *Culture Against Man* (1963) which argued that schools make children stupid, hospitals people sick and so on. The immediate predecessor to the AU was the Free University of New York (FUNY), mainly due to the people involved. FUNY later metamorphosed into the Alternate University of New York and faded out around 1969 as the Free School of New York.[41] It was founded largely on Trocchi's idea of a sigmatic university in July 1965 at 20 East 14th Street by, among others, Allen and Sharon Krebs, Jim Mellen, James Weinstein and Joe Berke who had set himself up as a New York sigma representative. The courses ranged from the history of the American Left to sexual liberation and astrology. As Berke (1965: 6) wrote in an article for Britain's *Peace News*, October 1965, preference was given to those courses which could not appear at an 'establishment' university and attention had to be paid to FUNY's radical, educational and political position.

It had become obvious with the meeting at Brazier's Park that the imaginaries of sigma and what would become the Philadelphia Association were quite similar.[42] Already before the meeting, Sigal described in his above-mentioned novel how the Association was looking for a place which was to be a healing centre 'on the edge of London' or in a 'rural house.' Interestingly in relation to sigma's ideas about town planning, Sigal's (1976: 114-5) alter ego in the novel, Sidney Bell, describes his acid-fuelled vision of this centre to Dr. Last (Laing in fictional form right down to the Glaswegian working class accent):

> Laid out like a medieval town, it was governed by a nuclear core of Perfectii, or Brothers, who studied or prayed in a shed-like temple far apart from the un-Elect (women, children, cats and dogs). Circling this inner sanctum was a ring of mobile prefab huts inhabited by the mad and broken down – i.e. patients who might also be any of us. Unlike the wives and families of the Perfectii, who were segregated in an Outer Zone where they contentedly raised chickens and bees to make the community self-sufficient, the mad always had free access to the Nuclear Brothers. Decisions were by democratic majority of the Sacred 7, ties to be broken by the F. O. C. (Father of the Chapel, a term I borrowed from my Nation Union of Journalists).

The Sacred 7 was obviously the board of the PA who would advertise their new commune to outside laymen as "a new direction in family therapy" while, on the inside, it was primarily about working out "individual transcendental destinies" (Sigal 1976: 115). In contrast to Trocchi who maintained a connection to political philosophy, it is clear, reading Sigal, that for the PA the objective was fundamentally a mystical quest into the self. He even writes that until they were ready to mount a credible major offensive – mobilised by the invisible insurrection – "we should cloak our more mystical aims in a 'tactical smokescreen.' Hence, no wild and wooly frontal assaults, no inflammatory oratory that might scare of potential angels" (Sigal 1976: 130).

In September 1965, Berke – who had been reading the sigma newsletter, met with Trocchi in Glasgow and is encountered as Marvin Munshin in Sigal's novel – relocated to London to work as a psychiatrist with R. D. Laing and live at Kingsley Hall.[43] In London, he soon planned to start a London Free University but his plans got thwarted due to the uncooperativeness of primarily R. D. Laing who did not want to provide rooms at Kingsley Hall for the sigmatic shenanigans (Mullan 1995; Berke 2011). Jeff Nuttall wrote in *Bomb Culture* (1970: 198) that Berke "hadn't accounted for the yawning gaps existing between the English underground, the English left-wing liberals, and his 'professionally' defensive colleagues in the Philadelphia Association, who refused to allow him to use Kingsley Hall for his week-end schools." Instead, Berke became part of the Institute of Phenomenological Studies (IPS) alongside colleagues David Cooper, Leon Redler and R. D. Laing.

The IPS – which was constituted by half of the Philadelphia Association, formed in 1965 to acquire the rights to Kingsley Hall – would become the public face and the main body behind organising the Congress of the Dialectics of Liberation, held in the Roundhouse, Camden from 15 July to 30 July 1967. The Roundhouse stood unused after it earlier had provided space for Arnold Wesker's Center 42. The empty building had already been claimed by the underground when *International Times* had launched itself there with a well-attended party in 1966. The DoL congress was "totally planned, financed and organized (or not) by those who participated in it" (Berke 1969b: 411). It can be seen as a sort of initiation of the AU project or, put another way, the AU was perceived as a way of continuing the Dialectics of Liberation discussion. It was an attempt to give the spirit of the congress permanent form and create "a genuine revolutionary consciousness by fusing ideology and action on the levels of the individual and of mass society" as it says on the back of the David Cooper edited collection of papers from the conference, *The Dialectics of Liberation* (1968).[44]

The congress was planned as a way to get together and form a long-term network of people who were interested in an unprejudiced examination of the human condition. To begin with they planned for something even bigger, the Albert Hall with Sartre and U Thant, the third secretary-general of the United Nations (Schneemann 2010: 111). A disillusioned R. D. Laing remembered it in later conversation as if "most people came along entirely in their own shell to propagate their own propaganda of their particular point of view and butt up against other people somewhat and then go away again" (Mullan 1995: 219). Even though it may not have lived fully up to expectations, it was thought of as a World Congress and, thus, followed in the vein of the Destruction in Art Symposium (DIAS) which had been held in London, 9 – 11 September 1966 at the Africa Centre in Covent Garden. The title of this latter event gives away the content and echoes the anarchist credo from Bakunin, that the creative urge is a destructive urge. During a three-day symposium, DIAS had included 50 artists, poets, musicians and psychiatrists – e.g. Joe Berke (who stated that he wanted DoL to be about creation in art), Gustav Metzger and John Latham – from 15 countries surrounded by a month of happenings and other events.

According to contemporary flyers (see Berke 1969b), the DoL congress was a "unique gathering to demystify human violence in all its forms, the social system from which it emanates and to explore new forms of action." Its topics included art, psychiatry, politics, the environment, racism and war. Interviewed by Peter Davis in 2010, Berke saw three main lessons coming out of the conference: 1) it is better to ask questions than to seek answers, 2) when you think about violence, look inside rather than outside, and 3) engage in micro-social projects.[45] Laing later described the contents with the following words: "The intellectual context went from a sort of parallel meta-Marxism of latter-day Sartre and the intellectual sophistication of the *New Left Review* type of mind, the Batesonian communication research and the world of Kingsley Hall" (Mullan 1995: 218). The congress thus brought together critical theorists, political activists, poets, Marxists, anarchists, existential psychiatrists, and a broad spectrum of other leftist and countercultural figures, among them C. L. R. James, Paul Goodman, Allen Ginsberg, Mircea Eliade, Angela Davis (who was part of Stokely Carmichael's entourage), Lucien Goldmann, and Bateson.

The congress was devoted to a wide-ranging engagement with a diverse range of Leftist issues, including debates on the future of capitalism, the role of violence in modern dissent, the possibility of revolution and liberation as well as nascent forms of radical ecology and environmentalism. It was an explicit point that the audience – which included Trocchi and Burroughs – were as important as the participants when it came to the discussions. Interestingly, as it was the case in sigma and the SI, the role

of women in both the coming revolution and the future society was still left completely unaddressed; there were few and far between the women presenting at the conference and not only being there as part of some male entourage.

One of the few women to participate was the American visual artist Carolee Schneemann, who choreographed 'a happening' at the Congress and went on to lead meetings around this at the Anti-University. In a 2010 interview with Peter Davis, she remembers how she felt frozen out at the congress and laments that there were too few women present even though her initial reaction, penned in a letter to Joe Berke dated 15 August 1967 (Schneemann 2010: 122), was more positive.[46] Here she described the congress as a "magnificent conjunction of energies" and thought that there "were beginnings, promises, things to try and a group of people who, more than any others I suddenly found or was found by, I should work with."

Each day at the congress would begin with a keynote address by a central speaker. After this there would be lunch followed by discussions and seminars. During the 16 days of the conference, some people stayed in the Roundhouse around the clock, turning it into a kind of temporary autonomous commune. One of the main aims of DoL was to outline an 'anatomy of violence,' as Peter Davis' short TV documentary, documenting parts of the congress, is called.[47] Another central question the congress tried to answer was why revolution is necessary in a world of increasing affluence and welfare, a question addressed most directly by Marcuse's talk on 'Liberation From the Affluent Society.'

A central theme was radical education. Martin Levy (2012: 14) finds that the term 'radical education' in the 1960s meant that these educators "were for anarchism or Marxism, for freedom of choice, for young people, for civil rights, for the Cuban revolution, for avant-garde art, for the free expression of sexuality and for creativity and spontaneity." This goes to say they were against capitalism and often focused on a "complete rejection of everything outside that door," as Jeff Nuttall (1968: 210) quotes Trocchi for saying in *Bomb Culture*.

In the 1960s there was a severe critique of the educational state apparatus handed down from the first half of the 20th century. The reason might be found in the immediate pre-history to the 1960s, i.e. the Second World War. It was partly due to the perceived rationality and uniformity of the Nazis that the counter-culture of the 1960s in general was pre-occupied with a critique of rationality, conformity and the 'squares.' Before the Second World War the project for the cultural Left was connected to the masses as a revolutionary subject. After WWII the mainstream became

the enemy. Perceiving that the Nazis were basically the masses turned evil by an institutional production of subjectivity through schools, churches and the family, conformity became something to avoid and it made the need for re-education and an alternative production of subjectivity all the more necessary.

It is in continuation of the idea we encountered in Chapter Two, that revolution is first and foremost a matter of producing new social relations and learn how to live together anew; and thus part of the sigmatic belief that everything and everybody are conditionable. This radical imaginary focuses on how society reigns through myth and monopoly by the stories we are telling each other; that it is possible to intervene on a cultural level through counter-images and other (hi)stories. This locates it in a terrain where lines of communication are of utmost importance. Spectacular society maintains the status quo and tells us we are living at the end-of-history by endlessly circulating the same information, "always returning to the same short list of trivialities, passionately proclaimed as major discoveries" (Debord 1988: 12). According to Debord, this manufactures a present which wants to forget the past and no longer seems to believe in a future.

The congress also attempted to bridge the hedonist and the political poles of the New Left, to link bohemianism and social criticism into a common project which would provide an escape route from alienated life by exploring various inner states. In his introduction to the edited collection of papers from the congress, David Cooper (1968: 10) wrote:

> It seems to me that a cardinal failure of all past revolutions has been the dissociation of liberation on the mass social level, i.e. liberation of whole classes in economic and political terms, and liberation on the level of the individual and the concrete groups in which he is directly engaged. If we are to talk of revolution today our talk will be meaningless unless we effect some union between the macro-social and the micro-social, and between 'inner reality' and 'outer reality'.

The stories of both sigma and the Anti-University thus show a sensibility towards a unified psycho-social approach, yielding inner and outer together. In his writings, Laing (1967: 18) kept returning to the meaning of 'inner' which we already have seen Trocchi focus on. The term is, the former stressed, used in its Blakean sense: "The 'inner,' then, is our personal idiom of experiencing our bodies, other people, the animate and inanimate world: imagination, dreams, phantasy, and beyond that to ever further reaches of experiences."[48] As we saw in Chapter Two, there is a

strong yearning for reinstating the sacred and provide wo/man with a possibility for transcendental experience in these yearnings of the underground which is related to this Blakean inheritance and the visionary tradition. Simultaneously, it can also be argued that the inner quest was for a sort of horizontal transcendence where it is more about transcending the bodily confines in an out-of-body experience (see, for example, Monroe 1972) than it is about reaching a higher (spiritual) level through a kind of *Aufhebung*. Laing (1967: 115) would later expand on the meaning of 'inner':

> By 'inner' I mean our way of seeing the external world and all those realities that have no 'external', 'objective' presence – imagination, dreams, phantasies, trances, the realities of contemplative and meditative states, realities that modern man, for the most part, has not the slightest direct awareness of.

It becomes a way of thinking the invisible and, as we shall return to later with TOPY, Laing (1967: 24) also argued in the tradition of spiritual teachers like Gurdjieff that being asleep and unconscious is the condition of normal man. He emphasises the importance of a politicisation of the personal since this is exactly what has been repressed (Laing 1967: 103):

> We are socially conditioned to regard total immersion in outer space and time as normal and healthy. Immersion in inner space and time tends to be regarded as anti-social withdrawal, a deviancy, invalid, pathological *per se*, in some sense discreditable.

In hindsight, though, the most interesting part of the Dialectics of Liberation congress might have taken place on the 'outer' level, being the interpersonal experience of sharing the same time-space coordinates during the so-called 'Summer of Love' even though most of the key participants seem to shrug it off and belittle what went on. In retrospect, Laing (interviewed in Mullan 1995) only had malevolent gossip to offer. Emmett Grogan (1972: 429), invited as representative for the San Francisco Diggers, paints the following image of a day at the congress in his autobiography, *Ringolevio*:

> The speeches were routine and predictable and were all sponsored by token honorariums from the London Institute of Phenomenological Studies, except Emmet's which was free. Psychiatrist R. D. Laing said everyone was crazy, including himself; John Gerassi had recently returned from Cuba and

spoke about the necessity for a violent revolution; Gregory Bateson talked about the scientific apocalyptic aspect of the anxiety syndrome from which everyone was suffering; Allen Ginsberg insisted that the best tactic of psychopolitical action was to 'make public all the private hallucinations and fantasies of our priest-hero-politician-military-police leaders, like those of John Edgar Hoover, for instance'; the keynote speaker, Stokely Carmichael, still very upset with Emmett, lashed out at the longhaired hippies who, he claimed, were advocating peace in time of revolutionary warfare and were traitors to the radical movement, because their upper-middle-class affluence afforded them the choice of nonviolence and the means with which to drop out of the fight for liberation which he quoted as 'only coming through the barrel of a gun!'; Paul Goodman suggested that governments might begin applying social welfare ideals and principles by paying, for example, people on New York's welfare rolls to live in the country, instead of in the city. 'Give them the same money, and say, 'You don't have to live *in* New York, you can live *out* of New York!'; Herbert Marcuse didn't say anything because he wasn't there, having hopefully found something more important to do with time.

Speaking with other attendants of the congress, it seems to mostly be remembered as part of the lineage of Black Power, specifically with Carmichael's keynote, simply entitled 'Black Power,' but also in relation to the main discussions and to Marcuse's 'Liberation from the Affluent Society.' Carmichael, who was honorary Prime Minister of the Black Panthers and Marcuse, a Frankfurt School theorist, both examined chattel slavery and its most prominent critic in the nineteenth century, Frederick Douglass, as one of the means by which to understand and articulate a critical position in the era of the New Left.

The attraction of Douglass as a model might be connected to the refusal to take violence completely of the table as a model for revolutionary action no matter if the perspective was black nationalism or utopian socialism. Douglass' action took the form of controlled violence or self-defence (e.g. Douglass 1852). Another take on racism can be seen to grow out of the congress in the writings of American poet Calvin Hernton, e.g. *Sex and Racism* (1965), who sees 'the racial problem' in terms of psychosexual oppression. Even though Hernton did not present at the congress, he would become a central figure in the circles around the AU, where he was to lead a course. Additionally, he can be seen as another connection between the New York

and London scenes of the 1960s, being a close friend of, for example, Aldo Tambellini and Ben Morea. Following his experiences in London, he wrote the novel *Scarecrow* in 1970 which is a *roman à clef* about his boat travel alongside Berke and others from New York to London in 1965, on their way to arrive at the communal affairs of Kingsley Hall. The flamboyant character of Dr. Yas, an acid-fuelled Jewish psychiatrist with deformed hands, is based on Berke with whom he would later go on to write a book on cannabis (Berke et al. 1974).

Bearing in mind the biopolitical perspective on Nazism's concentrated spectacle – trying to make people change from within through the use of a massive state and image apparatus built up around a charismatic leader – it is worth mentioning Grogan's prank at the congress. Grogan – as many of the other characters encountered in the field of cultural engineering never one to shy away from self-mythologising – recalls how he delivered his speech to standing ovation only to later reveal that it had been delivered the first time by Hitler to the German Reichstag in 1937. Apocryphal or not, this shows again that cultural engineering can be seen as a technique to intervene in mass culture and that, as a technique, it is as easily recuperable for the Right as for the Left. Grogan's (or Hitler's) speech bears some uncanny resemblances to the issues discussed both at the conference and in these pages so far like, for example, "'our revolution will do more to effect a real, inner transformation than all modern history's revolts taken together'" (Grogan 1972: 432). If we look for similarities to the broader cultural rupture of the 1960s, Grogan and the Diggers shared some of the aims of both DoL and sigma, wanting to "lay the foundation for an intercommunal planet where there would be no boundaries dividing up the world, just different tribes of people free to live their lives the way they want, instead of have to – which is the only way to keep it all from dying" (Grogan 1972: 435).

Iain Sinclair – the London-based psychogeographer, writer and filmmaker – attended the conference as part of the audience to shoot a short film, *Ah, Sunflower!* (1967), documenting Allen Ginsberg's visit to London. He wrote down his impressions in *The Kodak Mantra Diaries* (1971). The diaries map in detail the process of making the film and thus use considerable time on the experience of attending the conference as well as documenting interviews with both speakers and passer-byes. Regarding first hand impression, Sinclair (1971: 21) wrote: "[...] everyone is just sitting here, at THE CONGRESS OF THE DIALECTICS OF LIBERATION, which Ginsberg is at, everyone is just sitting here telling everyone else how the ship is going down, sinking, there is nothing we can do. We're in the position of Dr Benway in THE NAKED LUNCH, who as the ship sinks, this is the Lusitania and the band is playing AMERICA THE BRAVE, as it sinks, as

it sinks..." These premonitions of doom might also explain some of the appeal of Grogan for younger audiences at the congress, since " |...| he is still young. He has the energy. Look at it any way you want, the others are all sold out. They have taken money from the foundations, the tax-dodge liberal arts operators, the mass media octopus. [...] You can't trust them, the old men. Who knows what they represent. It is so ambiguous, so complicated" (Sinclair 1971: 17).

Basically, the questions raised by the Dialectics of Liberation were about how to change people's perspective(s). There is a certain doubleness in the term when Jeff Nuttall designates the British counter-culture of the 1960s as a 'bomb culture.' Not only did they want to change the world by detonating a cultural explosion, they were also living in the belief that the world was on the brink of nuclear annihilation, turning them into heirs of all the utopian, millenarian religious movements which have believed that the End Times are at hand and confidently expected that "the trumpets shall sound and we shall be changed, in a moment, in the twinkling of an eye" (1 Cor: 51-52). At the same time as this bomb culture constituted an underground trying to detonate the invisible insurrection and create a shadow society, it was populated by big egos and people who were starting to become extremely famous which is also why the congress can be seen as, for example, the culmination of Laing's political commitment. Right after, he travelled to India and went on a more mystical path, distancing himself from Kingsley Hall which would soon cease to exist as an anti-psychiatric community house.

> Dr. Yas put his great hands up in the air and tried to pop his fingers. 'Inner and outer space, baby, is all one space, like psychedelic!' He reached out and swooped up a girl.
>
> - Calvin Hernton 1970: 58

3.2.

The Anti-University

After the end of the Dialectics of Liberation, people continued meeting up to discuss the issues raised at the conference and to experiment; with communal living, with psychopharmacology and hallucinogens, with radical education, with free expression. The milieu around Kingsley Hall and the Institute of Phenomenological Studies soon spawned an ad hoc committee and, in December 1967, the Anti-University was created.[49] On 12 February, 1968 – with Allan Krebs as organising secretary – it opened its doors at 49 Rivington Street, Shoreditch, London, in a building owned by the Bertrand Russell Peace Foundation which until then had been occupied by the Vietnam Solidarity Committee. As a physical entity, a place with open doors you could visit, it lasted only a few months before it suffered the same fate as sigma: lack of funding. Instead, in a version of history that pays no attention to the ideas and social relations produced, it rapidly became a crash pad for junkies who were soon evicted.

The experiment itself echoed Trocchi in its essential definition of revolution through self-criticism and the insistence of Harold Norse – writing in *IT* #26, 1968 alongside Trocchi and Robert Tasher to give 'three views on the Anti-University' – that it should be "spontaneous" and bring about "a revolution in the mind" since that would be the only hope for "the moribund human race" (Norse 1968: 6). That the notion of a 'spontaneous university' was central to the experiment is also conspicuous in the general information section of the AU's first *Catalogue of Courses* (Berke 1968):[50]

> A small number of faculty and students will travel to other cities in England and elsewhere for a period of up to two weeks at various times during the year. The purpose of this is to create 'spontaneous universities' in outlying areas where

> people will have the opportunity to listen to, discuss, challenge and, in general, turn on to a multifaceted analysis of what is going on.

Interestingly, like sigma, the AU tried, in contrast to earlier avant-garde movements, to directly address the economy and think about how to fund their venture, thus no longer relying on the art market and the whims of collectors. It can be seen as an early attempt at self-institutionalising in order to valorise an alternative production of subjectivity. Even though they were outside the proper institutions – which famously became occupied by, primarily, the student movements in 1968 but also by some workers – they were anti-capitalists operating inside capitalism. According to the committee's first newsletter, accessible at the British Library, it was to be funded by a membership structure with a fee per quarter of £8, £5 for early birds, and 10 shillings for every course. This marks a slight rise from the first catalogue, showing that the making of the AU was a work-in-progress which continually evolved and mutated according to who put time and effort into it at any given moment. The first catalogue stated that

> membership is £5 per quarter (£20 per year). Attendance per course is 10/-, without reference to the number of meetings involved. Fees may be paid in money or goods or services. No one who wants to attend the Antiuniversity but cannot afford the membership fee in money need to be deterred from doing so. Scholarships are available.

It can be concluded that the venture was meant to be economically self-sustaining even though it was still highly idealistic since nobody were to be excluded due to pecuniary difficulties. Money was thus not a determining factor in who was included or not. In general, money to sustain the AU was to be raised through fund raising campaigns, fees, loans, gifts, etc., but, to begin with, the AU was supported by a grant from the Institute of Phenomenological Studies.

From the beginning, an emphasis on radical education and anti-hierarchical relations was conspicuous. The minutes from the ad hoc committee's meeting, 12 December 1967, states that the faculty is "to be asked not to give 'courses' so much as to meet with a group of interested people to present and discuss their current thoughts, work, etc." (reproduced in Jakobsen 2012a: 19).[51] Similarly, prospective 'students' were asked to fill in a form, giving a brief description of themselves, their work and points they would like to address, meaning that the AU was focused on

active participation among peers, thus renegotiating the relations between speaker and audience, performer and spectator. Showing an awareness of group power relations, the Anti-University additionally stressed it would not "use labels such as 'student' and 'teacher' to restrict or structure human relations" (Elzey 1969: 231). On the contrary, the committee wrote in the third catalogue:

> We must destroy the bastardized meanings of 'student', 'teacher' and 'course' in order to regain the original meaning of teacher – one who passes on the tradition; student – one who learns how to learn; and course – the meeting where this takes place. The Antiuniversity of London is not a university or a school. It gives no credits and grants no degrees. However, those who study full time under one or more faculty members may be given a letter from these people stating that said individual has sufficient expertise in a given subject to allow for 'higher' study.

Among the catalogues and letters collected by the British Library, there is also a calendar. It shows that the AU was meant to operate on a quarterly basis. The year was to be divided into four quarters lasting eight weeks each with courses being either biweekly or weekly and lasting about two hours at a time. The courses, or 'meetings,' as the committee preferred to call them, would take place in the evenings and there were to be two sessions, roughly 6:30pm – 8:30pm and 8:30pm – 10:30pm, Sunday to Friday inclusive. The calendar shows that registration would be possible between 22 January and 12 February 1968, where the first meetings took place. During the first quarter, more than 250 people, primarily students, signed up as members of the AU while the faculty consisted of up to 50 persons (Berke 1968).

As an experiment with education and a creation of a spontaneous university, the Anti-University, as such, was connected to the premises in Rivington Street which were inhabited by the AU from February to August 1968, i.e. it existed for about six months even though the beginnings of the project can be traced back to the summer of 1967 with the DoL congress. In this period, the organising committee printed three catalogues as well as a series of newsletters. The first catalogue was a white quadrangular issue with letters all over the front page as well as the information 'Antiuniversity of London, number one.' Besides courses, it also includes a few papers, e.g. David Cooper's presentation delivered in Havana, Cuba on 'Towards Revolutionary Centres of Consciousness' or a short paper by Jeff Nuttall on 'The Importance of Failure.'

The second catalogue, printed in a quadrangular format a bit smaller than a5 with a yellow sleeve that simply says 'Anti-University', goes a bit deeper into the general intention behind founding an anti-university:

> At the Antiuniversity, many of the original and radical artists, activists and intellectuals of London and Europe, America and the third world have a place to meet among themselves and others to discuss their ideas and work. The emphasis is on diversity of approach, but we shall work to unify disparate perspectives. Above all, we must do away with artificial splits and divisions between disciplines and art forms and between theory and action.

This goal puts them in continuation of the critique of alienation which we encountered with sigma. In a letter to Paul Goodman, dated 18 January, 1969, Berke explained the basic idea (Jakobsen 2012a: 20-21). It is related to both ideas of DIY and independent media production as well as to sigma's desire to bring all information out in the open, and, thus, the beginning of an information war, central for the invisible insurrections, where warfare becomes semiotic, performed on the level of signs. The objective becomes to democratise access to a privileged knowledge so it can be passed on to a generation that will realise a fuller notion of life:

> The purpose of the Antiuniversity is to provide a context for the original and radical scholars, artists and activists residing in London, as well as Europe, and America to communicate their work to young people and others outside the usual Institutional channels.

Later, in the spring of 1968, the ad hoc committee sent the following statement, which sums up their position, to the newsletter subscribers:

> The Antiuniversity of London has been founded in response to the intellectual bankruptcy and spiritual emptiness of the educational establishment both in Britain and the rest of the Western World. It seeks to develop the concepts and forms of experience necessary to comprehend the events of this century and the meaning of one's life within it, to examine artistic expression beyond the scope of the usual academy and to promote a position of social integrity and commitment from which scholars now stand aloof. The Antiuniversity of London will be a meeting ground for discussion, discovery,

> rediscovery and revelation. It is intended as an ongoing experiment in the development of consciousness and will be related to other revolutionary experiments in universities, communities, communes and direct action now taking place in Europe and America.

As we shall see later on with Academy 23 and thee Temple ov Psychick Youth, especially the emphasis on rediscovery and revelation becomes central to the trajectory of the underground following in the footsteps of the Anti-University, trying to win over a million minds. It is not only about producing new relations and discover new knowledges, it is also about gaining access to what is already there even though it might be hidden or forgotten, occult or esoteric. As such, it opens up for a militant research concerned with the re-mobilisation of previously marginalised knowledges that are being utilised in order to disrupt the present, not unlike the Foucauldian notion of genealogies that are picking up discarded knowledge in order to use them for attack on contemporary institutions and scientific discourse (Foucault 2003).

It shows that, on the one hand, the Anti-University was about creating a counter-power, a type of institution which could produce alternatives, while, on the other hand, it was about using subterfuge. Rather than trying to dispel authority with a counter-power, it was about using delegitimised and esoteric knowledges to bring the established order down to the same level of free floating signifiers. It can thus be argued that the Anti-University used disinformation in a strategic way that points toward the 1980s underground's fascination of conspiracy theories, etc. At the same time, it also constitutes a 'shadow knowledge' that corresponds to the invisible insurrection's creation of a shadow society. Carolee Schneemann (1991: 68) called it a 'double knowledge' and talked about how her inspiration stemmed from "the existence of a secret, separate history to research and investigate" which is concerned with the marginalised and the invisible.

In the AU newsletter from April, 1968, Berke goes on to write that our schools and universities are already dead. Therefore, they must be destroyed and rebuilt on our own terms. This, he sees as already happening with the Free University movement (including anti-universities and critical universities) which, he states, during the past three years has taken root in, for example, the US, Canada, New Zealand, Germany, Italy, Holland, Yugoslavia and Denmark. To Berke, the Free Universities are the vanguard of "a large scale political resistance which in the West takes the form of <u>CULTURAL</u> guerrilla WARFARE" (Berke 1968). He continues:

> Although most anything can and is discussed at the ANTI-UNIVERSITY, we give particular emphasis to material which could not otherwise have a public forum for either political or academic reasons. Moreover, we seek to demonstrate to young people the nature of class struggle and social conflict in their own terms. For example, in London, at present, this involves discussions about how and why the authorities supressive [sic] many of the activities which enagse [sic] people, anything from psychoactive drugs to 'underground' communications media to demonstrations of solidarity with the heroic National Liberation Front of Vietnam.

Besides reaching out to the activist scenes in words and writings, in the beginning the AU also arranged kip-ins, where members would spend the whole weekend from Friday to Monday at the premises and have a party Saturday night in order to meet people and 'groove.' About the same time the above newsletter was mailed to subscribers, Peter Upwood, the caretaker of the snack bar, had moved into the building joined by a group of six or seven friends which meant that the AU began to turn into a commune (Elzey 1968: 243). Early on, this catalysed a weekend workshop where many communes in the London area gathered at the AU at the end of April to share experiences and political ideas but in hindsight it can be seen as the beginning of the end of occupying the premises in Shoreditch.

To give a few examples, the courses at the Anti-University spanned the by now familiar spectrum from radical politics to drugs and the occult. Theodor Roszak, who popularised the term 'counter-culture' – and who I will return to in the next chapter – was part of the visiting faculty. He introduced his course, 'The Making of a Counter-Culture', thus: "I use the term counter-culture to describe a new psychic and intellectual constellation which diverges radically from the dominant cultural tradition and which aggressively challenges the mainstream". There were also Steve Abrams' course on 'Action Research Project on Racialism', or Joe Berke's on 'Anti-institutions Research Project' where he proposed to research the "[t]heory and practice of the anti-university, anti-hospital, anti-theatre, anti-family (the commune), underground communications media. Meetings will be concerned with formulating and carrying out specific action projects of use in illuminating the developments of a counter society." Additionally, Cornelius Cardew offered a course on 'Experimental Music', Bob Cobbing and Anna Lockwood offered 'Composing with sound: a course between poetry and music', C. L. R. James gave four lectures on 'Worker's Power in 1917, 1936, 1956 and 1968' and so on and so forth.

Of the more hip courses on offer there were, for example, Richard Martin's course on 'Alchemists and Hallucinatics from De Nerval to Joyce' where "[l]ectures will be antilogical, but will basically be concerned with phantasy and transcendence in art. The thesis is that the French artisan movement created a shift in libido from the visible to the invisible, to a world of mysticism," or Noel Cobb's course on "From comic books to the dance of Shiva: spiritual amnesia and the physiology of self-estrangement" which he presented the following way:

> A freewheeling succession of open-ended situations. Ongoing vibrations highly relevant. Exploration of Inner Space, de-conditioning of human robot, significance of psycho-chemicals, and the transformation of Western European Man. Source Material: Artaud, Zimmer, Gurdjieff, W. Reich, K. Marx, Gnostic, Sufi and Tantric texts, autobiographical accounts of madness and ecstatic states of consciousness – Pop art and twentieth century prose.

To name but a few, members of the faculty included, besides the ones already named, Richard Hamilton, Yoko Ono, Gustav Metzger, Harold Norse, Jeff Nuttall, Barry Miles and other luminaries of the UK Underground. The list of visiting faculty who would be involved when time and circumstance permitted it was just as impressive: Burroughs, Carmichael, Aage Nielsen, Hans Enzensberger, Ginsberg, Stuart Hall, Vinkenoog, Cedric Price, etc. Some of the courses, e.g. Cooper's (on 'Psychology and Politics') and Laing's (on 'Psychology and Religion'), were very popular. Others like John Latham's course, advertised as 'Anti-Know,' became a one-off event (Jakobsen 2012a: 23-24). Still other meetings never happened. In the second catalogue, Trocchi is appearing, leading a course on 'The Invisible Insurrection' where participants would meet fortnightly, Tuesdays at 8.30pm, throughout the second quarter. To present the course, he wrote:

> I take it that the Antiuniversity is an experiment in relation to the urgencies of the invisible insurrection, that what we are consciously undertaking is an exploration of the tactics of a broad (r)evolt. Speaking personally, I am quite able to express lucidly and comprehensively the main features of this cultural transition and can describe in immaculate intellectual terms the spiritual attitudes and the new economic scaffolding which must be brought into play as the tactical bases of any possible evolution of man.

Even though the tone is slightly aloof, Trocchi was not far off by seeing the AU as part of the invisible insurrection. Berke (1969a: 28-33) listed four developments and expansions which encompassed the framework of the cultural and political events in the parts of the underground concerned with the creation of an alternative society. Phase 1 would consist of the invisible insurrection as Trocchi formulated it in SP2. This would be the phase of cultural conflict, of the reawakening of Black Power as well as 'multifocal confrontation.' Phase 2 would consist of expansion, organisation and planned confrontation. Phase 3 would be the crisis and the collapse of the bourgeois state and, finally, phase 4 would be living in the coming counter society while being conscious about that the revolution always continues.

The second term at the AU started 6 May 1968. Where the first catalogue had offered 37 courses, the second offered 60 courses. At the same time, the ad hoc committee who de facto ran and organised the AU began to come under attack for, among other points, lack of transparency and reproducing the dreaded family structure with its repressive and violent nature. The turmoil made Allen Krebs step down as administrator. Instead, this role went to Bob Cobbing – who had not been part of the ad hoc committee until then – in a move that began to break down the committee's managing role.

In July 1968, Bob Cobbing resigned as administrator, partly due to organisational problems within the AU and partly in protest against that the catalogue was largely to be ignored. When the third catalogue, printed in a4 format with a light green sleeve containing the AU's name and address, was about to go to print, courses would no longer be based upon the name of the course leader. Instead, the participants were encouraged to see themselves as givers of the course, cf. the title on Tasher's short piece on the Anti-University in the above-mentioned *IT* #26, 1968: 'Don't enrol as a student, only as a teacher.'

This development led to the 'Anti-U Course Creation Rally' at Hyde Park Corner on 21 July 1968. The flyer for the rally (reproduced in Jakobsen 2012b: 12) announced that "All decisions on the allocation of Anti-U space time will be made at this meeting." The development also meant that course leaders were no longer going to be paid for running a course. In fact, due to the ongoing structural struggles, many members had already stopped paying the fee after the first quarter. This meant that the AU had been unable to pay its course leaders after the second term. Thus, from the third quarter, beginning 15 July 1968, the AU was going to be organised and maintained by the students, now with no money. Essentially, this spelled the end of it, bringing to mind Trocchi's words from SP2 that in

order to be successful in a pre-revolutionary, capitalist society, one needs to be successful in capitalist terms.

At the beginning of August, the Bertrand Russell Peace Foundation wanted its arrears for electricity, rent and telephone to be covered. Thus, the premises in Rivington Street had to be abandoned due to problems with paying the rent. After settling the bill, the AU left the premises and continued as an idea, a dispersed anti-institution relegated to be part of the late 1960s *zeitgeist*. A number of courses and meetings carried on around London with Bill Mason's flat in Soho as the hub and postal address, and advertisements running weekly in *International Times* until c. 1971.

One of the things that went wrong according to Berke was that too many intellectuals were involved and that too much thinking without practice is destructive. Another thing was, in general, that there were 'too many egos' (Berke 2011). According to Jakobsen (2012b: 12), the way the democratisation of the AU led to a less viable economic structure has to be seen in the light of "the resistance to the teacher-student structure that the contestation of the fee payment represented." Instead, a more decentralised Anti-University was needed and private flats began to be utilized as meeting places instead, spelling the de facto end of the singular nature of the experiment, its mutation into something else where the energies soon evaporated and the ideas found other outlets. In short, the anti-hierarchical ambitions of the AU descended into intercollegiate friction, proving that when the sun goes out, we will all be stars.

IV. THE POLITICS OF EXPERIENCE

Entry #42. To fight the Empire is to be infected by its derangement. This is a paradox; whoever defeats a segment of the Empire becomes the Empire: it proliferates like a virus, imposing its form on its enemies. Thereby it becomes its enemies.

Philip K. Dick 1981: 152

4.1.

Beyond Art and Politics

After having examined the histories of my first two case studies above, in this chapter I will discuss these initiatives in relation to some similar initiatives as well as situate them in a context of art, politics and the occult. I will pay special attention to the cultic aspects of my two cases. If the trajectory through the UK Underground from sigma to the AU transmutes from political to hermeneutic philosophy, how does this affect the idea of total transformation? When the politics become invisible, is it still possible to act politically?

The 1960s underground never followed a single-issue politics or a single theoretical line. Instead it espoused a bewildering, but in its own way defining mix of issues (Wilson 2005: 91): from the struggle for racial equality and sexual liberation to alternative living; from communes to the squatting movement to ecology to new age mysticism. The dozens of pages on sigma in the portfolio, complete with charts and diagrams, represent the design for an entire new social structure which was to be highly pluralistic with legalised drugs, infinite tolerance, open education and other themes very much in line with the rising counter-culture where revolt often mutated into style. Towards the end of the decade, the AU took a more hands on approach to the sigmatic ideas and began to experiment with self-institutionalisation, meaning that they tried to make their own bio-political apparatus with which to produce future subjectivities.

With the SI, art and politics became inside operations, capitalism would itself produce what was to overcome it – an idea which is in agreement with Marx – and there was no longer any outside (except possibly beyond the body and the planet (Dickens 2009)). The enemy's secret weapon was

social conditioning which is why one could only win by confronting the institutions reproducing this 'lie': the university, the family, the schools, etc. Sigma began from this realisation. It occupied a post-Situationist terrain based upon some of the insights and affects from the SI but added bits of anarchism, occult mysticism and drug romanticism to form a singular trajectory through London in the mid-1960s.

In his remembrance piece after Trocchi's death, McGrath (1985: 37) summed up the project's position:

> Trocchi had no patience for Marxism or any other political approaches which he considered as outmoded. Instead his revolution began in inner space, within human consciousness itself. Its proponents were those who already had an awareness of reality which was expanded beyond the bounds of their fellow men, those who, by one means or another, had escaped the frames and restrictions the standardised society had placed on the human mind.

Not only does this point to that Trocchi in his own self-understanding occupied an avant-garde position, it also shows his awareness that this position is no longer possible. This fundamental ambiguity highlights the force of the project which is simultaneously its major weakness: its in-betweenness, being just as often neither-nor as both-and. It occupied an ecstatic edge but it was double-edged. An aspect of this can be seen in that Trocchi wanted to engage in semiotic warfare through a barrage of turned images and communications, subverting the system from below. Simultaneously, there are traces of an earlier model of warfare, where one is interpellated as the physical opponent, building up strength in order to have a sort of final head-on confrontation with the enemy instead of engaging in a more random, urban guerrilla warfare, operating by stealth in a networked, anonymous resistance which would create a shadow reality through the creation of situations. It is a schism between visibility and invisibility.

In between anarchism and Marxism, Trocchi imagined a decentralised future where everybody lives with the traditional (and more or less imagined) freedom of the artist in small creative communes of like-minded individuals, creating everyday life. However, the way it was organised points more towards a Leninist vanguardist cell. Sigma was a project for Trocchi and his circle, i.e. at the centre stood Trocchi himself and the rest surrounded him at more or less the same distance. Not a hierarchical pyramid, but not a decentralised network either which it would have needed to become in order to make it truly international and self-determining.

In order for sigma to have been successful, enough of the incredulous would have needed to reach a state of awakeness and be converted into disciples, spreading the good word, for Trocchi himself to have been superfluous. It would have needed to become a meme in the original sense of being a self-replicating virus spreading through human consciousness. [52] Instead, today it exists only as a log of an idea and half-forgotten memories of an intoxicated weekend in Oxfordshire. The experiments-in-living and the mentality surrounding it were ephemeral but can be traced as powerful themes across the Sixties avant-garde.

The proselytising and quasi-religious aspects point to that sigma, besides fitting comfortably into the history of the evolution of Situationism and the trajectory of the modernist avant-gardes, in many ways can be seen as an attempt to establish a new type of cultic community: a secret society conspiring to create a new religion while worshipping a utopian future not unlike the future visible in a radical interpretation of the Gospels or the anarchist tradition. As such, sigma was an alchemical attempt at manufacturing the philosopher's stone, the key to the Kingdom of God where we are all living in joy and abundance, through revelation. *Visita Interiora Terrea Rectificandoque Venies Occultum Lapidem* as the alchemists of yore put it.[53]

Sigma was meant as propaganda-by-the-deed, a DIY way of life other eventually would participate in, thus working towards a type of revolution where the conspirators had learned the lesson from the SI. The latter group wrote in *Internationale Situationniste* no. 8 (Situationist International 1963: 148) that at

> this point in history, when the task is posed, in the most unfavourable conditions, of reinventing culture and the revolutionary movement on an entirely new basis, the SI can only be a Conspiracy of Equals, a general staff *that does not want troops*. We need to discover and open up the 'Northwest Passage' toward a new revolution that cannot tolerate masses of followers, a revolution that must surge over that central terrain which has until now been sheltered from revolutionary upheavals: the conquest of everyday life. *We will only organize the detonation*: the free explosion must escape us and any other control forever.

In relation to classical anarchism and/or Marxism, Trocchi ended with a less identifiable position incorporating insights from both but, ultimately, being its own singular concatenation of direct action, psychedelia, the

occult and the surreal combined with an open door policy contrary to the small numbers of people directly involved with the SI. Like the 2nd SI in Scandinavia, Trocchi's project was more aligned with certain strands of anarchism than with the Left communism of the French SI. As he wrote with Jeff Nuttall on the Moving Times/sigma poster (SP1): "[...] now and in the future our centre will be everywhere, our circumference nowhere. No one is excluded. A man will know when he is participating without our offering him a badge." Like the early SI, Trocchi was interested in developing a new plastic, a revitalised art which could not be described since the condition for its production did not yet exist. It would always be contingent on its specific situation and context and would thus be a new type of cultural production that would not only generate but also be generated by the invisible insurrection.

The invisible insurrection was also one of the elements in the AU's project. If one of the problems with sigma eventually became that Trocchi dominated at the centre, the history of the AU shows the contrary tendency: the problem of leaderlessness. This is relevant today in the context of the Arab Spring that has become the Arab Autumn and which, to begin with, was framed as a new type of leaderless revolution. History shows that when a given space is being abandoned by power, it is readily occupied by new vested interests. Another critique of the AU – which many of participants probably saw as a force due to their focus on spontaneity – can be directed against its lack of organisation: instead of constructing from the bottom up, meeting informally and then move on to a building, becoming institutionalised, the experiment starting out with the premises in order to jam it out from there, a tactic also favoured by Trocchi in SP2. Not forgetting the junkie contingent in both sigma and the AU, it is, at the same time, difficult to overestimate the part played not only by images and imaginaries, but also by power and vested interests in these sort of collective enterprises.

Even though they differed in organisation, sigma and the AU shared a romantic belief in the healing and world transforming powers of art and, especially, poetry. The way poetry became a weapon in the cultural revolution was, for example, addressed by Laing (1967: 37): "Words in a poem, sounds in movement, rhythm in space, attempt to recapture personal meaning in personal time and space from out of the sights and sounds of a depersonalized, dehumanized world. They are bridgeheads into alien territory. They are acts of insurrection."

Aesthetically, the underground was, in general, suspended between modernism and postmodernism, pictures that referred to ontological existence and pictures that only referred to other pictures, turned or not, with a heavy heritage from aesthetic modernism's focus on autonomy,

authenticity and alterity. The obvious critique is of the naivety in believing that art, poetry and music can have a direct and controlled political effect in the world, that it is something that can save us from alienation and separation. If art really wants to make a difference, maybe it is necessary to leave the aesthetic realm behind as the specto-Situationists argued even though they were themselves obviously fascinated by the aesthetic domain and Debord returned to film-making after dissolving the remnants of the group in 1972. To realise art, it has to stop being art and go beyond both art and politics where inner world and outer world, the ludic and the analytic, is unified in action and in existence. The failure, so far, of this struggle to realise art, which can be traced all the way through the twentieth century and into the twenty-first, might be because the institutions are able to incorporate their own negation and strengthen themselves through it or it might be that it is simply an unrealisable strategy, a myth in the Sorelian sense, that keeps invigorating and driving an interventionist art which, in the long run, is not able to negate its own status as art or escape the marketplace that commodifies and collects it.

The focus on poetry and subjective experience in both sigma and the AU points to that the personal became political. In Laing's *Politics of Experience* (1967: 20), he wrote: "Personal experience transforms a given field into a field of intention and action: only through action can our experiences be transformed." The term 'experience' is used in a quite specific meaning by Laing, since it is connected to his definition of a 'person.' This is a two-fold definition as, on the one hand, a centre of orientation of the objective universe in terms of experience, and, on the other, the origin of action in terms of behaviour, i.e. there is a distinction between experience and behaviour where the latter is a function of the former: "We act according to the way we see things" (Laing 1967: 24). This opens up for ideas about behaviourism and cultural engineering since it follows that in order to control the behaviour of large numbers of other people it is necessary to work on the experiences of these people: "Once people can be induced to experience a situation in a similar way, they can be expected to behave in similar ways" (Laing 1967: 80).

As mentioned earlier – for instance in relation to Trocchi's use of the adjective 'sigmatic' – there were quite a few similar initiatives to sigma and the AU in the 1960s. As a result, my case studies can be seen from a plethora of perspectives. From one such perspective, they can be seen as predecessors to today, pioneering contemporary concerns about art activism in a context of social movements organising around themes of education, direct action and communal living. In this perspective, both initiatives are firmly parts of the New Left and point towards a political position which is post-anarchist or post-Marxist with hints of autonomist ideas, i.e. being

critical towards the state and believing that the real locus of power resides with everyday people, including the marginalised and the impoverished.

Another perspective looks at their historical context and is, thus, synchronic instead of diachronic. The dreams for a sigmatic culture, outflanking the systems of capitalist power through mutation while being produced by and producing spontaneous action-universities can, for example, be fruitfully analysed in relation to the German artist Joseph Beuys' notion of social sculpture which shows obvious similarities: Beuys had an interest in radical pedagogy and self-schooling and was part of founding the Free International University in Düsseldorf in 1972 with the goal of pondering 'the future of society'. He defined his notion of social sculpture as 'the process of how to mould and shape the world in which we live', i.e. again we see a notion of cultural engineering. He wrote (Beuys 1986: 9): "My objects are to be seen as stimulants for the transformation of the idea of sculpture, or of art in general. They should provoke thoughts about what sculpture can be and how the concept of sculpting can be extended to the invisible materials used by everyone."

A third perspective is related to the history of the artistic avant-gardes. In contrast to Situationism, sigma was less militant and more oriented towards the exploration of inner space from spirituality to psychedelia. Besides the political current, there is a strong occult current in the sort of counter-cultural thinking apparent in sigma with the Tarot, I Ching, *The Tibetan Book of the Dead*, the Age of Aquarius, etc. (Lachman 2001). This current came partly through the messianic belief in a New Age, and partly through the crisis of rationality and the Enlightenment project which led artists to search for alternative ways of rigging the world.

Just as sigma seems to be close to the Scandinavian Situationists in spirit, Trocchi seems ostensibly closely related to the Danish artist Asger Jorn, even though the latter had a background in painting, not literature. To Jorn, the modern artist was a shaman who explores new and often dangerous territories just like in the string of psychonauts we have so far encountered from Crowley and Austin Osman Spare to Aldous Huxley, Ernst Jünger, Trocchi and Burroughs. In many ways, sigma is a British cousin of Jorn's Imaginist Bauhaus. The International Movement for an Imaginist Bauhaus (IMIB) began its existence in Switzerland, 1953, through a string of letters between Jorn and, primarily, Enrico Baj from the Nuclear Art Movement as well as some ex-COBRA members (Jorn 1957: 23). In 1955, Jorn, along with Pinot-Galizio and Piero Simondo, created the 'experimental laboratory for free artistic research' in Alba, Italy in order to focus not only on technique but also on fantasy and symbols. This school would not offer instructions, but it would create possibilities for artistic experimentation. As Jorn (1957:

24) concluded in his 'Notes on the Formation of an Imaginist Bauhaus': "Our practical conclusion is the following: we are abandoning all efforts at pedagogical action and moving toward experimental activity."

At the IMIB's experimental laboratory "aesthetics were to be based on a communication that would arouse and surprise, rather than rationality and functionalism; they should be concerned with the immediate effect on the senses, without taking into account utility or structural value" (Home 1988: 24). In 1956, the IMIB published the only number of their journal *Eristica* and, in 1957, they fused with the LI and the LPA to establish the SI. Jorn's brand of Marxism which he had picked up as a rank and file member of the communist party growing up in Silkeborg, Denmark, was a much more mystical materialism that reached out towards shamanism, the mythic past, altered states of consciousness and, thus, the occult. Like sigma, Jorn embraced a hybrid political position which he defined in the 'Critique of Political Economy' part of *Value and Economy* as the necessity of basing human progress on "*a radical revolutionary conservatism*" (Jorn 1962: 5).

It was conservative because Jorn wanted to not only go back to the constitutive elements of the First International but even further back to a sort of magical, psychogeographical past akin to Marx's idea about pre-historic primitive communism. He goes on to explain that this conservatism consists of three elements which are all needed in equal measures (Jorn 1962: 6): "*Anarchism, or the principle of expanding personal freedom; Syndicalism, or the creation of wise social organisations; and Socialism, or the recognition of all social phenomena's interconnectedness.*"[54]

Jorn's contribution to the SI was not only ideas of situlogy and trialectics (as opposed to Marxist dialectics), it was also an idea about communism (Tompsett 2011a; Wark 2011; Jorn 2011).[55] For Jorn, communism was "much older than the religions" and meant "both a consistency between the spiritual and the temporal, and a collaborative practice of aesthetic transformation of nature" (Wark 2011: 55). Jorn finds that a modern reinstatement of mystery can supply a cultural ideology to Marxism which encourages everyone towards cultural activity (Wark 2011: 55). Thus, for Jorn "real communism is an aesthetics of total and unconditional experimentation beyond the restriction of any social norm" (quoted from Jakobsen 2011: 225). He writes: "Real communism will be a leap into the domain of liberty, of values, of communication" (quoted from Jakobsen 2011: 225). What awaits us in a post-capitalist society is not an industrial five year plan, but radical, experimental freedom.

> Sometimes the results were pretty – well, freaking gibberish to normal human ears, most likely. Or, to the receptive standard intellectual who has heard about the 1913 Armoury Show and Erik Satie and Edgar Varèse and John Cage it might sound ... sort of *avant-garde*, you know. But in fact, like everything else here, it grows out of ... *the experience*, with LSD. The whole *other world* that LSD opened your mind to existed only in the moment itself – *Now* – and any attempt to plan, compose, orchestrate, write a script, only locked you out of the moment, back in the world of conditioning and training where the brain was a reducing valve...
>
> -Tom Wolfe 1968: 57

4.2.

Lead, Follow or Get Out of the Way

The turmoil of the 1960s was in a quite concrete way a generational conflict: what was at stake was the institution of the family since it was perceived that control operated through parental love and conditioning. Above all, it was about not becoming 'square' like one's parents, cf. the Terry Taylor quote in Chapter Two which described how the protagonist's feeling of alienation and separation was directed precisely towards the middle class suburban environment he grew up in. This drove him towards the city in search for new communities, jazz and an 'angry fix.' At heart, sigma and the AU was thus about gaining autonomy and be able to choose not to adapt to society's paternalistic structure (Laing 1967: 55):

> Adaptation to what? To society? To a world gone mad? [...] The Family's function is to repress Eros: to induce a false consciousness of security: to deny death by avoiding life: to cut off transcendence: to believe in God, not to experience the Void: to create, in short, one-dimensional man: to promote respect, conformity, obedience: to con children out of play: to induce fear of failure: to promote a respect for work: to promote a respect for 'respectability'.

Instead, it was about creating what Laing called the 'nexal' family and Berke the 'anti-family,' a term that covers tribes, gangs, bands, communes, affinity groups, and so on. In short, to experiment with social relations in order to discover new ones that could overcome the feelings of alienation spectacular society uses to rule us. The reason why this had to be founded on total revolution was due to that under "the sign of alienation every aspect of the human reality is subject to falsification, and a positive description can only perpetuate the alienation which it cannot itself describe, and succeeds only in further deepening it, because it disguises and masks it the more" (Laing 1967: 52).

The fact that the new art and the new political structures could not be described was proof of their usefulness; it was left an open question since it was first and foremost a question of acting in the present and awake from our dreamless dream-state. This is not unlike George Sorel's social myth and is, according to Judith Suissa (2006: 13), a fundamental aspect of the anarchist position, that one does not propose any blueprint for a future society. Along with the commitment to decentralised, non-hierarchical forms of organisation and the rejection of the state and its institutions, the belief that the exact form the future society will take cannot be determined in advance is one of the few general points of anarchism, be it mutualist, federalist, collectivist, communist or syndicalist. Instead, the creation of a harmonious, free society is seen as a constant dynamic process of self-improvement, spontaneous organisation and free experimen-tation. For Sorel (1908: 138-148), art should create images – the aforementioned 'social myths' – which could be used to act upon the present to transform it in a way that had no relationship to the past but also without any project of future social organisation.[56] It can be argued that this idea about the myth and its influence on anarchist and syndicalist approaches to aesthetics was the main influence on Marinetti when he wrote his first Futurist manifesto from 1909, i.e. it was ingrained in the modernist avant-gardes from their start.[57] Sorel saw the myth as an instigator of a class struggle – the essence of socialism according to him – which would create a catastrophic revolution of violence and aggression. Interestingly, one of the goals of the SI was to demythologise but in the end this can be seen as the destruction of one set of myths to reinsert another. This difficulty in going beyond myth might be connected to how we exist in a myth-saturated media landscape and how bio-political control operates through the use of images.

That control operates through myths which are essentially images gives us an interesting perspective on the emphasis on invisibility and the importance of hiding in the shadows in the sigma project. Acting through subterfuge and only entering the visible when the battle is already won had a powerful hold on the imaginaries of the 1960s and the whole notion of

constituting an 'underground', notoriously – and literally – with Charles Manson's idea of 'helter-skelter' where his Family would passively hide in a subterranean realm while a race war was being fought in order to later be able to resurface and rule the world (Bugliosi 1974; Sanders 2002; Gorightly 2009).[58][59]

Millennialism and esoteric ideas about evolution saturated the underground's imaginary, thus creating an occult revival which was intimately connected to the underground's flight from reason and its desire for untrammelled freedom. Louis Pauwel and Jacques Bergier wrote in their popular bestseller *The Morning of the Magicians – Secret Societies, Conspiracies and Vanished Civilizations* (1960: 294):

> Total intelligence and an awakened conscience – we feel that man is aiming at these essential conquests in a world in the throes of a new birth that seems to be urging him, to begin with, to renounce his freedom. "But freedom to do what?" asked Lenin. [...] It is true that [man] is gradually being deprived of his freedom to be merely what he always has been. The only freedom that will soon be granted him is his freedom to become something other, to rise to a higher degree of intelligence and consciousness. Freedom of this kind is not basically psychological, but mystical – according to ancient standards, at least, and in the terminology of yesterday.

Theodor Roszak touched upon the schism between bohemianism and the occult on the one side and the political and activist on the other, the tension between inner and outer reality, when he noted in his seminal *The Making of a Counter-Culture* (1968) that the traditional class consciousness in the underground gave way to what he calls '*consciousness* consciousness.' This he sees as the link between the beat-hip bohemianism of the 1960s and the politics of the New Left. The former tried to work out the personality structure and total life style that followed from the social criticism of the latter, thus seeking to invent a new cultural base for New Left politics by discovering new types of community and "new personal identities on the far side of power politics, the bourgeois home, and the consumer society" (Roszak 1968: 66). He wrote (Roszak 1968: 63-4):

> The easy transition from the one wing to the other of the counter culture shows up in the pattern that has come to govern many of the free universities. These dissenting academies usually receive their send-off from campus New Leftists and initially emphasize heavy politics. But gradually

> the curricula tend to get hip both in content and teaching methods: psychedelics, light shows, multi-media, total theatre, people-heaping, McLuhan, exotic religion, touch and tenderness, ecstatic laboratories [...] At this point, the project which the beats of the early fifties had taken up – the task of remodelling themselves, their way of life, their perceptions and sensitivities, rapidly takes precedence over the public task of changing institutions or policies. [...] As we move along the continuum, we find sociology giving way steadily to psychology, political collectivities yielding to the person, conscious and articulate behaviour falling away before the forces of the non-intellective deep.

Sigma fits this trajectory towards the personal from what was to begin with an outer reality of political transformation of society and its institutions, such as the idea about taking over UNESCO. I would argue, though, that, in general, this was not a one-way direction for the New Left and the free universities, but something more reciprocal, cf. that some of the militant groups of the 1970s had a background in the psychedelic counter-culture. The sigma project wanted to make intelligence conscious of itself which entailed a 'mental awakening,' a term which is abundant in occult literature and the tradition of esoteric mysticism but which also rears its head in, for example, Laing's writings: "[t]he condition of alienation, of being asleep, of being unconscious, of being out of one's mind, is the condition of the normal man" (1967: 24). What is interesting in this quote is how it juxtaposes a political term, alienation, with an occult term, being asleep, in order to describe (wo/)man. In contrast to earlier concepts of awakening, in the 1960s it can be seen as a radical democratic approach to the esoteric tradition, a democratisation of occult knowledge where it becomes a question of mass-initiation and demystification instead of a quest for the privileged few. The common denominators with the occult are the rejections of rationalism and Enlightenment thought – esoteric mysticism is nearly always a personal experience which is seldom verifiable – as well as the quest of becoming a "whole" man, the un-alienated man we saw described earlier by Marx in *The German Ideology*.

The inclusion of more esoteric practices in sigma points towards a fundamental difference between the SI and sigma. Where the former famously went through a row of exclusions, sigma wanted to include and unite every sort of dissident and experimental cultural tendency which was new, oppositional and able to mutate, thus creating the international shadow reality they aimed for and not just igniting the explosion. As Trocchi told Greil Marcus (1989: 387) in 1983:

> Guy [Debord] thought the world was going to collapse on its own and we were going to take over. I wanted to do that – to take over the world. But you can't take over the world by excluding people from it! Guy wouldn't even *mention* the names of the people I was involved with – Timothy Leary, Ronald Laing. [...] Ultimately, it leads to shooting people – that's where it would have led, if Guy had ever 'taken over.' And I couldn't shoot anyone.

Instead, sigma was a quest for revolution in the head and what was felt as real freedom, ultimate freedom, which is often the realm of conspiracy theories, worshipping a millenarian future where everything has changed. The dream is always a glimpse of a more intense, more fulfilled life, but it is a distorted glimpse: mythical symbols, in other words, both point to reality and conceal it.

Due to sigma's emphasis on oppositional clandestinity and the creation of a shadow society, it is possible to see sigma as an attempt at creating a secret society or, at the very least, a cultic milieu. Secret societies have a dual tradition which, on the one hand, is political (Bakunin, Lenin, terrorist cells, etc.) and, on the other, occult, mystical, spiritual (Freemasonry, the Ordo Templi Orientis, Scientology, The Process Church of the Final Judgment and so on). In contrast to the traditional secret society, sigma wanted to share information and empower its 'members' instead of using information to gain power over people. Instead, they wanted to liberate conscience for the coming Age of Aquarius where the revolutionaries simultaneously would be street fighters and prophets of a new (r)age.

Sigmatic culture would thus change the political landscape by intervening on the level of symbols and fantasies in order to take over millions of minds. The co-conspirators wanted to work on the basic drives, on human emotions, a realm traditionally reached through the aesthetic and, in many ways, Trocchi and sigma fit comfortably beside other artists working within an expanded notion of art in a post-Duchampian aesthetics, e.g. the writer Ken Kesey and his Merry Pranksters, who famously travelled the US from coast to coast in 1964 with Beat legend Neal Cassady as the driver of their bus "Furthur," attempting to make art out of everyday life. As Jeff Nuttall points out in *Bomb Culture* (1968: 67): "The destination, as far as art is concerned, is the journey itself." The experiments with living and the hedonistic extremes were already present in Beat where they can be connected to an interest in alternative thought systems such as Zen or Buddhism. Tibetan Buddhism, for example, has a long tradition for tantric yoga and dealing with the use of pleasure for spiritual ends (Lachman

2001: 52), and this drive found expression in the counter-culture with, among other methods, the use of acid, hash and heroin as well as experiments with sexuality deviating from the standards of hetero-normativity such as group sex and gay love.

Like Trocchi, Kesey can be seen as a link between the Beat generation of the 1950s and the hippies of the 1960s. Both projects experimented with living while being reminiscent of secret societies, cults around a charismatic leader, where the aim was mental revolution, the stakes the future of mankind. Like the Merry Pranksters, sigma seemed to end up representing those elements of the hip scene that emphasized personal liberation where the task of deprogramming and remodelling themselves took precedence over changing institutions and government policy. These were perceived to change by default by changing their clientele. Both projects thus partly became the mystic's journey, the search for unification with the godhead – ultimately meaning the world since they, like Bataille, considered themselves atheistic in the traditional sense – in order to overcome alienation. It was about living fully in the 'now.' The 'new journalist' Tom Wolfe (1968: 132) quoted one of Kesey's talks to the pranksters on the difference between the actual now and the perceived now:

> The present we know is only a movie of the past, and we will never really be able to control the present through ordinary means. That lag has to be overcome some other way, through some kind of total breakthrough [...] A person can overcome that much through intellect or theory or study of history and so forth and get pretty much into the present in that way, but he is still going up against one of the worst lags of all, the psychological. Your emotions remain behind because of training, education, the way you were brought up, blocks, hangups and stuff like that, and as a result your mind wants to go one way but your emotions don't.

In order to reach this ecstatic 'now,' a selfless now of instant sublation, art would have to work on the basic emotions and 'de-school' them. It would become mystical art, psychedelic art, alchemical art which would be occupied, like in traditional alchemy and the Western esoteric tradition, with, first and foremost, the transmutation of self and then, secondly, the transmutation of certain metals, i.e. the physical, material world.[60] It stresses the need for de-conditioning and autonomous education but, in some ways, it is more comparable with the urge to start a new religion than with the urge to transform quotidian existence, albeit not any organised religion with a dogmatic belief. Rather it is akin to a revival of medieval

heresies as, for example, the Brethren of the Free Spirit (Cohn 1957; Vaneigem 1986), with their notions of going 'beyond good and evil,' to use Nietzsche's words. This would, ultimately, lead to a sort of self-deification where man takes the place of God in order to become the new Man-God of the future, a theme also found in Nazi Occultism (Pauwels et al. 1960: 164-279), hinting that these techniques goes beyond any simple distinction between leftwing and rightwing.[61]

An artistic predecessor for this type of 'renewal' of art and politics by introducing the mystic experience and notions of the sacred can be found in the French writer George Bataille (1897-1962) who created his own obscure, secret society in the period from 1936-1939. Throughout 1935, Bataille had been working with Andre Breton in Roger Caillois's Contre-Attaque group which was meant to be a "Union of Revolutionary Intellectuals" (Richardson 1994: 10). After the dissolution of Contre-Attaque, Breton sought an alliance with Trotsky while Bataille engaged in more esoteric activities around Acéphale and the College of Sociology. In these groupings, Bataille sought to reinvigorate myth in contemporary society, not unlike the way the notion of myth was used by Sorel. The intention with Acéphale – the headless ones – was to bring about the transformation of the world by creating a new religion, nothing less, even though it was a religion celebrating a total lack of religion and the experience of God's death (Stoekl 1985: xix-xxiii).[62]

Acéphale was formed with, among others, Pierre Klossowski and Patrick Waldberg around an 11-point programme, dated 4 April 1936, which asserted various aims such as "Lift the curse of those feelings of guilt which oppress men, force them into wars they do not want, and consign them to work from whose fruits they never benefit," or "Participate in the destruction of the world as it presently exists, with eyes open wide to the world which is yet to be" (Bataille 1970: 15). Most of their writings were published in the journal *Acéphale* (4 numbers, 1936-39). To realize their new ecstatic community, it was necessary to create new myths, revealing true being, which had to be created with the "rigour proper to the *sacred* feeling" (Bataille 1938: 233). Myth, for Bataille, was the way open to man after the failure of art, science and politics to reach the essential human drives. In 'The Sorcerer's Apprentice' (Bataille 1938: 233), he concluded:

> The "secret society" is precisely the name of the social reality constituted by these procedures. But this novelistic expression must not be understood, as it usually is, in the vulgar sense of a "spy ring." For secrecy has to do with the constitutive reality of seductive experience, and not with some action contrary to the security of the State. Myth is born in

> ritual acts hidden from the static vulgarity of disintegrated society, but the violent dynamism that belongs to it has no other object than the return to lost totality; even if it is true that the repercussions are decisive and transform the world (whereas the action of parties is lost in the quicksand of contradictory words), its political repercussions can only be the result of existence.

Already in Contre-Attaque, Bataille had tried to establish a celebration of the beheading of Louis XVI, the death of the sovereign as a regenerative act, on each 21 January as a founding myth of a new society. Soon, though, he realised that the myth of contemporary society was an absence of myth, since society had deluded itself into believing it was without myth by making a myth of its very denial. In the essay 'The Absence of Myth,' he wrote (Bataille 1947: 48): "Myth and the possibility of myth become impossible: only an immense void remains, cherished yet wretched […] The *absence of God* is no longer a closure: it is the opening up to the infinite." The absence of myth is part of a more general absence where it also means the absence of the sacred.

Bataille defines the sacred very straightforwardly as communication. The absence of myth thus means a failure of communication that touches all levels of society. Communication for Bataille, as Michael Richardson (1994: 18) points out in his foreword to Bataille's writings on Surrealism, equals religion, or maybe more precisely, communion. Therefore, the forming of a new religion using a new language to communicate was seen as a possible path away from the present. Due to that the sacred is seen as a form of communication, what Bataille was looking for by positing the absence of myth was not a new form of mysticism, but to reintegrate the notion of ecstasy into the body social within which it would have a virulent and contagious quality. His interest was not in union with God, but with the social where the need would be to recover the primitive in a contemporary form (Richardson 1994: 21).

The basic idea connecting Acéphale, sigma and the prankster – that it is necessary to form a new religion using a new language to communicate in order to create a possible exit route to our present – is central to all of my case studies. The new and extraordinary mental states discovered and explored demanded a new language beyond both faith and reason to capture their essence. It can be seen as a neo-shamanic quest to become a modern primitive or technopagan since the primitive just as easily can be posited in the future as in the writings of John Zerzan.

What is essential is that the primitive entails a reversal of the modern tendency to put the individual before the collective. As such, it is the desire for belonging to a greater whole – 'a gathering of the tribes,' as the saying went in the underground – that leaves a remainder of the cultic or neo-tribal in my case studies. The underlying logic seems to imply that the transformation of the world and how we live in it – cultural engineering – is all about applying the proper technology to what is. Détournement is one such technology and, as we shall see, it can be argued that magical thinking is another. In the thinking of Crowley and Spare, technology is magick and magick is technology, a point I will return to in later chapters. [63] In this view, art is not a separate sphere, something to be contemplated by a multitude excluded from its innermost secrets but part of the collective life and labour of the whole community. It thus becomes indissolubly bound up with ritual and magic, the quest to enter into contact with hidden realms. As Laing (1967: 37) puts it in words that could just as easily apply to my next two case studies, Academy 23 and TOPY: "If there are no meanings, no values, no source of sustenance or help, then man, as creator, must invent, conjure up meanings and values, sustenance and succour out of nothing. He is a magician."

The notion of a spontaneous university is central to this discussion. If the revolution is to be mental, to be produced from the inside, it ties into the 'cultivation of young minds' and thus our churches, schools, universities and other institutions, which Cooper (1968: 16) imagined would become "revolutionary centre[s] for transforming consciousness." The self-organised anti-institutions of the 1960s and early 1970s tried to produce new subjectivities and self-valorise while they, at the same time, intuitively understood that they could not allow themselves to become fossilised institutions. Rather, they had to be mobile nodes in a network, continuously redistributing the power they accumulated. Sigma's spontaneous action-universities wanted to create a 'shadow society' and the Anti-University saw itself as a node in an international 'counter-society.' Just like sigma had used the portfolio to catalogue and report on similar initiatives all over the world, the AU listed the nodes of their counter-society – which, interestingly, included a summer school in Yugoslavia, part of the Eastern Bloc throughout the Cold War even though Tito was instrumental in forming the Non-Aligned Movement in 1961 – in the back of their second catalogue where they asked people to contact the secretary if they wanted to know more about or visit any of the following centres:

> Artists' Workshop, c/o John Sinclair, John C. Lodge and Warren, Detroit, Michigan, USA – Critical University, Singel 16 yIII, Karel de Leeuw, Amsterdam, Holland – Critical University, Berlin, Germany – Free University of Berkeley, 1703

Grove Street, Berkeley, California, USA – Free University of California, Los Angeles, California, USA – Free University of Minneapolis, Minneapolis, Minnesota, USA – Free University of Montreal, 3407 Clark Street, Montreal, Quebec, Canada – Free University of New York, 20 East 14th Street, New York, N. Y. 10003, USA – Free University of Palo Alto, Box 6691 S, Stanford, California, USA – Free University of Seattle – Free University of Washington – Korculanska ljetne skola, Korcula Summer School, Korcula, Yugoslavia (August, 1968) – New Left School, Los Angeles, California, USA – New Experimental College, Skyum Bjerge Pr. Hordum, Thy, Denmark.

Three tendencies can be perceived from this list of associate acts: 1) the Free Universities exist as pockets on the inside of existing institutions, e.g. in Berkeley it was something that happened on campus, i.e. a university-within-the-university, 2) they were anti-institutional and located on the outside of the institutions, e.g. the New Experimental College which was the university-as-commune where students and teachers live together. 3) The-university-as-collectivity where it is not a commune but independent bodies, created and developed by both students and teachers like most of the Free Universities. In the course of its six months of existence, the AU itself went from the third category to the second where it shortly became a sort of urban commune.

The movement in the 1960s was thus characterised by building up informal networks for the exchange of information, cf. not only the Free University movement, but also the infamous 'underground press' (Stewart 2011) or former Merry Prankster Stewart Brand's *Whole Earth Catalogue*, which has been hailed as both the internet before the internet and a predecessor to Google, an ambition also aimed for by TOPY in the 1980s.[64] From the 1960s to the 1980s, there is a continuity in the underground's politics of information where it is primarily about gaining access to knowledge as well as distributing and sharing it in order to empower various self-valorised communities. After the implementation of the World Wide Web in the mid-1990s, the territory changed and it became a question of sorting information instead of retrieving it.

> Despite disparate aims and personnel of its constituent members the underground is agreed on basic objectives. We intend to march on the police machine everywhere. We intend to destroy all dogmatic verbal systems. The family unit and its cancerous expansion into tribes, countries, nations we will eradicate at its vegetable root. We don't want to hear any more family talk, mother talk, father talk, cop talk, priest talk, country talk *or* party talk. To put it country simple we have heard enough bullshit.
>
> William S. Burroughs 1971b: 139

4.3.

'Who Owns You?'[65]

Sigmatic ideas can be found not only in the Anti-University but also in other 'Swinging London' initiatives, e.g. the London Free School, the Fun Palace, the Arts Lab and the Artist Placement Group. To a certain extent, the trajectory of these ideas also plots a history of the UK Underground: some of the ideas disseminated by sigma in the early 1960s reached a first high point in 1965 with the International Poetry Incarnation in the Albert Hall and from there built momentum until they, with the Summer of Love and the Dialectics of Liberation congress, reached a mass audience and became part of pop culture where they reappeared in the context of, for example, the 14 Hour Technicolour Dream, the UFO club and Pink Floyd.[66]

Framing it like this, the DoL-congress can be seen as a high mark of these collective energies. Afterwards, they started to descend into inner turmoil and outer crises and, thus, faded out through recuperation and commodification as capitalism entered a new phase of neo-liberal democracy where the self-managed cultural worker seems to have become the new model for the labour force, a point I will return to after examining my next two case studies. Suffice it to say for now that this points to the underground's fundamental doubleness, e.g. its leading figureheads who talked about anonymity and invisibility were rapidly becoming world famous celebrities and, also, the problematic relationship to commodities where the counter culture became a vehicle for commodification and valorisation of brand products like coffee cups carrying the visage of Che Guevara – an

ambiguity which can also be seen in the DoL-congress' focus on publicity, creating a range of books, vinyl records with speeches and discussions from the conference and other commodities while concentrating on anti-capitalist critiques, contradictions the participants were well aware off. This doubleness serves to remind us to relate the New Left and the 1960s critically to our own time. It can easily become a damaging metaphor to equate past and present in a one to one relationship, a new destructive figure of nostalgia where the radical imaginary is constrained by its own myths, symbols and figures, the way it thinks figuratively.

The goal of the invisible insurrection seems to have been a mystical worldwide proletarian revolution with unlicensed pleasure as its only aim. In its ultimate stage, communism means nothing less than an alteration of man's very mode of being in this world and this becomes part of a sigmatic spirituality. As mentioned in Chapter Two, the communist imaginary is often preoccupied with a notion of a 'future primitivism', to use John Zerzan's words, and the history of communism is filled with 'modern primitives' (Vale et al. 1989). It is primitive, due to that anthropologists, e.g. Mircea Eliade in his hugely influential *Shamanism – Archaic Techniques of Ecstasy* (1951), have argued that primitive society (where people are living under a primitive form of communism not unlike the communities of the early church) is a society without exploitation where production is still geared towards the satisfaction of human need. At the same time, a large part of the material resources are used to set aside the immediate struggle for existence and participate in a mode of activity which is enjoyed for its own sake. Thus work is suspended and life becomes play, transporting the participants into an ecstatic present. This outburst of the carnivalesque runs counter to the view of bourgeois rationalism which can only assimilate ecstatic experience to psychotic, delusional states. This is part of the reason why capitalism often has tried to reduce the primitive world-view to a species of devil worship. It also points to why the sigma dream is not only a political extreme, it is also a hedonistic extreme. As much as it is about fighting in the alleys, it is also about fucking in the streets and embracing the ecstatic present.

Sigma and the AU were about participating in the ultimate come-together in which the revolution would happen due to simple acts of pooling resources and sharing knowledge. However, it was also about the independent production of cultural entrepreneurs using guerrilla marketing to advertise and sell their commodities and creativity; it was about a limited company that wanted to be successful in capitalist terms, a strategy which today seems to be important for the general success of capitalism, such as Richard Florida's ideas about a new creative class which is seen as a key force for economic development (Florida 2002). Apparently, society's distinct doubleness is reproduced on a micro-level in counter-cultural

thinking and the parallels that exist between rightwing libertarian ideology and leftwing counter-cultural theory.

Sigma was an attempt at organising professional, cultural revolutionaries who would understand that what was necessary to produce was ourselves, not the things that enslave us. The aim was the establishment of a shadow society, new experimental cities close to the existing capital cities of the world with radical spontaneous universities as their nuclei. These new communities would produce an awakening, new collective subjectivities teaching us how to be together in a coming, decentralized future, reminiscent of the visions passed down from anarchism and communism and populated by conscious producers of the new culture, life-as-art. Trocchi could claim that these cities would be 'unpolitical' due to that what they were producing was existence itself, i.e. they operated on a more basic level beyond art and politics.

Cultural production in this context is not only a weapon of class war, it is also a shard of a possible future where the aesthetic experience, if art doesn't sublate itself into transformative action, opens up for a vibrant and mesmerising space from where one may imagine and construct new, alternative futures. This representation, it is hoped, will teach people how to live together without violence, a central theme at the Dialectics of Liberation which, as we have seen, produced a desire to meet among its attendants which spawned the AU. In turn, the AU carried on the dream of a sigmatic university centred around three general orientations – radical politics, existential psychiatry and the avant-garde of the arts – and the aim of producing a change in the relations among people before it was too late.

The central task to begin with for these initiatives was to come together and produce new social relations by founding a new type of university. Due to that paternalistic authority had become internalised nothing could be done before this had been undone. Laing (1967: 23) wrote:

> Our capacity to think, except in the service of what we are dangerously deluded in supposing is our self-interest, and in conformity with common sense, is pitifully limited: our capacity even to be see, hear, touch, taste and smell is so shrouded in veils of mystification that an intensive discipline of un-learning is necessary for *anyone* before one can begin to experience the world afresh, with innocence, truth and love.

Deprogramming and deconditioning became central occupations for the Academy 23. The Academy can be seen as a sibling to sigma and might be

the eccentric uncle to the AU. The basic idea can be found in the late 1960s writings of William Burroughs, primarily published in the underground press, especially *Mayfair* as well as in his 1974 interview book, *The Job*. Burroughs was one of the major players in sigma throughout the period as a co-conspirator and collaborator and, as we saw above, when Trocchi presented the sigma idea to the PA at Braziers Park, it was already explicit that the ideas had been developed through conversation with Burroughs. Not surprisingly, the themes discussed above were, thus, also central for Burroughs' own ideas, albeit in his case the information became even more esoteric. The political ideas from the AU clashed with the druggy excess of sigma and Burroughs' own post-Beat experimentalism, thus catapulting the Academy into a space where New Age conspiracies to elevate mankind's consciousness on this planet and elsewhere were thriving side by side with viral ideas about counter-information, self-determination and autonomy.

V. ACADEMY 23

> there was a grey veil between you and what you saw or more often did not see that grey veil was the prerecorded words of a control machine once that veil is removed you will see clearer and sharper than those who are behind the veil whatever you do you will do it better than those behind the veil this is the invisible generation
>
> William Burroughs 1974: 164

5.1.

'Curse, Go Back!'

If the trajectory leading from sigma to the AU began with an activist agenda before gradually becoming obscured by mysticism, the trajectory leading to Academy 23 was from the beginning a path mostly traveled by psychonauts – explorers of psychedelic vistas through a Rimbaudian 'derangement of the senses.' The Academy was more concerned with a flight from reason, drugs, notions of different spaces, astral projection and the destruction of pseudo-communication through playback, spells and magick than in how to organise in any effective way. Along this path any notions of the properly political were abandoned in order to colonise and conquer inner space. More often than not, the exact nature of the future was left to chance, but this did not stop the self-appointed cultural partisans from trying to temper with the aleatory and intervene in the circuits of control through will alone.

Whereas the writings surrounding sigma and the AU are fairly easy located in concatenations of communism and anarchism on the revolutionary Left in general from Western Revisionist Marxism and the New Left to Autonomia and beyond, they were often printed in the underground press back to back with speculative writings on everything from dolphin speak to UFOs, establishing a terrain of alternative myths and counter symbols. Simultaneously with the interest in social and political concerns an interest in spiritualism, urban shamanism, altered states, etc., has thrived in this tradition. This might be connected to the idea of the artist as an explorer of inner space, a medium connecting us to an outside or a beyond through his personal, inner journey, but it is also connected to deconditioning. In the late 1960s, this journey grew increasingly esoteric, resulting in, for

example, that David Cooper – the most politically oriented of the British anti-psychiatrists – left the Philadelphia Association in the early 1970s due to its increasing focus on spiritualism instead of politics. For the main part of the 1960s, the two tendencies, towards the inner and the outer, were perceived as a whole, though; two sides of the same coin.

That occult and aesthetic terms for a period of time were interchangeable with political terms is obvious from Sigal's above-mentioned *Zone of the Interior* (1976: 205). In the novel, Sidney Bell comments on the tendency in the period immediately after the unsuccessful meeting with the NON-RUT artists of the members of Clare Council – headed by Dr. Willie Last, the fictional counterpart to Ronnie Laing – to read biographies of Aleister Crowley:

> I should have seen it coming. Magic. Maybe it came from Last's feeling of despair and isolation after our fiasco at Armistice Hall. Whatever the ins and outs, Last broke his seclusion to announce: 'Brothers, magic is th' class struggle carried over in other worldly terms. It is th' rock for us to take our stand on.'

Thus, it became a secret objective for the invisible insurrection to re-enter the occult mainstream "forced underground by two millennia of Establishment suppression" (Sigal 1976: 205). Instead of class war, Last could preach that the occult is the superstructure's superstructure and politics "simply the modern name we gave to this struggle, backwards and forwards in time, to gain access to long-hidden founts of supernatural wisdom" (Sigal 1976: 205). This sort of thinking became widespread with the occult revival in the 1960s, mixing the New Left with the New Age. A pop-cultural example on this can be found in, for example, Robert Anton Wilson and Robert Shea's *The Illuminatus! Trilogy* (1975) with its call for the 'immanentization of the eschaton' which basically is a euphemism for reaping the rewards of the afterlife in the here and now.

The interest in magick and the occult fed into visions of a coming era's psycho-socialism or magickal Marxism, and these imaginaries, in turn, became constitutive parts of former sigmanaut William Burroughs's Academy 23. Throughout the 1960s, some of the most influential experiments with chance were performed by Burroughs with his frequent collaborator Brion Gysin. Much has been written about Bill Burroughs the Beat, the outlaw, the wife killer, the junky, the celebrity, the larger-than-life character, but not much attention has been paid to his multi-media experiments with collage, sound and video from primarily the late 1960s.[67]

Additionally, not much analysis has been given to his years in London and his utopian/revolutionary thinking of the late 1960s which combined ideas about revolution with experiments in what can be called multimedia magick in order to 'make it happen'.[68] There is also an under-examined cultic element in his 'new mythology for the space age' which is conspicuous not only from his involvement with Scientology in the 1960s but also his later involvement with the Illuminates of Thanateros, a chaos magick group, in the 1980s. In general, the literature seems to focus on his seminal breakthrough novel, *Naked Lunch* (1959), the so-called *Nova* trilogy of cut-up books (*The Soft Machine* (1961), *The Ticket That Exploded* (1962) and *Nova Express* (1964)) following it or his final so-called *Red Night* trilogy (*Cities of the Red Night* (1981), *The Place of Dead Roads* (1983) and *The Western Lands* (1987)). In contrast, my interest is primarily in his production of the late 1960s when he returned to a more straight-forward narrative and tried to give fictional form to the ideas he spoke about in *The Job* (1974) in novels like *The Wild Boys: A Book of the Dead* (1971), *Port of Saints* (1973) and the short story collection, *Exterminator!* (1973).

The time seems ripe to examine Burroughs, the caller of spirits, in order to better understand not only how he fitted into the context of the UK Underground with its focus on spontaneous universities but also how he came to be the High Priest of the 1980s underground. The evolution of Burroughs' ideas in the 1960s cannot be understood without examining his collaborations with Brion Gysin. The latter also seems to speak to our own time, e.g. *Brion Gysin: Dream Machine*, the first US retrospective of Gysin's art at the New Museum in New York from 7 July to 3 October 2010.

Burroughs had been coming to London on and off at least since 1960 when he moved there for a short spell in order to collaborate with Gysin, Antony Balch and their 'systems advisor' Iain Sommerville on experimental short films like *Towers Open Fire* (1963) and *The Cut-Ups* (1966). Due to a restrictive visa he could not stay. In 1966, he settled in London at 8 Duke Street in Marylebone which he used as a semi-permanent base until he in 1974 relocated to the infamous 'Bunker' at 222 the Bowery on the Lower East Side of Manhattan where a generation of rock musicians would later court him.[69]

In London, Burroughs evolved into becoming a revolutionary thinker dreaming up left-field guerrilla tactics for the overthrow of society. As we saw in Chapter Two, Burroughs was part of sigma's steering committee in the early 1960s as far as it was ever realised, contributing with several pieces to the portfolio, e.g. 'the invisible generation,' just as Trocchi can be seen as part of the 'virus board' in *Towers Open Fire!*[70] Additionally, he attended the Dialectics of Liberation and was a part of the Anti-University's visiting faculty as well.

Burroughs' ideas about a cultural revolution were also centred around a kind of free spontaneous action university or centre. Just like with sigma and the AU, the idea was to deprogram and offer a collective re-education so we could inhabit a new future, or, in other words, self-institutionalise in order to produce an alternative educational apparatus. In the case of Burroughs, though, the idea of End Times was even more at the fore. He thought that the path we are on collectively would lead to certain extinction for the human race. The only thing that could save us would be a form for willed mutation, preparing us for migration to outer space as astral bodies. Central for Burroughs was an idea akin to the situationist détournement: that it is possible to intervene with what is already there, making intervention into an inside operation, something which is hidden and deceitful in the sense that it is not what it looks like. This makes mutation possible.

In order to will mutation into existence, Gysin and Burroughs perfected the cut-up method as the 'art and science of causing change to occur in conformity with the will' which happens to be Aleister Crowley's (1997: 126) definition of magick from his introduction to *Magick in Theory and Practice* (1929), a point I will return to shortly.[71] The basic idea is that it becomes possible to create a revelation through juxtapositions – an artistic equivalent of throwing the I-Ching – which eludes not only the cult of genius but human intervention in general; invisible forces speak through the producer and provide the type of insights said to reveal themselves in hypnagogic states. This resulted in that not only was Burroughs a central collaborator in sigma and an important connection between the London and New York experimental scenes of the 1960s, but – along with Gysin, Aleister Crowley, Austin Osman Spare and The Process Church of the Final Judgment – he would also become the main inspiration for the philosophy, rituals and practice of TOPY in the 1980s.[72] In order to understand this impact, in the following I will focus not only on Academy 23 – which TOPY can be seen as an embodiment of – but also pay attention to Gysin and Burroughs' 'third mind', their ideas on control, magick and the space age as well as Dream Machines – part of the sigmanauts' essential equipment, cf. SP2 – and the cut-up method.

The 'third mind' was a term Gysin and Burroughs used to describe the "psychic symbiosis" (Geiger 2005: 143) which characterised their collaboration it its most intense period from 1958 – 1965 where they in periods stayed together at the famous 'Beat Hotel' at 9, rue Gît-le-Cœur in Paris' Latin Quarter.[73] In this period Gysin's visual art and Burroughs' prose were equivalents, sharing the same goals: to liberate words and create new modes of expression (Hoptman 2010b: 99). The culmination of their shared works and world-views became *The Third Mind*, a book-length collage

collaboration they finished in 1965, but which was never published in its original form.[74] The book was meant to be a 'book of methods' on the use and execution of cut-ups in its various forms. "No two minds ever come together without, thereby, creating a third, invisible, intangible force which may be likened to a 'third mind,'" explains the introduction while stating that the book is "a manual of elementary illusion techniques" which "traces a series of such collaboration" (quoted from Hoptman 2010b: 100). Simply put, the third mind is the collaborative practice itself when people are actively participating, collaborating and knowledge-sharing thus making the whole greater than the sum of its parts. Gysin and Burroughs took the term from Napoleon Hill's self-help book *Think and Grow Rich* from 1937 which suggested that when you put two minds together the result will always be a third and superior mind which will be an unseen collaborator (Robinson 2011: 29).

As an artist, Gysin was interdisciplinary in the extreme. At an early age, he had moved in Surrealist circles until he was excluded from a group show in 1935 by Breton (Geiger 2005). Besides painting, he was drawing, filming, photographing, performing, singing as well as combining all of the above in some of the very first 'happenings' on British soil (see below). He also tried his hand at writing, with, for example, the novel *The Process* (1969) which records a hallucinatory pilgrimage through the Sahara Desert.[75] His painting style can be situated in between European Art Informel and American Abstract Expressionism. As such, it is not too dissimilar from the ink-splattered paintings of Henri Michaux or the Lettrist paintings of the 1950s, incorporating text, image and calligraphy even though Gysin's works were not meant to exhibit readable words and phrases. Instead, they were a type of asemic writing where the calligraphies functioned as a kind of spells, meant to defeat materiality and free words, images, and even the body.

His signature became a grid pattern which can be seen as background to many of the collages in *The Third Mind* as well as in Burroughs' scrap books. Made with a modified roller, the grid often consisted of lines of script running both right to left as well as up and down. It was inspired by the Kabbalah as well as a Moroccan curse he blamed for shutting down his restaurant in Tangiers, the 1001 Nights, in 1956. There is an additional point in that the words would often be unreadable, that they appear disappearing, which would become central for his and Burroughs' thoughts on control. As he wrote in his notebook in 1962: "Rubbing out the words is the real essence of magick Poetry" (quoted from Hoptmann 2010b: 64).

The multimedia aspect, working with combining sounds, texts and images, made Burroughs and Gysin important precursors to the Happening

and performance scenes of the late 1960s. Their first staged event of this sort, *Action Painting and Poetry Projection*, was held at the Heretics Club at Corpus Christi College, Cambridge University in 1960. By combining their work with light projection and theatrical performance, Gysin, who arranged the event, hoped to produce the aforementioned 'derangement of the senses' in order to break the bounds of what was perceived as a culture of pervasive control, enforced by language and by image. This was later followed in December 1960 by the show *Brion Gysin Let the Mice In* at the ICA in Dover Street, combining Ian Sommerville's light show with Burroughs's voice, radio static, Arabic drumming, and Gysin's abstract paintings (Miles 2010: 130). The experiments would later be described by George Maciunas in his famous treatise on Fluxus as "Expanded Cinema" and were meant to create a sort of total theatre in the tradition of Antonin Artaud's Theatre of Cruelty featuring manipulation, *décollage*, permutation and superimposition in order to create what Burroughs would call "an anxiety of bewilderment" (Geiger 2005: 158).

Artaud's ideas, stemming back to Surrealism, were ubiquitous in the 1960s, cf., for example, not only sigma and the AU but also the Panic Movement in Paris, the group *Solvognen* (Eng.: The Sun Wagon) in Copenhagen or the Exploding Galaxy in London. As such, they constituted a fundamental inspiration for the developing performance and happening scenes. Artaud called for a new theatre which would enable its participants to dissolve the stage and intervene directly into affective reality through performances. These would essentially operate on a metaphysical level while transgressing boundaries and communicating in a language before words that would be "incantational" and "conceal what it exhibits" (Artaud 1938: 53-71). This sort of re-enchantment of the theatre is intimately connected to the hidden tradition of magick and the occult, just as it can be argued that the Surrealist techniques of automatic writing and automatic drawing – practices that were pioneered by spiritualism – are magick methods on par with the cut-up.

In the third mind of Burroughs and Gysin, a shift happened where the cut-up became intertwined with the urge to battle control. It came to be seen as a magickal practice, enabling its practitioner to intervene tactically in the world by re-arranging relations between text, image and content. According to Laura Hoptman (2010b: 64) who curated the show at the New Museum, Gysin saw the making of art as quasi-magical, "akin to the practice of scrying, where an image is willed into apparition in a reflected surface by the mirror or crystal-ball gazer. Equally, the casting of spells is meant to conjure, but it is also meant to cause things to disappear." Through material intervention, what was supposed to disappear was existing control forms while the cultural production should conjure

up new vistas of freedom. As such, Gysin's magick as art performed either an exorcism or the casting of protective spells. Hoptman (2010b: 58) sums up Gysin's artistic practices in the following words: "Bent as they are on proving art's service as a weapon against control, Gysin's experiments are methods of escape from conventional ways of thinking and seeing, and vehicles for the exploration of areas of mind heretofore unknown."

Gysin had (re-)discovered the cut-up technique accidentally in 1959 by cutting up newspaper articles placed on his worktable to protect the surface. After discovering that the juxtapositions produced new surprising meanings, he began to rearrange the sections randomly. This resulted in *Minutes to Go* (1960, with Burroughs, Gregory Corso and Sinclair Beiles), the first manifesto of the cut-up method including instructions in how to make them and the reasoning behind them. It initiated a series of experiments that culminated in *The Third Mind*, which, in its paint-splattered pages with cut out words, has some resemblance to the collaboration between Debord and Jorn in *Fin de Copenhague* (1957) as well as the underground publications of the time. The technique is related to surrealist language games and already Marcel Duchamp had experimented with putting four texts into quarters of a square grid in his *Rendez-vous du dimanche 6 février 1916 à 1 h.3/4 après-midi* (1916). As such, it dates back at least as far as Dada, cf. Tristan Tzara's famous example from his 'Dada Manifesto on Feeble & Bitter Love' (1920) on how to create a poem: cut up the text, place the words in a hat, draw them up randomly and write down the words in their new order.

What is generally referred to as 'the cut-up' actually consists of two different methods: the cut-up and the fold-in. The latter consists of folding the page over itself and read the sentences across. In the tradition of Dada and following the ideas of John Cage, both are aleatory methods, incorporating chance into the work. A third variation is permutations where the words change place in the sentences as it is known from Gysin's poetry, most famously in 'I Am That I Am.' This permutated poem has become a classic example on early sound art in the BBC recording of it, broadcasted in 1961 as *The Permutated Poems of Brion Gysin*, where Gysin experimented with radio technology and the treatment of sound as a material. In general, Gysin preferred to use the cut-up for poetry, resulting in permutations, while Burroughs used it for prose, resulting in the fold-in.

Related methods of literary collage can be found in the works of a wide array of modernist writers from T. S. Eliot to Gertrude Stein and artists have practiced this kind of collage/assemblage extensively at least since Cubism, e.g. Gil J. Wolman used cut-up techniques in some of his lettrist works of the early 1950s, connecting the method to the LI and, by extension, the

SI, who, as we saw in Chapter Two, were well aware of the revolutionary potential of the cut-up with its cultural attack on authorship, private property and copyrigt (Debord et al. 1956). The cut-ups differ from Tzara's method, though, in that they are not an aleatory means of generating text from scratch, but rather a method of treating existing text. This aligns them more with the détournement than with Dada and there are a number of intersections connecting it to Situationism, e.g. Trocchi obviously knew both Burroughs and Debord, and Ralph Rumney knew Gysin (Baker 2010: 149).

The most basic cut-up is to take a page, "cut it down the middle and across the middle and then re-arrange the four sections" (Burroughs 1974: 29). This creates new hybrid sentences where one is encouraged to look for hidden meanings in chance combinations and abandon old meanings and interpretations altogether in favour of a sensory relation to the text. It is possible to control what goes into the montage but not what comes out, thus making it a revelatory technique.

The re-discovery of the cut-up led Gysin – who famously declared that, at last, literature was no longer fifty years behind painting – and Burroughs to commence upon a series of psychic experiments, applying the technique across medias and materials while also dabbling with ESP and magick. These experiments evolved from explorations of altered states through sensory perception to ideas about incantations and playback as a form of modern magick. The first extension to the method was introduced by Gysin (Burroughs 1974: 28) using tape-recorders to record material and then cut in passages at random in a series of experiments that would be seminal for TOPY and the underground of the 1980s.[76]

Gysin's idea with the cut-up was to basically align it to a literal recording of life and of experience (Robinson 2011: 32). The string of words making up a linear sentence and the time it takes to read renders language as if it was a reel of audio tape or film and, thus, suggests that to cut and re-align text is to cut and re-align one's experience with tangible, physical results. Wo/man's reliance on word is, as we shall see below, not only psychological, it is biological, and in the third mind thinking of Burroughs and Gysin to cut into the 'running loop of words' and alter the 'word-process' is tantamount to cutting into history, changing the future or altering a string of DNA.

In the public mind it is primarily Burroughs who has been connected with the cut-up method and this *hombre invisible* – 'invisible man' – is a towering figure in the invisible insurrections from the early 1960s until his death in 1997. With his cut-up trilogy, Burroughs tried to intervene into the centre of the concatenations of dreams and revolution. In a 1964 interview, he

quipped (Burroughs 2001: 55): "In *Naked Lunch* and *The Soft Machine* I have diagnosed an illness, and in *The Ticket That Exploded* and *Nova Express* suggested remedy. In this work I am attempting to create a new mythology for the space age." He went on to explain this new mythology (Burroughs 2001: 55):

> Love plays little part in my mythology, which is a mythology of war and conflict. I feel that what we call love is largely a fraud - a mixture of sentimentality and sex that has been systematically degraded and vulgarized by the virus power. Heaven and Hell exist in my mythology. Hell consists of falling into enemy hands, into the hands of the virus power, and heaven consists of freeing oneself of this power and achieving inner freedom, freedom from conditioning.

The main issue for Gysin and Burroughs was an alteration of consciousness in order to subvert 'Control'. They dedicated their practices to this with the use of cut-ups, collage, tape-recorders, films and by insisting that 'anything that can be done by drugs can be done in other ways.'

Turning the official view on human evolution upside down - and making up his own fictitious experts to back up his ideas when needed like the Herr Doktor Kurt Unruh von Steinplatz - Burroughs' postulate (1974: 11) was that the word was a virus of biologic mutation, affecting a change in its host which was then genetically conveyed. As he writes in the 'Playback from Eden to Watergate' section of *The Job*, in the beginning was the word: not only the word in the form of speech, but also as writing - the storage and transmission of which made culture possible in the first place. The birth of a virus occurs when "our virus is able to reproduce itself in a host and pass itself on to another host" (Burroughs 1971a: 188). Because apes never mastered writing, the 'written word' mastered them: a 'killer virus' that made the spoken word possible. In the beginning of human culture, the killer virus reconstructed the ape's inner throat which was not designed for speech and, thus, created humans. Along the way, most apes died from sexual frenzy or because the virus caused death through strangulation and vertebral fracture but with two or three survivors the word was able to launch a new beginning. Burroughs goes on to discuss silence as a desirable state, a sort of exodus from control, since words are potentially blocks both by their linearity in language and by the manner in which they narrow definitions of experiential events and actions.

In 'Electronic Revolution', Burroughs (1974: 14) explains that a virus is a very small unit of word and image that act as communicable virus strains.

Since words and images are vessels for control, society's control over the individual – be it religious or political – basically consists in structures of communication and verbal association lines. As a virus, it operates autonomously, spreading from host to host without human intervention. It derives its power from infecting us and grafting itself onto other bits of language from where it spreads and reproduces, thus reducing the subject to a node in a network through which ideas pass but where there is no real division between subject and object, only a perceived notion. The virus generates artificial identities, thereby isolating each person in their physical body and obscuring the path to spiritual transcendence. Moreover, as Edward Robinson (2011: 48) has noted, the virus imposes reductive binary models and thought that justify oppressive bureaucratic structures of command and exploitation, and then uses these structures (such as the corporate mass media) to create insoluble conflicts among people.

In the period I am interested in here, Burroughs and Gysin searched for a type of communication that went beyond word structures by replacing words with colours, covering whole lines with blue, red, etc., all the while further eroding the border line between image and text.[77] If the word is control and it was there from the start, then there is only one thing to do to change things: rub out the words. Re-arrange them. If the virus is in us, getting rid of it takes careful effort not to destroy others or ourselves. In order to do so we must exploit the strange loops that appears when we start to cut.

Greg Bordowitz (2010: 18) goes into the tactic of the virus in his small book on the art group General Idea's AIDS activism where he argues that a virus fundamentally uses confusion: it continuously mutates and changes its composition while it, at the same time, continuously repeats itself, infecting large portions of the signifying field by copying itself endlessly. In the contemporary, especially the internet has turned out to be a great breeding ground for these infectious mind viruses and the various alternative accounts of reality they often entail. Before the internet, it was part of the underground press' function as an independent news channel as well as a topic to be discussed in the shadow society's spontaneous universities.

The notion of the meme crystallises this view of the communication process as a sort of viral transmission that operates through contagion. Memes – a term coined by evolutionary biologist Richard Dawkins in *The Selfish Gene* (1976) – are self-replicating webs of ideas (e.g. myths, hypotheses, dogma) that function like social glue (Bloom 1995: 108). The core of the meme concept is that memes spread through society the same way that genes spread through a population. In a way, the aspect of the meme which today has made the word nearly synonymous to 'image macro' on various social

networking sites, is that it can be conceived as a communication technique utilising a type of Brechtian alienation effect to create a sudden shock of cognitive dissonance that enables the empowerment of the meme.

How do these ideas spread? They spread as affects, as exposure to words, images, ideas, through communication: as West Nile virus on migrating birds, as mosquitoes carrying malaria, as a man sneezing in a rush hour tube. What makes a meme successful is simply that it encourages the people who accept it to transmit it to as many other people as possible. Essentially, the idea of memes overlaps in its key aspects with Burroughs's theory of words as a virus. Arguably, memes are always a matter of ideas, but these do not take the form of incontrovertible principles as much as currents and imitations that come to incite people as they act collectively just like it was the case with Sorel's image myths. Therefore, the sources of insurrection are not to be sought in the individual but in a particular circulation of affect and ideas, aided and abetted by their material support in new forms of communication. As the Deterritorial Support Group (2012: 32) write: "Prior to the invention and popularisation of the internet the meme was an interesting theory – today it's a conceptual tool without which our understanding of information transfer would be unable to function," before they propose that memes plus sincerity might equal communism.

The cut-ups thus take on significance as weapons to battle control. Sentences need to be cut up and re-arranged in order to break the hold of control and make new perceptions, ideas, thoughts, forms-of-action possible. The cut-up, which Burroughs would experiment with over a wide range of medias including tape-recorders, films and images, makes it possible to manipulate reality through an editing process. As Genesis P-Orridge (2006: 287), one of the central figures of TOPY who tried to apply Gysin and Burroughs's methods and magick on their everyday lives, would later write:

> The real hidden doctrine handed down through the ages, the central agenda, is control. Why do those who control seek to maintain control? For its own sake. How do they control? By controlling the story, by editing our collective memory, conscious and unconscious. In many ways the edit is the invisible language of control and its corporate media allies. They cut and paste in order to separate us from each other by entrancing us with a pre-recorded reality that seamlessly isolates us in a world designed by those who would immerse us in service to their fundamentalist consumerism, simultaneously divorcing us from the universe that is creation itself in an infinite pre-sensory source.

Since the word is the limit of thought, the way we have been conditioned to read and react to words ultimately controls our behaviours and our possibilities for thinking the radical new. The cut-ups are techniques to create new memories and new myths out of the cultural debris surrounding us. Both the sigma project and the Academy wanted to de-mythologise quotidian life and bring all information out in the open. By destroying myth they wanted to escape its control, but, along the way, a new myth, this time about escape, revolution and freedom is being reinstated. Realising that this just replaced one myth with another, Burroughs began to think of the struggles against control as inside operations. It is no longer about creating the new, it is about decoding what is already there. Without the order of language, wo/man is lost but by utilising the newly cut loopholes, we are able to create other narratives to produce values and identity with and, ultimately, to imagine a spontaneous future which is not always already pre-recorded. Thus, his fiction became a parafiction, mixing fiction and faction while using myths in a parodic way: they are not symbols of a transcendent reality, they are strictly material.

The cut-up wanted to slice up reality which was seen as a prerecorded fantasy by control which will lead to extinction. Instead, a new mythology was to be created by re-assembling the pieces. If what we imagine to be reality is the equivalent of a recording, then we become empowered to edit, re-arrange and re-contextualise by cutting up and reassemble our own reality. According to the definition Crowley (1997: 126) set forth in *Magick in Theory and Practice* (1928), i.e. making change happen by will alone and 'following the laws of nature,' this can be seen as an essential magical practice. Magick has 'the method of science and the aim of religion' as the catchphrase ran on Crowley's journal *The Equinox* and it thus aims at discovering scientific techniques for the mental control of probability. It is a non-transcendent methodical de-mystified process that allows its users to force the hands of chance in order to make things one 'truly' desire happen, a formulation that points to the mystical experience of unity. What the cut-ups offer is not just a new way of intervening with the world but a new way of thinking it. Burroughs (1974: 91):

> The new way of thinking has nothing to do with logical thought. It is no organismal subconscious body thinking. It is precisely delineated by what it is not. Like a moving film the flow of thought seems to be continuous while actually the thoughts flow stop change and flow again. At the point where one flow stops there is a split-second hiatus. The new way of thinking grows in this hiatus between thoughts. […] The new way of thinking is the thinking you would do if you didn't have to think about any of the things you ordinarily

> think about if you had no work to do nothing to be afraid of no plans to make. Any exercise to achieve this must themselves be set aside. It's a way you would think if you didn't have to think up a way of thinking you don't have to do. We learn to stop words to see and touch words to move and use words like objects.

Additionally, the cut-ups could also be used for divinating the future: "I would say that my most interesting experience with the earlier techniques was the realization that when you make cut-ups you do not get simply random juxtapositions of words, that they do mean something, and often that these meanings refer to some future event" (Burroughs 1974: 28). As Burroughs writes in 'the invisible generation' after he has instructed the new revolutionaries to get a "philips compact cassette recorder handy machine" for street recording and playback so the "invisible brothers can invade present time" (1966: 163): "[M]ix yesterday in with today and hear tomorrow your future rising out of old recordings" (Burroughs 1966: 167). In his interviews as well as the lectures he gave at the Naropa Institute in Boulder, Colorado during the 1970s and 80s, he repeatedly stated that 'if you cut into the present, the future leaks out.'[78] That the invisible generation, schooled at Academy 23, is deeply connected to sigma's invisible insurrection, that they might even be its sigmatic protagonists becomes clear from a letter Burroughs (2012: 235) wrote to Gysin, dated 21 November 1966:

> Response on the tape recorder article has been excellent so far, people are actually doing the experiments described, needless to say I will push the project as far and as fast as possible. Alex [Trocchi] is in contact with a lot of young people through Project Sigma who are willing to do the work of writing letters, organizing tape recorder evenings, etcetera, plenty of young people here who want *something to do*.

Gysin and Burroughs were cutting up texts and re-arranging them to destroy their face-value meanings, but also to reveal hidden ones, in an operation not unlike tea-leaf or entrails reading. The tape-recordings ultimately became an audio virology that could intervene directly into the surroundings, since if "you want to start a riot put your machines into the street with riot recordings move fast enough you can stay just ahead of the riot" (Burroughs 1966: 168). Burroughs call this technique of manipulating reality 'waking suggestion', a concept he took from the occult writer Dion Fortune's classic *Psychic Self-Defense* (1930: 13) in which it describes

an exposure to sounds and images that are being registered by a subject while his/her attention is diverted elsewhere, but which would have been perfectly visible or audible, had the subject been attentive.

Regarding who controls, Burroughs (1975: 119) wrote: "Who, then, need to control others but those who protect by such control a position of relative advantage? Because they would soon lose this position and advantage and in many cases their lives as well, if they relinquished control." Control is always secret, hidden, subtle, it never shows it true intention and its object is always the protection of vested interests. As in sigma, one way of battling control would be through transparency where all information is out in the open: "When people start talking about the danger posed by making psychic knowledge available to the masses, they are generally trying to monopolize this knowledge for themselves. In my opinion, the best safeguard against such abuse of knowledge is widespread dissemination" (Burroughs 1993: 57). Burroughs thus casts himself in the role of whistleblower. The inclusion of detailed 'scientific' instructions for the replications of his experiments within his work serves to enable others to repeat them, and, thus, make knowledge freely available to all.

> I went on to talk about adrenaline and the other neurotransmitters in the body, like serotonin and the various endorphins. Inside my head – inside all our heads – there is a sea of chemicals. And it is we of the 1960s who are the blessed generation, for, thanks to the new pharmotechnology, thanks to LSD, methedrine, and other drugs, for the first time in human history, we have the means to navigate upon this strange sea. We can become as gods. Is this not the most wonderful thing to have happened ever?
>
> Robert Irwin 1999: 202

5.2.

Academy 23

As we saw above, Bataille realised that when all political solutions seem to have failed, ultimately it becomes a matter of belief. As it was the case for sigma and the AU, a common project for many cultic experiments has been to find both a new way of living in the world and a new way of perceiving it, thus realising the Kingdom of Heaven on Earth by creating new ecstatic communities. With Academy 23, not only the political extremes of the counter-culture but also the hedonistic extremes found their institution even though it was an imaginary one. The fusion of the two wings of the underground – a concern with hidden (and often fringe) knowledge and a desire for revolution – opened a new playing field which doubled the tactical terrain to be political *and* mystical. It can be argued Academy 23 was as much an idea about a free monastery as it was about a free university, concerned as it was with not only revolution and new social movements, but also with evolution and new religious movements.

One of the goals of Academy 23 would be to train youth to become aware of how Control uses the word as a conditioning device. Burroughs (1974: 138) gave the following example:

> Opinion control is a technical operation extending over a period of years. First a population segment – 'segment preparation' – is conditioned to react to words rather than word referents. You will notice in the subsidized periodicals a

> curious prose without image. If I say the word 'chair' you
> see a chair. If I say 'the concomitant somnolence with the
> ambivalent smugness of unavowed totalitarianism' you see
> nothing. This is pure word – conditioning the reader to react
> to words. 'Preparations' so conditioned will then react pre-
> dictable to words.

In Burroughs' analysis, words are the principal instruments of control since the "technocratic control apparatus" (Burroughs 1975: 117) rules through suggestions, persuasions and orders which all consist of words. This relational character of control suggests it is always partial and never complete. In a world of information overload and perpetual distraction, control and repression might as easily manifest themselves through a dismissive giggle or a yawn of boredom as in violent suppression. In an example of what Herbert Marcuse (1965) called 'repressive tolerance,' freedom is allowed as long as it is stripped of all political meaning.

Academy 23 was concerned with alternative futurities that could reclaim this freedom. Revolution was needed in order to create these new futures and evolution was needed in order to inhabit them. For revolution to effect basic changes in existing conditions three tactics are required: "1. Disrupt. 2. Attack. 3. Disappear. Look away. Ignore. Forget. These three tactics to be employed *alternatively*" (Burroughs 1974: 98). (R)evolution was the only escape route due to that humankind was stuck in a biologic dead end left with only two choices: mutate or become extinct.

The Academy wanted to take the idea from sigma and the AU, that self-transformation is necessary for revolution, to an extreme length. It wanted to prepare us for an evolutionary task: human consciousness needed to mutate through a process of deprogramming and reconditioning in order to be able to emigrate to space as astral bodies. In order to provoke this mutation, it wanted to pool, share and teach 'unimaginable extensions of awareness.' Regarding what could push us into the great unknown, Burroughs (1974: 137-8) stated:

> [Y]oung people will learn to get really high... high as the Zen
> master is high when his arrow hits a target in the dark... high
> as the karate master is high when he smashes a brick with his
> fist... high... weightless... in space. This is the space age. Time
> to look beyond this rundown radioactive cop-rotten planet.
> Time to look beyond this animal body. Remember anything
> that can be done chemically can be done in other ways. You
> don't need drugs to get high but drugs do serve as a useful

> short cut at certain stages of the training. The students would receive a basic course of training in the non-chemical discipline of Yoga, karate, prolonged sense withdrawal, stroboscopic light, the constant use of tape recorders to break down verbal association lines. Techniques that are now used for control of thought could be used instead for liberation.

First and foremost, the Academy wanted to show its students how to free themselves from past conditioning thus sharing a goal with not only the anti-psychiatrists but also with Scientology which again emphasises its cultic aspects. The latter incorporated in 1953 as a form of psychotherapy with the trappings and organisation of a religious movement. In order to achieve freedom from past conditioning himself, Burroughs had been involved directly with Scientology during some of his years in London (Wills 2013). Today, where so much attention focuses on the science fiction origins of Scientology (L. Ron Hubbard launched Dianetics as a story in the May 1950 issue of *Astounding Science Fiction*), it is easy to forget how seemingly in harmony the Church was with a whole range of countercultural, New Age and anti-psychiatric practices in the Sixties. As an alternative to psychiatry, various gods were seen as representing archetypes, aspects of the self to be worked on and/or links to one's subconscious. As Burroughs explained in *The Job* (1974: 40), Dianetics talks about the analytic and the reactive mind instead of the conscious and the unconscious mind. Instead of neuroses, the reactive mind stores crippling, unhappy memories – some from previous incarnations – called engrams. These memories condition our behaviour. The goal was to diagnose the cause and the cure of nervous tension which is also the premise for the Church's most famous 'religious artefact': the E-meter (or P-meter as it was called by the Process Church who also used it extensively, see Wyllie 2009).

Scientology's central technique is auditing which became one of Burroughs's obsessions, resulting in that in 1968 he put up a notice in Barry Miles' hip bookshop Indica, offering free audits (Baker 2010: 161). Basically, the person being audited is asked a series of questions while an auditor interprets the needle's movements. Instead of psychoanalytic free associations, he relies on what is basically a simple lie detector device, the E-meter. The needle will jump anytime the person audited is asked anything that makes them tense, but it is possible to work through these subjects until the needle gives a flat reading (Baker 2010: 163). When this has been done sufficiently, the person is 'Clear' on that topic. All the engrams have been erased. In Scientology, the aim is to get people to pay for each level of initiation on the 'Bridge to Total Freedom.' The result is that the members gradually become 'Operating Thetans' – a superior kind of Scientological

being to mere Clear and a title claimed by, for example, Charles Manson, a.k.a. Jesus Christ, who was audited in prison before he began to prepare Helter Skelter.

As such, both the Academy and Scientology are examples on countercultural communities coming together and organising around cultic activities. One of the main problems with these, in general, are that they easily become a money-making scheme for con-men and that it, maybe for the same reason, easily evolve into pseudo-fascist, authoritarian structures – 'acid fascism' as David Felton calls it in his 1972 sourcebook *Mindfuckers* – suitable just as easy for right-wing militias as for left-wing libertarians. In the case of Scientology, with Sea Org, established in 1968, they made their own elite paramilitary organisation which taught the highest levels. This organisational structure was one of the reasons for Burroughs to later distance himself from the Church even though he was involved on and off for most parts of a decade. As he wrote in his 'I, William Burroughs, Challenge You, L. Ron Hubbard,' published in the London-based magazine *Mayfair*, May 1970 and later by the Los Angeles Free Press, he found their methods valuable and the E-meter a useful device but found the organisation fascist and disagreed with the concept of charging huge amounts of money for hidden knowledge (Burroughs 1970: 58):

> He [Hubbard] says he has the road to freedom. Others have been a long time on that road. At the Edinburgh Writer's Conference in 1962 Alex Trocchi coined the phrase 'astronauts of inner space'. Let Mr Hubbard show his confidential materials to the astronauts of inner space: Alex Trocchi, Brion Gysin, Allan Ginsberg, Timothy Leary [...]. Let him show his materials to those who have fought for freedom in the streets: Eldridge Cleaver, Stokely Carmichael, Abe Hoffman, Dick Gregory, to the veterans from Chicago, Paris and Mexico City. Above all young people have a right to see his materials. So let him set up a centre and give his processing and materials free of charge and without any restrictions of any kind to anyone under the age of 25. [...] Unimaginable extensions of awareness are now possible in terms of existing techniques. Let's set up a centre where all these techniques are pooled and interchanged. Let's explore and chart inner space. Your inner space belongs to you. It is time to demand what is yours and challenge anyone who claims he has knowledge of inner space to come out and show what he has.

The goal of Academy training was exactly to share knowledge about states of total freedom and expand consciousness through non-chemical means. This would result in an expansion of human possibilities and, according to the principle of evolution, a following mutation of the species. To achieve this end, dream machines were an essential means since they could provide drug-free hallucinations. As we saw in Chapter Two, they were also meant to be part of the equipment of the sigma centres (SP2). The basic idea behind these machines is to explore the connection between flicker experience and altered states of consciousness – a connection which has probably been known since the discovery of fire – in order to provide a drug-free hallucinatory experience, often described in terms similar to a LSD trip.[79]

As with the cut-up, chance and coincidence seem to have played an instrumental part in the discovery that led to the experiments: Gysin was travelling on a bus between Rustique Olivette and Marseille in the south of France in 1958 when passing a long avenue of trees. Closing his eyes against the setting sun he encountered a flood of colour visions, stopping abruptly when the bus left the trees. He immediately wrote Burroughs about the discovery, who, according to Geiger (2005: 160), replied with a "We must storm the citadels of enlightenment, the means are at hand." Those means, decided Gysin, would be to develop a machine harnessing the visionary potential of flicker, to "make the ghosts walk in public" (quoted from Geiger 2005: 160), making illusory experience available at the flick of a switch.

Using the dream machine (or, later, dreamachine), a variety of symbols, crosses, spirals, appear on the eye-lid after a few minutes due to that the light interruptions – at a rate of 8–13 flicks per second – will synch with the brain's alpha rhythms. The pulsating light stimulates the optic nerve and alters the brain's electrical oscillations. In effect, it makes us dream while we are awake and causes individuals to see colours, visions or even entire three-dimensional landscapes with their eyes closed. It has been claimed that viewing a dreamachine allows one to enter a hypnagogic state (Kerekes 2003: 13). The phenomenon was first described by William Grey Walter in his book *The Living Brain* (1952) and, in 1960, Ian Sommerville wrote Gysin to tell him that he had made a simple 'flicker machine,' the blueprint for which is more or less the same as the DIY ones TOPY would create, distribute and sell in the 1980s: place a cylinder with slits at a regular interval on a turntable and let it rotate at 78 rpm. Suspend a light bulb inside so the light will flicker at a precise intermittency. Then look at it from close distance with eyes closed.

In 1961, Gysin took out a patent for the procedure and apparatus, Patent PV no. 868,281: "[T]he invention which has artistic and medical application, is

remarkable in that perceptible results are obtained when one approaches one's eyes either opened or closed, to the outer cylinder slotted with regularly spaced openings revolving at a determined speed" (Geiger 2003: 66). The flicker experience with its fragmentation of continual images found its way, alongside the tape experiments, into the cut-up trilogy. Burroughs commented on it as a new art form in *The Job* (1974: 174):

> 'Flicker' creates a dazzling multiplicity of images in constantly altering relationships which makes the 'collages' and 'assemblages' of so-called 'modern' art appear utterly ineffectual and slow. Art history is no longer being created. Art history as the enumeration of individual images ended with the direct introduction of light as the principal agent in the creation of images which have become infinitely multiple, complex and all-pervading.

The invention of the dream machine provided a way out of the materiality of the object. It was less an artwork than a tool for achieving a state of creative production that did not necessitate painting, drawing or writing. It would rub out the word and replace it with its disembodied essence – a vision of an archetype (Hoptman 2010b: 122). Unfortunately, Gysin failed to find a manufacturer for the machines, turning it into a mass-produced home component like TV, but stroboscopic lights was soon taken up in works of art, e.g. Tony Conrad's film *Flicker* (1966), as well as by the drug culture (Geiger 2003; Hoptman 2010a). By the late 1960s, flicker was everywhere just like the transmedia experiments.

In the messianic now-time of Gysin and Burroughs we are 'here to go'. This enigmatic three words combination is one of the central concepts in both *The Job* as well as in Burroughs and Gysin's mythology in general, cf. the interview book with Brion Gysin, *Here To Go* (1982). It refers to one of Gysin's favourite sayings: 'Why are we here? We are here to go. To leave the planet and take off into space' (Gysin 1982). The idea also finds expression in Burroughs' statement "I feel like I am on a sinking ship and I want off" (Burroughs 2001: 65). Leaving the planet has nothing to do with conventional space travel: to explore outer space is to explore inner space, making it akin to astral travelling. When we go, we will go as pure consciousness, making it impossible for the word to follow us since we will then think in images and association blocks and no longer have vocal chords or hands with which to write. Everything was permitted to reach this end since they were working under the impression that there were only 'minutes to go' as Terry Wilson, Gysin's assistant, explains in the documentary film *Flicker* (2008). Like sigma, they were working under

the impression that the world was on the brink of total apocalypse. Their belief system seems curiously close not only to medieval heresies centred around turning the world upside down and become as gods ourselves (Cohn 1957; Hill 1972; Vaneigem 1986; Blissett 2000) but also to more modern beliefs such as the one that led members of the Heaven's Gate cult to leave their earthly containers behind in the spring of 1997 in order to travel through space with the comet Hale-Bopp.

The way to rub out the word was to edit the message of control, to engage in a semiotic information war and re-arrange meaning, an idea not too dissimilar from Trocchi's notion of mental jiu-jitsu and the situationist détournement which also consisted of turning already existing materials in order to conceptualise what already is in a new way. Official language, and thus official information, needed to be decoded. Burroughs (1974: 138) wrote:

> The aim of academy training is precisely *decontrol* of opinion, the students being conditioned to look at the facts *before* formulating any verbal patterns. The initial training in non-chemical methods of expanding awareness would last at least two years. [...] The program proposed is essentially a disintoxication from inner fear and inner control, a liberation of thought and energy to prepare a new generation for the adventure of space.

Space might be the central metaphor in Burroughs' work from this period in the late 1960s and early 1970s. It signifies everything that is at stake in the struggle against control as well as the belief that in order to progress we must take the step into space. This step is made possible by shedding the confines of our bodies and move beyond it. For Burroughs, dreams represent our connection to a fantasy of space and their function is to train the individual for future conditions. By constructing a One God Universe, control is attempting to destroy human's capacity to dream by keeping all thoughts of space out of the minds of the population. The Academy's purpose was to teach us how to dream big.

Big dreams and space metaphors are familiar tropes in occult thinking. Connected to a belief in that we are standing on the threshold of a quantum leap in evolution and consciousness which will result in mutation and the beginning of a new age, be it the space age, the Aeon of Horus or the Age of Aquarius, it has been one of the major ideas fermenting the rise of the so-called New Age movement. It is also a common theme in much science fiction, e.g. Arthur C. Clarke's *Childhood's End* (1953), which sees human consciousness expanding rapidly after we come in contact with

"the Overlords" who prepare us to leave the planet as pure consciousness in less than a generation, or Doris Lessing's *The Sirian Experiment* (1981) which provide an angle on the evolution of Planet Earth and its inhabitants seen from a superior race of colonisers and administrators living on Sirius. The idea also resurfaces in a lot of counter-cultural writings, e.g. Robert Anton Wilson's *Cosmic Trigger: Final Secret of the Illuminati* (1977) or, albeit on a more general level, in Wilson and Timothy Leary's SMI²LE-project, an acronym for 'Space Migration, Increased Intelligence, Life Extension'.

Part of this imaginary found popular form in Gene Roddenberry's *Star Trek* (1966-69) television series where Captain Kirk and his crew on the starship *Enterprise* declared space 'the final frontier' and set the mission to 'boldly go' where no one has gone before. This found an echo in Burroughs's foreword to *The Job* where he wrote that "space is the final frontier. [...] To travel in space you must leave the old garbage behind: God talk, country talk, mother talk, love talk, party talk. You must learn to exist with no religion no country no allies. You must learn to live alone in silence. Anyone who prays in space is not there."

For Burroughs, to be in space is to achieve a particular mystical mindset that results in complete freedom from past conditioning and control. To achieve this state, it is not necessary with interstellar travel, spacesuit and air support, it is necessary to take the step into regions literally unthinkable in verbal terms in order to break the patterns of control. To this end, the esoteric tradition is exactly consisting of older systems to think the unthinkable, e.g. the Tree of Life glyph from Jewish Qabalah which can be seen as a visual representation of the descent of mind into matter and, thus, the different stages of creation (Fortune 1935). Like Trocchi, Burroughs and Gysin were psychonauts exploring a kind of alchemical anarchism where there is a direct connection between inner and outer space, a literal psycho-geography for a new ecstatic community produced by the underground's spontaneous universities.

At Academy 23, the invisible insurrection would be invisible the way electricity is invisible. It would detonate through the unlearning of our former conditioning which can be traced using E-meters. Then new subjectivities and new social relations would be produced while the students would learn how to transform the world through an 'electronic revolution' brought about by using cut-ups and playback to 'make things happen'. Essentially, it was Tactical Media (TM) before the term was coined, or, better, it was tactical magick.[80] In Burroughs' analysis of Control, control has already become post-Fordist, it operates through virus power with memes, self-replicating structures, and the only way to battle it is to become invisible, like the virus itself, and reassemble its transmissions into new meanings.

They were servants of that social machine of the future in which all irrational human conflict would be resolved, all conflict of interest negotiated, and nature's resonance condensed into frequencies which could comfortably phase nature in and out as you please. So they were servants of the moon. Their living rooms looked like offices precisely because they were ready to move to the moon and build Utope cities there – Utope being, one may well suppose, the only appropriate name for pilot models of Utopia in Non-Terrestrial Ecologically Sub-Dependent Non-Charged Staging Areas, that's to say dead planets where food must be flown in, but the chances for good civil rights and all-out social engineering are one hundred percent xap!

Norman Mailer 1968: 16

5.3.

Wild Boys Always Shine

In the 1960s a lot of 'hidden knowledge' from the Western esoteric tradition leaked into popular culture and began to be widely available, resulting in a torrent of new religious movements and cults. In general, the radical imaginary is saturated with millennial phantasies but the invisible ones have traditionally belonged to the realm of the occult. Due to the feeling of being on the brink of something completely new, the cultural production of the underground was concerned with not only the total destruction of the existing system, it was also a total rejection of its social, material and spiritual values. This imaginary is not only concerned with revolution but also with prophecies about an unknown future that will rise from the ashes of the old. Thus, while reformulating radical politics for the post-war generation with tactics which were both improvisational and based on revelation, they applied the same tactics to an often gnostic spirituality. One of the most conspicuous strains of occultism in this spirituality, besides the one from Blavatsky and Theosophy, descends from the teachings of Alisteir Crowley who created a belief system, Thelema, primarily based on his experiences as a member of the Hermetic Order of the Golden Dawn (Regardie 1971; Kaczynski 2002). Even though Crowley – mountaineer, poet and occultist – became very influential in the 1960s,

it is important to stress that the influence was more occultural than occult proper, since it found a home among patchwork cults and collectives who read Crowley side by side with Marx, the weird tales of H. P. Lovecraft and other pulp fiction cosmologies.

Crowley saw himself as the prophet of a new age: his was the Aeon of Horus, of the child, a time where play again would become important which aligns his teachings with other major ideas of the 1960s like the idea about Homo Ludens. Crowley was a pivotal figure for updating the occult into the 20th century and the notion of sex magick – which I shall return to below – is partly inspired by Crowley's teachings as they evolved from his early involvement the Golden Dawn to the two Crowley-led Thelemic magical fraternities: the A∴A∴ (often referred to as the Order of the Silver Star) and the Ordo Templi Orientis (OTO) which have been the most influential on 20th century occulture.

Another central outlet for Crowleyan ideas into the mainstream came through Scientology. In the 1940s, L. Ron Hubbard stayed with OTO's Agape Lodge in Los Angeles, led by the rocket scientist Jack Parsons, where he performed rituals with its members and learned about the Church of Thelema until he took off to Florida with Parsons's wife, Marjorie Cameron, as well as his savings.[81] Apparently, Hubbard repeatedly stated during his stay in the OTO that he wanted to start a new religion, seeing it as a way to get rich fast (Pendle 2005: 252ff; Miller 1987: 112ff). Through Parsons, sex magick also flowed into American Science Fiction where it, among other things, inspired the plot of Robert Heinlein's *Stranger In A Strange Land* (1961).[82] In this novel, the Man from Mars returns to Earth after receiving an education in Martian wisdom, leading him to found a free love church – which today actually exists in the 'real' world, i.e. the neopagan Church of All Worlds – while along the way inventing the verb 'to grok' which found common usage in the 1960s. The book became essential to the growing hippy counter-culture where it was read widely by, among others, the Merry Pranksters and the Manson Family and inspired the lifestyle of many new communities.

The sort of sex magick that was practiced esoterically by occult groups stems from tantric yoga but was popularised by the OTO and by Crowley. From Crowley, sex magick flowed via the Agape Lodge into Scientology (and Science Fiction) and onwards to the Process Church, TOPY and freakish pop culture in general. Basically, it is about harnessing the ecstatic energies from orgasm and the dissolution of personality, *le petit mort* as the French call it. The practitioners focus on the object or state that they want to bring about while climaxing and, often, they have made a talisman of semen if the ritual involves masturbation or mixed secretions of it is heterosexual sex.

It is important to emphasise that even though Crowley's influence can be traced into the occulture of the 1960s and 1980s, the magick of Burroughs and Gysin, and later TOPY, is not Thelemic magick in the tradition of Crowley. To give but an example, the main 'commandment' of the Church of Thelema is 'love is the law, love under will.' In Burroughs's space opera, there is no love, there is only perpetual war and conflict since love is thought of as the hated paternalistic love, the anti-psychiatrists also fought. As such, the influence is mainly, as previously stated, occultural.

Cultic communities often seem determined to return to a pre-Enlightenment mindset and lifestyle.[83] The roots of the occult revival, the flight from reason, can be traced back to the mid-19th century with spiritualism and Theosophy. The latter offered a synthesis of the world's religions, suggesting that Christ, Buddha, Lao Tzu and the rest were all equally 'Masters' while promoting a fascination with non-Western cultures, e.g. Egypt, India and Tibet (Lachman 2003; Drury 2004). As Phil Baker (2011: 20) puts it in his biography on Austin Osman Spare: "Along with more dubious ideas – that a body of Himalayan adepts was running the world behind the scenes, for example, and that it was possible to contact them – Theosophy gave a basic introduction to Hindu and Buddhist ideas, including reincarnation and karma, and popular occult ideas such as the astral body and the astral plane where the astral body can go flying during sleep." Interestingly, although the occult would be associated through the twentieth century with reactionary tendencies from the novels of Dennis Wheatley to the philosophy of Julius Evola, in the nineteenth century it was bound up with progressive politics, e.g. the women's rights movement and colonial self rule as can be seen with, for example, Annie Besant.

Especially occult ideas about the astral body would have a tremendous impact on Burroughs and Gysin and their ideas about space travel. Futuristic as these ideas might seem they are intimately connected with ideas known all the way back to shamanism. The interest in shamanism soared in the 1960s, not least due to the popularity of Mircea Eliade's study *Shamanism: Archaic Techniques of Ecstasy* (1951) and the success of Carlos Castaneda's (fictional) series of books on the teachings of Don Juan (Castaneda 1968). On the topic of shamanism and astral travelling, Alan Cohen (1992: 26) wrote:

> But the most characteristic of all the shaman's powers is the ability to 'fly': to project his consciousness 'outside' of his body, to engage in spirit-flights either across the familiar earthly landscape or to the otherworldly realms of heaven and hell. This is the true 'ecstasis', the being 'beside-oneself'; it is this above all which gives the shaman access to the realms of myth, to the archetypal secrets of the world.

This adds a slight twist to Burroughs' demand to the Academy's students that they learn to be high as kites. It brings to mind how Tiqqun (2011: 178f) sees the starting point of the communist programme in becoming a sorcerer which will turn the 'imposed schizophrenia of self-control' into an offensive conspiratorial argument: "The magician know [sic] how to *go beyond himself*, not in the ideal sense, but actually, in the existential sense." This implies that the strain of counter-cultural thinking yearning for total change still, today, are influenced by the kind of non-transcendent material and occult spirituality which was a constituent part of the spontaneous universities of the 1960s.

The hotchpotch of ideas that constituted Academy 23 can thus be traced back to various Western secret societies, i.e. Freemasonry, the Golden Dawn, OTO, etc. (Hall 1928). The main part can be traced to Crowley and his 'spiritual philosophy,' Thelema. Thelema had been invented by revelation during 8, 9 and 10 April 1904 in Cairo when a being named Aiwass – a minister of Horus the Child aka Hoor-paar-kraat or Harpocrates, Thelemic cosmology's central deity – dictated *The Book of the Law* to Crowley. Interestingly, Crowley sees the future as the age of the child which probably had a certain attraction to the imaginary of the 1960s which as we have seen was fuelled by ideas about ludic man in the leisure society. Also, Crowley discussed the "Magical Being or Body of Light" as "the essential magick work, apart from any particular operation" in his 1929 book *Magick in Theory and Practice*.[84] Burroughs was concerned with invisibility and becoming astral bodies and Crowley addresses this head on when he concludes that "the first task is to separate the astral form from the physical body; the second, to develop the powers of the astral body, in particular those of sight, travel, and interpretation; third, to unify the two bodies without muddling them. [...] This being accomplished, the Magician is fitted to deal with the invisible."

Tactical magick thus consists in the ability of fragments randomly juxtaposed, of collage, assemblage and montage, to make it possible to tell one's own stories and shape the perception of reality. This is not a matter of claiming that 'History' is only made up of the stories we tell ourselves, but simply that the logic of stories and the ability to act as historical agents go together, as the French philosopher Jacques Rancière (2000: 39) has pointed out. Politics, art, myths, forms of knowledge construct 'fictions,' that is to say material rearrangements of signs and images that influence the relationships between what is done and what can be done.

The themes and ideas around revolution, dreams and control in *The Job* found a fictional form in *The Wild Boys* which introduced several significant themes that would become important to the underground of the 1980s: the

struggle to escape the mechanisms of control, the search for transcendence of the biological trap of duality as well as the ability to rewrite one's own past. Set in an apocalyptic near-future, the novel contrasts the last remnants of civilisation which exists in totalitarian enclaves with the wild boys – a revolutionary tribe who are able to subvert through rewriting identity and history. These new revolutionary subjectivities found a voice and an identity with the following outburst: "I have a thousand faces and a thousand names. I am nobody I am everybody. I am me I am you. I am here there forward back in out. I stay everywhere I stay nowhere. I stay present I stay absent" (Burroughs 1971b: 140).

The wild boys are imagined as feral packs of youth exchanging skills in a world-wide network. They share a common language based on transliterations of a simplified hieroglyphic script, they are deep into sex and violence and they are continually joined by boys from all over the world. The image of a smiling wild boy becomes a hugely popular media icon and spreads the wild-boy virus across civilisation (Burroughs 1971b: 151), making youth from all over the world run away from home and gather in nomadic tribes. The wild boys lack an individual sense of self. They exist in a liminal state where rigorous training in guerrilla tactics has led towards specialised biological mutations and from where they are able to wage anonymous guerrilla warfare in a hit-and-run terrain, standing with one and a half foot in the shadows, ready to penetrate and infect everything.

As such, the wild boys echo the tactics for sigma's invisible insurrection, but, at the same time, they precede The Invisible Committee's desire to flee visibility and turn anonymity into an offensive position (The Invisible Committee 2007: 112). To be socially nothing, to avoid being named, becomes the condition for maximum freedom of action as well as a method to avoid recuperation since it necessarily needs to be in constant flux. It is no longer important to be recognised if one does not seek society's recognition. Instead, it is necessary to become completely invisible from the social order. When a tactic becomes locked in language, in words, in meanings, it becomes recognisable. Thus, it becomes harmless and is recuperated, i.e. it exists only on spectacular conditions.

When asked by Daniel Odier how the concept of the nation could be attacked, Burroughs (1974: 98) answered simply: "By the withdrawal of like-minded individuals into separate communities within nations." What has to be done according to this line of thought is to found new experimental communities, ecstatic communes, sigma centres which pool their resources and where each commune de-conditions, re-educates and network in order to create the shadow society.

This idea of revolution as connected to the founding of new communes resonates from sigma and Academy 23 to TOPY to the contemporary where The Invisible Committee ended their 2007 pamphlet, *The Coming Insurrection*, by demanding all power to the communes, hinting that the vision is as relevant now as then. In their chapter on insurrection, they (2007: 117) write: "The commune is the basic unit of partisan reality. An insurrectional surge may be nothing more than a multiplication of communes, their coming into contact and forming ties." The task is then to find one another since a commune forms "every time a few people, freed of their individual straitjackets, decide to rely only on themselves and measure their strength against reality" (The Invisible Committee 2007: 102).

The Committee echoes tactics from the 1960s underground by insisting on constant movement between the communes and a circulation of knowledge in order to cancel hierarchy as well as by insisting that "[t]here's no ideal form of action. What's essential is that action assume a certain form, that it give rise to a form instead of having one imposed on it" (The Invisible Committee 2007: 123). At the same time there is a notion of that it has to be a network of individuals where each person should do their own reconnaissance and then, later, the information would be put together, not unlike sigma's refusal to offer anybody a badge or TOPY's insistence, as we shall see, that in order to become involved one should act as if one was already involved, i.e. produce a 'zine or newsletter, open an Access Point or, in general, be pro-active.

VI. THEE TEMPLE OV PSYCHICK YOUTH

> Let thy lips blister with my words! Are they not meteors in the brain? Back, back from the face of the accursed one, who am I; back in the night of my father, into the silence; for all that ye deem right is left, forward is backward, upward is downward.
>
> Aleister Crowley 1911: 448

6.1.

Our Aim is Wakefulness, Our Enemy is Dreamless Sleep

TOPY can be seen in direct continuation of the new religious and new social movements of the 1960s. Where sigma led to an anti-university, Academy 23 led to an anti-cult. As a 1980s embodiment of the Academy, the Temple attempted to create a new ecstatic commune with a decentralised and horizontal network structure which would learn us the necessary skills to survive in an imaginary future. On one hand, TOPY was interested in inner growth and occult ideas about being a group working with radical individual liberation and thus more an order than an art collective. On the other, its interests were occulture and cultural engineering – attempts at putting a signature on the mainstream. TOPY proudly claimed that they did not seek any followers nor did they have any gurus (London Access Point 1991). They tried to show by example their chosen way of life. Then it was up to people if they wanted to join or not. In this sense, it was entirely DIY.

To begin with, they studied other 20th century cults. Especially the Process Church was examined for 'the best' in cult aesthetics: TOPY needed an ideology for those involved, levels to achieve, secrets to reveal, an inner and an outer order, symbols and uniforms, regalia, internal writings and so on (P-Orridge 2008: 405). In order to make it appear as a serious, focused, militant network, TOPY started out with a logo and a strong visual look inspired by the Process who had an identifiable visual image: they wore tailor-made black uniforms and was often accompanied by German Shepherds.

The Temple's methodology was primarily based on the cut-up ideas from William Burroughs and Brion Gysin. This heritage was displayed openly, if

coded: parts of the early TOPY uniform were, besides a shaved head with ponytail, a grey priest shirt, grey military-style trousers, combat boots, a Psychick Cross and a number 23 insignia, worn to be identified as a member of the community (P-Orridge 2008: 406). This uniform was adhered to in roughly the period from 1981 until 1985-86 when the Temple entered its second, so-called 'hyperdelic,' phase. They also carried an ID card – 'Thee Frequency Ov Truth' – which stated that the bearer was an active 'Individual' in TOPY, i.e. one of "those with thee courage to touch themselves" (P-Orridge 2009b: 465). Furthermore, the ID stated (P-Orridge 2009b: 465) that TOPY was "dedicated towards thee establishment ov a functional system of magick and a modern pagan philosophy without recourse to mystification, Gods or Demons but recognizing thee implicit powers ov thee humane brain (Neuromancy) linked with guiltless sexuality focused through WILL Structures (Sigils)."

The number 23 was ubiquitous in TOPY: they wore it as a badge, the central ritual demanded 23 sigils created on the 23rd of each month at 23 hours Greenwich Mean Time and the Psychick Cross was a vertical line with three horizontals, the central line shorter than the other two and all the lines in the proportion of 2/3. The number holds a special place in Burroughs's space mythology where it is claimed the number appears with a noticeable higher frequency than suspected according to statistics. It can also be found in the writings of other counter-cultural luminaries like Robert Anton Wilson.

For TOPY, the number is a reminder of "the inherent plasticity of our inherited reality" (P-Orridge 2006: 291). It was chosen to represent a magical vision of life instead of a linear and existential one. An awareness of the relation to Academy 23 on behalf of TOPY is also obvious from that the Temple arranged for a couple of evenings with William Burroughs in 1983. These events – which included readings, projections, concerts and contributions from various artists from the industrial scene – were called *The Final Academy*.[85]

The roots of TOPY can be found in Industrial Culture, the band Throbbing Gristle (TG) and, earlier, the performance group COUM Transmission. The punk chronicler Jon Savage (1983: 4) explored the field of industrial culture in his introduction to *RE/Search #6/7: Industrial Culture Handbook* (1983) which presented itself as a reference guide to the philosophy and interests of a 'flexible alliance of deviant, international artists':

> In the gap caused by the failure of punk rock's apocalyptic rhetoric, 'industrial' seemed like a good idea. Punk's implicit concentration, in its purest form, on situationist theory – the

'boredom' of everyday life, and the images that filled fanzines and sleeve graphics – graffiti, 'cut-ups' of fifties consumer goods and the council block death factories of South London' – had left the door open for an even more comprehensive investigation of capitalism's decay.

Savage (1983: 5) went on to list five ideas he would 'prefer to call' industrial, while, at the same time, emphasizing that pop music was no longer important. Instead, for a short period, television was. Television was perceived as the terrain where the next battle in the "Information War" – a war where "information is a bullet, the human voice a weapon" (Dwyer 1989: 47) – would be fought. Savage's five ideas were: 1) Organizational Autonomy. This is primarily about self-owning one's record label but also about self-organising and building one's own networks. Additionally, it points towards the bio-political turn in which people become their own managers, accepting to work more hours for a lower wage in the social factory. 2) Access to Information. The participants in what would become the industrial scenes started to disseminate their own information and philosophy through newsletters, 'zines and philosophical and spiritual pamphlets due to an understanding of that the struggle for control is no longer territorial but communicatory. 3) Use of Synthesizers and Anti-Music. 4) Extra-Musical Elements. This covers an introduction of especially literary elements in a thorough manner (e.g. the cut-up) as well as the use of films and videos. 5) Shock Tactics. A tried and tested method to get noticed.

The common denominator between COUM Transmission, TG and TOPY is self-proclaimed cultural engineer and auto-mythologiser Genesis Breyer P-Orridge (GPO), born Neil Andrew Megson in Manchester, 1950. For a short period in the late 1960s GPO was a member of the Exploding Galaxy, described by *IT* as a "love-anarchist dance group" and by Paul Keeler as "a theatre which is becoming an art form" (Miles 2010: 248). The members of the Exploding Galaxy lived communally from 1967 onwards, first in a house at 99 Balls Pond Road owned by two of the founders, Paul Keeler and David Medalla, and then in a house on Islington Park Street called Galaxy Mark II under the leadership of the artist Gerry Fitzgerald. Both GPO and the film director Derek Jarman, who would later collaborate with TOPY, spent time at the latter house (Miles 2o1o: 253).

The Exploding Galaxy would provide a lasting influence. The Galaxy experimented with almost all the art forms – poetry, dance, film, performance art, happenings, sculpture, painting, kinetic drama. It was concerned with radical behavioural modification and, thus, the production of new subjectivities. It was "a crash course in stripping away bourgeois values and inherited

ways of being by using brutal deconditioning techniques and group sessions" (P-Orridge 2008: 412). As GPO explained to Tony Oursler in the video project *Synaesthesia* (1997 - 2001), the members of the commune could not sleep or eat at the same time.[86] All their clothes were in a big chest: whatever you pulled out determined what you wore that day as well as your sex. If a man pulled out a skirt, he would be female all day. They also experimented with a new language called 'scrudge' that would later influence the writings (and the way of spelling) of GPO and TOPY in general, e.g. "thee," "L-if-E" and "ov" - a form that internally would be known as 'TOPY speak.

By late 1969, P-Orridge had moved into the Ho-Ho-Funhouse in Hull where COUM Transmissions (CT) began. CT started as a free improvisation musical group committed to the reconstruction of behaviour, identity and imagination (Ford 1999). After Cosey Fanni Tutti joined in 1971 they eventually left the music behind and began to work as a performance group in a style heavily inspired by the Vienna Actionists (Brus et al. 1999) and not too dissimilar to other 1960s Artaud-inspired action art groups.

In a 1994 interview, GPO explained that CT went from being street theatre to having more to do with art galleries because those were the places it was safe to experiment. Already at this time, he had become interested in ritualising the events, making them have to do with states of consciousness (Kinney 1994: 323). The group started out being involved in body movement but very quickly went into sexual taboos. They worked in a fairly well-defined performance form influenced by Bruce Lacey and his family as well as earlier artists such as Yves Klein, Allan Kaprow and Joseph Beuys but were trying to get themselves and their audiences to confront the most unacceptable and forbidden areas of their being. Among other things, this included sexual lust and self-mutilation. Barry Miles (2010: 342) writes in his countercultural history: "Continuing the ideas that Genesis had absorbed during his three months with Transmedia Explorations [aka Exploding Galaxy], he set out to shock their audiences into a clear recognition of present time, devoid of prudery, hypocrisy or any preconceived notions of behaviour."

On 3 September 1975, COUM Transmissions became Throbbing Gristle - apparently Yorkshire slang for an erection (Ford 1999: 5.16) - which soon became the main focus for their activities. CT seemed to have reached a climax with the infamous retrospective 'PROSTITUTION' at the ICA. TG debuted at the opening which Tory MP Nicholas Fairbairn described in the *Daily Mail* the next morning, 19 October 1976, as "a sickening outrage. Sadistic. Obscene. Evil [...] Public money are being wasted here to destroy the morality of our society. These people are the wreckers of civilisation" (quoted from Ford 1999: 6.22).

In 1981, TG split down the middle. Chris Carter and Cosey Fanni Tutti continued as the duo Chris & Cosey while Peter 'Sleazy' Christopherson and GPO continued in Psychic TV (PTV), co-founded with Alex Ferguson. GPO explained in the aforementioned interview (Kinney 1994: 330):

> That stopped because it had got so there were no games left. With the best will in the world of trying to confound it, we'd become a rock band. The one thing we didn't want to be, that we despised, was the rock band, and we'd become one. We could go on stage and be as atonal and confrontational and dismissive as we chose, and the more we were, the more it was OK. Because people had worked out that that was what we did. [...] Before the whole thing ended, I was already beginning to put out leaflets 'from the Psychick Youth Headquarters.' I was beginning to build the next project into TG.

In a RE/Search-interview with Throbbing Gristle from 1979, GPO tells Vale (1979: 86) that

> [y]ou need a movement which has no rules ... not an anarchist movement, but where it encourages people to express their individuality. That's what we never had. All these movements always have a set of answers and rules and *these are what we are*. There's never been one where everybody's different, and all that they agree on is that they're trying to go in a particular direction, but each one in their own way. We need an *anti*-cult! We have all the cults – what we need is an anti-cult, for all the people who don't fit in. [...] I want to keep it as a temple, *the temple of psychic youth*. And if somebody wanted to celebrate something in a ritual, they would invent their own ritual and celebrate it. Everybody could have a totally different one. [...] it would be like, completely, totally flexible. Most of the time it could be concerts, sometimes it could be a workshop, sometimes it would be empty, it doesn't matter. I want somewhere where it didn't matter *what* happened, where nobody had to feel anything *had* to happen either.

This project would evolve into TOPY. Their first headquarter, or temple, was 50 Beck Road in Hackney, London, a house which earlier had housed Industrial Records. The name grew out of Throbbing Gristle's live performances. TG had begun to experiment with the more common expectations to fandom by starting to refer to the concerts as "psychic gatherings" and

to fans as "psychick youth" (Vale 1979: 86), e.g. the last TG single to be released, "Discipline," had the words "Marching Music for Psychick Youth" printed on the sleeve. These notions continued into Psychic TV where fandom was used consciously as a way of mobilising people around music and other cultural issues, cf. the trajectory of TOPY which became more and more a sort of decentralised social movement throughout its existence with several members continuing in the networks around the Association of Autonomous Astronauts (AAA) after the demise of the first incarnation of the Temple around 1991 (Eden 2010).

The AAA was a proletarian network trying to build their own spaceships in the 1990s which explicitly operated in the grey areas between art and activism using humour and notions of the occult. In another synchronicity, the AAA's initial five years plan ran from 23 April 1995 to 23 April 2000. They were very visible during the J18 demonstration in London, 18 June 1999, but their particular brand of activism was as much about 'here to go' as about challenging the monopolies and vested interests of capitalism. This mixture of occulture, anarchism and autonomous Marxism can be found as mobilisation points across the art-activist (or 'post-situ') scenes of the 1990s, e.g. Stewart Home's hermetic Neoist newsletters or London Psychogeographical Association's focus on rosicrucianism, freemasonry and ley-lines (Home 1997, Tompsett 2011b). In TOPY itself, the activism took the form of, for example, picketing the Dolphinarium in Brighton every week until it closed (P-Orridge 2008: 425). Members of TOPY were also involved in the Neoist Alliance's attempt at levitating Brighton's Pavilion Theatre during a Stockhausen concert, 15 May 1993 (Home 2006), as well as in Anti-Fascist Action and the Anti Poll Tax (London Access Point 1991). There were also several sticker and stencil campaigns in the streets with relations to TOPY as, for example, the 'Assume this phone is tapped'-stickers in London phone boxes in the mid-80s (Dwyer 1989: 39). This was again based on ideas of cultural engineering where art on the street is seen as more instantly social effective.

TOPY presented itself as a deliberately shadowy entity on PTV's *Force the Hand of Chance* album and, as it grew from there, it began to improvise organizational structures. The basic idea, to use music as a platform for propaganda, was already present in TG. It was meant to mobilise people and arouse them into a sort of awakening in an ecstatic here-now. As such, the Temple began as a discussion between GPO and the American performance artist Monte Cazazza (P-Orridge 2009a: 175) where they had considered what might happen

> if a rock band, instead of just seeing fans as an income flow and an ego booster, focused that admiration and

> energy toward a cultural and lifestyle-directing network? What would happen if we created a paramilitary occult organization that shared demystified magickal techniques? Sleeve notes could become manifestos, a call to action and behavioural rebellion.

Thus, the Temple began as what some has accused of being merely a PTV fan club or a personality cult (Eden 2010). PTV became the propaganda wing of the Temple, just as the Temple can be seen as the ideological wing of PTV. It evolved to become a sort of democratic and weirdly semi-fictitious social movement with a penchant for art, activism and occultism, inspired by Burroughs' ideas about the Wild Boys and running the gamut from individualist to authoritarian to democratised to dissolved during its lifetime. It was "an experimental community and network that took the practice of magical techniques seriously as a means to 'short-circuit control'" (P-Orridge 2008: 412). In the beginning, the Temple was centred around GPO and his close collaborators, e.g. 'Sleazy' Christopherson, who created all the early visuals for the Temple, John Balance, who would form Coil with Christophersson in 1984, Jon Savage, who wrote some of the texts, David Tibet, who performed in some of the early videos, as well as people like Hilmar Örn Hilmarsson and Simon Norris (aka Ossian Brown).

The idea was to create an informal network of people who would prove their commitment to the group by doing an unusual thing, i.e. performing ritual magick. It evolved to become a "group of writers, musicians, technicians, film makers, painters that is as much a mutually supportive, though often diverse, arts movement as it is anything else [...] In all areas, the Temple is a co-operative venture" (Dwyer 1989: 41). Regarding the 'particular direction', GPO (2008: 401) later stated:

> My lifelong obsession is for focused mutability, and to change the means of perception. To challenge every status quo as a matter of principle and never rest, never assume or imagine that the task of reinvention has a finite ending. Permanent change toward a radical, positive and liberating evolutionary mutation of the human species is the core essence and motivation of every single aspect of my creativity.

Like Sigma and the Anti-University, the organised psychick youth also had a business plan. Both PTV and TOPY were subdivisions of a company created in 1981 called PSYCHIC TELEVISION LTD (Dwyer 1989: 46). An album track from *Force the Hands of Chance*, 'Message From the Temple,'

was as mentioned above the initial open call to affiliation with TOPY. It features the voice of Mr. Sebastian (aka Alan Oversby), who later would become a central person in the so-called Spanner Trial in 1991 (Louv 2006: 19). On top of a violin-soaked drum machine track, he reads the first short text of *Thee Grey Book* (1982), a basic mission statement and explanation of sigil magick: "Thee Temple strives to end personal laziness end engender discipline. To focus the Will on one's true desires, in the belief, gathered from experience, that this maximizes and makes happen all those things that one wants in every area of Life [...]" (quoted from P-Orridge et al. 1982: 37). The text is also being read in the video work *First Transmission* (1982) where Mr. Sebastian again provides the voice while Derek Jarman the body.

Thee Grey Book was intended as an instructional manual. David Keenan (2003: 41) calls it "a compendium of techniques for usurping control logics and recovering mastery of self" in his book on PTV associates Coil and Current 93. It states the mission clearly: "We are not seeking followers, we are seeking collaborators, Individuals for a visionary Psychick Alliance. What we suggest next is *not* instruction. It is a method [...] Our interest is therefore *practical*." (P-Orridge et al 1982: 41). The enemies are also named: it is continuity and coherence, restriction and confinement, guilt and fear (P-Orridge et al. 1982: 39). It was the process which was important, its method rather than its identity (the band) or the results of that band's activity (the record). Following Crowley's definition of magick, this is a magical act on a very basic level, and so was any act of successful cultural engineering perceived to be. Crowley (1997: 126):

> It is my Will to inform the World of certain facts within my knowledge. I therefore take 'magical weapons,' pen, ink, and paper; I write 'incantations' – these sentences – in the 'magical language,' i.e., that which is being understood by the people I wish to instruct; I call forth 'spirits,' such as printers, publishers, booksellers, and so forth, and constrain them to convey my message to those people. The composition and distribution of this book is thus an act of [magick] by which I cause changes to take place in conformity with my will.

From the beginning PTV presented themselves as more of an experimental film and video collective than as an actual band. Additionally, they produced their own TV programs, e.g. the above-mentioned *First Transmission* (1982). GPO credited the expansion into new technologies to TOPY mentors Burroughs and Gysin. To him, they were 'occultural alchemists' and 'practicing magicians' whom he had looked up to and befriended during

the 1970s. They had pointed out to him that "the alchemists always used the most modern equipment and mathematics, the most precise science of their day" (P-Orridge 2006: 293). Thus, in order to be an effective magician in contemporary times one have to utilise the most practical and cutting-edge technology and theories of the era. For PTV and TOPY it meant cassette recorders, dream machines and flicker, Polaroid cameras, Xeroxes, E-prime, etc. since "basically everything that is capable of recording and/or representing 'reality' is a magical tool just as much as a weapon of control" (P-Orridge 2006: 293).

This is in accordance with the cut-up method, and Gysin and Burroughs's ideas about the recorded nature of reality, the relationship of the past to the future and how to intervene into the space-time continuum itself had a seminal influence on TOPY's activities. In an essay concerning the magick of Gysin and Burroughs, P-Orridge (2006: 279) wrote:

> Everything is recorded. If it is recorded, then it can be edited. If it can be edited then the order, sense, meaning and direction are as arbitrary and personal as the agenda and/or person editing. This is magick. For if we have the ability and/or choice of how things unfold – regardless of the original order and/or intention that they are recorded in – then we have control over the eventual unfolding.

Ironically, the scientific worldview and the technological acceleration some say have produced the spiritual vacuum and social fragmentation that are fertile ground for millenarian beliefs are, thus, spawning a techno-eschatology of their own. Mark Dery (1996: 9) calls this 'a theology of the ejector seat' and Gysin already summed it up with his 'here to go.' Especially television became an essential area for TOPY to invest in. Since one's programming is a virus and TV, at the time, was the perceived vehicle of a kind of mass-programming of behaviour – just that it stopped transmitting late at night could be interpreted as Control saying "Goodnight. Time to go to bed," not to mention the opinions it helped its audience to form – it was especially this media that drew attention as a possible way to battle the virus power through subversion and editing. It was seen as an actively, oppressive mode of Control in Burroughs' sense of the word where it is an intrinsic function of any linear form of mass communication (Dwyer 1989: 41).

The methods for subversion were détournement and the cut-up method, the idea of the third mind and the introduction of chance into the editing process which created the possibility for a Guattarian auto-poiesis of the

subject: "Without formatting, one image may clash with another, creating a third, new image. One idea may clash with another, creating a third idea. A new idea. And new ideas lead to new understandings, and new perceptions" (Dwyer 1989: 48). As Dada did with painting and Gysin and Burroughs did with writing, PTV did with TV: breaking it up in order to see what happens. The videos were distributed by mail – by the West German-based 'De-Coder' branch due to problems with English authorities (Dwyer 1989: 50) – and were incorporated into live performances.[87] Though it hardly chipped away at the structure of commercial TV, TOPY's first transmissions were meant to "be the first step towards a deprogramming without regard for the preoccupations of commercial TV, or redundant assumptions about entertainment and value" (P-Orridge et al 1982: 50). Precisely for this reason, they were meant to be shown "between the hours of midnight and six a.m." (P-Orridge et al 1982: 50). This invisible insurrection was about taking over the means of perception. *Thee Grey Book* (P-Orridge et al 1982: 49) combined this analysis with experimental research into sexual energies:

> The manipulation and the use made of the sexual instinct through visual media has turned a large portion of people into unknowing fetishists – they are investing sexual energy in images and objects without knowing it, and are thus unable to reclaim and make use of that energy [...] This process breeds a host of scopophilia, people who obtain simulated sexual gratification through the process of watching. [...] Indulging in scopophilic activity (and people nowadays hardly seem to have any other choice) can, in the long run, result in an unconscious acceptance of the separation between mind and body, sexuality being denied its natural course. The fragmented world-view that keeps people from drawing the right conclusions and seeking active release from their circumstances is reinforced. Over the last fifty years, TV has been the greatest single factor in the control of the attitudes of people. Even if it was unintentional, which seems unlikely, the prevailing view of the world as seen by the writers, producers and controllers of TV companies has become the accepted 'norm' to which the viewer inevitably compares herself.

This quote also shows their awareness that spectacular capitalism rules through images and separation. In a short paragraph on chaos magick, Erik Davis mentions TOPY in his *Techgnosis: Myth, Magic and Mysticism in the Age of Information* (1998). He finds they are loosely echoing Jacques

Ellul, Adorno and other critics of modern civilisation in that they consider "mainstream society as nothing more than a totalitarian system of social control. Like de Certeau's poachers, they try to outwit and trick the society of the spectacle, breaking its ideological spell through atavistic magic, experimental media, and darkside sexuality" (Davis 1998: 222). He goes on to remark that "TOPY's most brazenly imaginative – if rather desperate – act of media poaching was the television magic described in Orridge's book *Esoterrorist*. Though deploring TV's use as a tool of mass indoctrination, Orridge also believed that, actively engaged, the tube could be a 'modern alchemical weapon,' an electromagnetic threshold into the primal goo of dreams" before he concludes that "[t]his kind of occult pop art is an extreme example of the techno-pagan will to reenchant contemporary psychic tools along the lines of archaic ones" (Davis 1998: 223).

This re-enchantment of psychic tools points to the occult imaginary that has surrounded TV since its beginning. Jeffrey Sconce argues in his book, *Haunted Media* (2000), that the transmission signal encountered with TV is linked to fantasies about an uncanny, alternate dimension, a limbo realm not unlike the vast expanses of outer space with which TV has frequently been identified (Sconce 2000: 142). Sconce, who looks at electronic, disembodied presence via telegraph, ether, radio, TV, etc., writes in a sentence that links directly to the ideas about 'bodies of light' circulating in TOPY (Sconce 2000: 92):

> Wherever streams of consciousness and electrons converge in the cultural imagination, there lies a potential conduit to an electronic elsewhere that, even as it evokes the specter of the void, also holds the promise of a higher form of consciousness and transcend the now materially demystified machine that is the human body.

Due to that the message of the Temple was primarily spread abroad by the Psychic TV records, it was most often music fans rather then already serious seekers of occult knowledge that created the network. In the early days this created credibility issues with more established magickal fraternities such as the OTO or the Illuminates of Thanateros (IOT). As such, TOPY was just as much a descendant of the infamous Hellfire Clubs of the 18th century (e.g. the 'Order of the Friars of St. Francis of Wycombe') which consisted of rich aristocrats challenging conventional morality through a cocktail of violence and hedonism as of the esoteric tradition (Lord 2010).

The more enthusiastic individuals that got in touch were told it was an open, self-generating and non-hierarchical network and were invited to

open up their own Access Points – subgroups administering sigils, questions and suggestions for the region or zone as well as distributing information, newsletters and various kinds of tapes, videos, etc. The Access Points were overseen by what became the TOPY Stations, main headquarters that administered a whole country or territory. At its peak, there were three stations: UK, USA and Europe (London Access Point 1991). Each TOPY house would have a 'Nursery' – a room dedicated to rituals and sigilisation (P-Orridge 2008: 414), what was just called a 'Temple' by OTO and the Process Church (Wyllie 2009; Wassermann 2012). 50 Beck Road became the London TOPY Station and later the TOPY STATION UK. Several initiates lived and worked there after 1988 when the inner circle around GPO – the equivalent of the Process Omega – relocated to Brighton which became home to the TOPY GLOBAL STATION. This was part of a search for a 'Big House' – a long term aim to create a TOPY tribal research centre – that went on until 1991 (P-Orridge 2009b: 232), not unlike Trocchi's dream of a 'vacant country house' to found the prototype of the spontaneous university in. Soon TOPY had five houses in Brighton and the purpose of this commune also rings familiar with sigma in mind: "We posited that by sharing all our skills, properties and assets voluntarily we could all live a lifestyle way beyond our personal resources" (P-Orridge 2008: 411).

At this time, it had become clear that in order to continue to evolve, TOPY had to become the template for a way of life by trying to combine a system of living with spiritual and mental exploration: "Transformation can only occur if the Individual is prepared to sacrifice all they have, including a previous personality, and place in a status quo. Smashing old loops and habitual patterns is essential" (P-Orridge 2008: 407). In order to maintain the network and the costs of post and printing, TOPY Benefits and TOPY Merchandise were initiated which made TOPY more visible in the street culture and drew in more people who in turn began more Access Points. At the end of the 1980s, "quite a few TOPY Individuals became Nomadic, travelling about the Access Point network exchanging labor and other skills for shelter" (P-Orridge 2008: 411). These years also saw the Brighton HQ visiting other communes like Zendik Farm, a commune/cult focusing on self-sufficiency outside Los Angeles as well as studying the Moonies, The Children of God, the Source, Jim Jones, Manson, etc. These studies led GPO to conclude that there is "no question that a totalitarian system can facilitate an unorthodox organization. There were times we coveted such monolithic techniques, but in the end TOPY persevered with as democratic system as possible" (P-Orridge 2009a: 183).

In traditional cults, it is a basic technique to change the names of initiates in order to remove ties with the past while, at the same time, solidifying the sense of belonging to a special community with knowledge specific

to itself. In receiving the new name, one is reborn into the cultish way of life.[88] TOPY initiates were also renamed, not in order to gain control over them but primarily to keep sigils secure and anonymous. Each individual would be given a name, Eden for males and Kali for females, the same for all in order to stress equality, as well as a number, generated at random in order to avoid claims to seniority (P-Orridge 2008: 416). At its peak in the late 1980s, TOPY, according to GPO, had around 10,000 individuals sigilising and/or connected worldwide with Access Points in England, Scotland, Holland, West Germany, U. S. A., Canada, Italy, Australia and Scandinavia (P-Orridge 2008: 417). As Eden 229 points out, though, the Temple had a massive turnover with many people being involved for short periods of time and then leaving again. At his estimate, it was never more than c. 200 people sigilising and being productive at the same time. Beyond them, there were maybe 10,000 people buying the records, reading the books and being interested in the ideas and beyond them a wider group of family and friends who had a vague idea (Eden 2010).

Even though it was never admitted to neither the public nor the individual members – due to a concern that it would create elitism and smell of hierarchies – the Brighton Station used a table of so-called 'ratios' to simplify the running of the network (P-Orridge 2008: 417). Ratio One was contact and purchase of *Thee Grey Book*. Ratio Two was the ones sending in sigils even if it was not the required 23. Ratio Three was involvement in an Access Point or completion of the 23 sigils. Ratio Four was administration of an Access Point, active participation in a TOPY Station or living in a TOPY house. And, finally, Ratio Five was full-time dedication – administration of a Station, working for Temple Press or Temple Records or being involved with TOPY GLOBAL STATION on a need-to-know basis. Spread out over this network, TOPY became a

> temple without walls that draws it initiates from an international conspiracy of unrest. Dealing with contemporary art, sociology, religion, communication, neurology, and that grey area between the finite fact of science and the dogma of theology – Philosophy. A combination of interests glued together under the Psychic Cross and run along the lines of an intellectual urban(e) terroristic organisation and mock 'occult' fraternity. The type which the occult establishment would rather do without (Dwyer 1989: 51).

Creativity played an interesting part. Not only was it a creative mythology where one could write one's own rituals, it was also a sort of anti-art, made by an interest in observing process rather than creating products. TOPY

invited everybody to engage in artistic production at least once a week through ritual practice. This de-mystified practice was centred around a particular approach to sigil magick as derived from and modernised by the London based painter and writer Austin Osman Spare (1886 – 1956) in the early years of the 20th century. Spare, in turn, drew on a tradition stemming back at least to Cornelius Agrippa in the 16th century (Louv 2006: 20). Crowley had been brought into the heady mix that was the Temple in its early incarnation by David Tibet who shortly had been a member of the Kenneth Grant-led Typhonian OTO in the late 1970s, while it was Hilmar Örn Hilmarsson and John Balance (Keenan 2003: 41) who infused Osman Spare and sigil magick into the mix.

Sigil magick consists in the creation of a magically charged symbol. A quick how-to could read as follows: write down the object of desire and erase all vowels, leaving only a string of consonants. Squash the string down, throw out or combine lines, play with the letters, and end up with an appropriate looking glyph. That is the sigil. In order to charge it, concentrate on its shape and evacuate all thoughts (Morrison 2003: 19). These "no-mind" states can be reached in a number of ways, fasting, spinning, fear, sex, intense exhaustion, but the preferred way in TOPY was through basic sex magick, i.e. masturbation. You masturbate and at the moment of orgasm, or just before, you project the image of your chosen sigil in your mind's eye. According to adepts one do not need to believe in it since it has nothing to do with faith. If it is done, it works.

The method is based on Crowleyan sex magick which again was derived from Tantra: "Most Initiates of the Temple believe that there is a power and effect released by orgasm, focused through Will, that enhances not only the process of Self fulfilment and contentment but also the achievement of creative goals. The strength of this process forces the hand of chance and brings close the objects of your desire" (P-Orridge et al 1982: 42). That the magickal method was a de-mystified, immanent technique for the psychick youth is clear from the ending (P-Orridge et al. 1982: 56-7):

> We must reject totally the concept and use of faith, that sham. We must emasculate religion. The 'universe of magick' is within the mind of mankind. The setting is but an illusion to the thinker. The Temple is committed to building a modern network where people are given back their pride in themselves, where destruction becomes a laughable absurdity to a brain aware of its infinite and immeasurable potential. The Temple is committed to triggering the next evolutionary cycle in order to save this flawed but lovable animal. […] Fear

breeds faith. Faith uses fear. Reject faith, reject fear, reject religions and reject dogma.

The central ritual that was required in order to join TOPY was 'Thee Sigil of Three Liquids.' This consisted of that on the 23rd day of each month at 2300 hours GMT for 23 consecutive months, each TOPY member would ponder something they truly needed, create an appropriate sigil – which took the form of paintings, sculptures, drawings, collages, assemblage, mixed media, etc. – and then write down in detail what they wanted to happen, thereafter anointing the paper with blood, spit, sexual fluids and a clipping of hair (P-Orridge et al. 1982: 46). After drying, it would be placed in an envelope and mailed to a TOPY STATION and eventually TOPY GLOBAL where it would be filed under each sigiliser's identity number within the Temple. According to Jason Louv (2006: 20), these archives remain undisturbed at an undisclosed location somewhere in the world to this day.

Basically, the ritual combines elements of Crowley's sex magick with Spare's development of an individual 'alphabet of desire' with elements of the sacrificial use of blood and saliva as well as other techniques to maximize the experience (Abrahamsson 2009: 12).[89] As a by-product it creates an artwork to act as a 'receiving' vessel or talisman for the desired. Art thus played a major role in this disciplining of the self, but it was an art that was not meant to be seen, somewhat circumventing the logic of the art market due to its talismanic nature. At the same time, it required a masturbatory intensity of concentration, maybe more pleasurable than the art itself, where the process was the product. Even though it was contemporary, it constantly bordered on the future, at least in the very moment of creation, giving form to future desire.

The idea behind the sigil ritual was, on one level, to inspire self-discipline and regularity, to unite with other adepts in time, to initiate personal empirical research about ritual magick and, not forgetting, to honour the 23 enigma as inherited from Burroughs and Gysin. On another level, it was about using orgasm to "in a sense 'post' a desire into the deep conscious, bypassing social barriers and filter" (P-Orridge 2008: 412). This would result in that "the usual laws of probability broke down and one's effective focus was increased, making what you wished to happen more and more likely as you continued using sigils to reinforce your will" (P-Orridge 2008: 412).

Ritual (which in this context becomes indistinguishable from a type of private performance art) was a way then that the individual could 'force the

hand of chance' as well as a way in which "demolished man and woman can be healed" (Dwyer 1989: 59). Additionally, thee Sigil ov Three Liquids fits neatly into the trajectory of Mail Art and Fluxus with the act of sending bodily fluids through the post. The whole playing with bureaucracy and institutions – pretending to be a fully fledged professional organisation – can also be traced to Mail Art where it was common to use one's own rubber stamps and set one self up as 'The International Foundation of [fill out blank].' The people involved in the network could easily be one person doing art, but they would not be artists, they would be an establishment or an organisation.

Home (1995: 135) notes regarding the influence of Fluxus on later art movements that "although P-Orridge no longer has anything to do with the TOPY, there is a direct line of transmission through his Mail Art activities to the Temple, making this organisation far closer to what Maciunas envisioned as the outcome of Retro-Futurist activities than the aesthetic garbage being perpetrated by those artists who are now claiming affiliations with Fluxus for careerist purposes." Simon Dwyer (1989: 17), who was involved at an early stage in writing some of the texts in *Thee Grey Book*, also makes the connection to Mail Art in his *Rapid Eye* interview with GPO:

> By the mid '70s he [GPO] was involved in Mailart, (a peripheral member of the Fluxus movement that included La Monte Young and Joseph Beuys, and a correspondent with the likes of Anna Banana and Monte Cazazza in San Francisco), and, again, his contacts made during this time, such as Al Ackerman, and the influence of the philosophies of people such as Fluxus' founder George Maciunas, show some bearing on the later work of the Temple, who, viewed in this light, close-up, appear not so much as a Satanic Church, as a Mail Art movement focused on religious imagery and various forms of ritual.

When interviewed, Eden 229 told a story that sums up how many got involved (even though it was always for different reasons since it was a question of individuals): he got into Psychic TV and became fascinated by the sleeve notes due to that they emphasised an open-ended, spiritual approach to life unlike "the other game in town," the anarcho-punk scene around the band Crass whose members lived communally at the Dial House in Epping Forest, Essex (Eden 2010). If TOPY was related to the Stirner end of Anarchism, Crass was arguably related to the class struggle end of Anarchism. Later on, Eden 229 went through a phase mailing back and forth with various people doing 'zines and reading all the interviews,

etc., until he in the summer of 1988 mailed in his first sigil. This resulted in a little welcome pack with suggestions to further reading including Burroughs, Gysin, Spare and Crowley as well as some general counter-cultural texts.

After the move of the P-Orridges to Brighton, he participated in mailing out newsletters and answering the correspondence that arrived at Beck Road. Besides meeting up weekly to socialise and do rituals, the members of the London Access Point produced 'zines, books, videos and tapes centred around their interests and research which they distributed in the TOPY network. They also reached out towards the local community and arranged events, concerts, performance art evenings, workshops, social outings to stone-circles, etc. Many of these practices would later be carried onwards into the 1990s by kindred spirits like AAA or LPA.

Many of the TOPY Access Points were involved in releasing material for distribution and Eden 162 tells a similar story (Abrahamsson 2009: 11) about his involvement in the Scandinavian section of TOPY, TOPY SCAN. He emphasises that the field of research within TOPY never was occultism per se or culture per se. It was since day one always about 'occulture' – a term coined in TOPY to signify the interchangeability where the clearcut borders were gently erased (Abrahamsson 2009: 11). Due to the focus on the unhampered sharing of information, hidden or otherwise, he sees the global TOPY Network as a sort of precursor to the internet, just like Eden 229 who also sees TOPY as "kind of the internet before it happened" (Eden 2010).

As such, magick was never the primary goal of TOPY; it was just one tool to be used in the "formulation and execution of a radically new approach to life outside the confines of the mundane" (Abrahamsson 2009: 11). In his interview with GPO, Dwyer (1989: 54) saw the Temple's only political step in that it admitted and initiated anyone who had the genuine desire to become associated and then promoted informed self-discovery to them: "By passing information on like a viral infection, one-to-one, it hopes to nudge society gradually into perceiving reality in a different, and more 'realistic' way."

The members of the London Station explained when interviewed in 1991 that they were attempting to bring about a "radical improvement in the quality of everyday life." Most people pursuing this aim – from political parties and performance artists to writers and occult orders – limited themselves to certain areas of activity, they argued. By contrast, the Temple was designed to be active in any area, "to free our minds by any means necessary. We are ready to use, abuse or ignore any concept from culture"

(London Access Point 1991). What was important was to try to put words into action and, ultimately, negate control and fear.

From Crowley, TOPY took the experimental approach and the idea of keeping a log, a magickal diary stating that when this is done, this and that happens. From Spare, they took the idea that our ideas shape the world we observe.[90] In their way of adopting Spare and Crowley into a de-mystified sigil-based practice where there are no pointy hats or Latin words, no formalised rituals, the magick thinking of TOPY is very similar to the chaos magick scenes of the 1980s (Dukes 1975; Carroll 1987) even though TOPY called their approach for "intuitive magick" (P-Orridge 1978: 413). Before this the prevalent occult tradition was from W. E. Butler (1959) where occult practice was seen as a way of working on one's inner archetypes, i.e. a form of advanced psychotherapy on the self as in the Process Church or Scientology.

Like TOPY, chaos magick rejects the historical symbolic systems of the occult as arbitrary constructs devoid of any intrinsic 'spiritual' power. Instead, having learned the lesson from Crowley (who saw Nietzsche as one of the 'saints' of Thelema), the true source of magic is the mage's own will in the "existential emptiness of a relativistic cosmos" (Davis 1998: 221). As GPO (2006: 297) stresses in an essay on how cut-ups and the notion of 'waking suggestion' can tear the fabric of reality:

> We are not talking about a matter of faith here; faith is something that has a low quotient in these experiments. Rather, we are looking at prophetic predictions based upon a magical vision of the universe and the resulting, practical application of alchemical theories and exercises. In fact we are looking at an early, workable model of the future, in which a positive, compassionate unfolding of our latent qualities as a species is defined and described in the vainglorious hope that we 'abandon all rational thought' and immerse ourselves in an ecstatic series of creative possibilities.

Thus, the history of the Temple can be seen in the trajectory of new religious movements trying to create their own ecstatic communities, e.g. Bataille's Acéphale cult, and attempting to devise a new religion without gods, faith and transcendence. Instead, it is a creative patchwork mythology tailored to the individual, meaning that it is unique for each person, but still embodying a conception of what 'we' were, are and shall be. In contrast to, for example, Eden 229 who sees TOPY in the trajectory of more straight punk and industrial culture and as a gateway into activism,

collectivism and social, not art or religious movements (Eden 2010), Jason Louv (2006: 25) emphasises the occult and individualist strain in TOPY when he writes:

> The Ordo Templi Orientis or OTO, a Masonic body founded in Germany in the late Nineteenth Century and later captained and reformulated by Aleister Crowley in the early Twentieth, can be considered the clearest precedent to TOPY, a secret society created as an access point into the world of magick. [...] – halfway points for those interested in the hidden undercurrents of reality, training wheels that, when eventually discarded, would lead the individual either towards more abstruse orders of robed spiritualists or, preferably, onto their own two feet and their own personal apotheosis.

As such, TOPY can be seen as an element of what the American political scientist Michael Barkun (2003: 11) has called 'improvisational millenarianism.' Per definition, this is an art of bricolage wherein disparate elements are drawn together in new combinations but – since it is bricolage – these can be treated both holistically and in terms of their constituent elements. TOPY can fruitfully be seen as one of these odd conceptual structures, a patchwork cult where a Fortean emphasis on stigmatised knowledge combines with constitutive elements from more than one esoteric tradition but especially Spare and Crowley as well as art, science, technology and radical politics.

Simon Dwyer sees the temple as neither a social movement nor an occult fraternity, but more like "an open-ended Information Exchange that expresses itself using a hybrid of the traditional, esoteric, and contemporary arts." The spiritual philosophy, according to Eden 229, was accepting that one could experiment with ritual magick but that it was all a product of human consciousness and connected to archetypes and other products of human creativity (Eden 2010):

> If you're interested in developing your communication skills you can do a ritual around Mercury who's involved with communication and you can look back and see what other rituals people have done to invoke Mercury and you can do that. And the idea is that you do that as part of a sigil. I can sit here now and say 'I desire to be a more effective communicator', but that's a rather weak statement. If you're sitting in your room, 11 o'clock at night and there's some heavy-duty ritual type music playing, you've got your Mercury incense

> burning, you're focusing your whole body physically and psychologically around this idea, then you're performing a kind of ritual based on things you got through other occultists that have done this and that adds a level of intensity to it. Some people would say that by doing that you're communicating with the gods up in the air. For me, it is just a way of embedding it more effectively in your subconscious, so that you can do it.

TOPY's magickal practice was essentially a post-modern hybrid of the Western esoteric tradition, centred around visualisation, just like, for example, Neuro-Linguistic Programming, and based on the idea that identity is an internalised, fictional construct which can be remade at will and told in a new way. Whereas the study of Crowley demands, among several other qualifications, a working knowledge of Egyptian mythology, TOPY had a more DIY approach, taking bits and pieces and assembling them to a new whole where the only measure was whether it worked for the individual or not. They are still open, though, for the same sort of essentialist critique as can be directed at not only Crowley but also essentialist anarchism: by operating with the notion of a 'true will,' they are operating under the premise that some things are more authentic than other things.

As such, TOPY was the inheritor of a century's worth of occult and countercultural 'science,' and then some, a crustpunk laboratory where radical and, in many cases, previously forgotten ideas were synthesized into a way of life (Louv 2006: 19). TOPY tried to break personal habits and preconceptions in order to generate an autonomous space for the practitioner to individualise their identity and create their own chosen narrative (P-Orridge 2008: 413). By being suspicious towards all forms of dogma, the Temple was interested in "non-aligned, undogmatic investigation into what exactly is going on. Minus the bullshit of organised religion, the rhetoric of party politics, or the promises of 'occultism' that only serve to pervert that understanding and thus strengthen the foundations of Control" (Dwyer 1989: 67). It tried to trigger people's own imagination by existing in the form of a question.

In contrast to the role of women in sigma and the AU as well as the misogyny of Burroughs and Gysin (in whose mythology neither words nor women can go into space, cf. the track 'Last Words of Hassan Sabbah' from *Nothing Here Now But the Recordings*) and maybe foreshadowing GPO's later interest in pandrogeny, queer theory and questions of gender, there is an explicit feminist perspective in the Temple's analysis of Control and its apologies for orgasm: "By studying the oppression of women through

the ages we can see in a nutshell the nature, methods and manifestations of oppression as it is used in any society and in any age against those who are pro-life and expanding. Yet on a broad scale, encompassing both sexes, the repression of sexual instincts functions to make people submissive and inclined to irrational behaviour, and thus paralyzes their potential" (P-Orridge et al 1982: 42). This might go to explain that people like the American novelist Kathy Acker was temporarily involved with the Temple in the early to mid 1980s when she lived in London.

> When official science has come to such a pass, like all the rest of social spectacle that for all its materially modernised and enhanced presentation is merely reviving the ancient techniques of fairground mountebanks – *illusionists, barkers and stool-pigeons* – it is not surprising to see a similar and widespread revival of the authority of seers and sects, of vacuum-packed Zen or Mormon theology.
>
> Guy Debord 1988: 41

6.2.

The Frequency of Truth

In the period from 1981 to 1991, TOPY went through three distinct phases. The first was the early militarised phase which was introduced as a fashion. The members "took on uniformity to test the individual and public response to it. To play a mischievous game with fashion in order to negate it" (Dwyer 1989: 29). This phase was 'nothing short of total war,' to use one of TG's slogans, and was a sort of tribal declaration of war on man's sleepwalking state, sitting passive in front of the TV.

The second phase was roughly initiated around the time PTV had its biggest commercial success with the single 'Godstar' and a cover version of the Beach Boys' 'Good Vibrations.' This was the multi-coloured, psychedelic phase with silk saris and purple slacks, a fashion GPO termed 'hyperdelic' – "psychedelia forged with modernism," as he explains it to Dwyer in the above-mentioned interview (Dwyer 1989: 29). In this period, the Temple spoke about 'Angry Love' – a unification of the hippie's peaceful idealism with the more militant ideas from the Situationists c. 1968 that resulted in "a love that is selective, an anger which is justified, and born out of sheer frustration" (Dwyer 1989: 29).

During the third phase from roughly 1988 – 1991, this continued into experiments with acid-house (a term coined by GPO), raves and MDMA which saw PTV becoming the "Merry Prankster-esque cheerleader squad for sex, drugs and magick" (Louv 2006: 21) while the production of the Temple increasingly became oriented towards producing transcendental bliss instead of waging war on Control and the powers that be. This

period saw PTV travelling the forefronts of the new rave-scenes in their tour bus named 'Even Furthur' in a nod to the Pranksters and becoming instrumental in starting the DIY-culture of the early 1990s. A last, sort of posthumous, phase can be traced in the period from 1991 – 1994 after GPO had left the network and its members increasingly became people without an interest in PTV and/or GPO who mobilised shortly under the Psychick Cross before drifting on.

TOPY's explicit focus on a modernisation of sex magick became both their selling point and their downfall. First, the 'Spanner' case happened which involved a group of men being accused of having a gay S/M porn ring involving piercings and tattoos. One of the men on trial was Mr. Sebastian, the voice on the message from the Temple. Initiates from the London Station showed up at court every day to shelter him from journalists and the public (Eden 2010). The case ended with that tattooing and piercing were ruled criminal acts of grievous bodily harm, punishable with a sentence up to seven years (P-Orridge 2008: 422). Mr. Sebastian was found guilty in Actual Bodily Harm and sentenced 15 months, suspended in two years (Keenan 2003: 228). The whole affair drew attention to TOPY due to their public support of Mr. Sebastian while, at the same time, *RE/Search #12: Modern Primitives* (1989) – which featured an interview with GPO and his first wife, Paula, who both had helped put the book together – was used by the prosecutor and, subsequently, seized at customs. Initially, GPO had been on the list of people to try and even though he was dropped from the list, it had become clear that the authorities kept an eye on him and TOPY.

On Saturday, 15 February 1992, 23(!) detectives from Scotland Yard's Obscene Publications Squad raided the Brighton home of Genesis and Paula P-Orridge, confiscating more than two tonnes of material – sculptures, musical instruments, letters, unseen film footage by Burroughs, Gysin and Derek Jarman as well as every single photographic negative in the house (Hill 2009: 528) – material which they apparently destroyed. Before this action, yet another media storm had been raised around GPO and TOPY due to an episode of the Channel 4 documentary series *Dispatches*, screened in early February 1992 (Hill 2009: 526).

This programme was a sensationalist investigation of ritual satanic child abuse, allegedly happening throughout Britain at the time and conducted by a network of evil child-molesters. *Dispatches* showed edited clips from a supposedly secret cult video showing what they claimed was forced abortion and torture, a video which turned out to be *First Transmissions* which, ironically, was partially funded by Channel 4 to begin with (Dwyer 1989: 81). It also showed interviews with a witness, 'Jennifer', later proven to suffer from False Memory Syndrome. In the programme, she told how she

had been taken to a house in East London with a dentist chair (as could be found at 50 Beck Road) where she had been ritually abused in the basement (no basement at 50 Beck Road) and later forced to kill her own child as a sacrifice to Satan.

The *Dispatches* team pointed GPO out to the police as "Satanic ring-leader" just before the program aired, threatening to tell on air that the police knew who it was but refused to act on it, resulting in the raid. It was later proven that the programme was backed by strong Christian interests. On 1 March 1992, *The Mail on Sunday* exposed it as part of a right-wing Christian conspiracy. They were able to both expose the witness as well as trace the television presenter, Andrew Boyd, to the fundamentalist Petersfield Fellowship Church (Hill 2009: 527). In addition, they featured an interview with Derek Jarman, expressing shock and outrage since he was in the video and knew it had been shot already in 1982. Nonetheless, various medias jumped the bandwagon and accused GPO and TOPY of being Satanists who abused children. At the time of the raid, GPO and his family were travelling in Asia. They chose self-imposed exile in the US instead of returning to Brighton.

Around 1992, GPO circulated a short message internally in TOPY, simply stating "Changed Priorities Ahead" (P-Orridge 2009b). This was accompanied by a letter stating that he had closed down the network already in 1990. Many members decided to continue TOPY, but the momentum left with P-Orridge. Over the next couple of years, TOPY UK slowly disappeared into the shadows. At this point, the network had started to open up and become something different, also recruiting members who did not listen to PTV or who painted graffiti and were into hip-hop, etc. (Eden 2010). At the same time, other bands had begun to use the Psychick Cross in a very visible way, e.g. Dutch techno band Thee Psychick Warriors Ov Gaia. In a way, GPO shut down the network just as it was becoming clear that TOPY was not a personality cult, but its own self-replicating entity. A cynical reading would be that TOPY, ultimately, was an extension of GPO's brand and that he wanted to keep it 'pure' even though it seems just as plausible that media witch hunts had turned TOPY into an albatross around his neck, that it had become too visible in the public's eye.

According to P-Orridge, he closed down the network 3 September 1991 in accordance with his original intent: it was a temporary catalyst and was always meant to only exist in a ten year circle in order to avoid recuperation and locked identities, cf. how the Association of Autonomous Astronauts also operated with a five year plan. Therefore, everything claiming to be TOPY today is "totally bogus and brutally deceptive" (P-Orridge 2009b: 539). It was an anti-cult and the goal was always to break habitual forms of

behaviour and avoid any kind of permanent institutionalisation: to keep performing the same rituals would have involved that TOPY and the Sigil Ov Three Liquids eventually would become like the Catholic Church and the Holy Communion. As GPO explained in a 1994 interview with Philip H. Farber (P-Orridge 1994):

> T. O. P. Y. was always meant to end, because we knew that there's a natural human need to flatten things and to give them shape and form that's familiar. To have routines and to have a comfortable sense of status. But that's not what it was about. So it had to be terminated, it had to be honorably discharged before it became that which it was actually meant to expose. We didn't want it to be a parody.

Since c. 1994, there has been silent around the TOPY network in the UK and Europe. In the US, the network continued until 2008 where it merged with other occult organisations to form a new network called AIN – Autonomous Individuals Network. In recent years, GPO himself has continued something he calls TOPI – a 'unified principle,' not an acronym, and not an 'open source' network – which covers the 'ongoing energy from the TOPY experiment.'[91] This also includes the pandrogeny experiments he commenced upon in the early 2000s with his late second wife, Lady Jaye Breyer P-Orridge. They applied the ideas of cut-up and the third mind directly on their bodies in order to overcome the biological gender-dualism and create a third being, Breyer P-Orridge. The years since TOPY have generally changed the direction of GPO's efforts in cultural engineering from a macro to a micro level due to a perceived change over the last 20 years. In the documentary film *Flicker* (2008), GPO argues that it is no longer about fighting control as it was for Gysin and Burroughs. Control has become all-pervasive with the internet. Instead, it is about fighting inertia.

To TOPY's initiates, magick was the realisation and redirection of one's will toward conscious ends. To reach these, people had to disconnect from all sources of information that attempted to program them into unconscious submission and replace them with information to access one's own magical and technological abilities. The goal was to develop a magical technology of liberation while also using occult means to reach psychological ends. The method was based on cut-up techniques: disruptive and recombinant tactics that could be deployed in music, visual media and collage art in order to rupture social programming and consensus trance. It can be argued that the Temple basically was a network of people having orgasm at the same time. It can equally be argued that they were a techno-pagan cult seeing orgasm as an easy way to reprogram their own subconscious,

using the energies of chaos magick as a wake-up call. A common critique of TOPY was that they became the autocratic cult they set out to parody (Keenan 2003: 48). GPO claimed that did not happen until after 1991 and that the experiment had to end exactly in order to avoid recuperation.

With its decentralised network, the structure of TOPY is, like sigma, reminiscent of 19th century anarchism even though it is more indebted to Stirner than to Tolstoy or Bakunin, due to a focus on individualism and imagination instead of, respectively, love or revolutionary force. They aimed at establishing pagan communities of free spirits where the exchange of (dis)information between the various individuals in the network played the binding role in the social structure that dogmatic hierarchies often play in more orthodox religions. The binding myth between them was about access to a sort of hidden information – a secret doctrine – that Control supposedly wanted to suppress and destroy because it would entail mass awakening to a new culture. The access points were safe houses for the underground resistance in these information wars.

> Today these stories seem very far distant, standing by themselves and not a part of the present, laboriously asserting their claim to a dim kind of life only in the memory, and the artist struggles in vain for a lively idea of them, for though he may not like to admit it to himself, his inner voice has been dulled by the things of this world.
>
> E. T. A. Hoffmann 1820-22: 259

6.3.

The Wastelands of the Real vs the Kingdoms of the Occult

Like sigma, TOPY was a network of individuals, pooling their resources and creativity while obtaining informational access to a subterranean world of strangeness: art, magick, revolution, sexual deviance, etc. Like sigma, it also struggled organisationally with how to cope with and extend from its centre, the man in the middle. The Temple was trying to navigate the atomized world that electronic media has helped to create, but their solution entailed a shift from politics to religion. The initiates were proud to label themselves fanatics (Vale 1979; Vale 1983). Closely related to the visionary, the figure of the fanatic is always looming over radical attempts to change society and behaviour.

In his study of fanaticism, Alberto Toscano points out that it often takes the form of a politics of abstraction, of universality, partisanship and egalitarianism. He notes that the anti-revolutionary critique, stemming back to the French revolution with, for example, Edmund Burke and Hippolyte Taine, depicts the very essence of fanaticism as the social implementation of a philosophy (Toscano 2010: xiv). For many commentators, such as Norman Cohn and Dominique Colas, it has been seen exactly as the transgression of the proper boundary between religion and politics, as a slippage from the religious to the political field (Toscano 2010: 158). As such, it can be seen as the political mobilisation of the refusal to compromise, pointing towards subjectivities that oscillate between the anti-political and the ultra-political due to their total opposition to existing society and their rejection of the present world. The present itself has become a time of rupture, a mystical "now-time" as Walter Benjamin (1940: 253) calls it in his theses on history, where time stands still and is

shot through with chips of Messianic time, a moment laden with unexpected historical possibilities.

Interestingly, Toscano (2010: 30) also sees fanaticism as a kind of neophilia since "radical novelty, as opposed to mere modification, always involves some kind of rupture with representation and mediation, some leap beyond a finite condition in which all happenings are mere combination, variation or repetition." Regarding how this rupture is arriving, Toscano (Toscano 2010: 48) characterises millenarian movements with words that might as well apply to sigma or TOPY: "Suffused with an apocalyptic ideology either drawn from a pre-existing canon or syncretically fashioned, they are also, because of their hostility to the political world as it stands, affected by a 'fundamental vagueness about the actual way in which the new society will be brought about.'" As we have seen with sigma and TOPY, they passionately long for an indeterminate future which, just like the Futurists who killed Time yesterday, often seems as a wish to break out of time altogether – unstable amalgams of nostalgias for a mythical past, encounters with a violently novel present or aspirations for a redeemed future. Theirs becomes the most extreme of utopias – and a very modern one – where time is theologically negated and concentrated into a molten instant pointing towards the political importance of time as revolution, pitted against every feature of the reigning order. It is not defined by theological form, though, but by affective content and transformative collective energies.

A mass in the Temple, in the form of PTV gigs in the late 1980s, consisted of naked bodies writhing in orgiastic sex, skinheads crowding the staircases, a mad wild-eyed shaman shouting incoherent words into a microphone on stage while showing the usual marks of possession, everywhere young people out of their heads on MDMA, LSD and other acronyms, constantly being bombarded with a barrage of visual and auditory signs, psychick crosses and strobe lights, rebelling against control, storming the citadels of enlightenment. Ecstasy is always about stepping out of one-self, transgressing the individual and leaving the human body behind. Testing the always-contemporary problem of the limits of experience and sensation, TOPY searched for an altered state of mind, be it biochemically or ritually induced, by actively researching extremes. As GPO told Kinney (1994: 344) when interviewed: "There's a difference between tribalism and the mob mind. Our tribe was based on individual strength, while the mob is based on individual weakness and communal strength."

In the perspective of invisible insurrections, its initiates often claimed that TOPY was a ghost (Louv 2006: 18). Like sigma, it can be seen as part of a hidden current through the cultural production of the 20th century that

wants to destroy all rational thought with the feverish ecstasy of an intoxicating cult. It was a ghost because they walked invisible among us, but also because it was a hauntological remainder of something long past: ecstatic mysticism and shamanism. Even though TOPY claimed that their spirituality was atheistic and their technique was de-mystified, there was still a remainder of the quest for *gnosis* – direct personal experience of and unification with the godhead – in the Temple's transgressive focus on alchemy and magick. Simultaneously, the Temple was also a reminder about how capitalism and its disciplinary routines continue to be haunted by what it has promised and repeatedly failed to deliver: a life free from the bridle of scarcity and the monotony of mundane labour, while rich in human solidarity and sensual, aesthetic expressivity. TOPY was a complex knot of desires involving increased autonomy and a demand for the promise of capitalism to be fulfilled immediately.

The practice of sharing a name like Eden and Kali in TOPY aligns the Temple with other fringe phenomena in the late 1980s and early 1990s such as Neoism, the 'zine *SMILE* and the use of multiple names like Karen Eliot, Monty Cantsin and Luther Blissett. Multiple names as a strategy have been used from Ned Ludd and back to Spartacus as envisioned by Stanley Kubrick. They work as a shield against the established power's attempt to identify and individualise the enemy, to get to know it. To counter this, they establish a sort of open myth of elastic and redefinable factors to be used by a network. It is a game with identity where humour and images are used as the way to invade a million minds. As such, it rejects the organisational practice of the New Left. As we have seen with especially sigma and the AU's attempts at creating an alternative society, the cultural politics of the New Left showed a desire to establish its own separate governance and identity.

In contrast, TOPY and related projects point the way towards the 1990s and the new millennium by presenting themselves not as a set of beliefs or a set politics, but as a non-identity whose fleeting manoeuvres invert normal expectations, including those of traditional socialism or communism. As the artist and activist Gregory Sholette has shown in his *Dark Matter* (2011), this is in concordance with various tactical practices in the present, which he sees (Sholette 2011: 12) as developing "the closest thing to a sustainable twenty-first century dissident culture."

It can be argued, that the Temple was a proto-Tactical Media (TM) collective. They claimed they were cultural engineers but they were just as much culture jammers, mimicking the language of control to turn it back on itself and, hopefully, devour itself, or, if nothing else, at least become too confused to be effective. Seen in this perspective, they were not invisible

as a ghost; they were invisible as a virus. TM – a term coined by Geert Lovink and David Garcia even though artists have been experimenting at least since the 1960s with producing a type of hit-and-run guerrilla media – can be conceptualised as 'Michel de Certeau plus electricity' and has also been known in primarily a German speaking context as 'communication guerrilla' (Blissett et al. 2001).

According to Lovink and Garcia's manifesto *The ABCs of Tactical Media*, TM is "what happens when the cheap 'do-it-yourself' media, made possible by the revolution in consumer electronics and expanded forms of distribution (from public access cable to the internet), are exploited by groups and individuals who feel aggrieved by or excluded from the wider culture" (Lovink et al 1997: 1). As such, it is combining the practice from the artistic avant-garde and art-activist groups like ACT UP and Gran Fury from the 1980s with the post-situationist analysis from Certeau's *The Practice of Everyday Life* (1984). Certeau wanted his everyday dissidents to become cultural poachers and TM celebrates this sniping at the symbolic order as a liberatory escape from capital (Thompson et al. 2004). Typically, TM borrows new media technology made accessible by global capitalism and turns it against the state and corporate authority.

For Sholette, the term includes media pranks, culture jamming, digital swarming, hacking corporate websites and other hit-and-run electronic guerrilla tactics aimed at a Debordian society of the spectacle. He writes (2011:12): "No less than opportunistic capitalists, TM and other interventionist activists have learned to tinker with this wreckage, taking it apart, reassembling it again, parodying or clowning about with its elements, mimicking its functions." Lovink and Garcia (1997: 3) supplements this in their manifesto by concluding that besides always questioning the premises of the channels TM works with, what counts is "the temporary connections you are able to make. Here and now. Not some vaporware promised for the future. But what we can do on the spot with the media we have access to."

The French post-Marxist philosopher Jacques Rancière (2000: 63) finds that 'suitable' political art produces a double effect: the readability of a political signification as well as a perceptual shock caused by the uncanny, by that which resists signification. Due to its focus on magick and occulture, it can be argued that TOPY's production, especially in the later phases, fell into the trap of pure hedonism we encountered with the Free Schools of the late 1960s, where the readability of political signification disappeared in drug-fuelled parties – these can be interpreted as a such of exodus, but are, ultimately, just confirming the status quo – whereas their most successful actions pointed toward an alternative where people are mentally liberated

to create themselves; who they want to be and what life they desire to live. As such, TOPY can be seen as an attempt at founding a new, atheistic religion that preached life-as-art and that aimed at liberating us through a kind of living diegesis where the social world takes shape from the stories we tell. Their tactics would be magick due to that they perceived a vibrant relationship between the inner and the outer but it would be magick with a marked absence of cloaks, incense, pentagrams and general Dennis Wheatley-style paraphernalia.

> Let my servants be few & secret: they shall rule the many and the known.
>
> Alistair Crowley 1997: 305

6.4.

When nothing is true, everything is permitted

The subchapter title above is, according to Burroughs and Gysin, the last words of Hassan-i Sabbah, legendary late 11th century leader of the Ishmaelian sect of the *hashashins*. The words led TOPY on a path to freedom aimed at complete self-fulfilment and enjoyment. This, in turn, led them to embrace an individualist strain in the philosophies of freedom that runs from Sade to Stirner to Nietzsche to Crowley's famous maxim "Do what thou wilt shall be the whole of the Law."[92] To these thinkers, traditional religion and conventional morality are incompatible with the idea of freedom. Thus, they try to forge their own ethical codes, often arguing, like Sade, that they are following nature which becomes the prime mover of the universe in place of God if they are not going all the way, claiming, like Nietzsche, that nature itself is totally arbitrary and contingent: only chance rules. Albeit a chance manipulatable by will.

Like sigma, Academy 23 envisioned a possible future not too dissimilar to the decentralised model known from classic Anarchism. The goal of their third mind thinking was to forge the way beyond the already defined and controlled into a much freer, uncharted area of the mind, causing a new kind of perception yet to be discovered. Additionally, it was about establishing communes and pooling resources. Interestingly, a lot of the same ideas resurfaced among right-wing militias and one of the most striking examples of a group which literally became the Wild Boys – with the difference that in reality it was adolescent girls – might be the infamous Manson Family. The approach blurs the boundaries between the radical Left and the radical Right by its focus on extreme individualism simultaneously with its focus on a new collectivism, but it also makes the Left easily recuperable by the Right.

This latter tendency becomes more pronounced with communities like TOPY and the similarly minded NSK (Neue Slovenische Kunst) where a

door opened to the use of fascist imagery in a more or less 'authentic' way (see New Collectivism 1991).[93] To begin with, NSK's ideas were primarily distributed through the industrial network even though it in later years has become the art scenes. As well as playing with cultish elements and fascist imagery, NSK launched their own avant-garde called 'retro-grade' and were heavily involved in a kind of communication guerrilla relaying on over-identification with the institutional language of fascism, resulting in a sort of Brechtian *verfremdung*.[94] Retrogradism thus attempted to "free the present and change the future via the reworking of past utopianisms and historical wounds" (Monroe 2005: 120). Like TOPY, they shared a belief in that the battlefield in the 1980s had become communicatory, that it was now an information war. They also shared a belief in that setting up one's own institution – in their case a passport issuing state – was a way to counter-act society's institutional powers and control, and the relationship between NSK and Laibach mirrors the relationship between TOPY and PTV (the latter is the former's propaganda wing).

As mentioned above, the individualism in TOPY's case is reminiscent of the German philosopher Max Stirner's egoism. Stirner's goal was also to destroy language, the word, the subject in order to find new and often ephemeral subjectivities. In *The Ego and His Own – The Case of the Individual Against Authority* (1845), Stirner argues for an anarchist society consisting of 'unions of egoists' who would form contractual relationships and compete peacefully with each other. In his defence of personal autonomy and his analysis of control, Stirner anticipated Burroughs and Gysin: "Language or 'the word' tyrannizes hardest over us, because it brings up against us a whole army of *fixed ideas*" (Stirner 1845: 346). This leads him to conclude that truth, as something embedded in language, is purely a human construct. He writes: "The truth is dead, a letter, a word, a material that I can use up. All truth by itself is dead, a corpse; it is alive only in the same way as my lungs are alive – to wit, in the measure of my own vitality" (Stirner 1845: 354). There is also a mystical core in Sterner's vitalism: realising the Ego becomes a sort of self-deification, making the Ego into a new God, as Marx and Engels pointed out in their attack on 'Saint Max' in *The German Ideology*. This sort of self-deification was also TOPY's ultimate goal as it is in much mysticism and what has become known in occult circles as the left-hand path.[95]

The most common criticism of this sort of individualism from a Left perspective is that revolution becomes a question of lifestyle instead of class struggle (Bookchin 1995). Individualism easily creates hierarchies, thus excluding all individuals who are not living their life animated by strong passions; the one's who are fully awakened become an elect few, the *übermenschen* of human evolution. It stresses how the techniques of cultural

engineering goes beyond Left and Right since the ideas are equally important for Right as for Left libertarians: both want a Nietzschean transformation of humanity where the individual 'becomes who he are' and makes a work of art out of himself. For Nietzsche, the emancipated human being is an egoist concerned with developing himself who helps the unfortunate because he is overflowing with generosity and strength, but whose ultimate ideal is to realise in himself the 'eternal joy of becoming' (Marshall 1992: 159). TOPY's quest for ecstatic experience was thus also a search for the psychedelic superman, arguably also one of the production goals for my other three case studies.

Since individual rebellion often plays into the hands of vested interests, it easily becomes a fixed identity. As has been shown by various authors over the last ten years plus, in a way individuality has become the new conformity and, thus, fuel for consumer culture (Frank 1998; Heath et al. 2005; Niedzviecki 2006). This means that the post-punk strategy today has been recuperated by the new spirit of capitalism, a point I will return to in my discussion below. TOPY's vision of the future was living in an environment in which communication and socialising has taken the place of material culture, like great whales in the ocean. Increasingly though, communication and socialising have become material culture in the sense that those are the commodities we consume. From the 1970s onwards free market capitalism has put more and more value in ideas, brands and ephemeral consumerism as well.

Due to the contractual agreement in the networks of individuals that constituted TOPY and sigma, it might be more fitting to see the individuals in these initiatives as always already 'singular plural,' to use a term from Jean-Luc Nancy's writings. There, the experience of freedom is indissociable from a political passion but the aim is collective individualism; it is more anarchism than fascism. Nancy shows in *The Inoperative Community* (1986) that the experience of freedom, and thus the experience of community, is the experience of the real. Christopher Fynsk (1991: xiii) argues in his foreword to Nancy's book that while deconstructing the notions of the individual, Nancy points to the singularity of the self that knows itself as opening to alterity in a process where freedom becomes another name for ecstasy. It is the opening, in thought, to the possibility of a world, an idea that can also be found in the writings of Bataille.

As we saw in Chapter Four, the sacred and the religious equalled communication for Bataille, and communication also played a vital part in the proceedings of both Academy 23 and the Temple. But even though TOPY used artistic and magickal means, it was, ultimately, not in order to create a new artistic movement or a new religious movement, it was in order to

create a social movement by producing new collectivities and new social relations. As a shadowy self-institution, it was threatening to institutions of any kind, since its very existence was proof that an 'alternative' approach, founded on a purely information-based system can work, devoid of hierarchies and limiting structures of belief (Dwyer 1989: 57). It did not give rise to any sustained politics or way of life, but it showed that self-institutions at some point need to close down and redistribute their accumulated power to their network or grassroots if they want to stay dangerous and not become recuperated as proper institutions. It is not only necessary to take power, it is just as necessary to disperse it, to empower one's network, to create feedback loops but also to play the system back to itself. The place from which resistance is possible is always only temporary. Mobility is needed in order to avoid recuperation.

In his study on the dislocation of power, Saul Newman (2007: 4) points out that essentialism – that we have been constituted as subjects and pinned down with an identity – along with the universal, totalising politics it entails, is the modern place of power. Therefore, the political task today is not to posit a certain identity in opposition to power, but rather to dismantle the binary structure of power and identity itself, to "disrupt the theoretical and political logic which reproduces this opposition and which limits thinking to these terms" (Newman 2007: 171). Newman sees the politics of what he calls post-anarchism as a question about avoiding fixed identities and remain open to an indefinite field of different articulations of resistance (Newman 2007: 153). This is structurally reminiscent of the position found in the various writings produced by TOPY. It becomes a minimum ethics of singularity, respecting and recognising autonomy and difference. As such, the position is sort of outside-on-the-inside, inspired by Lacan's idea of trauma and post-structuralist ideas about subjectivity and not unlike the autonomist stance of inside-but-against, formulated by, for example, Mario Tronti.

During the 2000s, simultaneously with a focus on the ideals of independence from the existing state or market structures, practitioners of the hybrid art forms and tactical medias indebted to sigma and the evolution of the underground from the Sixties to the Eighties have approached the social-democratic institutions of art pragmatically and found them a useful source of material support while, conversely, the institutions have found the cultural wing of the new social movements attractive. This points to that the conditions which Futurism wanted to disrupt and that forced sigma out of the established art world in order to engage with politics to some extent have been reversed in the contemporary. When art practices today result in temporary overlaps between aesthetic practice and revolutionary ideas in the currents of the counter-globalisation movement, the

movement against precarisation or the occupy movement, they may perhaps be briefly marketed in the art field, but, as Will Bradley also notes in his introduction to the reader *Art and Social Change* (2007), if national Arts Councils are sponsoring the revolution, it is very unlikely to be the revolution. The struggles through which the radical themes might be realised and the contradictions with the surrounding global capitalist system are rarely discussed. Instead, it might be the art of maintaining social balances through the management of cultural trends.

In terms of concrete, political suggestions on how to build a better world, none of my four case studies presented a blueprint. They sought a beginning but were self-critically aware of the failure of revolutions past, evolving into totalitarian systems, state capitalism or even the creative, bio-political capitalism that has come to dominate since the 1960s. Like the Situationists, they were more interested in an all-refusing theory, a rupture that would lead toward the all new. History has shown that often when we live in a time of transition as we do in the present and as we did in the 1960s, it is mostly a transition to a new type of capitalism, not a transition to 'socialism' or 'communism'. Since the system always seem to survive, it might be necessary with a total exodus from the system and its institutions even though there is no clearly defined goal or replacement. According to the tradition examined in these pages, it is necessary to leave the body and the planet behind, to be in (inner) space and explore the possibilities there.

In the cosmism of the Academy and the Temple, exodus is not only about leaving the planet, it is also about dying. As such, they are realising the thinking on life extension and human immortality done by the Russian Cosmists – who also were a direct influence on Bogdanov and Proletkult – by taking their speculations to their logical conclusion (Fedorov 1906; Rosenthal 1997; Young 2012). They wanted to create new commons to combat the capitalist enclosures but also, in a quite literal way, they wanted to prepare us for a future where death is the only certain common where all the heterogenous elements become homogeneous. Leaving the body behind can quite conceivably be thought of as a state only reachable beyond death. As such, Burroughs's writings and the Temple's teachings can be seen as preparations for dying and for how to enter and act in a *bardo*, the Tibetan Buddhist term for the period between death and rebirth as it is known from the *Bardo Thodol* – the famous funerary text commonly known as the *Tibetan Book of the Dead* in the West on which Timothy Leary, Ralph Metzner and Richard Alpert based their manual for the use of psychedelic drugs, *The Psychedelic Experience* (1964).

VII. INVISIBLE INSURRECTIONS AND RADICAL IMAGINARIES

> A confused disturbance, shouts, the noise of wood splintering and glass breaking came from one of the streets where looting was going on. A crowd had broken into the shops. They had no leader, no fixed objective. They were just a disorderly mob surging about in search of excitement and booty, frightened, hungry, hysterical, violent. They kept fighting among themselves, picking up anything that could be used as a weapon, snatching each other's spoils, taking possession of all they could lay hands on, even the most useless objects, then dropping them and running after some other plunder. What they could not take away they destroyed. They had a senseless mania for destruction, for tearing to shreds, smashing to smithereens, trampling underfoot.
>
> - Anna Kavan 1967: 104

7.1.

A Sinister Dream Factory

Sigma wanted to build up all-encompassing action universities, centres that would be sustained by a kind of DIY cultural production and would grow until their communards would be able to take over the world. The AU wanted to expand this cultural revolution while penetrating the inner secrets of madness, the family and the human condition in order to create and maintain critical networks, thus gradually creating an alternative society through a combination of radical education and 'snowball effect.'

Academy 23 took the social concerns about how to live together and weaved occult and spiritual meanings into them to create a new mythology and provide tools for entering the Space Age by stepping outside one's bodily confines and commence upon exodus to the stars as bodies of light. TOPY was an embodiment of these ideas even though its initiates became cultural engineers in their own right, working across disciplines with a type of proto-Tactical Media. They desired to intervene into the reproduction of work and individuals by popularising a notion of sex magick and the power of orgasm, thus seeing a patchwork revival of Western esotericism as a viable alternative to both materialist science and dogmatic Christianity.

All four experiments wanted to create fleeting situations which would create moments of awakening, turning passive spectators into active participants. Their invisible insurrection would be a transformation of human consciousness itself through a transformation of artistic creativity into ecstatic communion. At the core was a belief that a type of new, spontaneous university where knowledge could be produced and shared would be able to detonate this transformation and, thus, the invisible insurrection. These new universities would instigate a global, cultural revolution spreading through viral transmission which would result in total systemic change. The choice of a kind of university stresses that it is through experimental learning spaces that new subjectivities can be produced and new forms of life invented. Before we can enter a truly new future past conditioning needs to be unlearned. In order to contest alienation, this 'action university' would be an integral part of the whole environment, not just a place for specific training. The insurrection would be a communal affair which would improvise a new type of social relation into being by deconditioning us here and now without any blueprints for the future except to 'make it happen.' Thus, it was focused on first practice, then theory.

The sigma conspirators as well as many other 'movers and groovers' in the 1960s underground shared a sense of urgency, that it seemed necessary to culturally engineer on a planetary scale and shatter social domination through the implementation of counter-memes and new apparatuses. They felt it was the last chance to save humanity from a catastrophic future we had created ourselves. This apocalyptic vision, they juxtaposed with an idealist type of dream politics reaching back to German Romanticism. Often, this dream seemed to centre around the production of a new common knowledge on which a new mythology, a new image politics picturing us coming together could be built by the continuous recombination of what is already there into ever new cut-ups and collages that would be both critical and self-critical while being fuelled by a crisis of representation.

Jameson found in his short essay, 'Periodizing the 60s' (1984), that the political innovation of the 1960s was possible due to a crisis in existing institutions and class consciousness, resulting in the prodigious expansion of culture where it became coterminous with social life in general after its former autonomous realm started to crumble. This, ultimately, paved the way for a culture of the simulacrum in Baudrillardian terms. Capitalism got enlarged on a global scale through a dialectical combination of decolonisation and neocolonialism which freed certain social energies, yet this freedom, which was an objective reality for a short period in the 1960s, turned out to be a historical illusion, caused by the transition from one systemic age of capitalism to another (Jameson 1984: 208). This points to the idea that the transition of capitalism is intimately connected with

the expansion of the cultural realm where the utopian fervour and counter-culture of the age masked, and in a sense mirrored, the unleashing of new forms of repression and new economic forces. Questions of recuperation thus become unavoidable.

One of the things that sets the examined initiatives apart from earlier revolutionary movements, besides the non-violent means, is a sensibility towards a politics of information and knowledge power where knowledge sharing becomes a way of redistributing wealth and the objective becomes one of seeking information in order to pool it, ideas that since the 1990s also, ambiguously, has formed part of the neo-liberal discourse of the 'knowledge economy.' As Brian Holmes and Gregory Sholette also acknowledge, Certeau's everyday dissidents who we encountered above always appear on the verge of mutating into something else, described by neoliberal theorists as "the networked engine of twenty-first-century capitalism" (Sholette 2011: 150). This argument is in line with the autonomist Marxist idea that capital is a parasite and resistance is primary, resulting in that capital evolves exactly by co-opting the critique against it (Hardt et al. 2000). The tactical games on the inside thus operate in two directions simultaneously. They provide means by which ephemeral flashes of resistance can hide from the panoptic gaze of power by disappearing into some temporary autonomous zone, but the same act of mimicry inadvertently projects something that might in a moment of panic be mistaken as an exaggerated menace as it happened to TOPY with the satanic child abuse accusations in 1991.

According to Luc Boltanski and Eve Chiapello in their *The New Spirit of Capitalism* (1999), the distinctive feature of the 1960s was exactly that the 'artistic critique' of alienation from bohemians and artists and the 'social critique' of inequality from worker's movements melted together as we saw above with, for example, Roszak's definition of counter-culture as the unification of bohemianism and the New Left. After the sixties, it seems like the critique of social injustice has been drowned out by marketing language co-opting the critique of alienation thus neutralising the appeal of radicalism while re-organising capitalism into the flexible, network-intensive knowledge economy of today.

James Gilbert (2008: 38) argues, following Boltanski and Chiapello, that it was because capital, labour and the state failed to arrive at a new compromise which "could satisfy the radicalised 'social critique' of the increasingly militant worker's movement, that it became necessary for capital to re-organise itself in such a way as to accommodate much of the 'artistic critique' which had become so fundamental to the attitudes of large numbers of young professionals." The schism might be related to the idea that work

always has two elements, as the Invisible Committee (2007) has pointed out: traditional Marxism does not understand the participatory element in working while managerial rhetorics do not understand its exploitative dimension.

Even though I have argued that the position of my four case studies were beyond art and politics in the sense that they first and foremost provided access to tools that anyone could utilise, in general, the political thinking of this tendency tends to be localisable in a concatenation of Left communists, communisation theorists, autonomous Marxists, and anarcho-communists. In short, they each contributed to the sort of non-dogmatic Left that Lenin accused of being an 'infantile disorder.' Recuperation by the Right of these ideas has become more conspicuous post-1991 with the rise of, for example, neo-folk or the appearance of an organised 'social Right' in Italy who have used the notion of a third position beyond (such as the one found in the dialectic sublation) to legitimise their politics. When I throughout this book think inner and outer space together while being open to a third position, it is thus clearly more in the spirit of Jorn's trialectics than any variation of Hegelian dialectics.

My case studies can be conceived of as efforts to create new social spheres in which academic as well as other forms of knowledge intersect in creative ways, raising questions about the privileged status of the university and the role it plays in broader social processes of knowledge production. One of the striking things working with these histories on the brink of disappearing from living memory and, thus, having their experiences erased from the general intellect, has been how timely some of the ideas have seemed. The remainders of a type of anarcho-communism reared its head again with Los Indignados, Occupy, the Arab Spring, etc., where for a certain time there seemed to be a promise about a leaderless revolution even though it lacked the overtly hedonist tendencies from the underground and does not seem to have, for example, a music scene. While I have been researching and writing, a wave of protests around changes in higher education started to happen across the UK with a new wave of free schools and critical universities opening their doors in the context of social centres and other occupied places. Spaces such as those facilitate pedagogical encounters across differences, providing concrete examples from the practices of alternative media activists. It highlights that the significance of these movements lies in the emphasis activists place on collective knowledge production and mutual learning in their search for promising future escape routes.

In the ultra-Left imaginary of the 1960s and early 1970s, there was a deep connection between knowledge of oneself – especially of one's own

pleasure – and knowledge of the world, and satisfaction was regarded as the only way to reach autonomy. There was a vivid awareness that colonisation operates through the mind and the body, and that the only way to reach freedom was by working on one's subjectivity. The invisible insurrection would thus ignite a revolution which would be as much about coming through a journey of self-discovery and libertarian experiments as about a militant confrontation with the powers that be. With their shared focus on inner reality and outer reality, the sigmanauts in all their disguises tried – like Marcuse or the Surrealists before them – to apply the methods of both Freud and Marx to their present situation while, simultaneously, going beyond them towards the unknown.

The radical Left of the 1960s still has a strong appeal with its critique of particularly the institution of the family (which is related to the fundamental insight that revolution has to go beyond kin) and its internalisation of power relations. A critique of the ideas of hedonism and leaderlessness in the context of new social movements could be that the communist party is necessary because it does not know what will happen in the future, and because mass spontaneity will not bring revolution to the 'proletarians' (Dean 2012). Other related points can be raised from a more Leninist conception of social change – engaging the question of, for example, vanguardism – than the one achieved here where it has been my primary goal to examine the politics as they were revealed in the cultural production of the book's protagonists who tend to be poets and artists, not Marxist scholars.

After the fall of the Berlin Wall in 1989, many, who rejected vanguardist organisation in favour of immediate and specific action, found room in what Simon Critchley (2007) refers to as Neo-Anarchist movements by which he means what has also become known as the counter- or anti-globalisation movements after Seattle, 1999. These forms of direct action had to be more diffuse, to combine components of visibility and invisibility, and become interventions into everyday life. The result of this was that these movements, under influence from the counter-cultural ideology of the 1960s, re-invented political struggle as artistic intervention, but where these initiatives in the 1960s and 1970s were preoccupied with freedom and the liberation of eros (McKay 1996), they were now more focused on responsibility and sustainability. The idea about either a complete rupture or total innovation does, thus, not seem feasible today. On the other hand, cultural revolt and lifestyle anarchism are not enough to challenge capitalism if the aesthetic actions are not followed by social actions, echoing the split from 1968 between those who believed imagination was enough and those who believed that social and political struggle entailed a return to Marxist forms of analysis, conflict and action.

These sort of affects from our immediate past thus re-enter the present full of warnings and semi-occult notions of awakening from a somnambulistic state as well as dreams of a more fulfilling life. Their concern is with how to utilise culture in order to intervene on the level of social reproduction and produce alternatives. In the 1960s, this was perceived as being connected to an aesthetic practice of creating feedback loops of cut-ups which, it was believed, would make the system collapse under its own weight through a kind of over-identification. Eventually, it was hoped this would result in a new global supreme fiction, a type of poetry we all want to believe. For an example of this we need only look at how the rise of the internet occasionally gives rise to a myth of cyber-communism.

As a prolegomenon to a discussion of the immediate future seen from our contemporary, these examples raise questions about the relations between discourse and beliefs as well as the centrality of myth and images. Whose interests do these stories serve and who gains from them? Is the task at hand to produce knowledge and distribute it in temporary networks or is it more about 'refusal to work' and semiotic guerrilla warfare? Or is the question really one of leaving this world? One thing seems to be certain: it is no longer solely a question about gaining visibility and representation as it was for a lot of the art-activism of the late 1990s and early 2000s in the context of the anti-globalisation movement but also increasingly a question about organising and growing in the shadows, becoming invisible, becoming anonymous, staying hidden until strong enough to take over.[96]

The main objective for the initiatives I have examined has been the creation of new, experimental communities. The participants felt marginalised in mainstream society and wanted to create a new un-alienated community in which they could belong and, along the way, this idea became radicalised as part of the general rupture of the 1960s and the resurfacing of utopian socialism, concerned not only with education and schooling but also with, for example, food, housing and medical care. It thus became entangled with ideas about changing the world through cultural activism where another world would be made possible through a revolution fought on the level of ideas, words and images which would remain open to participation.

In any revolution, the first thing needed is destruction of the past in order to escape conditioning and make space for the new. Otherwise, nostalgia for the recent past and hopes for the present becomes the sentimental compensation for an uncertain future. In the analysis of the 1960s, what was holding the system together was Love as in parental love and the 'normal family,' which might hint at why there is no room for love in Burroughs's mythology. Basically, it is then about inventing a language which the

'parents' do not understand. The problem is that nostalgia makes it almost impossible to uproot bourgeois culture completely as can be seen from, with a more contemporary example, that most people blamed the Taliban for destroying the Buddhas of Bamiyan in 2001 and saw it as a reactionary gesture instead of a progressive one. In early 2013, plans to rebuild them were well on their way.

In order to leave this world behind, wo/man needs to change, to invent new tactics and new languages. Therefore, the sigmanauts and their descendants struggled to find a new language that would no longer prescribe what must be done but instead would be experimental and concerned with some of the same issues as the emergent mid-twentieth century discourses on cybernetics, communication media and systems theories. It would be a language which would be conscious that, as Laing (1967: 53) wrote, the "choice of syntax and vocabulary are political acts that define and circumscribe the manner in which 'facts' are to be experienced. Indeed, in a sense they go further and even create the facts that are studies."

The invisible insurrection was thus a sort of meme war in the social body where the stakes are the formation of wo/men's attitudes. The notion of invisibility leads from a quantifiable world into a shadow world of viruses, bacilli, genes, molecules, atoms, the stuff that constitutes reality but cannot be seen and where the borderline between propaganda, information and art begins to erode, as Jacques Ellul (1965) warned against.

Gregory Sholette also plays with the notion of invisibility in his exploration of the dark matter of the art world which in turn is influenced by Silvia Federici's (1974) writings for the *Wages for Housework*-campaign: just as capitalism is based on unpaid labour, most of the proper 'art' world – understood not as a field of vested interests but as a field of creative cultural production and rebellion, producing new ephemeral subjectivities as well as resistance to capitalism – is creative dark matter, i.e. it is invisible. According to Sholette, the term 'dark matter' describes the up to 96% of artistic production which is outside the institutional spotlight even though the tactical media field has begun to filter in and become visible in what has been referred to as 'Capitalism 2.0', where the art of subcultures to a certain point has become fetishised by people in the art world, not to mention the world of advertising. The spread of information technologies has done that invisibility today becomes more and more corporeal. This is a question of recuperation and another reminder that subjectivities need to be in constant flux if they want to escape being locked into recognisable meanings and, thus, become a part of control's structure. Increased visibility always poses certain risks.

By grasping the politics of their own invisibility and marginalisation these artists covered by dark matter inevitably challenge the formation of normative values. When this excluded mass is made visible it is always ultimately a matter of politics and a rethinking of history due to that working in the outer margins of the art world often is connected to reasons of social and political critique. The larger question for these 'collective phantoms,' to use Brian Holmes's concept, is one of re-organising society, not one of getting acknowledged and economically rewarded by existing institutions. Sholette (2011: 4) writes: "Here 'politics' must be understood as the imaginative exploration of ideas, the pleasure of communication, the exchange of education, and the construction of fantasy, all within a radically defined social-artist practice."

What can be said of creative dark matter in general – and therefore by extension the invisible, that which is its own disappearance – is that either by choice or by circumstance it displays a degree of autonomy from the critical and economic structures of the art world by moving in-between its meshes. It is an antagonistic force simultaneously inside and outside, "like a void within an archive that is itself a kind of void" (Sholette 2011: 4). In this dark matter, Sholette locates what he calls 'mockstitutions' – artistic collectives playing with self-institutionalising and corporate identities in a more or less fictive way. He writes (Sholette 2011: 13):

> As if superimposing two different states of being in the world – one deeply suspicious of institutional authority of any sort and therefore informally organized, and one mimicking, sometimes with impressive precision, the actual function of institutions, these mock-institutions appear to be filling a gap left by missing social reality. Perhaps the clearest example of this is visible in the wave of new pedagogical structures being assembled around the world by art students from the United States, Great Britain, and Europe to Asia, Africa and the Middle East. Using materials and means they salvage from the very edifice of a crumbling social system, students and artists are reinventing sustainable democratic forms. Nevertheless, the nature of this new mock-institutionalism is quite unlike the 'alternative art movements' of the 1960s and 1970s. Though it borrows from these past tendencies (after all this too is part of the rubble), the new social architecture is discontinuous and contradictory, sometimes borrowing aspects of traditional not-for-profit organizations, at other times looking more like temporary commercial structures, and still other times appearing as a semi-nomadic band or tribe stumbling

across a battered social landscape made all the more dire by
the economic collapse of 2007-8.

This points to another part of the timeliness of my subject: in a way, this book itself points to that its topic has become recuperable by the art institutions and the universities who seem to be able to embrace everything on the condition that it is made known, safe, harmless.

> In fact, nothing really new can be expected until the masses in action awaken to the conditions that are imposed on them in all domains of life, and to the practical means of changing them.
>
> Guy Debord 1955: 11

7.2.

Across the Great Divide

Due to the idea that it was conformity that made the Germans accept the Nazi rule, the underground was focused on the individual. This quest for distinction resulted in that the counter-culture and the conceptual and performative art practices of the 1960s in hindsight can be seen as helping to give birth to a new, post-Fordist capitalism which does not rely on production and property; it is more dependent on consumption, the buying and selling of commodities and creativity. The consumer replaces the citizen and the promise of commodity abundance becomes a substitute for social revolution. Paradoxically, it is thus rebellion, not conformity, which for decades has been the driving force of the market place and the market does a good job in responding to the demand for anti-consumerist products. The ideological system that sustains capitalism has not seemed to be too troubled by various acts of counter-cultural rebellion and 'freeing the imagination' has not seemed to galvanise the proletariat, much less cured injustice, eliminated poverty or stopped war. Due to that it tends to be temporary individual-anarchic eruptions more than the constitution of permanent alternatives, it often seems to be rebellion that provides entertainment for the rebels instead of social change. This was already pointed out by Jameson (1984: 196) who noted that postmodernism, though equally as offensive as high modernism, no longer is oppositional, indeed, "it constitutes the very dominant or hegemonic aesthetic of consumer society itself and significantly serves the latter's commodity production as a virtual laboratory of new forms and fashions."

The invisible insurrection tried to avoid commodities and wanted to stay in the shadows until it believed itself strong enough to take over. From the shadows, it would detonate a meme which would spread like a virus. As it is for viruses, invisibility was of major concern since not only was

the production often ephemeral but the biggest transformation would be inside ourselves. Slowly, we would mutate towards an unknown future, becoming concrete formations of the general intellect connecting with a social body, producing shared knowledge in new formations and giving shape to things to shape ourselves by forming an approach that thinks inner and outer together (while being open for that it always can be something else than expected in the spirit of Jorn's trialectics).

This points to that sigmatic tactics have gained renewed interest at a time when social, research-based and post-studio forms of artistic practice raise questions about education and identity as well as the status of institutional critique. Today, one of the most immediate lessons concern visibility and invisibility. We need to work with a new notion of invisibility where it becomes possible to organise and mobilise and make commons but where we, at the same time, avoid some of the more obvious trappings from the 1960s where the individual – and individual fame – came in the way and made the creation of new worlds into a vanity project. A world-creating project does not necessarily need to have a teleological goal as leaving the planet. Instead, it can begin in a micropolitical space with considering our everyday psychogeography and decide how it is we actually want to live and organise while providing frames for us to meet and greet and, thus, produce new social relations. The neo-liberal response to the 1960s became a dynamic of false inclusion and it is still up in the air whether a true program of inclusion – including the non-Western world, operating with a global sense of justice and basing social relations more on affinities than opportunities – is feasible at all.

The great divide in my case studies is related to how a political rage in the form of radical activism connects to a turning away from the world that borders pure escapism, or, to put it another way, how the anti-political and the ultra-political connects. A central concern for the imaginaries I have examined was the creation of a homebuilt apparatus that could be used to connect the general intellect to a social body, in this case a stream in the broader Free University movement of the 1960s. Through this they hoped to intervene into the social reproduction of labour by producing new subjectivities and new social relations. This was to be done by a general unleashing of creativity which in itself intended to boost its practitioners into higher states of consciousness while, at the same time, mobilising people through a kind of play, or better: a game, i.e. making placards and banners together, practice a routine, discuss or in other ways come together, thus making what Rancière would call a new distribution of the sensible. We need to reclaim our dreams for the future and utopian thinking, and the alternative might, as Berardi also points to in his writings, lie in understanding the current crisis as something more fundamental than an economic

crisis: it is a crisis of the social imagination and it demands a new language by which to address it.

This points towards a concern for aesthetics which, on the one hand, can be traced back to Romanticism and its search for a new artistic language, but, on the other, it also points forward to newer social movements where aesthetics often have played a central role in order to get one's message amplified through the medias who are always looking for an interesting image. It shows a concern for controlling the images by, for example, creating one's own media organisations which is another perspective on initiatives like sigma and TOPY and points forward towards creating one's own media outlets like, for example, the journal *Tidal*, coming out of Occupy Wall Street.

The focus on medias and taking part in an information war adds to the ambiguity of the projects since medias are not only something to produce but also something we are produced by. This is a fundamentally paranoid approach to society: there is already another shadow organisation, an 'invisible government' as Edward Bernays (1928) calls it, controlling our thoughts and actions by planting secret messages in our minds. It suggests that everything that we watch on a screen or listen to through the media is arranged to control and brainwash us. This points to a media theory focusing on how the technological apparatus produces the cultural, political and societal environment at any given time and is thus more aligned with the ideas of Friedrich Kittler, who was inspired by, among others, Jacques Lacan and Foucault, than the ideas of Marshall McLuhan who became a celebrity during the 1960s (the 'first apologist of the spectacle' as Debord refers to him) and who sees the media as an extension of wo/man.

The projects' fundamental ambiguity – their oscillation between political and hedonistic poles as well as between direct, revolutionary action and cultural guerrilla warfare – makes them still relevant today. Their in-betweenness, their ability to escape developing a fixed identity, their insistence on being about the process might be the only way to avoid recuperation and the commodification of dissent: to never be fixed but always in motion, always changing, always becoming through a process of being not only critical, but self-critical, continuously evaluating the terrain occupied in order to avoid that the invisible insurrection turns into what Berardi (2012) calls 'the silent apocalypse' where a poisoned environment has become the second nature in which we live.

By their nature, such experiments with new forms of life do not happen in universities or museums; they partake in the shift of social production from enclosed, disciplinary structures to the open space of the metropolitan

territory. It also points to how the various initiatives we have examined in the period from 1961 to 1991 used streets and public spaces as places to get their messages across from Trocchi and Nuttall who wanted to hang SP1 in the underground to GPO who was part of generating semi-anonymously campaigns in the streets with stickers and stencils in order to see what effects it could have in generating gossip. This points forward to later graffiti and street art scenes (Ganz 2004) due to an urge to communicate to as broad a public as possible, also the multitudes who never visit an art gallery, as well as a belief in that art on the street is instantly social effective, an argument that would resurface in the 1990s where political street art campaigns (Banksy, Shepherd Fairy, etc.) became the norm in metropolitan areas.

The notion that these ideas need to spread like memes and networked contagion becomes in the bio-metaphor the equivalent of that they spread like a virus as Burroughs thought. This is interesting from the point of view of the social factory: in a world where the factory has reached far beyond its walls, disease has become anti-capitalist in itself since it is today one of the few socially acceptable ways not to be productive.

Another perspective opened up by my inquiries that could be further explored is the strain from cybernetics that points towards some of the singular combinations of the 1990s where cybernetics and cyberculture met and gave rise to a new imaginary about the liberatory power of the internet and the computer. This points to the intersection of scientific terminologies and conceptual schemas that opened up during my analyses where, for example, scientific terms from cybernetics and quantum mechanics are becoming part of the framework for the interpretation of philosophical and social problems, thus eroding the divide between the two cultures identified by C. P. Snow in 1959. This again emphasises the idea of being inside-but-against: the giddy speedup of post-war culture is almost entirely a consequence of the computer, the information engine that has wrenched us out of the age of factory capitalism and hurled us into the post-industrial era of, first, transnational capitalism and since the finance capitalism of today.

Simultaneously, the computer is not only the tool that makes planetary transformation possible, it is also necessary as a way to democratise media production – the period I am concerned with can be defined by its increasing democraticisation of the access to new media technologies, i.e. in the 1960s it was the mimeograph and the photocopier, during the 1970s the rise of home video technology followed where as today it is the publishing capacities of the personal computer. At the same time, this access to media technologies emphasises capitalism's paradoxical promise, that we will be

set free by what enslaves us. The ultimate victory of the society of the spectacle is exactly how it uses our various screens to create spectators who end up being spectators to their own lives through the way online search machines and various filters are creating the society in which we orientate, already having taken all decisions for us by not including choices which can only be found through having a pro-active relationship to reality, i.e. by only showing us what is available at Spotify, what will appear on the first couple of pages of Google, etc.

One of the major activist efforts since the late 1990s has been to map these new modes of domination as well as trying to create a new poetics of resistance, what Brian Holmes has called 'a virtual class struggle' alongside the embodied one that never has disappeared. It becomes a question of battling the virus power on its own terms and on its own territory: by infecting the networks of communication with edited messages and confused identities. It entails a change from being outside capitalism to fighting the struggle within the economy of cultural production and intellectual property like a 'collective phantom' where creativity is not restricted to art practices but operates within the wider context of popular culture as a tool for class war. Additionally, it is a change that involves a consideration of the fundamental political question: where are the dissenting subjects of today? And how do new contestatory forms enable a leftist solidarity that can move cultural radicalism beyond the postmodern obsession with new subjectivities? In any case, I would argue, the answer must involve a serious consideration of cultural (re-)production as well as the role of the university where it is not just the university *per se* we need to reflect upon but also the social sculpture of the university and its constituent parts of paramilitary politicos, occult lodges, fraternities, orders, art collectives and the radical imaginaries shared by them all. Thus, it involves a consideration of the role of culture and education in the creation of new affective communities.

VIII. AFTERWORD

> – If You Won't Let Us Dream, We Won't Let You Sleep.
>
> Occupy slogan, 2012, #worldrevolution

8.1.

Conclusions

In conclusion I will revisit the concept of invisible insurrections one last time. We have seen that they primarily consisted of viral attacks on bourgeois capitalist culture carried out by expanded media experiments, happenings, cut-ups, détournements, noise, music, flicker, the creations of situations as well as a mind-expanding psychogeography. By radically altering the human sensorium, the cultural engineers involved in my case studies wanted to generate an entirely new reality, primarily on the level of perception but also on the level of architecture and urban planning.

In common for all my case studies was an idea that in order to make change happen, it was necessary to found a new university which would produce new knowledge and a new type of behaviour and disseminate both. They were part of an upsurge in the autonomous publishing of pamphlets, newsletters, 'zines, chapbooks, etc., a media explosion that formed the backbone of the underground press. It was a micro-publishing movement that spawned sellers on street corners, at poetry readings and so on, but their cultural production was not meant to enact small-scale resistance against the status quo in the social domain, it was meant to fundamentally transform human nature, inspired by ideas from cybernetics and behaviourism.

The goal was to take the next step in the evolution of humankind. This would mean to leave the planet and conquer space as bodies of light, a state which to the un-initiated observer might as well be death due to that the physical bodies would be left behind. That it, thus, was concerned with dying, one way or the other, implies that the concern ultimately was with survival since a conscious awareness of death might help us to better appreciate being alive. The means to reach this goal of expanded being and a fuller notion of life would be a non-chemical expansion of awareness made possible through, for example, cut-ups, flicker experience and

playback. These methods are often descended from the Western esoteric tradition, but it is a material and non-transcendent magick which rather is a type of multimedia magick, closer related to the tactical media scenes of the early 2000s than to any kind of Black Mass. It is patchwork magick where one takes what one can use and leaves the rest, creating singular assemblages.

These manoeuvres would give rise to a new, hybrid form of psycho-socialism, a magickal Marxism focused on overcoming separation, alienation and divisiveness in order to obtain unity in spiritual as well as political terms, thus producing a new 'we' which is not just the 99 percent, but the 100 percent, one whole sigmatic earth that would not be a perfect utopia of idleness but instead a launching pad for species space migration, along the way melting away not only the distinctions between Left and Right but also between right and wrong.

My argument has been that instead of seeing these histories solely in the context of art history or political science, they might be better understood as attempts at cultural engineering trying to intervene into the mainstream with tools for social change as well as for the self-transformation needed for revolution. Seen as a new social movement, these aspects of the UK Underground in the period from 1961-1991 can arguably be posited within the domains of anarcho-communism while, seen as a new religious movement, they are part of a belief system descended from especially Crowley and, by extension, the Western esoteric tradition as it was systematised by the Hermetic Order of the Golden Dawn even though it is an extremely heterogenous belief system which also incorporate Theosophy as well as myriad Eastern philosophies and perceived paganisms.

The way out was thus first and foremost a way in, leading towards self-transformation which in turn would result in the human race entering a new age. It is a reminder not to be scared to dream big and it points to that by recovering untold stories in the already established fields of cultural history from oblivion, the archive can be mobilised and activated into our contemporary to point the way towards critical ways of thinking and discussing possible futurities and, thus, perform the first tentative steps towards a critical futurology. What future is it we want to live in and how do we begin to reorganise institutions and reorient life?

ENDNOTES

I. INTRODUCTION

1. In Clancy Sigal's semi-fictitious auto-biographical novel *Zone of the Interior* (1976) which I will revisit in Chapter Three, the character of Dr. Willie Last, a thinly disguised R. D. Laing, is shown to be fond of saying 'the dreadful has already happened' at any given chance.

2. That these people overlapped in many ways around the central themes of altered consciousness and creativity can be seen from, as Robert Hewison (1988: 128) mentions, that one of the promised, but unwritten, books of the 1960s was "a collaboration between Trocchi, William Burroughs and R. D. Laing on a definitive anthology of 'Drugs and the Creative Process'".

3. This schism between a primitivist utopia and a technological one seems to be the dominant cross road facing wo/men in the radical imaginary of the late 20th century.

4. Possibly related to the success of Hardt and Negris's *Empire* (2000) which marked a major breakthrough for theories combining Italian autonomous Marxism and French post-structuralism.

5. In a way the general intellect can be seen as the ideological superstructure, the apparatus which produces us while it, simultaneously, is produced by us through the values with which we identify.

6. *Autonomia Operaia* was part of the Italian extra-parliamentary '77-movement and has been influential on later autonomist social movements alongside related organizations like *Potere Operaia* and *Lotta Continua*. It can be seen as a successor to *Operaismo*, or Workerism. Influential figures in the latter movement include Mario Tronti, Raniero Panzieri, Sergio Bologna as well as Antonio Negri who also was influential in the former alongside, for example, Franco 'Bifo' Berardi and Paolo Virno. The shift from Operaismo to Autonomia is often dated to 1973 when Potere Operaio ceased to exist. During the early 1980s, the Italian left was violently repressed by the state. Some of the ideas characteristic for this line of thought include the notion that resistance and worker's struggles are primary, that new forms of organizing can be deciphered from studying the changing composition of the working class as well as an emphasis on Marx's description of a 'general intellect' in *Grundrisse*. Today, this sort of thinking is visible not only in the writings of Bifo, Negri, etc. but also, for example, in the writings of the Midnight Notes Collective which include thinkers like George Caffentzis, Silvia Federici and Peter Linebaugh. See, for example, Lotringer and Marazzi 2007 as well as Wright 2002 on Autonomia, Lotringer 2007 and Katsiaficas 1997 on autonomism and Balestrini 1987 for a docu-fictional account of the movement of 1977.

7. As such, this line of inquiry relates to what in the 1970s was called Apparatus Theory which became a part of especially Film Studies post-1968 where it was an attempt, inspired by Jacques Lacan and Louis Althusser, to rethink cinema as

a site for the production and maintenance of the dominant state ideology, cf., for example, the writings of Jean-Lous Baudry, Jean-Louis Comolli, Laura Mulvey or Peter Wollen (Rosen 1986).

8. For Hardt and Negri (2000), 'Empire' described a new type of (post-modern) sovereignty. It is the paradigmatic form of bio-power which rules us through police measures in a global state of exception, a notion borrowed from Agamben. Empire is a fluid, hybrid system of monetary and communication networks that subverts any system of localized, state-centered control. The passage to Empire abolishes the dichotomy between inside and outside.

9. A predecessor to this kind of prank, signing with fake names, can be found among the Scandinavian Situationists, where Ambrosius Fjord signed several manifestos and edited a book on their activities. The name was used as a sort of multiple name by, among others, Jens Jørgen Thorsen. To begin with, it had been the name of Jørgen Nash's horse at Drakabygget, the farm on which he lived in Sweden.

10. Cf., to name but a few, The Public School (see http://thepublicschool.org/), Edu-Factory (The Edu-Factory Collective 2009), University for Strategic Optimism (University for Strategic Optimism 2011) or, more unambiguously placed in the art world, Free Home University (see http://www.freehomeuniversity.org/en).

11. LSX is an abbreviation of London Stock Exchange.

12. Jacotôt's 'intellectual emancipation' was based on three principles: all men have equal intelligence, every man has received from God the faculty of being able to instruct himself as well as the enigmatic 'everything is in everything' (Rancière 1987).

13. The last decade has seen a renewed interest in anarchism within academia, though, often in the guise of 'post-anarchism' (Newman 2007; D. Rousselle et al. 2011; Critchley 2012). A primer for this field that reads classical anarchism against French post-structuralism is May 1994.

14. Bürger (1974) defines the historical avant-garde as consisting of Futurism, Dada, Surrealism and Russian Constructivism.

15. For an exposition on how the term avant-garde itself came into being around French Utopian Socialist Henri de Saint-Simon, see Egbert 1967.

16. This expression refers to how especially Nirvana succeeded in taking the music of the so-called 'American Underground' to the mainstream with their *Nevermind* album, thus creating a divide between 'alternative' and 'indie' with the former being seing as 'commercial' and the latter as 'authentic'. See, for example, Dave Markey's 1993 documentary film *1991 – the Year Punk Broke*, which put the term in common usage. On the American Underground music

scene of the 1980s, see, for example, Azerrad 2001.

17. For an example on Trocchi's use of the term cultural engineer – and contrary to P-Orridge's claim that he coined the term – see the version of Trocchi and Phil Green's revised Situationist manifesto reprinted as 'Project Sigma: Cultural Engineering' in Campbell et al 1997: 189.

II. THE SIGMA PROJECT

18. For biographical detail on Trocchi, see, for example, Campbell 1997 or Scott 1991. The latter is deliberately misinterpreting London-based events as if they were set in Glasgow in order to claim the story for Scotland. The same critique can be raised at Gardiner 2008 which also tingles with the facts to meet a Scottish nationalist perspective. For a fictional take on Trocchi in the 1960s, see Home 2005.

19. Just as *Young Adam* (1954) originally had been published under the pseudonym Francois Lengel, the string of erotic novels where published under various pseudonyms including Oscar Mole, James Fidler, Carmencita de Las Lunas, Jean Blanche and Frank Harris.

20. For example, Debord wrote Trocchi a letter, dated 21 September 1957, to tell him that the International had now become "situationist" and hoping for Trocchi's soon return (Debord 2009: 51).

21. A huge amount of Trocchi's correspondence as well as manuscripts – published, unfinished as well as to be included in the portfolio – can be accessed in the Trocchi Papers at the Department for Special Collections, Washington University, St. Louis, MO. My research is primarily based on the copy at the British Library.

22. McKenzie Wark (2011: 130) sees this as sigma's major achievement: it created a web of logs before the internet and can thus be seen as an early example of blogging.

23. A 16-year old girl was stopped with a prescription carrying Trocchi's name and he had to flee the country while out on bail. During this era of McCarthyism's focus on 'un-American Activities', selling drugs to minors where punishable with death in the electric chair. According to Scott 1991, Norman Mailer gave him money to get to Montreal where Leonard Cohen put him on a steamer to Glasgow. The Situationists publicly paid tribute to him at the Fourth Conference of the Situationist International, held at the ICA, London on 27 September 1960, where they demanded his immediate release and repatriation to the UK.

24. Even though the Marxist strain in Surrealism tends to be more Messianic than dogmatic, e.g. Benjamin and Bataille.

25. Especially the Gramscian notion that transformation is possible in the superstructure by developing a counter-hegemony where the working classes and socialist intellectuals promote and develop a new oppositional culture (Gramsci 1929-35: 3-43).

26. Debord 1967: 84: "The proletariat has not been eliminated, and indeed it remains irreducible present, under the intensified alienation of modern capitalism, in the shape of the vast mass of workers who have lost all power over the use of their own lives."

27. For an elaboration of the differences between Debord and Gramsci, see Gilman-Opalsky 2011: 69ff.

28. For every single published issue of *International Times* (1966-1994, 2011-), see http://www.internationaltimes.it/archive/. For the sigma masthead, see, for example, *IT*, Vol. 1, issue 4, 1966 from which it, additionally, is clear that sigma and *IT* for a brief moment in time shared an office space at 102 Southampton Row in Holborn (i.e. at the Indica Bookshop which had opened at the address in the summer of 1966, see Trocchi 1966:2).

29. 'A Revolutionary Proposal' was first published in *New Saltire Review*, Edinburgh 1962 and afterwards translated and published in various languages and journals including *Internationale Situationniste 8* (as 'Technique du coup de monde', 1963), *City Lights Annual* and *The Journal of the Architectural Association*.

30. Other attendees at the meeting included, besides Trocchi, Nuttall, Laing, Cooper and Sigal, among others Tom and Maureen McGrath, John Latham, Bob Cobbing, Aaron Esterson, Sid Briskin, Joe Schoerstein, Beba Lavrin, Lyn Trocchi, Graham Howe and Joe Turner.

31. The Philadelphia Association was formed in 1965 in order to acquire the rights to Kingsley Hall and register it as a charity. It is still active today in a somewhat more conventional form, see http://www.philadelphia-association.co.uk/. When formed in 1965, it consisted of R. D. Laing, David Cooper, Leon Redler, Joseph Berke, Clancy Sigal, Aaron Esterson, Joan Cunnold and Sid Briskin.

32. See Chapter Five for a more thorough analysis of the dream machine.

33. In, for example, describing mankind as only becoming, Trocchi wrote in a strikingly Deleuzian language.

34. Originally published unsigned in *Internationale Situationniste* #4 (June 1960). Later published in German in *SPUR* #1 (1960), signed by Debord, Jorn, Constant, Wyckaert, Pinot-Galizio and Gruppe SPUR.

35. As reported by William Burroughs (2012: 236) in a letter to Gysin dated 21 November 1966.

36. For a history as Provo as a sort of anarchist resistance movement, see Kempton 2007.

37. Quoted from http://www.lnalhooq.net/LNALHOOQ/Livres/FarrenMickAlexanderTrocchi.html – accessed 110411.

38. In a conversation with Allan Ginsberg and Peter Orlovsky, transcribed in Campbell et al. 1997, Ginsberg asks Trocchi if he knows "what was behind that?", i.e. X's execution, to which Trocchi replies: "Oh well, I think I know. One of the things that was brought up in Michael's trial was this International Communist Conspiracy called sigma!" (Campbell et al. 1997: 218).

III. THE ANTI-UNIVERSITY OF LONDON

39. The notion of anti-psychiatry was also picked up by Scientology and other cultic affiliations trying to affect change through the formation of autonomous brother- and sisterhoods, arguing that capitalism a kind of mental pollution and, thus, a state of mind. The latter position is easily exemplified by the economic crisis of 2008 where capitalism in various medias were described as a patient suffering from depression, a metaphor that also appears in the writings of Franco Berardi who has been a well-known collaborator of another famous anti-psychiatrist, namely Felix Guattari.

40. In a critique of anti-psychiatry – especially Laing but also Foucault, Erving Goffman and Thomas Szasz – from the Left, Sedgwick (1982) argued, for example, that with their private practices, the anti-psychiatrists essentially failed patients on the NHS, i.e. the working class, who could not afford private treatment.

41. The 'University' – part of the title had to be dropped because New York State at the time demanded that a 'university' had at least $100,000 in the bank.

42. The Philadelphia Association is still active today in a somewhat more conventional form, see http://www.philadelphia-association.co.uk/. When formed in 1965, it consisted of, besides the four mentioned above, Clancy Sigall, Aaron Esterson, Joan Cunnold and Sid Briskin.

43. Kingsley Hall existed as an anti-psychiatric community house from 1965 to 1970.

44. This collection includes the papers given at the congress by R. D. Laing, Gregory Bateson, Jules Henry, John Gerassi, Paul Sweezy, Paul Goodman, Lucien Goldmann, Stokely Carmichael, Herbert Marcuse and David Cooper. In the US, it was published under the name *To Free a Generation*, New York: Macmillan 1968.

45. Peter Davis has kindly given me access to his unedited recordings of the interview.

46. The interview is part of an unedited series of video interviews with survivors conducted by Peter Davis. The videos were shot as part of a project revisiting the congress re-staging key events in relation to the so-called Dialektikon events which, so far, has taken place in 2011 and 2012. For more information, see http://www.dialecticsofliberation.com/.

47. Additionally, Peter Davis shot about eight hours of outtakes from the congress, documenting deliveries, discussions and ambiences which he has kindly given me access to.

48. That the UK Underground in general was hugely indebted to William Blake and his visionary anarchism is obvious, e.g. the Michael Horovitz edited anthology of 'poetry from the underground', *Children of Albion* (1969). The anthology not only had a Blake engraving as cover but also promised 'a Blakean cornucopia of afterwords, tracing the development of oral and jazz poetry', while featuring writers such as Trocchi, Tom McGrath and Michael X.

49. The members of the committee at this point were Berke, Krebs, Cooper and Redler as well as Asa Benveniste, Juliet Mitchell, Stuart Montgomery, Aubrey Raymond, Morty Schatzman and Russell Stetler.

50. Berke 1968 is a general reference to the selection of the AU's catalogues and newsletters in the possession of the British Library.

51. Jakobsen 2012a, *The Antihistory Tabloid*, photographically reproduces a lot of archival material, including the newsletters from the AU, stored at the Planned Environment Therapy Trust Archive and Study Centre (pettarchive.org) in Gloucestershire, UK, which hosts papers from the Institute of Phenomenological Studies and the Antiuniversity.

IV. THE POLITICS OF EXPERIENCE

52. Most of what are called memes in today's media environment are actually image macros, consisting of an image with a superimposed text of an often humorous nature.

53. V.I.T.R.I.O.L. – an alchemical credo that roughly translates as 'visit the inner earth and by rectifying it you will find the hidden stone'.

54. This and the preceding Jorn quote are in my translation from Danish.

55. Jorn's primary outlet for these ideas was the five books he published in Danish under his Scandinavian Institute for Comparative Vandalism-moniker, i.e. *Den naturlige orden (The Natural Order*, 1962), *Værdi og økonomi (Value and Economy*,

1962), *Held & Hasard (Luck and Chance*, 1963), *Ting og Polis (Things and Polis*, 1964), and *Alfa og omega (Alpha and Omega*, 1964, publ. 1980).

56. For an analysis of Sorel's thought, see Sternhell 1989: 36-91.

57. Other important influences includes the language of Symbolism as well as the thinking of Bergson, Nietzsche and Alfred Jarry (Opstrup 2009). Interestingly, if examining the esoteric influences on the politics of the avant-garde, Bergson's younger sister, Moira Bergson, would eventually marry Samuel Liddell MacGregor Mathers who was one of the founders of the Hermetic Order of the Golden Dawn.

58. Helter Skelter was an apocalyptic war between the races which Manson had extrapolated from the songs of the Beatles. The war would be ignited by the Manson Family's music and would end in a victory for the black race who would more or less exterminate the whites (Its paranoid vision was very much fueled by the 1960s race tensions and riots in the US). While the slaughter was being performed the Family would hide in a sort of Hollow Earth scenario inspired by Hopi Indian legends. Afterwards, the Family would rise from their secret city underneath Death Valley to lead the black people who in Manson's analysis would be too stupid to lead themselves after their victory. The preparations for Helter Skelter turned the Manson Family into a 'dune bug attack battalion' in Ed Sanders's words, worthy of an as yet unmade Mad Max film.

59. For a study of the role played by Hollow Earth ideas in the popular imagination, see Standish 2006.

60. As Stewart Home (1995: 134) has pointed out, "the constant transformation of ordinary objects and events into art, and art into the everyday, is a modern form of alchemy."

61. The relationship between Nazism and the occult has given rise to its own industry from popular fringe classics like Ravenscroft 1973 to more scholarly works such as Goodrich-Clark 1985 which argues that Nazism ideologically can be traced back to ariosophical cults and the followers of Guido von List.

62. The name points to both the absence of God(s) and that, like in sigma, there would be no leaders.

63. This kind of thinking has been immortalised in popular culture and among generations of science fiction fans as Clarke's Third Law, named after the sci-fi writer Arther C. Clarke: "Any sufficiently advanced technology is indistinguishable from magic".

64. See www.wholeearth.com where, among other resources, many of the back issues can be read online as digital flipbooks.

65. The title stems from a poster on the wall of 49 Rivington Street, cf. Elzey 1968: 245.

66. It can be argued that the two seminal events constituting the London underground of the 1960s were the DoL conference and the International Poetry Incarnation in the Albert Hall, 11 June 1965. The latter is often seen as a 'gathering of the tribes' where the underground for the first time realised that they were many by selling out all 7,000 seats. It had Trocchi as conferencier as it can be seen in Peter Whitehead's documentary *Wholly Communion* (1965). If this can be seen as the official going public event of the underground, the DoL conference might be seen as the beginning of the underground's demise, its mutation into other forms of struggles and resistance. A third seminal event which had more influence on the psychedelic scenes than the ones working with cultural revolution and engineering even though they partly overlapped was the 14 Hour Technicolour Dream, a concert cum festival held at the Great Hall in Alexandra Palace on 29 April 1967. This latter event has also become emblematic for the so-called 'Summer of Love'. See, for example, Nuttall 1969, Miles 2011, Wilson 2005 or the documentary *A Technicolor Dream* (2008).

V. ACADEMY 23

67. *The Burroughs File,* which collects a lot of dispersed texts from the late 1960s, including some which had previously been available in German only, was printed in 1984. It includes a few pages with reproductions of his collage notebooks. Until recently, this publication has been the only source widely available with his collages, juxtaposing words and images and often made in collaboration with Gysin. In 2012 a few catalogues have seen the light of day, hinting at a certain timeliness, that this practice is rapidly becoming institutionally recognised, i.e. the exhibition *the name is BURROUGHS – expanded media* was shown from 24 March – 12 August at the Zentre für Kunst und Medientechnologien in Karlsruhe, Germany, presented a primer on the European and North American art circuit (which traditionally has been more focused on his writings and shotgun paintings) with its focus on primarily his multimedia experiments. This exhibition was followed by a show paying particular attention to his collages and collaboratiosn as well as his paintings, *Cut-ups, Cut-ins, Cut-outs – The Art of William S. Burroughs* at the Kunsthalle Vienna in Austria from 15 June to 21 October 2012, pointing towards the celebration of his centennial in 2013.

68. A notable exception is a special issue of *Ashé – Journal of Experimental Spirituality*, #2.3, entitled *Playback – The Magic of William Burroughs* with contributions from, among others, Phil Hine and Genesis P-Orridge.

69. For biographical details, see Burroughs 2001 and Baker 2010. The 'official' biography – which seems to have its share of erroneus facts – is Morgan 1988. This do not cover his final years. Barry Miles' biography from 1993 (Miles 1993) covers some of the years in Kansas and puts greater emphasis on his writings and their context.

70. 'The invisible generation' was also printed twice in *IT* (no. 5.5, Dec 1966 on a poster which promised to be "a new concept in cut-out manipulatable posters" (see http://www.international-times.org.uk/ITarchivePart1.html, accessed 271010, for pictures and references) and again in no. 6, Jan 1967. Additionally, it was printed in the *Los Angeles Free Press*, as an appendix to *The Ticket That Exploded* in its 1967 edition and in Burroughs' messianic interview book with Daniel Odier, *The Job* (1974). This shows the extreme dispersion of Burroughs' writings in this period and explains why it has been difficult to collect and market them in the same way as the novels.

71. *Magick in Theory and Practice* is reprinted Crowley as part three of *Magick: Liber ABA Book 4* – Thelema's primary source book which includes both rituals and a theoretical exposition of occult philosophy. Crowley states that it is possible to cause any change of which the object is "capable by nature". The postulate was that any "required Change may be effected by the application of the proper kind and degree of Force in the proper manner through the proper medium to the proper object". He further defined magic as "the Science of understanding oneself and one's conditions. It is the Art of applying that understanding in action" in this introduction. Crowley spelled magic with a -k in order to differentiate from stage magic and illusionism. See Crowley 1997: 125-127.

72. The Process, led by Robert DeGrimston and Mary Anne MacLean – 'the Omega' – started as an offshoot of Scientology in the mid-1960s, but evolved into a fully fledged theology based on the reconciliation of opposites that made them pray to Satan as well as to Jehovah, a move that made the public press decry them as satanists. They believed in four gods (Christ, Lucifer, Satan and Jehovah) but these were more thought of as archetypical psychological states than metaphysical beings. In popular culture they have achieved notoriety due to claims that they inspired Charles Manson and Son of Sam (Wyllie 2009).

73. So called due to that the extended family of Beat artists, e.g. Allan Ginsberg, Harold Norse, Gregory Corso and Peter Orlovsky, stayed there at various times in the late 1950s.

74. A revised version with texts and twenty-six of the seventy-odd photo-collages was published in French in 1977, a version in English followed in 1978 and, at the moment of writing, they are both long out of print.

75. It should be emphasised here that the title has nothing to do with the Process Church of the Final Judgment, the infamous 'Satanic Mindbenders from Mayfair' who also became a strong influence on TOPY alongside related experiments such as Charles Manson's Family, Jim Jones' People's Temple and Anton LaVey's Church of Satan.

76. Examples can be heard on the Genesis P-Orridge edited album of Burroughs' tape experiments, *Nothing Here Now But the Recordings*, released as the very last album on Throbbing Gristle's record company Industrial Records in 1981.

77. Burroughs had a life-long interest in pictorial alphabets like the Mayan, Aztec and Egyptian hieroglyphs and petroglyphs. See Fallows 2012 for examples on his visual production.

78. Burroughs's lectures and classes from Naropa Institute can be found online in the Naropa Poetics Audio Archive at www.archive.org/details/naropa. Hear, for instance, his lecture on public discourse, August 11, 1980: http://www.archive.org/details/naropa_william_s_burroughs_lecture_on (accessed 011110).

79. The flicker experience was part of the popular imagination of the 1960s and resulted, among other things, in the ubiquitousness of stroboscopic lights, e.g. Geiger 2003. Other examples stemming from the underground milieu on the interest in flicker in relation to thought control, subliminal advertising and the programming of Manchurian Candidates can be found in Philip K. Dick's novel *Valis* (1981) or Theodor Roszak's novel *Flicker* (1991) which both examines ideas around not only cultic communities but also film as a tool for controling the masses in fictional forms.

80. In the early 2000s, this notion caught on in the wake of the creative resistance around the so-called alter-globalisation movements where the Center for Tactical Magic humourously intervened in political protests with a mobile unit which was half ice cream truck/half info hub. Cf., for example, Thompson et al 2004 or see http://www.tacticalmagic.org/.

81. An event which has entered popular culture through pulp fiction and comics is the rituals worked in the period from January to March 1946 by Jack Parsons and L. Ron Hubbard, known as the 'Babalon Working'. The goal was to make manifest an incarnation of the divine feminine goddess, a so-called 'Moonchild'. Both men apparently took the manifestation to be complete in Marjorie Cameron. Traces of this goddess worship can be traced through Scientology to the Process Church where the members also thought that Mary Ann MacLean was an incarnation of the goddess (Pendle 2005; Miller 1987; Wyllie 2009).

82. Parsons was also a member of the Los Angeles Science Fantasy Society alongside writers like Heinlein, Ray Bradbury and Jack Williamson (Pendle 2005: 169ff).

83. For a study of the esoteric tradition's (hidden) relation to the Enlightenment, sharing a common goal of a future new age of increased knowledge and power over nature, see Yates 1972.

84. This was the only work by Crowley widely available in the 1960s outside the rare books market. It was before the reprinting industry in the 1970s took off (Wasserman 2012: 24).

VI. THEE TEMPLE OV PSYCHICK YOUTH

85. The events were held in London and Manchester. A film, *The Final Academy Documents*, was later released, documenting the multi-media events and Burroughs' readings.

86. In which Oursler interviewed 12 persons from the Downtown New York art, music and performance scenes c. 1970 – 2000.

87. *Decoder* is also the name of a 1984 West German film, directed by Muschka and featuring not only William Burroughs and Genesis P. Orridge but also F. M. Einheit and Alexander Hacke from the Berlin based industrial band Einstürzende Neubauten. The film is trying to realise some of the ideas related to Burroughs' methods.

88. E.g. Aleister Crowley who became 'Frater Perdurabo' when he joined the Golden Dawn (Kaczynski 2002).

89. How to use the elevated state of mind reached at and before the orgasmic climax to mentally charge a symbol of the desired was the Ninth Degree secret of the OTO which had been 'democraticised' by Crowley.

90. GPO would later also interpret quantum physics, especially the theories of Niels Bohr, the observer effect and the Heisenberg Uncertainty Principle, to argue that sub-atomic particles require an observer to come into existence. Away from us the universe is "a measureless resonating domain of frequencies that are an open source that only gets transformed into the world as we think we recognize it after being accessed by our senses and entering our brain" (P-Orridge 2006: 285).

91. For a period, TOPI ran the website http://www.onetruetopitribe.com which was defunct again by mid-2012.

92. Crowley was in turn inspired by the 'do what thou wilt' written over the door to the Abbey of Thélème in the first book of Rabelais' *Gargantua and Pantagruel* (c. 1532-1564).

93. Its founding members were the visual arts group Irwin, the band Laibach and the theatre group Scipion Našice Sisters (today called Noordung) The collective has since grown to include, for example, a theoretical wing, the Department of Pure and Applied Philosophy, and a film and video collective, Retrovision. For the story of NSK, see Monroe 2005.

94. Zeev Sternhell argues convincingly in his *The Birth of Fascist Ideology* (1989) that the roots of fascism can be found with the Italian revolutionary syndicalists, i.e. in anarchism, who nearly all, along with the Futurists, were in the international movement that wanted Italy to join the First World War which was perceived as the conditions for a moral and spiritual renewal. In this movement,

the syndicalist leaders realised the mobilising powers of nationalism and thus combined the two into their national-socialist myth and their strength-in-unity credo. The common denominator bringing these supposedly opposite ideologies, Futurism, nationalism and the syndicalist strain of revisionist Marxism, that led to fascism together was, as Sternhell (1989: 30) points out, "their hatred of the dominant culture and their desire to replace it with a total alternative."

95. Most occult practitioners differ between the right-hand path where the goal is ego-loss and unification with the divine and the left-hand path where the goal is immortality and self-deification.

VII. INVISIBLE INSURRECTIONS AND RADICAL IMAGINARIES

96. For a reading of *the* Anonymous and their meme's origin on the online megafora 4chan.org, see Deterritorial 2012.

LIST OF WORKS CITED

#

1991: The Year Punk Broke (1991), dir. Dave Markey, We Got Power Films

A

A Technicolor Dream (2008), dir. S. Gammond, Eagle Rock Entertainment

Abrahamsson, Carl (2009): 'Foreword – The Deconstruction of a Map of an Unknown Territory', in: P-Orridge 2009b: 11-17

Adams, Cameron and D. Luke, A. Waldstein et al (eds.) (2013): *Breaking Convention – Essays on Psychedelic Consciousness*, London: Strange Attractor

Agamben, Giorgio (1990): *The Coming Community*, trans. M. Hardt, Minneapolis: University of Minnesota Press 2007

Agamben, Giorgio (2006): 'What is an Apparatus?', in: *What is an Apparatus? and Other Essays*, trans. D. Kishik and S. Pedatella, Stanford: Stanford University Press 2009, pp. 1-24

Ah, Sunflower! (1967), dir. R. Klinkert & I. Sinclair, The Picture Press

Alberro, Alexander and Blake Stimson (eds.) (2009): *Institutional Critique – An Anthology of Artists' Writings*, Cambridge: The MIT Press

Allen, Felicity (ed.) (2011): *Education*, London: Whitechapel Gallery

Althusser, Louis (1970): 'Ideology and Ideological State Apparatuses', in: *On Ideology*, London: Verso 2008, pp. 1 – 60

Andreotti, Libero & X. Costa (eds.) (1996): *Theory of the Dérive and Other Situationist Writings on the City*, Barcelona: Museu d'Art Contemporani de Barcelona

Anatomy of Violence (1967), dir. Peter Davis, NET Science

Artaud, Antonin (1938): *The Theatre and Its Double*, transl. V. Corti, London: Oneworld Classics Ltd 2010

Aureli, Pier Vittorio (2008): *The Project of Autonomy – Politics and Architecture within and against Capitalism*, New York: Princeton Architectural Press

Azerrad, Michael (2001): *Our Band Could Be Your Life: Scenes from the American Indie Underground 1981-1991*, Boston: Little, Brown an Company

B

Baker, Phil (2010): *William S. Burroughs*, London: Reaktion Books Ltd

Baker, Phil (2011): *Austin Osman Spare – The Life and Legend of London's Lost Artist*, London: Strange Attractor Press

Balestrini, Nanni (1987): *The Unseen*, London: Verso 2011

Barkun, Michael (2003): *A Culture of Conspiracy – Apocalyptic Visions in Contemporary America*, Los Angeles: University of California Press

Bataille, Georges (1933): 'The Psychological Structure of Fascism' in: *Visions of Excess – Selected Writings, 1927 – 1939*, ed. and trans. A. Stoekl et al., Minneapolis: University of Minnesota Press 2008, pp. 137-160

Bataille, Georges (1938): 'The Sorcerer's Apprentice', in: *Visions of Excess – Selected Writings, 1927 – 1939*, ed. and trans. A. Stoekl et al., Minneapolis: University of Minnesota Press 2008, pp. 223-234

Bataille, Georges (1947): 'The Absence of Myth', in: Bataille 1994: 48

Bataille, Georges (1954): *Inner Experience*, trans. L. A. Boldt, New York: State University of New York Press 1988

Bataille, Georges (ed.) (1970): *Encyclopædia Acephalica*, London: Atlas Press 1970

Bataille, Georges (1994): *The Absence of Myth: Writings on Surrealism*, ed. and trans. M. Richardson, Verso: London and New York 2006

Baudelaire, Charles (1860): *Artificial Paradise*, trans. P. Roseberry. London: Broadwater House 2000

Bell, David & M. Parker (eds.): *Space Travel and Culture: From Apollo to Space Tourism*, Oxford: Blackwell Publishing

Benjamin, Walter (1929): 'Surrealism', trans. J. A. Underwood, in: *One-Way Street and Other Writings*, London: Penguin Books 200, pp. 143-160

Benjamin, Walter (1940a): *The Arcades Project*, trans. H. Eiland et al., Cambridge, Mass.: Harvard University Press 2002

Benjamin, Walter (1940b): 'Theses On the Philosophy of History', trans. H. Zorn, in: *Illuminations*, London: Pimlico 1999, pp. 245-255

Berardi, Franco 'Bifo' (2009): *The Soul at Work – From Alienation to Autonomy*, Los Angeles: Semiotext(e)

Berardi, Franco 'Bifo' (2011): *After the Future*, Edinburgh: AK Press

Berardi, Franco 'Bifo' (2012): *The Uprising – On Poetry and Finance*, Los Angeles: Semiotext(e)

Berger, Dan (2006): *Outlaws of America – The Weather Underground and the Politics of Solidarity*, Oakland: AK Press

Berke, Joseph (1965): 'The Free University of New York', in: *Peace News*, October 1965, pp. 6-7

Berke, Joseph (ed.) (1968): *The Antiuniversity of London – Catalogue of Courses*, vol. 1, 2, 3 + newsletter, 1968, London: Antiuniversity of London

Berke, Joseph (1969a): 'The Creation of an Alternative Society', in: Berke 1969b: 12-35

Berke, Joseph (ed.) (1969b): *Counter Culture: The Creation of an Alternative Society*, London: Peter Owen Limited

Berke, Joseph (2011). Personal interview. 08 Aug. 2011

Berke, Joseph and C. Hernton (1974): *The Cannabis Experience – An Interpretative Study of the Effects of Marijuana and Hashish*, London: Peter Owen Limited

Bernays, Edward (1928): *Propaganda*, New York: Ig Publishing 2005

Beuys, Joseph (1986): *What Is Art? – Conversation with Joseph Beuys*, Forest House: Clearview 2007

Bey, Hakim (1985): *T. A. Z. – The Temporary Autonomous Zone, Ontological Anarchy, Poetic Terrorism*, New York: Autonomedia 2003

Bey, Hakim (1994): *Immediatism*, Edinburgh: AK Press

Bishop, Claire (2012): *Artifical Hells – Participatory Art and the Politics of Spectatorship*, London: Verso

Blissett, Luther (1997): *Anarchist Integralism – Aesthetics, Politics & the Apres Garde*, London: Sabotage Editions

Blissett, Luther (2000): *Q*, transl. S. Whiteside. London: Arrow Books 2003

Blissett, Luther, autonome a.f.r.i.k.a. gruppe & Sonja Brünzels (2001): *Handbuch der Kommunikationsguerrilla*, Berlin: Assoziation A

Bloom, Howard (1995): *The Lucifer Principle – A Scientific Expedition into the Forces of History*, New York: The Atlantic Monthly Press 1997

Boal, Iain & J. Stone, M. Watts, C. Winslow (eds.) (2012): *West of Eden – Communes and Utopia in Northern California*, Oakland: PM Press

Bolt, Mikkel (2004): *Den sidste avantgarde – Situationistisk Internationale hinsides kunst og politik,* Copenhagen: Rævens Sorte Bibliotek.

Bolt, Mikkel (2009): *Avantgardens selvmord*, Copenhagen: Forlaget 28/6

Boltanski, Luc & Eve Chiapello (1999): *The New Spirit of Capitalism*, trans. G. Elliott, London: Verso 2007

Bookchin, Murrray (1995): *Social Anarchism or Lifestyle Anarchism*, Stirling: AK Press

Boon, Marcus (2002): *The Road of Excess: A History of Writers on Drugs*, Cambridge: Harvard University Press

Bordowitz, Greg (2010): *General Idea – Imagevirus*, London: Afterall

Bourriaud, Nicholas (1998): *Relational Aesthetics*, transl. S. Pleasance & F. Woods, Dijon: Les Presses du Réel 2002

Boyd, Andrew & D. O. Mitchell (eds.) (2012): *Beautiful Trouble – A Toolbox for Revolution*, London: OR Books

Bradley, Will (2007): 'Introduction', in: W. Bradley and C. Esche (eds): *Art and Social Change*, London: Tate Publishing, pp. 9 – 24

Brus, Günter, O. Muehl, H. Nitsch & R. Schwarzkogler (1999): *Writings of the Vienna Actionists*, trans. M. Green, London: Atlas Press

Buchloh, Benjamin (2001): *Neo Avantgarde and Culture Industry*, Cambridge: MIT Press

Bugliosi, Vincent with C. Gentry (1974): *Helter Skelter – The True Story of the Manson Murders*, London: Arrow Books 1992

Bürger, Peter (1974). *Theory of the Avant-garde*, trans. M. Shaw. Minneapolis: University of Minnesota Press 1989

Bürger, Peter (1992): *The Decline of Modernism*, Cambridge: Polity Press

Bürger, Peter & C. Bürger (1992): *The Institutions of Art*, Lincoln: University of Nebraska Press

Burroughs, William S. (1966): 'The Invisible Generation', in: Burroughs 1974: 160-170

Burroughs, William S. (1968): *The Ticket That Exploded*, 2nd ed., London: John Calder 1985

Burroughs, William S. (1970): 'I, William Burroughs, Challenge You, L. Ron Hubbard", in: *Mayfair*, Vol 5, No. 1, March 1970, pp. 52-58

Burroughs, William S. (1971a): 'The Electronic Revolution', in: Burroughs 1974: 174-203

Burroughs, William S. (1971b): *The Wild Boys: A Book of the Dead*, London: Penguin Classics 2008

Burroughs, William S. (1975): 'The Limit of Control', in: Burroughs 1985: 117-121

Burroughs, William S. (1985): *The Adding Machine – Selected Essays*, New York: Arcade Publishing 1993

Burroughs, William S. (1993): *Letters 1945–59*, ed. O. Harris, London: Penguin Books 2009

Burroughs, William S. (2001): *Burroughs Live: The Collected Interviews of William S. Burroughs 1960–1997*, ed. S. Lotringer, Los Angeles: Semiotext(e)

Burroughs, William S. (2012): *Rub Out the Words: The Letters of William S. Burroughs 1959-1974*, ed. B. Morgan, London: Penguin Classics

Burroughs, William S. & D. Odier (1974): *The Job: Interviews with William S. Burroughs*, London: Penguin Books 2008

Butler, W. E. (1959): *Magic, Its Ritual, Power and Purpose*, Loughborough: Thoth Publications 2001

C

zCain's Film (1969), dir. J. Wadhawen, Chronos Films

Calder, John (1985): 'Alexander Trocchi', in: *Edinburgh Review 70 – Trocchi Number*, August 1985, pp. 32-35

Camatte, Jacques (1995): 'On Organization', in: *This World We Must Leave and Other Essays*, trans. D. Loneragan, New York: Autonomedia

Campagna, Federico & E. Campiglio (eds.) (2012): *What We Are Fighting For – A Radical Collective Manifesto*, London: Pluto Press

Campbell, Allan and Tim Niel (eds.) (1997): *A Life in Pieces – Reflections on Alexander Trocchi*, Edinburgh: Rebel Inc.

Canetti, Elias (1960): *Crowds and Power*, trans. C. Stewart. New York: Farrar, Straus and Giroux 1984

Canjeurs, Pierre & Guy Debord (1960): 'Preliminaries Toward Defining a Unitary Revolutionary Program', in: Knabb 1981: 387-392

Carroll, Peter J. (1987): *Liber Null and Psychonaut*, San Francisco: Red Wheel/Weiser

Castaneda, Carlos (1968): *The Teachings of Don Juan: A Yaqui Way of Knowledge*, London: Penguin Books 2004

Cauter, Lieven De, Ruben De Roo & Karel Vanhaesebrouck (eds.) (2011): *Art and Activism in the Age of Globalisation*, Rotterdam: Nai Publishers

Certeau, Michel de (1984): *The Practice of Everyday Life*, trans. S. Rendall, Berkeley: University of California Press 1988

Clarke, Arthur C. (1953): *Childhood's End*, New York: Ballantine Books 1990

Cohen, Alan (1992): *The Decadence of the Shamans – or Shamanism as a Key to the Secrets of Communism*, London: Unpopular Books

Cohn, Norman (1957): *The Pursuit of the Millennium – Revolutionary Millenarians and Mystical Anarchists of the Middle Ages*, London, Random House 2004

Cooper, David (ed.) (1968): *The Dialectics of Liberation*, Middlesex: Penguin Books 1971

Critchley, Simon (2007): *Infinitely Demanding – Ethics of Commitment, Politics of Resistance*, London: Verso

Critchley, Simon (2012): *Faith of the Faithless – Experiments in Political Theology*, London: Verso

Crowley, Aleister (1911): 'The Vision and the Voice', in: Regardie, Israel (1974): *Gems from the Equinox – Instructions by Aleister Crowley for His Own Magical Order*, San Francisco: Red Wheel/Weiser 2007

Crowley, Aleister with M. Desti and L. Waddell (1997): *Magick – Liber ABA – Book Four, Parts I-IV*, San Francisco: Weiser Books 2010

Cunningham, John (2010): 'Clandestinity and Appearance', in: *Mute*, Vol. 2, no. 16, http://www.metamute.org/editorial/articles/clandestinity-and-appearance, accessed 010412

D

Davis, Erik (1998): *Techgnosis – Myth, Magic and Mysticism in the Age of Information*, New York: Serpent's Tail 2004

Davis, R. G. (1968): 'Cultural Revolution – U.S.A., 1968', in: Berke 1969: 36-58

Davisson, Sven (2003): 'Over the Hills and Far Away – The One God Universe and Dreams of Space, in: *Ashé! Journal of Experimental Spirituality*, Vol, 2(3), pp. 80-95

Dean, Jodi (2012): *The Communist Horizon*, London: Verso

Debord, Guy (1955): 'Introduction to a Critique of Urban Geography, in: Knabb 1981: 8-12

Debord, Guy (1958): 'Theses on Cultural Revolution', in: Knabb 1981: 53-54

Debord, Guy (1967): *Society of the Spectacle*, trans. D. Nicholson-Smith, New York: Zone Books 1995

Debord, Guy (1988): *Comments on the Society of the Spectacle*, trans. M. Imrie, London: Verso 1998

Debord, Guy (2009): *Correspondence – The Foundation of the Situationist International (June 1957 – August 1960)*, trans. S. Kendall & J. McHale, Los Angeles: Semiotext(e)

Debord, Guy & G. J. Wolman (1956): 'A User's Guide to Détournement', in: Knabb 1981: 14 – 21

Decoder (1984), dir. Muscha, Fett Film

Dery, Mark (1996): *Escape Velocity – Cyberculture at the End of the Century*, London: Hodder & Stoughton

Deterritorial Support Group (2012): 'All the Memes of Production', in: Lunghie et al. 2012: 32-38

Dick, Philip K. (1981): *Valis*, London: Gollancz 2001

Dickens, Peter (2009): 'The cosmos as capitalism's outside', in: Bell et al 2009: 66 82

Diederichsen, Diedrich & Anselm Franke (eds.) (2013): *The Whole Earth. California and the Disappearance of the Outside*, Berlin: Sternberg Press

Dobbs, J. R. "Bob" and The SubGenius Foundation (1983): *The Book of the SubGenius*, New York: Simon & Schuster, Inc. 1987

Douglass, Frederick (1852): *The Heroic Slave and Other Tales of Madison Washington*, New York: Darkinboddy Editions 2013

Drury, Nevill (2004): *The New Age – Searching for the Spiritual Self*, London: Thames & Hudson Ltd

Duberman, Martin (1972): *Black Mountain: An Exploration in Community*, Evanston: Northwestern University Press 2009

Duignan, James & B. Stabler (eds.) (2010): *Proximity #8: Education as Art*, Winter 2010

Dukes, Ramsey (1975): *S.S.O.T.B.M.E. Revised: An Esssay on Magick*, London: The Mouse That Spins 2001

Duncan, Michael and Kristine McKenna (2005): *Semina Culture – Wallace Berman and his Circle*, New York: Distributed Art Publishers, Inc.

Duncombe, Stephen (1997): *Notes from Underground – Zines and the Politics of Alternative Culture*, London: Verso 2001

Dwyer, Simon (1989): 'From Atavism to Zyklon B: Genesis P-Orridge and the Temple of Psychic Youth (From A to Z and back again)', in: S. Dwyer (ed.): *Rapid Eye, vol. 1*, London: Annihilation Press 1993, pp. 6 – 85

E

Eden, John (2010). Personal interview. 20 Apr. 2010

Edu-Factory Collective, The (eds.) (2009): *Toward A Global Autonomous University – Cognitive Labor, The Production of Knowledge and Exodus from the Education Factory*, New York: Autonomedia

Egbert, Donald D. (1967): 'The Idea of 'Avant-Garde' in Art and Politics', in: *The American Historical Review*, No. 2, pp. 339-366

Egbert, Donald D. (1970): *Social Radicalism and the Arts: Western Europe*, New York: Alfred A. Knopf

Eliade, Mircea (1951): *Shamanism: Archaic Techniques of Ecstasy*, Princeton: Princeton University Press 2004

Ellul, Jacques (1965): *Propaganda – The Formation of Men's Attitudes*, New York: Vintage Books 1973

Elzey, Roberta (1969): 'Founding an Anti-University', in: Berke 1969: 229 – 248

Embray, Richard (2009): *Please Add To & Return To Ray Johnson*, London: Raven Row

F

Fairfield, Richard (2010): *The Modern Utopian – Alternative Communities of the '60s and '70s*, Port Townsend: Process Media

Fallows, Colin & S. Genzmer (eds.) (2012): *Cut-Ups, Cut-Ins, Cut-Outs: The Art of William S. Burroughs*, Vienna: Kunsthalle Wien

Fanon, Frantz (1961): *The Wretched of the Earth*, trans. C. Farrington, London: Penguin Books 2001

Farren, Mick (2001): *Give the Anarchist a Cigarette*, London: Random House

Federici, Silvia (1974): *Wages Against Housework*, New York: Falling Wall Press 1975

Fedorov, Nikolai (1906): *What Was Man Created For? The Philosophy of the Common Task*, Bath: Honeyglen Publishing 1990

Felshin, Nina (ed.) (1995): *But is it Art? The Spirit of Art as Activism*, Seattle: Bay Press 1996

Felton, David (ed.) (1972): *Mindfuckers – A Source Book on the Rise of Acid Fascism in America*, San Francisco: Straight Arrow Books

Flicker (2008), dir. Nik Sheehan, Alive Mind Media

Florida, Richard (2002): *The Rise of the Creative Class and How It Is Transforming Work: Leisure, Community and Everyday Life*, New York: Perseus Book Group

Ford, Simon (1999): *Wreckers of Civilisation: The Story of COUM Transmissions &*

Throbbing Gristle, London: Black Dog Publishing

Ford, Simon (2005): *The Situationist International: A User's Guide*, London: Black Dog Publishing

Fortune, Dion (1930): *Psychic Self-Defense*, San Francisco: Weiser Books 2001

Fortune, Dion (1935): *The Mystical Qabalah*, San Francisco: Red Wheel/Weiser 2000

Foster, Hal (1996): *The Return of the Real*, Cambridge: MIT Press

Foucault, Michel (1977): 'The Confession of the Flesh', trans. C. Gordon, in: C. Gordon (ed.): *Power/Knowledge: Selected Interviews and Other Writings*, New York: Pantheon Books 1988

Foucault, Michel (2003): *Society Must Be Defended: Lectures at the Collège de France, 1975-76*, trans. D. Macey, New York: Picador

Foucault, Michel (2008): *The Birth of Biopolitics: Lectures at the Collège de France, 1978-79*, ed. M. Senellart, trans. G. Burchell, New York: Palgrave Macmillan

Fourier, Charles (1972): *The Utopian Vision of Charles Fourier: Selected Texts on Work, Love, and Passionate Attraction*, trans. J. Beecher and R. Bienvenu, New York: Jonathan Cape

Frank, Thomas (1997): *The Conquest of Cool: Business Culture, Counterculture and the Rise of Hip Consumerism*, London: The University of Chicago Press 1998

Freire, Paolo (1974): *Education for Critical Consciousness*, trans. M. B. Ramos, London: Bloomsbury 2013

Fynsk, Christopher (1991): 'Foreword: Experiences of Finitude', in: Nancy 1982: vii-xxxv

G

Ganz, Nicholas (2004): *Graffiti World: Street Art from Five Continents*, London: Thames & Hudson 2009

Gardiner, Michael (2008): 'Alexander Trocchi and Situationism', in: G. Grindon (ed.): *Aesthetics and Radical Politics*, Newcastle upon Tyne: Cambridge Scholars Publishing, pp. 63-82

Geiger, John (2003): *Chapel of Extreme Experience: A Short History of Stroboscopic Light and the Dream Machine*, New York: Soft Skull Press

Geiger, John (2005): *Nothing Is True Everything Is Permitted: The Life of Brion Gysin*, New York: Disinformation

Gilbert, James (2008): 'After '68 – Narratives of the New Capitalism', in: *New Formations* No. 65 / Autumn, pp. 34-53

Gilman-Opalsky, Richard (2011): *Spectacular Capitalism – Guy Debord & the Practice of Radical Philosophy*, London: Minor Compositions

Goldwag, Arthur (2009): *Cults, Conspiracies, and Secret Societies – The Straight Scoop on Freemasons, the Illuminati, Skull and Bones, Black Helicopters, the New World Order, and many, many more*, New York: Vintage Books

Goodrich-Clarke, Nicholas (1985): *The Occult Roots of Nazism – Secret Aryan Cults and their Influence on Nazi Ideology*, London: Tauris Parke Paperbacks 2011

Gordon, Alastair (2008): *Spaced Out – Crash Pads, Hippie Communes, Infinity Machines, and Other Radical Environments of the Psychedelic Sixties*, New York: Rizzoli International

Gorightly, Adam (2009): *The Shadow Over Santa Susana – Black Magic, Mind Control and the Manson Family Mythos*, London: Creation Books

Gramsci, Antonio (1929-35): *Selections from the Prison Notebooks*, trans. Q. Hoare & G. N. Smith, London: Lawrence and Wishart 2007

Green, Jonathon (1988): *Days in the Life – Voices from the English Underground 1961-1971*, London: Pimlico 1998

Grindon, Gavin (2011): 'Surrealism, Dada, and the Refusal of Work: Autonomy, Activism, and Social Participation in the Radical Avant-Garde', in: *Oxford Art Journal*, Vol. 34, issue 1, pp. 79-96

Grogan, Emmett (1972): *Ringolevio – A Life Played for Keeps*, New York: New York Review of Books 2008

Guattari, Félix (1992): *Chaosmosis – An Ethico-Aesthetic Paradigm*, Sydney: Power Publications

Guattari, Félix (1996): 'Subjectivites; for Better and for Worse', in: G. Genosko (ed.): *The Guattari Reader*, Oxford: Blackwell Publishers, pp. 193-203

Gysin, Brion (1967): *The Process*, Woodstock & New York: The Overlook Press 2005

Gysin, Brion & T. Wilson (1982): *Here To Go: Bryon Gysin*, London: Creation Books 2001

H

Hahne, Ron, Ben Morea and the Black Mask Group (2011): *Black Mask & Up Against the Wall, Motherfucker – The Incomplete Works of Ron Hahne, Ben Morea and the Black Mask Group*, Oakland: PM Press

Hall, Manly P. (1928): *The Secret Teachings of All Ages – An Encyclopedic Outline of Masonic, Hermetic, Qabbalistic and Rosicrucian Symbolical Philosophy*, Marston Gate: Forgotten Books 2008

Hardt, Michael & Antonio Negri (2000): *Empire*, Cambridge: Harvard University Press 2001

Hardt, Michael & Antonio Negri (2009): *Commonwealth*, Cambridge: Harvard University Press 2011

Heath, Joseph & A. Potter (2005): *The Rebel Sell: How the Counterculture Became Consumer Culture*, Chicester: Capstone Publishing 2006

Hebdige, Dick (1979): *Subculture: The Meaning of Style*, London: Methuen & Co., Ltd.

Heinlein, Robert A. (1961): *Stranger in a Strange Land*, London: Hodder & Stoughton Ltd 2005

Hernton, Calvin C. (1965): *Sex and Racism*, St Albans: Paladin 1973

Hernton, Calvin C. (1970): *Scarecrow*, New York: Doubleday & Company, Inc 1974

Hewison, Robert (1986): *Too Much: Art and Society in the Sixties 1960-75*, London: Methuen 1988

Hill, Christopher (1972): *The World Turned Upside Down*, London: Penguin Books 1975

Hill, Desmond (2009): 'Family Fortunes', in: P-Orridge 2009b: 525-529

Hoffmann, E. T. A. (1820-22): *The Life and Opinions of the Tomcat Murr*, transl. A. Bell, London: Penguin Classics 1999

Holmes, Brian (2008): *Unleashing the Collective Phantoms: Essays in Reverse Imagineering*, New York: Autonomedia

Holmes, Brian (2009a): *Escape the Overcode – Activist Art in the Control Society*, Eindhoven: Van Abbemuseum

Holmes, Brian (2009b): 'Extradisciplinary Investigations: Towards a New Critique of Institutions', in: Raunig et al 2009: 53-62

Home, Stewart (1988): *The Assault on Culture – Utopian Currents From Lettrisme to Class War*, Edinburgh: AK Press 1991

Home, Stewart (1995): *Neoism, Plagiarism & Praxis*, Edinburgh: AK Press

Home, Stewart (ed.) (1996): *What Is Situationism? A Reader*, Edinburgh: AK Press

Home, Stewart (ed.) (1997): *Mind Invaders – A Reader In Psychic Warfare, Cultural Sabotage and Semiotic Terrorism*, London: Serpent's Tail

Home, Stewart (2005): *Tainted Love*, London: Virgin Books Ltd.

Home, Stewart (2006a): 'Walk On Gilded Splinters – In Memorandum to Memory, 13 April 1969', in: I. Sinclair (ed): *London – City of Disappearances*, London: Penguin Books 2007, pp. 398 – 409

Home, Stewart (2006b). Personal interview. 23 Nov. 2006

Hopkins, David (ed.) (2006): *Neo-Avant-Garde*, Amsterdam: Rodopi

Hoptman, Laura (ed.) (2010a): *Brion Gysin – Dream Machine*, London and New York: Merrell Publishers Ltd

Hoptman, Laura (2010b): 'Disappearing Act: The Art of Brion Gysin', in: Hoptman 2010a: 57-143

Horovitz, Michael (ed.) (1969): *Children of Albion – Poetry of the 'Underground' in Britain*, London: Penguin Books 1970

Hussey, Andrew (2001): *The Game of War – The Life and Death of Guy Debord*, London: Jonathan Cape

I

Ilich, Ivan (1970): *Deschooling Society*, London: Marion Boyars 2004

Invisible Committee, The (2007): *The Coming Insurrection*, Los Angeles: Semiotext(e) 2009

Irwin, Robert (1999): *Satan Wants Me*, Cambridge: Dedalus 2007

Ivison, Tim & T. Vandeputte (eds.) (2013): *Contestations: Learning from Critical Experiments in Education*, London: Bedford Press

J

Jakobsen, Jakob (2011): 'The Artistic Revolution: On the Situationists, Gangsters and Falsifiers from Drakabygget', in: Rasmussen et al 2011: 215-275

Jakobsen, Jakob (ed.) (2012a): *The Antihistory Tabloid*, London: MayDay Rooms

Jakobsen, Jakob (2012b): 'Anti-University of London – An Introduction to Deinstitutionalisation', in: Jakobsen 2012a: 9-12

Jameson, Fredric (1984): 'Periodizing the 60s', in: S. Sayres, A. Stephanson et al.(ed.): *The 60s Without Apology*, Minneapolis: University of Minnesota Press

Jappe, Anselm (1999): *Guy Debord*, trans. D. Nicholson-Smith, Berkeley: University of California Press

Jorn, Asger (1957): 'Notes on the Formation of an Imaginist Bauhaus', in: Knabb 1988: 23-24

Jorn, Asger (1962): *Værdi og Økonomi – kritik af den økonomiske politik og udbytningen af det enestående*. Copenhagen: Borgens Forlag

Jorn, Asger (2011): *Fraternité Avant Tout: Asger Jorn's Writings on Art and Architecture 1938-1957*, ed. R. Baumeister, trans. P. Larkin et al., Rotterdam: 010 Publishers

K

Kaczynski, Richard (2002): *Perdurabo – The Life of Aleister Crowley*, Berkeley: North Atlantic Books 2010

Kaczynski, Theodore J. (2010): *Technological Slavery – The Collected Writings of Theodore J. Kaczynski*, Port Townsend: Feral House

Katsiaficas, Georgy (1997): *The Subversion of Politics – European Autonomous Social Movements and the Decolonization of Everyday Life*, Edinburgh: AK Press 2006

Kavan, Anna (1967): *Ice*, London: Peter Owen Publishers 2006

Keenan, David (2003): *England's Hidden Reverse – A Secret History of the Esoteric Underground*, London: SAF Publishing Ltd

Kempton, Richard (2007): *Provo – Amsterdam's Anarchist Revolt*, Brooklyn: Autonomedia

Kerekes, David (2003): *Headpress 25: William Burroughs & the Flicker Machine*. London: Headpress

Keucheyan, Razmig (2010): *The Left Hemisphere: Mapping Critical Theory Today*, transl. G. Elliott, London: Verso 2013

Kinney, Jay (1994): 'Music, Magic and Media Mischief: The Gnosis Interview With Genesis P-Orridge', in: P-Orridge 2009b: 323 – 344

Kittler, Friedrich A. (1986): *Gramophone, Film, Typewriter*, trans. G. Winthrop Young & M. Wutz, Stanford: Stanford University Press 1999

Knabb, Ken (ed.) (1981): *Situationist International – Anthology*, trans. K. Knabb, Berkeley: Bureau of Public Secrets 2006

L

Lachman, Gary (2001): *Turn Off Your Mind – The Mystic Sixties and the Dark Side of the Age of Aquarius*, New York: Disinformation 2003

Lachman, Gary (2003): *A Secret History of Consciousness*, Great Barrington: Lindisfarne Books

Lachman, Gary (2008): *Politics and the Occult – The Left, the Right, and the Radically Unseen*, Wheaton: Quest Books

Lachman, Gary (2012): *Madame Blavatsky – The Mother of Modern Spirituality*, New York: Jeremy P. Tarcher/Penguin

Laing, R. D. (1967): *The Politics of Experience and The Bird of Paradise*, London: Penguin Books 1990

Leary, Timothy (1980): *The Politics of Ecstacy*, Berkeley: Ronin Publishing 1998

Lee, Martin A. & Bruce Shlain (1985): *Acid Dreams – The Complete Social History of LSD: The CIA, The Sixties and Beyond*, New York: Grove Press 1992

Lemke, Thomas (2011): *Biopolitics – An Advanced Introduction*, trans. E. F. Trump, New York: New York University Press

Lessing, Doris (1981): *The Sirian Experiment*, London: Flamingo 1994

Levy, Martin (2012): 'Dialectics of Liberation Congress and Radical Education', in: Jakobsen 2012a: 14-15

Lippard, Lucy R. (ed.) (1973): *Six Years: The dematerialization of the art object from 1966 to 1972*, Berkeley: University of California Press 2001

London Access Point (1991). Interview. June 1991. available from http://www.sacred-texts.com/eso/topy/intrview.txt (accessed 301010)

Lord, Evelyn (2010): *The Hellfire Clubs: Sex, Satanism and Secret Societies*, New Haven: Yale University Press

Lotringer, Sylvère (ed.) (2007): *The German Issue*, Los Angeles: Semiotext(e)

Lotringer, Sylvére & C. Marazzi (eds.) (2007): *Autonomia: Post-Politica Politics*, Los Angeles: Semiotext(e)

Louv, Jason (2006): 'Introduction – On the Way to Thee Garden', in: P-Orridge 2009: 17-28

Lovink, Geert & David Garcia (1997): *The ABCs of Tactical Media*, from: http://www.ljudmila.org/nettime/zkp4/74.htm – accessed 040111

Lunghi, Alessio & S. Wheeler (eds.) (2012): *Occupy Everything – Reflections on why it's kicking off everywhere*, Wivenhoe: Minor Compositions

M

Madoff, Steven Henry (ed.) (2009): *Art School (Propositions for the 21st Century)*, Cambridge: MIT Press

Mailer, Norman (1968): *The Armies of the Night*, London: Plume 1994

Marcus, Greil (1989): *Lipstick Traces – A Secret History of the Twentieth Century*, Cambridge: Harvard University Press 2003

Marcuse, Herbert (1965): 'Repressive Tolerance', in: Robert Paul Wolff, Barrington Moore, jr., and Herbert Marcuse (1969): *A Critique of Pure Tolerance*, Boston: Beacon Press, pp. 95-137

Marihuana, Marihuana (1972), dir. J. Wadhawen, Chronos Films

Marinetti, Filippo (1909): 'The Foundation and Manifesto of Futurism', in: F. Marinetti: *Critical Writings*, ed. G. Berghaus, transl. D. Thompson, New York: Farrar, Straus and Giroux 2006

Marshall, Peter (1992): *Demanding the Impossible – A History of Anarchism*, London: Fontana Press 1993

Martin, Jim (1991): 'Orgone Addicts: Wilhelm Reich versus the Situationists', in: Home 1996: 173-191

Marx, Karl (1858): *Grundrisse – Foundations of the Critique of Political Economy (Rough Draft)*, trans. M Nicolaus, London: Penguin Books 1993

Marx, Karl and Friedrich Engels (1845): *The German Ideology*, New York: Prometheus Books 1998

Marx, Karl and Friedrich Engels (1848): *The Communist Manifesto*, ed. G. S. Jones, London: Penguin Books 2002

Massumi, Brian (1992): *A User's Guide to Capitalism and Schizophrenia – Deviations from Deleuze and Guattari*, Cambridge: The MIT Press

May, Todd (1994): *The Political Philosophy of Poststructuralist Anarchism*, State College: The Pennsylvania State University Press

McGrath, Tom (1985): 'Remembering Alex Trocchi', in: *Edinburgh Review 70 – Trocchi Number*, August 1985, pp. 36-47

McKay, George (1996): *Senseless Acts of Beauty: Cultures of Resistance since the Sixties*, London: Verso

Metzger, Richard (ed.) (2003): *Book of Lies – The Disinformation Guide to Magick and the Occult*, New York: Disinformation 2009

Miles, Barry (1993): *William Burroughs – El Hombre Invisible*, London: Virgin Books 2010

Miles, Barry (2010): *London Calling – A Countercultural History of London Since 1945*, London: Atlantic Books

Miller, Ron (2002): *Free Schools, Free People – Education and Democracy After the 1960s*, New York: State University of New York Press.

Miller, Russell (1987): *Bare-Faced Messiah – The True Story of L. Ron Hubbard*, London: Penguin Books

Monroe, Alexei (2005): *Interrogation Machine – Laibach and NSK*, Cambridge and London: The MIT Press

Monroe, Robert A. (1972): *Journeys Out of the Body*, London: Souvenir Press 2012

Morgan, Ted (1988): *Literary Outlaw: The Life and Times of William Burroughs*, New York: Avon

Morris, William (1890): *News from Nowhere and Other Writings*, London: Penguin Books 2004

Morrison, Grant (2003): 'Pop Magic!', in: Metzger 2003: 16 – 25

Mullan, Bob (1995): *Mad to be Normal – Conversations with R. D. Laing*, London: Free Association Books

Müntzer, Thomas (1524): *Sermon to the Princes*, trans. M. G. Baylor, London: Verso 2010

N

Naipaul, V. S. (1974): 'Michael X and the Black Power Killings in Trinidad', in: *The Return of Eva Peron and the Killings in Trinidad*, London: André Deutsch 1980, pp. 11-92

Nancy, Jean-Luc (1986): *The Inoperative Community*, trans. P. Connor et al., Minneapolis & London: University of Minnesota Press 2008

Nash, Jørgen et al. (1962): 'The Struggle for the Situcratic Society', in: Jacqueline de Jong (ed.): *The Situationist Times*, no. 2

Neal, Charles (ed.) (1987): *Tape Delay*, Wembley: SAF Publishing Ltd 1992

Neill, Alexander S. (1960): *Summerhill: A Radical Approach to Education*, London: Penguin Books 1970

Neville, Richard (1970): *Playpower*, London: Paladin 1971

New Collectivism (eds.) (1991): *Neue Slovenische Kunst*, Los Angeles: AMOK Books

Newman, Saul (2007): *From Bakunin to Lacan: Anti-Authoritarianism and the Dislocation of Power*, Lanham: Lexington Books

Niedzviecki, Hal (2006): *Hello, I'm Special: How Individuality Became the New Conformity*, San Francisco: City Lights Books

Norse, Harold (1968): 'Free University of Love', in: Jakobsen 2012a: 39

Noys, Benjamin (2011): *Communization and its Discontents – Contestation, Critique, and Contemporary Struggles*, Wivenhoe: Minor Compositions

Nuttall, Jeff (1968): *Bomb Culture*, London: Paladin 1971

O

O'Neill, Paul & Mick Wilson (eds.) (2010): *Curating and the Educational Turn*, Amsterdam: Open Editions

Opstrup, Kasper (2004): 'Am I Evil?', in: A. Bonnesen, S. E. Jepsen et al. (eds.): *Formskrift*, Copenhagen: Det Kongelige Danske Kunstakademi, pp. 105-114

Opstrup, Kasper (2009): 'Instead of the Past, the Future!", in: K. Veel & K. W. Meyhoff (eds.): *The Cultural Life of Catastrophes*, TBC

Opstrup, Kasper (2012): 'A Heart of Concrete Through Fire and Water', in: A. Dunn & J. MacPhee (eds.): *Signal 02*, Oakland: PM Press, pp. 142-159

Ozmon, Howard (1969): *Utopias and Education*, Minneapolis: Burgess Publishing

P

Papadopoulos, Dimitris, Niamh Stephenson and Vassilic Tsianos (2008): *Escape Routes – Control and Subversion in the 21st Century*, London: Pluto Press

Parker, Martin (ed.) (2002): *Utopia and Organization*, Oxford: Blackwell Publishing

Pauwels, Louis and Jacques Bergier (1960): *The Morning of the Magicians – Secret Societies, Conspiracies and Vanished Civilizations*, Vermont: Destiny Books 2009

Pekar, Harvey, G. Dumm et al. (2008): *Students for a Democratic Society – A Graphic History*, New York: Hill and Wang 2009

Pendle, George (2005): *Strange Angel – The Otherworldly Life of Rocket Scientist John Whiteside Parsons*, London: Phoenix 2006

Performance (1970), dir. Donald Cammell & Nicolas Roeg, Goodtimes Enterprises

Pias, Claus (ed.) (2004): *Cybernetics – Kybernetik – The Macy Conferences 1946-53*, Zürich: Diaphanes Verlag 2004

Pinchbeck, Daniel (2002): *Breaking Open the Head – A Psychedelic Journey into the Heart of Contemporary Shamanism*, New York: Broadway Books 2003

Plant, Sadie (1990): 'The Situationist International: A Case of Spectacular Neglect', in: Home 1996: 153-172

Plant, Sadie (1992): *The Most Radical Gesture*, New York: Routledge 2006

Plant, Sadie (1999): *Writings on Drugs*, London: Faber & Faber

P-Orridge, Genesis Breyer et al (1982): 'Thee Grey Book', in: P-Orridge 2009b: 37-50

P-Orridge, Genesis Breyer (1994). Interview with Philip H. Farber. Available at http://genesisporridgearchive.blogspot.com/search/label/Interviews (accessed 291010)

P-Orridge, Genesis Breyer (2006): 'Magick Squares and Future Beats: The Magickal Process and Methods of William S. Burroughs and Brion Gysin', in: P-Orridge 2009b: 275 – 298

P-Orridge, Genesis Breyer (2008): 'Thee Process is thee Product', in: P-Orridge 2009b: 401 – 430

P-Orridge, Genesis Breyer (2009a): 'Thee Process is thee Product – The Processean Influence on Thee Temple Ov Psychick Youth', in: Wyllie 2009: 173-184

P-Orridge, Genesis Breyer (2009b): *Thee Psychick Bible: Thee Apocryphal Scriptures ov Genesis Breyer P-Orridge and the Third Mind ov Thee Temple Ov Psychick Youth*, Port Townsend: Feral House

R

Rancière, Jacques (1987): *The Ignorant Schoolmaster – Five Lessons in Intellectual Emancipation*, trans. K. Ross, Stanford: Stanford University Press 1991

Rancière, Jacques (2000): *The Politics of Aesthetics*, trans. G. Rockhill. London: Continuum 2007

Rasmussen, Mikkel Bolt (2011): 'Scattered (Western Marxist-Style) Remarks about Contemporary Art, Its Contradictions and Difficulties', in: *Third Text*, Vol. 25, Issue 2, pp. 199 – 210

Rasmussen, Mikkel Bolt & J. Jakobsen (eds.) (2011): *Expect Anything, Fear Nothing – The Situationist Movement in Scandinavia and Elsewhere*, Copenhagen: Nebula

Raunig, Gerald (2007): *Art and Revolution: Transversal Activism in the Long Twentieth Century*, trans. A. Derieg, Los Angeles: Semiotext(e)

Raunig, Gerald & Gene Ray (eds.) (2009): *Art and Contemporary Critical Practice – Reinventing Institutional Critique*, London: MayFlyBooks

Ravenscroft, Trevor (1973): *Spear of Destiny*, York Beach: Samuel Weiser, Inc 1982

Regardie, Israel (1971): *The Original Account of the Teachings, Rites and Ceremonies of the Hermetic Order of the Golden Dawn*, 6th ed., Woodbury: Llewellyn Publications 2012

Richardson, Michael (1994): 'Introduction', in: Bataille 1994: 1 - 27

Roberts, Andy (2012): *Albion Dreaming - A popular history of LSD in Britain*, Padstow: Marshall Cavendish Editions

Roberts, John & S. Wright (eds.) (1994): *Third Text*, vol. 18, issue 6

Robertson, George (1988): 'The Situationist International: Its Penetration into British Culture', in: Home 1996: 107 - 133

Robinson, Edward S. (2011): *Cut-Up Narratives from William S. Burroughs to the Present*, Amsterdam: Rodopi

Rosen, Philip (ed.) (1986): *Narrative, Apparatus, Ideology: A Film Theory Reader*, New York: Columbia University Press

Rosenthal, Bernice Glatzer (ed.) (1997): *The Occult in Russian and Soviet Culture*, New York: Cornell University Press

Rosemont, Franklin & C. Radcliffe (eds.) (2005): *Dancin' In the Streets! - Anarchists, IWWs, Surrealists, Situationists & Provos in the 1960s As Recorded In the Pages of The Rebel Worker & Heatwave*, Chicago: Charles H. Kerr Publishing Company

Roszak, Theodore (1969): *The Making of a Counter Culture*, Berkeley and Los Angeles: University of California Press 1995

Roszak, Theodore (1975): *Unfinished Animal - The Aquarian Frontier and the Evolution of Consciousness*, London: Harper & Row 1977

Roszak, Theodore (1991): *Flicker*, Harpenden: No Exit Press 2009

Rousselle, Duane & S. Evren (eds.) (2011): *Post-Anarchism: A Reader*, London: Pluto Press

Rumney, Ralph (1999): *The Consul*, trans. M. Inrie, London: Verso 2002

S

Sadler, Simon (1998): *The Situationist City*, Cambridge: The MIT Press 1999

Sanders, Ed (2002): *The Family*, revised and updated edition, Cambridge: Da Capo Press

Savage, Jon (1983): 'Introduction', in: Vale 1983: 4-5

Sartwell, Crispin (2010): *Political Aesthetics*, Ithaca and London: Cornell University Press

Schneemann, Carolee (1991): 'interview with Andrea Juni', in: Vale et al 1991: 66-77

Schneemann, Carolee (2010): *Correspondence Course – An epistolary history of Carolee Schneemann and her circle*, ed. K. Stiles, London: Duke University Press

Sconce, Jeffrey (2000): *Haunted Media: Electronic Presence from Telegraphy to Television*, Durham & London: Duke University Press 2007

Scott, Andrew Murray (1991): *Alexander Trocchi – The Making of the Monster*, Edinburgh: Polygon

Scott, James C. (1990): *Domination and the Arts of Resistance: Hidden Transcripts*, New Haven: Yale University Press

Sedgwick, Peter (1982): *Psycho Politics*, London: Pluto Press 1987

Shaviro, Steven (2011): 'More on (or against) biopolitics)', from: http://www.shaviro.com/Blog/?cat=12&paged=2, accessed 010512

Sheikh, Simon (2009): 'Notes on Institutional Critique', in: Raunig et al 2009: 29-32

Sholette, Gregory (2011): *Dark Matter: Art and Politics in the Age of Enterprise Culture*, London and New York: Pluto Press

Shukaitis, Stevphen (2009): *Imaginal Machines – Autonomy & Self-Organization in the Revolutions of Everyday Life*, London: Minor Compositions

Shukaitis, Stevphen and Joanna Figiel (eds.) (2012): 'Guest Editorial', in: *Subjectivity*, Vol. 5, Issue 1, pp. 1-14

Sigal, Clancy (1976): *Zone of the Interior*, West Yorkshire: Pomona 2005

Sinclair, Iain (1971): *The Kodak Mantra Diaries*, London: Beat Scene magazine 2006

Situationist International, The (1960): 'Situationist Manifesto', trans. F. Thompsett, from: http://www.infopool.org.uk/6003.html

Situationist International, The (1961): 'Instructions for an Insurrection', in: Knabb 1981: 84-86

Situationist International, The (1963): 'The Counter-Situationist Campaign in Various Countries', in: Knabb 1981: 145-149

Skinner, B. F. (1971): *Beyond Freedom and Dignity*, Indianapolis/Cambridge: Hackett Publishing Company, Inc. 2002

Slater, Howard (1989): 'Alexander Trocchi & Project Sigma', in: Jakobsen 2012: 27-30

Slater, Howard (2001): 'Divided We Stand – An Outline of Scandinavian Situationism', in: J. Jakobsen (ed.): *Infopool*, no. 4

Slater, Howard (2012a): "Anomie/Bonhomie: Notes Toward the 'Affective Classes'", in: Slater 2012b: 70-136

Slater, Howard (2012b): *Anomie/Bonhomie & Other Writings*, London: Mute Books

Sorel, Georges (1908). *Reflections on Violence*, trans. T. E. Hulme and J. Roth. Mineola, New York: Dover Publications 2004.

Standish, David (2006): *Hollow Earth: The Long and Curious History of Imagining Strange Lands, Fantastical Creatures, Advanced Civilizations, and Marvelous Machines Below the Earth's Surface*, Cambridge: Da Capo Press

Steiner, Juri & S. Zweifel (eds.) (2006): *In Girum Imus Nocte Et Consumimur Igni: Die Situationistische Internationale (1957-1972)*, JRP/Ringier Kunstverlag

Sternhell, Zeev (1989): *The Birth of Fascist Ideology*, trans. D. Maisel, Princeton: Princeton University Press 1995

Stevens, Matthew Levi (2012): *The Forgotten Agent & The Magical Universe of William S. Burroughs*, London: Wholly Books

Stevens, Matthew Levi & Emma Doeve (eds.) (2012): *Academy 23 – An Unofficial Celebration of William S. Burroughs & 'The Final Academy'*, London: Wholly Books

Stewart, Sean (2011): *On the Ground – An Illustrated Anecdotal History of the Sixties Underground Press in the US*, New York: PM Press

Stimson, Blake & G. Sholette (eds.) (2007): *Collectivism After Modernism: The Art of Social Imagination After 1945*, Minneapolis: University of Minneapolis Press

Stirner, Max (1845): *The Ego and His Own – The Case of the Individual Against Authority*, trans. S. T. Byington, New York: Dover Publications 2005

Stoekl, Allan (1985): 'Introduction', in: G. Bataille: *Visions of Excess – Selected Writings, 1927-1939*, Minneapolis: University of Minnesota Press 2008, pp. ix-xxv

Stojanović, Jelena (2007): 'Internationaleries: Collectivism, the Grotesque, and Cold War Functionalism', in: B. Stimson and G. Sholette (ed.) (2007): *Collectivism After Modernism – The Art of Social Imagination After 1945*, Minneapolis: University of Minnesota Press, pp. 17-44

Suissa, Judith (2006): *Anarchism and Education*, Oakland: PM Press 2010

Synaesthesia (1997-2001), dir. Tony Oursler. Available from http://23narchy.com/synesthesia-genesis-p-orridge-1997-2001-tony

Szwed, John F. (1997): *Space Is the Place – The Life and Times of Sun Ra*, New York: Da Capo Press 1998

T

Taylor, Terry (1961): *Baron's Court, All Change*, London: New London Editions 2011

Thacker, Eugene (2010): *After Life*, Chicago: University of Chicago Press

Thacker, Eugene (2011): *In the Dust of This Planet*, Alresford: Zer0 Books

Thompson, Nato (ed.) (2012): *Living As Form – Socially Engaged Art From 1991 2011*, New York: Creative Time Books

Thompson, Nato & Gregory Sholette (eds.) (2004) *The Interventionists – User's Manual for the Creative Disruption of Everyday Life*, Boston: The MIT Press

Tiqqun (2010): *Introduction to Civil War*, trans. A. R. Galloway and J. E. Smith, Los Angeles: Semiotext(e)

Tiqqun (2011): *This Is Not a Program*, trans. J. D. Jordan, Los Angeles: Semiotext(e)

Tompsett, Fabian (2011a): 'Open Copenhagen', in: Rasmussen et al 2011: 46-74

Tompsett, Fabian (2011b). Personal interview. 25 May 2011

Toscano, Alberto (2010): *On Fanaticism*, London: Verso

Trocchi, Alexander (1960): *Cain's Book*, London: John Calder Publisher 1998

Trocchi, Alexander (ed.) (1964-7): *Sigma Portfolio 1 – 39*, London: sigma

Trocchi, Alexander (1966): 'Sigma', in: *International Times*, Vol. 1, issue 4, 1966, pp. 2

U

University for Strategic Optimism (2011): *Undressing the Academy, or The Student Handjob*, London: Minor Compositions

V

Vague, Tom (ed.) (2000): *King Mob Echo – English Section of the Situationist International*, London: Dark Star

Vale, V. (ed.) (1979): *RE/Search #4/5: W. S. Burroughs, B. Gysin, Throbbing Gristle*, San Francisco: RE/Search Publications 2007

Vale, V. (ed.) (1983): *RE/Search #6/7: Industrial Culture Handbook*, San Francisco: RE/Search Publications 2006

Vale, V. & A. Juno (eds.) (1989): *RE/Search #12: Modern Primitives – An Investigation of Contemporary Adornment and Ritual*, San Francisco: RE/Search Publications

Vale, V. & A. Juno (eds.) (1991): *Angry Women*, San Francisco: RE/Search Publications

Vaneigem, Raoul (1967): *The Revolution of Everyday Life*, trans. D. Nicholson Smith, London: Rebel Press 2003

Vaneigem, Raoul (1986): *The Movement of the Free Spirit*, New York: Zone Books 1998

Vaugh, Mark (ed.) (2006): *Summerhill and A. S. Neill*, Maidenhead: Open University Press

Vetter, Grant (2012): *The Architecture of Control – A Contribution to the Critique of the Science of Apparatuses*, Winchester: Zero Books

W

Walker, John A. (1995): *John Latham – The incidental person – his art and ideas*, London: Middlesex University Press

Wark, McKenzie (2008): *50 Years of Recuperation of the Situationist International*, New York: Princeton Architectural Press

Wark, McKenzie (2011): *The Beach Beneath the Street – The Everyday Life and Glorious Times of the Situationist International*, London: Verso

Wark, McKenzie (2013): *The Spectacle of Disintegration*, London: Verso

Wasserman, James (2012): *In the Center of the Fire – A Memory of the Occult 1966-1989*, Lake Worth: Ibis Press

Webb, James (1974): *The Occult Underground*, Chicago: Open Court 1990

Weir, David (1997): *Anarchy & Culture: The Aesthetic Politics of Modernism*, Amherst: University of Massachusetts Press

Wholly Communion (1965), dir. Peter Whitehead, Lorrimer Films

Williams, John L. (2008): *Michael X – A Life in Black and White*, London: Century

Wills, David S. (2013): *Scientologist! – William S. Burroughs and the 'Weird Cult'*, London: Beatdom Books

Wilson, Andrew (2005): 'Spontaneous Underground: An Introduction to London Psychedelic Scenes, 1965-68', in: C. Grunenberg and J. Harris (2005) (eds.): *Summer of Love – Psychedelic Art, Social Crisis and Counterculture in the 1960s*, Liverpool: Liverpool University Press/Tate Liverpool 2007, pp. 63-98

Wilson, Robert Anton & R. Shea (1975): *The Illuminatus! Trilogy*, London: Constable & Robinson Ltd 1998

Wilson, Robert Anton (1977): *Cosmic Trigger: Final Secret of the Illuminati*, Las Vegas: New Falcon Publications 2009

Wright, Steve (2002): *Storming Heaven – Class Composition and Struggle in Italian Autonomist Marxism*, London: Pluto Press

Wolfe, Tom (1968): *The Electric Kool-Aid Acid Test*, London: Black Swan Books 1989

Wyllie, Timothy et al. (2009): *Love Sex Fear Death: The Inside Story of the Process Church of the Final Judgment*, Port Townsend: Feral House

Y

Yates, Frances A. (1972): *The Rosicrucian Enlightenment*, New York: Routledge 2002

Young, George M. (2012): *The Russian Cosmists: The Esoteric Futurism of Nikolai Fedorov and His Followers*, Oxford: Oxford University Press

Z

Zerzan, John (1994): *Future Primitivism*, Brooklyn: Autonomedia

Zorach, Rebecca (2010): 'A Potpourri of Harangues: The Free University Movement in Chicago, 1965 – 1972', in: *Proximity*, issue 8, winter 2010, pp. 83 – 89

Ø

Ørum, Tania (2009): *De eksperimenterende tressere – kunst i en opbrudstid*, Copenhagen: Gyldendal

Minor Compositions

Other titles in the series:

Precarious Rhapsody – Franco "Bifo" Berardi

Imaginal Machines – Stevphen Shukaitis

New Lines of Alliance, New Spaces of Liberty – Felix Guattari and Antonio Negri

The Occupation Cookbook

User's Guide to Demanding the Impossible – Laboratory of Insurrectionary Imagination

Spectacular Capitalism – Richard Gilman-Opalsky

Markets Not Capitalism – Ed. Gary Chartier & Charles W. Johnson

Revolutions in Reverse – David Graeber

Undressing the Academy – University for Strategic Optimism

Communization & its Discontents – Ed. Benjamin Noys

19 & 20 – Colectivo Situaciones

El Martillo – Eclectic Electric Collective

Occupy everything! Reflections on 'why its kicking off everywhere' – Ed. Alessio Lunghi and Seth Wheeler

Punkademics – Ed. Zach Furness

[Open] Utopia – Thomas Moore & Stephen Duncombe

Contract & Contagion – Angela Mitropoulos

Squatting in Europe – Squatting Europe Kollective

Artpolitik: Social Anarchist Aesthetics in an Age of Fragmentation – Neala Schleuning

The Undercommons – Fred Moten & Stefano Harney

Nanopolitics Handbook – Nanopolitics Group

Precarious Communism: Manifest Mutations, Manifesto Detourned – Richard Gilman-Opalsky

FutureChe – John Gruntfest & Richard Gilman-Opalsky

Lives of the Orange Men – Major Waldemar Fydrich

State in Time – Irwin

Crisis to Insurrection – Mikkel Bolt Rasmussen

Occupation Culture – Alan W. Moore

Forthcoming:

Micropolitics of Play – Ed. Dimitrina Sevova

Islam & Anarchism – Mohamed Jean Veneuse

Art, Production and Social Movement – Ed. Gavin Grindon

Hypothesis 891 – Colectivo Situaciones

Learn to Listen – Carlos Lenkersdorf

A Short Philosophical Dictionary of Anarchism from Proudhon to Deleuze – Daniel Colson

 As well as a multitude to come…